HUNDREDS AND THOUSANDS:
THE JOURNALS OF AN ARTIST

EMILY CARR

HUNDREDS AND THOUSANDS: THE JOURNALS OF AN ARTIST

Irwin Publishing
Toronto, Canada

Copyright © 1966 Irwin Publishing Inc.

Canadian Cataloguing in Publication Data

Carr, Emily, 1871-1945.
 Hundreds and thousands

Originally published: Toronto: Clarke Irwin 1966.
ISBN 0-7725-1617-0

1. Carr, Emily, 1871-1945. 2. Painters — Canada —
Biography. I. Title.

ND249.C3A2 1986 759.11 C86-093171-4

Cover painting: *Red Cedar* by Emily Carr
 Reproduced by permission

Printed in Canada by Webcom Limited

Published by Irwin Publishing Inc.

Preface

Why call this manuscript *Hundreds and Thousands*? Because it is made up of scraps of nothing which, put together, made the trimming and furnished the sweetness for what might otherwise have been a drab life sucked away without crunch. Hundreds and Thousands are minute candies made in England—round sweetnesses, all colours and so small that separately they are not worth eating. But to eat them as we ate them in childhood was a different matter. Father would take the big fat bottle off his sample shelf in his office and say, "Hold out your hands." Father tipped and poured, and down bobbed our three hands and out came our three tongues and licked in the Hundreds and Thousands, and lapped them up, lovely and sweet and crunchy.

It was these tiny things that, collectively, taught me how to live. Too insignificant to have been considered individually, but like the Hundreds and Thousands lapped up and sticking to our moist tongues, the little scraps and nothingnesses of my life have made a definite pattern. Only now, when the river has nearly reached the sea and small eddies gush up into the river's mouth and repulse the sluggish onflow, have they made a pattern in the mud flats, before gurgling out into the sea. Thank you, tiny Hundreds and Thousands. Thanks, before you merge into the great waters.

From a notebook found among Miss Carr's papers

Contents

Publisher's Foreword

From letters found among her papers we know that Emily Carr intended her journals to be published. She even thought of the title, *Hundreds and Thousands*, and her explanation of the choice is contained in the preface to this volume. In a letter to Ira Dilworth, her literary executor, she says, "I have been planning all summer to do with *Hundreds and Thousands* as I did with the Biography and give it to you as my Christmas present. Of course it will be yours in any case, but perhaps it would seem especially yours that way. . . . I think it is something I shall have to keep working on as long as I live."

In the journals Miss Carr poured out her private thoughts. The notebooks were, she said, "to jot me down in, unvarnished me, old at fifty-eight. . . ." What emerges is indeed the unvarnished Emily Carr, who often felt old and tired and crotchety, often discouraged and doubting, but who was always honest and true to her own ideals. The jottings present a vivid, revealing self-portrait of an intensely interesting person.

The work of preparing the journals for publication was commenced by Ira Dilworth after Miss Carr's death. He began the monumental task of transcribing the notebooks from the artist's handwriting. The publishers have carried on where he left off, with the support of Dr. Dilworth's niece and heir, Mrs. Phyllis Inglis of Vancouver.

In this task the publishers have taken as their guide the author's expressed views on the editing of her writing. She objected violently

to being polished and said at one point, "I don't know how much one should be influenced by critics. I *do know* my mechanics are poor. I realize that when I read good literature, but I know lots of excellently written stuff says nothing. Is it better to say nothing politely or to say *something* poorly? I suppose only if one says something ultra-honest, ultra-true, some deep realizing of life, can it make the grade, ride over the top, having surmounted mechanics." At another point she said, "Flora is correcting and it galls me. She has command of English; I have not. I am glad of the help; I want it. But when she and Ruth have finished with them, I hate my manuscripts. I feel that the writer (me) is a pedantic prig. If they'd only *punctuate* and let me be me and leave them at the best I can do. . . ." Taking this as their terms of reference, the publishers have refrained from tidying up the author's sentences, but have sought always to preserve the spontaneous eccentricities of her style.

They are grateful for the interest evinced by friends of Emily Carr who have checked names and supplied useful information. They are particularly indebted to Miss Flora Burns in this respect, but Mr. Willard Ireland, Miss Ruth Humphrey, Mrs. Nan Cheney, Mrs. Doris Shadbolt, Miss Margaret Clay and Dr. Dorothy Dallas were also helpful, as were many others who knew the artist and her work.

The publishers greatly appreciate the courtesy of the owners of Emily Carr paintings contained in this volume: the Vancouver Art Gallery; Dr. and Mrs. Max Stern of the Dominion Gallery, Montreal; the Provincial Archives of British Columbia; Mr. C. S. Band; Mr. G. I. Clarke; and Dr. W. H. Clarke.

HUNDREDS AND THOUSANDS:
THE JOURNALS OF AN ARTIST

Meeting with the
Group of Seven, 1927

Thursday, November 10th

I left home Tuesday night, November 8th. Called at the Vancouver Art School and met Mr. Varley. He was very pleasant, and took me home with him. His sketches most delightful, appealingly Canadian, a new delineation of a great country. Mrs. Varley, a dear little woman, gave me warm welcome.

12 o'clock noon. We have passed through a vast mileage of fireswept mountain country—snow, and ground with dark stubs standing and lying till they form a black and white check pattern across the snow-covered hills, and the green-grey river at their base. It is mysterious, weird. Now we are in heavier pine-wooded country and it is snowing hard. The trees are heavy with it. There is a cold, mysterious wonder amid the trees. They are not so densely packed but that you can pass in imagination among them, wonder what mysteries lie in their quiet fastness, what creeping living things, what God-filled spaces totally untrod, what voices in an unknown tongue.

2:15 p.m. Ten minutes at Blue River. Had a good walk in the snow. Entered quite a little settlement. The higher mountains are wrapped in snow mists. Oblivious, though, the sun shines coldly, touching the snow here and there with patches of pale gold. What a lot of different varieties of pines there are! Why? How does the seed of different species get here? There are lots of slim straight cedars too. We have left the green river now and are running beside a brown one. The patches of snow and half-frozen ice look like water-lilies. Since we left the ranges with the brown cattle with white

3

faces, we have seen no living creature. There are many little lonely roofless cabins of rough logs proudly used when the road was in construction. How desolate they look!

I should like, when I am through with this body and my spirit released, to float up those wonderful mountain passes and ravines and feed on the silence and wonder—no fear, no bodily discomfort, just space and silence. A logging camp, grey shacks hung thick with icicles, and ruddy-faced men pausing with big hooks in their hands to watch us pass. We're on a down grade. Daylight is drawing in and it is only 3 o'clock.

Friday, November 11th

8:00 a.m. We have stopped at Edmonton and are on our way again. As we were late we did not stay long. Edmonton was awake; tram cars running and lights everywhere at 6:30. The night was a slow affair. We were going over muskeg beds and the travel was rough and jerky with frequent stops. We were late. We have left the mountains now. It is flat, brown and white; snow and dry grass and low, scrubby, bare trees. Grain elevators everywhere.

11:00 a.m. Wainwright. Had a nice brisk walk for ten minutes and made friends with a big kind dog. Bright sunshine, snow, but not so cold. Large stuffed buffalo in glass case at station to advertise the buffalo preserve at Wainwright.

Saskatoon. Held up here one and a half hours already. I took a half-hour's brisk walk, then we were bustled on to the train, but though the doors were shut we are still here. Saskatoon is a big town. The station was crowded and bustling. It was cold and clear, but not so cold as Edmonton as there was no wind.

Saturday, November 12th

1:30 p.m. Arrived Winnipeg. The fatherly porter set me on the way. Winnipeg cold and sunshiny. Streets glibbed with ice. Had lunch in the station and then set out for a walk, but everyone I asked the way of was foreign. The Westerners are gentler, more refined, than the prairie folk, who look much foreigner and less British. They are all running hither and thither huddled in fur coats. Guess they'd have to or they'd freeze in their tracks. It was 5° below this morning in Winnipeg.

It's snow everywhere. The pine trees are different to ours. They are much smaller and straight from top to bottom, not pyramidal like the Western ones. I saw one little bird flutter up, the only living thing in all these miles.

Sunday, November 13th

7:40 a.m. Arrived in Toronto. Went straight to Mrs. Mather's. When they saw it was me the welcome was warm. I spent the day there till late afternoon. Then we found a hotel, the Tuxedo, 504 Sherbourne Street.

Monday, November 14th

Slept till nearly noon. Went with Miss Buell and Mrs. Housser to tea at Mr. A. Y. Jackson's Studio Building. I loved his things, particularly some snow things of Quebec and three canvases up Skeena River. I felt a little as if beaten at my own game. His Indian pictures have something mine lack—rhythm, poetry. Mine are so downright. But perhaps his haven't quite the love in them of the people and the country that mine have. How could they? He is not a Westerner and I took no liberties. I worked for history and cold fact. Next time I paint Indians I'm going off on a tangent tear. There is something bigger than fact: the underlying spirit, all it stands for, the mood, the vastness, the wildness, the Western breath of go-to-the-devil-if-you-don't-like-it, the eternal big spaceness of it. Oh the West! I'm of it and I love it.

Tuesday, November 15th

Today I am going to Mr. Arthur Lismer's studio and see his things. These men are very interesting and big and inspiring, so different from the foolish little artists filled with conceit that one usually meets. They have arrested the art world. They are not afraid of adverse criticisms. They are big and courageous. I know they are building an art worthy of our great country, and I want to have my share, to put in a little spoke for the West, one woman holding up my end. I feel the group will be dissatisfied when they see my work and I think I could do better now I know they're there. I *must* get back to it and let other things go. If not, my chance is gone. I've not so much time left now. Every year after sixty one is going downhill

in vitality. Soon I'll reach that mark. Perhaps it will be easier after this trip and the girls may not feel it quite such a waste of time, a useless quest.

Wednesday, November 16th

I have met the third of the "Group of Seven," Arthur Lismer. I don't feel as if these men are strangers. Somehow they wake an instant response in me. Lismer's two last pictures gave me a feeling of exhilaration and joy. All his works are fine, but he is going on to higher and bigger things, sweep and rhythm of the lines, stronger colours, simpler forms. He was extremely nice. I wonder if these men feel, as I do, that there is a common chord struck between us. No, I don't believe they feel so toward a woman. I'm way behind them in drawing and in composition and rhythm and planes, but I know inside me what they're after and I feel that perhaps, given a chance, I could get it too. Ah, how I have wasted the years! But there are still a few left.

Lismer's studio is apart from his house, warm and light and quiet —ideal. He has only recently quit teaching at the Toronto School of Art. The "other element" made things impossible for him. He is lecturing now, spreading the gladness of the newer way, revealing the big, grand things of our country to its sons and daughters without the fret and carping of his students or the scorn of his adversaries. He is spreading his wings and soaring up, up! He is more poetical than Mr. Jackson, but Mr. Jackson is steady and strong. His feet are planted firmly and he has the grit to push and struggle and square his shoulders and stand by the others and by his convictions. He is still young in years but old. Probably the war did that. Oh, they're very fine! I'm glad, glad I have seen them and their work. Tomorrow I shall meet Lawren Harris, another of them.

Thursday, November 17th

Oh, God, what have I seen? Where have I been? Something has spoken to the very soul of me, wonderful, mighty, not of this world. Chords way down in my being have been touched. Dumb notes have struck chords of wonderful tone. Something has called out of somewhere. Something in me is trying to answer.

It is surging through my whole being, the wonder of it all, like a great river rushing on, dark and turbulent, and rushing and irresistible, carrying me away on its wild swirl like a helpless little bundle of wreckage. Where, where? Oh, these men, this Group of Seven, what have they created?—a world stripped of earthiness, shorn of fretting details, purged, purified; a naked soul, pure and unashamed; lovely spaces filled with wonderful serenity. What language do they speak, those silent, awe-filled spaces? I do not know. Wait and listen; you shall hear by and by. I long to hear and yet I'm half afraid. I think perhaps I shall find God here, the God I've longed and hunted for and failed to find. Always he's seemed nearer out in the big spaces, sometimes almost within reach but never quite. Perhaps in this newer, wider, space-filled vision I shall find him.

Jackson, Johnson, Varley, Lismer, Harris—up-up-up-up-up! Lismer and Harris stir me most. Lismer is swirling, sweeping on, but Harris is rising into serene, uplifted planes, above the swirl into holy places.

Friday, November 18th
I wrote and read late into the night. Around 3 o'clock I slept heavily and always I was away in that new world of planes and spaces. Never have they been absent a minute from my consciousness. I must talk with Mr. Harris again. He told me to go back. I'm going and I want to go alone. I want to see again "Above Lake Superior" and that stern mountain cradling the cloud. I want to see them all, but those two I *must* see before I go West again. I am tired today. Yesterday I was so deeply stirred, moved beyond what I can express. It has exhausted me.

Miss Buell and I went to MacDonald's studio today. His son, Thoreau, a boy all spirit, almost too fine to stay down on this earth, showed us his father's things, Mr. MacDonald himself being at his school teaching. The boy is clever and will do great things one day (if he lives). They all speak of him as something apart. They say his mother is a lovely woman. In this atmosphere of intimacy with the Group, how could such a sensitive soul fail to rise to wonderful heights?

Mr. MacDonald's canvases were big and fine—lovely design and

7

sometimes good colour. At other times I found them a little hot and heavy and earthy. I enjoyed them greatly but without thrill. They waked few emotions in me. "The Tangled Garden" I liked about the best. Possibly I may see more in Ottawa and understand his things more.

I left my glasses in MacDonald's studio. Tomorrow I shall go for them and, if I can bear it, I will go and see if Lawren Harris is in and ask to see his things again. He meant it when he said, "Come back again." They have been good to me, these men. Harris said to me as he brought out his things, "If you see anything you can suggest, just mention it, will you?"

Me? "I know nothing," I said.

"You are one of us," was his reply.

Oh, how wonderful to think they feel that! Their works call to my very soul. Will they know what's in me by those old Indian pictures, or will they feel disappointment and find me small and weak and fretful? Have the carps and frets and worries that have eaten into my soul, since I returned from Paris full of ambitions and then had to struggle out there alone, made me small and mean, poor and petty—bitter? They too have had to struggle and buffet and battle, but they've stood together and the fire in them has burned steadily. They're rising above it with sincerity and bigness and courage. They've forged ahead, helping each other, sympathizing, strengthening each other and straightening out the way, working vitally and serenely. Surely a movement that has such men for its foundation must prevail and live and become an honoured glory to our land. If I could pray, if I knew where to find a god to pray to, I would pray, "God bless the Group of Seven."

Saturday, November 19th
Rhythm and space, space and rhythm, how can I learn more about these? Well, old girl, you'll have to get down and *dig*.

Thoreau has returned my glasses to the Arts and Crafts. I'm sorry. Now I have no excuse to visit MacDonald. It doesn't seem fair to disturb those workers again, though I know they are big-hearted enough to help one. I've got to go and shop. How I hate it! And there's a tea this afternoon. I don't care about that.

10:00 p.m. I *did* care. The Houssers were delightful. Mr. Housser feels so strongly with the Group. He's surely one of them in spirit. His wife is painting too. He has two splendid canvases of Harris's, a Lismer, a MacDonald and a Jackson. They live on a hill-top in a beautiful new house. Mr. Housser is a newspaper man.

Monday, November 21st
This morning I left to go to Carol's by the 8:45 train but the train was 7:45. As there was no other train, I hustled off and saw about my ticket and money. Both happened to be in the same building. Then I got price lists from the Artist's Supply, 77 York Street, had lunch, and took the 1:30 train to Ottawa—a long, hard, hot, horrid trip. The train was stifling and smelly. I watched the country. Rather nice—no snow but rain. Jolly farm country with queer gaunt houses set down anyhow. No gardens. Straight up and down with a peak gable and small windows, sitting uncomfortably with no compromise. Dark set in early and the landscape was blotted out. I'm wondering if Carol's disappointed, poor kid, but I really couldn't go back and take a room at the hotel for one night with my things all at the station.

Tuesday, November 22nd
I went up to the museum about 11:30 and asked for Mr. Brown. I entered the upper office and there they all were, Mr. Brown, Mr. Barbeau, Mr. Holgate, Mr. Lismer, Mr. Pepper, Peggy Nicol and Mr. McCurry. They gave me a royal welcome and we went down to the lower floor. There sat the exhibition all round the floor. They were just starting to hang it. There are ripping things of Langdon Kihn, and Mr. Holgate and Mr. Jackson. I felt my work looked dead and dull, but they all say I have more of the spirit of the Indian than the others. They were lovely to me about them. Peggy Nicol paints too, Indian things, but they're feeble. Poor kid, she's so enthusiastic, a dear little soul, and perhaps it will carry her on. She's young.

Mr. Brown took us to lunch. There were Lismer, Holgate, Peggy, the Browns and I. We were all happy and gay and the Browns' flat is charming. Afterwards Peggy took me to collect my things. We went to my room and then on to the gallery for the rest of the afternoon.

9

I just longed to buckle to and do some of the hanging. Men talk and squint and haggle so long over hanging. Holgate's things are ripping, so strong. He asked me if any of my watercolours were for sale, and the rugs.

Mr. Barbeau and Mr. Lismer called for me, after I'd dined at Bromley Hall and met some people. The Barbeaus' home is delightful and she is just charming. I saw the two dear little kids in bed. Mr. Pepper and Mr. Holgate came in and we spent a delightful evening talking. Mr. Barbeau beat a great Indian drum and sang some Indian songs that were very touching and real. I did not get home till 12 o'clock. It was a delightful evening with a touch of the foreign; both Mr. and Mrs. Barbeau are French. Supper was wine and dainty sandwiches and French pastries.

Mr. Lismer has gone back to Toronto. He asked me to look him up again when I go back. How nice they are, these big, earnest painters! They make painting so worth while. I almost feel as if I were home. Three of my things were on Barbeau's wall. The gallery was strewn with them, and my rugs and pots. He's not showing the watercolours. They are for some other show that comes later.

Sunday, November 27th

Lots has happened. It has been a full and happy week. They've all been so lovely. Yesterday I had cold clutches of homesickness, but drowned it in hard work at the museum on the Indian designs I was sketching. I had not been in the gallery since Wednesday because I was afraid of intruding. They asked me to design a cover for the catalogue and I made one. I made two ghastly mistakes, first in size and another in print and could have cried with mortification. I had worked till 1:00 p.m. and was tired out anyway and disgusted.

Mrs. Brown gave a tea for me Wednesday. We met in the museum and saw the Old Masters and then went to the Browns'. On Thursday Mr. Brown took me for a drive and Saturday I worked all day in the museum.

Today I went to the Barbeaus' in the morning and met Mr. Jackson there. We had dinner and three charming French Canadians came. The atmosphere of that house is delightful. There is sincerity, cleverness and a joyfulness that catches you up. The children are

darlings. I came home at 4 o'clock and was called for and taken to the Cheneys' to tea. Charming young people with a lovely home on the canal. She paints. Peggy Nicol, Mr. Pepper and Mr. and Mrs. Brown were there. The talk was largely art and books.

I feel as if I have met the "worthwhiles" on this trip, people who really count and are shaping a nation. They are all so big and broad, so kind to the younger struggling ones, so proud of the bigness of their country, so anxious to probe its soul and understand it. Lawren Harris's work is still in my mind. Always, something in it speaks to me, something in his big tranquil spaces filled with light and serenity. I feel as though I could get right into them, the spirit of me not the body. There is a holiness about them, something you can't describe but just feel.

December 5th
The exhibition has opened, and I might almost say opened and closed again. It was horrid. Up to the very night of the affair, Mr. Barbeau was so full of enthusiasm and hope, so gay. He opened a bottle of wine for supper and we drank a health. He purred over the programmes and was pleased with them. "There will be a great jam," he said at supper, "it's the best show we've had, and it is always packed." I saw his wife was anxious. She asked me several times just what Brown had said about it being "quite informal." She hesitated when I asked if we wore gloves and said she'd take them anyway and see.

We got there in a cab. I thought we were the first but there were a few others. Not many came after us. It was a dead, dismal failure. The big rooms with the pictures hanging in the soft, pleasant light were almost empty. The grand old totems with their grave stern faces gazed tensely ahead alongside Kihn's gay-blanketed Indians with their blind eyes. I was glad they were blind. They could not see the humiliation. The Browns were there, a trifle too forced in their gay humour. A great many of the few present were introduced to me. They were all enthusiastic in their praise. Maybe it was honest, maybe not. Mrs. Barbeau's eyes were flashing angrily. Her body was tense. It was as though she could slay the Browns. "Look at my husband," her eyes seemed to say. "They've wounded him and humbled

him and hurt him." What could I say? Mr. Barbeau never said a word. His face was set and hard and all the light and enthusiasm had gone from it.

A little past 10 o'clock we went to the Browns' and had coffee and met some dull people. Mr. Brown tried to be gay and asked us facetiously how we liked it and wasn't it splendid? No one answered except one small, hysterical, stupid little woman who raved over everything. We came home tired and quiet. I could have cried for Mr. Barbeau. He had worked so hard to make it a success, old Brown leading him on and making him believe it was a big affair. "Usually there were 2,000 invitations, such a crush you couldn't move, and a great feed of refreshments." No invitations were sent out except to a few artists and those in the building. Others were angry at getting no cards or notices except the eleventh hour general invitation that came too late to be taken. All Mr. Barbeau said was, "Well that's over. Now we'll go on to the next job."

And down in the basement, turned face to the wall, are four beautiful canvases, far better than anything upstairs, rejected, hidden away, scorned—beautiful thoughts of fine men picturing beautiful Canada. Canada and her sons cry out for a hearing but the people are blind and deaf. Their souls are dead. Dominated by dead England and English traditions, they are decorating their tombstones while living things clamour to be fed. For me, half of the things they had me send are in the basement too. For myself I do not mind as much as I do for the others. Mine are not so good in workmanship. Only one point I give to mine. I loved the country and the people more than the others who have painted her. It was my own country, part of the West and me.

It is humiliating to have nothing to tell them of the opening at home, to admit it was a fizzle. No one will come now. If the people are not caught up in the first swirl, they do not come; enthusiasm is not worked up.

Montreal
Arrived 11:50 and after lunch went straight to the Royal Canadian Academy. It was a good show. The big room (mostly Group of Seven) was very enjoyable. It was the first time I have been able to sit and take my time over the Group of Seven. I studied them sepa-

rately and together. There was Jackson, Lismer, Harris, MacDonald, Carmichael and Casson represented—all except Varley.

Harris's "Mountain Forms" was beautiful. It occupied the centre of one wall—one great cone filled with snow and serenely rising to a sky filled with wonderful light round it in halo-like circles. Forms purplish in colour lead up to it. He gets a strip of glorious cold green in the foreground and the whole sky is sublimely serene.

I sat and watched it for a long, long time. I wished I could sweep the rest of the wall bare. The other pictures jarred. Two fashionable women came in and called others. They laughed and scoffed. After wondering if the thing was an angel cake, they consulted the catalogue. "It is 'Mountain Forms'." They all laughed. How I longed to slap them! Others came and passed without giving more than a brief, withering glance. A priest came. Surely he would understand. Wouldn't the spirituality of the thing appeal to one whose life was supposed to be given up to these things? He passed right by even though he walked twice through the room—blind, blind!

Jackson's "Autumn in Algoma" did not please. It was thin and unconvincing and unfinished. But his "Barns" was delightful, and his other things. "Barns" had such a swing to the earth and sky—a huddled group of old barns with a flock of sheep trying to shelter from the wind. Lismer had "Happy Isles," red-brown rocks with windswept trees, and sky forms that followed the shapes of the trees too closely I thought. I did not find the canvas restful though there is lots of liveliness in it. MacDonald's "Solemn Land" is very big and powerful and solemn. I wish he wasn't quite so fond of broom. His design is lovely but he has not the true movement or imagination I want. His "Glowing Peaks" I like except for the brown water, but his other rocky things did not please me. An unpleasant cloud form was speared by a mountain peak. I did not like the colour. Carmichael is a *little* pretty and too soft, but pleasant. Casson I don't care about. His work is cold, uncompromising, realistic. His "Dawn" gave me no pleasure.

I wish I could paint as well as any one of these men. In criticizing them I am only trying to see further. Their aim is so big it makes the rest of the stuff seem small and poor and pretty. There are a few others worth while and some fine women.

Had a visit at the hotel from Annie Savage. She was very nice and friendly. Was glad I'd rung her up. As she teaches, she came right after 4 o'clock. I had a furious nosebleed in the morning that delayed me getting out but I spent half an hour at the gallery and went over my favourite pictures again, especially the Group work. Mr. Holgate left a message at the hotel for me and Miss Savage and I went to his studio and saw his things. I like him. He is young and enthusiastic and clever. His work is strong and full of form but a little dull and dead in colour.

Took the 6:45 train to Ottawa. I phoned the Barbeaus and had a nice conversation with both. Mr. B. was much brighter about the exhibition. He says Brown is going to give an evening and wake things up a bit. Toronto, Montreal and Winnipeg want the exhibition afterwards, but I don't know if it will go to all three yet. I was glad to hear him more cheerful.

Sunday, December 11—Toronto
Got up about 9 o'clock and was cross and cold. I wanted something badly in the back of my mind and was nervous and uncertain. Those pictures of Lawren Harris's, how I did long to see them again before I went West, and yet I did not like to ring up and ask. What right had I to take up his time? But in my heart of hearts I was sure he would be willing to help a stranger from the West. I went to the phone and was told he was at dinner and to ring again. My heart sank but after lunch I phoned again. Yes, I could go on Tuesday at 2:30 to his studio. I was delighted. Fifteen minutes later he rang up and asked me to go to supper tonight.

I went to the museum and saw some Pueblo pottery with lovely black and white and red designs. A little before 7 o'clock Mr. Harris came for me in his car. Mrs. Harris welcomed me and I gave a long look to see what she was and how she influenced his work. She was beautiful, quiet, gentle, not very young, a peaceful person. I decided she would be a great help and strength to him. The little daughter, Peggy I think, came in. I loved the little girl. She was about eleven or twelve I should say. A smaller boy was singing to himself upstairs in bed.

I left my things in the hall and we went into the drawing-room.

Oh! On the mantle was one of his quiet seas. A heavenly light lay upon one corner, shining peacefully. Three cloud forms, almost straight shafts with light on their tips, pointed to it. Across a blue-green sky, a long, queer cloud lay lower down, almost on the horizon, but you could move in and on and beyond it. A small purplish round island, then four long, simple rock forms, purple-brown, with the blue sea lapping them. Two warmer green earth forms and some quiet grey forms that might be tree trunks in the foreground. Peace. My spirit entered the quiet spaces of the picture.

There were two woodsy and lake paintings, one each side, happy things with gold autumn foliage in the foreground and quiet sunny islands covered with pines. A little group of quiet dull-green pines was on the lower flat and then a white sky with a mellow golden sort of light. The trees in the foreground were painted in rather solid gold masses. They were very joyous. Down further hung three smaller pictures in a row, all on a more tragic note. Opposite was one of his beautiful old houses in a snow-storm, solid and fine.

In the dining-room was a snow scene at Jasper—pine trees weighted with heavy snow, weighty substance, quiet and cold, and an autumn seashore, all queer tree forms in golden shades reflected in the water. Opposite, a gay autumn thing with bare trees in foreground, reflection and reality scarcely distinguishable. The bark of the trees was painted in rather gay blobs. On one side hung a Tom Thomson and on the other Jackson's "Edge of the Maple Wood."

Mrs. Harris curled up on the sofa and sewed. Mr. H. showed me all kinds of small things, pottery from Damascus and rugs, all interesting and beautiful. It is a lovely house, full of quiet, dignified objects, and it's homey. Then Mr. Harris played a long symphony on his magnificent orthophonic. It was superb, such volume of glorious sounds filling the big quiet room. He had just brought the record from New York. To sit in front of those pictures and hear that music was just about heaven. I have never felt anything like the power of those canvases. They seem to have called to me from some other world, sort of an answer to a great longing. As I came through the mountains I longed so to cast off my earthly body and float away through the great pure spaces between the peaks, up the quiet green ravines into the high, pure, clean air. Mr. Harris has painted those

very spaces, and my spirit seems able to leave my body and roam among them. They make me so happy.

Monday, December 12th

Fifty-six years ago tonight there was a big storm out West and deep snow. My dear little Mother wrestled bravely and I was born and the storm has never quite lulled in my life. I've always been tossing and wrestling and buffeting it. How little I've accomplished! And the precious years are flying by and never, never one minute will the clock tick backwards. Tomorrow I am to see the pictures again. That's a wonderful birthday treat.

Tuesday, December 13th

A splendid birthday. Got up late and went to the museum to sketch a little. Miss Buell and Miss Bertram had lunch with me and then I went down to Mr. Harris's studio. It's so big and quiet and grey and very restful. He was painting and I hated to feel I was stopping him, but he wouldn't hear of my going away for a bit. He said he had got to a good place to stop. He was working on a big canvas—rock forms in deep purples with three large rocks in the middle distance. The sky was wonderful—swirly ripples with exciting rhythms running through them. The right corner was in brilliant light and from under the clouds shafts of strong sun pierced down on the rocks in straight wide beams that made a glowing pool of pure light on the water that lay flat and still. Behind, was a deep, rich blue distance. To the right the shafts of light turned it paler green-blue. On the other side a blinding blue played richly with the purple rocks. Under the left side of the rippling, swirling grey cloud forms the water lay flat in blue-grey wonderfulness. The foreground was unfinished but would be dark rocks. There was a wonderful feeling of space.

Mr. Harris showed me the different qualities he put in his paint to give vibration. He often rubs raw linseed oil on to the canvas and paints into that, and he oils out his darks, when they sink in, with retouching varnish. I wonder if he realizes how I appreciate his generosity and what the day meant to me in trying to solve the riddles and mysteries that I've plugged along with alone for so long. Of this I am convinced: that he has come up to where he now is by

diligent, intelligent grinding and wrestling and digging things out; that he couldn't do what he is doing now without doing what he has already done; that his religion, whatever it is, and his painting are one and the same. I wonder where he will rise to. In eight years his work has changed entirely. In eight years more what will happen to it?

He showed me a black and white sketch inspired by the coal strike in Halifax. A woman, distraught, gaunt, agonized, carrying a child who was pitiful, drooping, hopeless and dumbly submissive. Half of the face of another child was cut by the bottom of the picture. The background was houses, black and desolate. There was a thunderous, stupendous horror in the air. The woman's eyes were wild and frantic. Someday he will make a canvas of it. It will be terrific.

He showed me "Above Lake Superior" again. It is wonderful, but I believe I love the mountains better than the tree forms. Bleached, wonderful, in purified abandon, they are marvellous. The great mountain with the swirling shaft of cloud leaping from the crater is beautiful, but the cloud is not quite compatible yet.

Over the mantle is a huge canvas of a mighty mountain mass. It is the fifth time he has worked it out and he is still unsatisfied and wants to do another canvas of it. The sky is dark and wild. Blue clouds are tossed behind the peaks. In the centre the lines are not harmonious, and he doesn't like the foreground, considering it too realistic. It has the long, cold greens he gets. It is a superb subject.

He brought out some very old ones. Lovely colour, but oh, so different! At one time I would have loved them, but after the newer ones they seem tame and uninteresting and unconvincing. The new ones make me so intensely happy. The old ones are sadder, more full of worldly trouble and tragedy.

I was there about two hours. He told me they want two more canvases for their exhibition of my stuff and he asked me a bit about my work, and said he hoped I'd go on. He said that Jackson and Lismer both felt that though my knowledge was poor, I had got the spirit of the country and the people more than the others who had been there—Kihn, Jackson, Holgate. I am very glad. I long to return to it and wrestle something out for myself, to look for things I did not know of before, and to feel and strive and earnestly try to

17

be true and sincere to the country and to myself. Mr. Harris gave me the names of four books he thought would help me in the struggle. I'll get these if it costs my last penny because I want so terribly to feel and know more, to understand.

Wednesday, December 14th
I left Toronto last night at 9 o'clock. It had been a busy day. I went downtown and hunted for the books. Of the four I was only able to get two, *Art* by Clive Bell and *Tertium Organum* by Peter Ouspensky. I attended to my bank business and then went to the Grange. There is a little picture exhibition on there. All the Group are represented except Carmichael. As I walked through the gallery each member of the Group stood out clearly. I looked round quickly at the others and summed up that there were none of particular interest.

At the end of the second gallery I felt the irresistible call of the Harrises, seven small pictures in silver frames. Whenever I go into a room or a gallery where they hang they draw me irresistibly, and instantly my inner consciousness responds to the call. Everything else in the gallery seems to grow small and insignificant, just paint in fact. Although the rest of the Group pictures charm and delight me, it is not the same spiritual uplifting. These satisfy a hunger and rest the tired in me and make me so happy. Three of them were for sale—$65, $75 and $85. How I'd love to have bought one! What a joy to possess! But I have the memories and no one can take them away, ever. It has been a privilege to see so many.

What a long day it's been! I have read and knitted, read and knitted with monotonous regularity. I have read a lot of P. D. Ouspensky. I get glints here and there but such lots of it I don't understand. That's not strange since I haven't studied along these lines before. It interests me vastly. I shall stick at it and try to see it in time, for I am sure somehow it will help my work. It produces the quality of spaciousness in Mr. Harris's pictures that I lack. One more day and I'll be home to the sisters and dogs and monkey.

Sunday, December 18th
We got to Brûlé at sunrise. It was very wonderful—a superb peak

and a grey-blue sky with warmer purplish clouds and spots of brilliant gold, some little bigger than stars. The mountains are glorious, powdery with fresh snow, majestic and quiet and lofty. We have just passed Rainbow Lake from where the Athabaska and the Fraser take their course, the Fraser to the West, the Athabaska to the East. The mountains seem more beautiful since I have seen Mr. Harris's pictures which have helped me to see them in a bigger way. I judge space better now. How I do want to learn more about space!

Sunday, December 25th
Christmas Day and I've been four days home. Now it's all like a dream, my wonderful trip. Christmas, and sick dogs, and sick Teddy, and Christmas parcels, all the oddments of jobs and cleaning up of things indoors and out after my long absence have taken every minute and left me woefully tired. When will I start to work? Lawren Harris's pictures are still in my brain. They have got there to stay. I don't believe anything will oust them. I hope not because they make my thoughts and life better. The memory of them is a never-failing joy. They are the biggest, strongest part of my whole trip East. It is as if a door had opened, a door into unknown tranquil spaces. I don't tell anyone about them because they would not understand. I spoke about them to Mr. Varley but he does not feel about them as I do. He thinks Harris is going too far, brings religion in too much. For his own part, he says, he likes to stick a bit firmer to good old Earth. Maybe, but somehow to me there is more reality in a Lawren Harris than in any of the others. I seem to know and feel what he has to say. To me it is a clearer language than the others are using. Why, I wonder? I have never studied theosophy and such things, and I don't think I want to. But there's something that gets at me, and if it is theosophy that gives that something I'd like to hear about it. It could be nothing bad that inspired those pictures. Dig! Delve! Study! Think! Keep your thoughts high and clear and pure! I shall never do much myself, I'm afraid, and time is pushing me into the sixties. It's so hard to keep from being choked and swallowed up in the little petty cares and bothers of a home. But I must hold my end up and not let my sisters down for in their unselfish, hard-working lives they're the finest women ever.

Simcoe Street
1930-33

Sunday, November 23rd

Yesterday I went to town and bought this book to enter scraps in, not a diary of statistics and dates and decency of spelling and happenings but just to jot me down in, unvarnished me, old me at fifty-eight—old, old, old, in most ways and in others just a baby with so much to learn and not much time left here but maybe somewhere else. It seems to me it helps to write things and thoughts down. It makes the unworthy ones look more shamefaced and helps to place the better ones for sure in our minds. It sorts out jumbled up thoughts and helps to clarify them, and I want my thoughts clear and straight for my work.

I used to write diaries when I was young but if I put anything down that was under the skin I was in terror that someone would read it and ridicule me, so I always burnt them up before long. Once my big sister found and read something I wrote at the midnight of a new year. I was sorry about the old year, I had seemed to have failed so, and I had hopes for the new. But when she hurled my written thoughts at me I was angry and humbled and hurt and I burst smarting into the New Year and broke all my resolutions and didn't care. I burnt the diary and buried the thoughts and felt the world was a mean, sneaking place. I wonder why we are always sort of ashamed of our best parts and try to hide them. We don't mind ridicule of our "sillinesses" but of our "sobers," oh! Indians are the same, and even dogs. They'll enjoy a joke with you, but ridicule of their "reals" is torment.

When I returned from the East in 1927, Lawren Harris and I

exchanged a few letters about work. They were the first real exchanges of thought in regard to work I had ever experienced. They helped wonderfully. He made many things clear, and the unaccustomed putting down of my own thoughts in black and white helped me to clarify them and to find out my own aims and beliefs. Later, when I went East this Spring, I found he had shown some of my letters to others. That upset me. After that I could not write so freely. Perhaps it was silly, but I could not write my innermost thoughts if *anybody* was to read them, and the innermost thoughts are the only things that count in painting. I asked him not to. He saw my point and said he wouldn't. I trust him and can now gabble freely. Still, even so, I can't write too often, hence this jotting book for odd thoughts and feelings.

I've had a good Sunday in the blessed quiet studio. Pulled out my summer sketches and tried to get busy. It wouldn't come. I got to the typewriter and described Fort Rupert minutely, its looks and feeling and thoughts. Then I got to some charcoal drawing and commenced to *feel* it but got nothing very definite. At night I heard a sermon where the Children of Israel said their enemies regarded them as "grasshoppers" and they felt they were. How they lacked faith and failed, he said. Everyone needed faith in God and faith in himself. The good of the sermon was all undone by the beastly streetcars. Took me till after ten to get home. I was chilled to the bone waiting on corners in fog and got very ratty and rasped. Went to bed with nerves jangling.

Monday, November 24th
This morning I've tried the thing on canvas. It's poor. I got a letter from Tobey. He is clever but his work has no soul. It's clever and beautiful. He knows a lot and talks well but it lacks something. He knows perhaps more than Lawren, but how different. He told me to pep my work up and get off the monotone, even exaggerate light and shade, to watch rhythmic relations and reversals of detail, to make my canvas two thirds half-tone, one third black and white. Well, it sounds good but it's rather painting to recipe, isn't it? I know I am in a monotone. My forests are too monotonous. I must pep them up with higher contrasts. But what is it all without soul? It's dead. It's

21

the hole you put the thing into, the space that wraps it round, and the God in the thing that counts above everything. Still, he's right too. I must pep up. I wonder if he had seen my stuff in Seattle. I thought perhaps Hatch would write but no word, only a printed invitation to preview some Japanese prints and temporary shows, so I suppose I'm lumped with the "temporary shows." It's a bit of a kick and goes to show I am conceited and thought my show was to be the main item of the galleries in Seattle for the month, but I'm only lumped in "temporary."

Wednesday, November 26th
No word from Seattle. The show opened last night. Well, forget it old girl, I guess your work is only humdrum—ordinary anyhow— just a little sideshow of the galleries for the month.

I have copied a bit from Lawrence's book, *St. Mawr*, about a pine tree. It's clever but it's not my sentiments nor my idea of pines, not our north ones anyhow. I wish I could express what I feel about ours but so far it's only a feel and I have not put it into words. I'll try later because trying to find equivalents for things in words helps me find equivalents in painting. That is the reason for this journal. Everything is all connected up. Different paths lead to the great "it," the thing we try to get at by hook and by crook. Lawrence's book is so sexy. Everything these days is people talking of sex and psychology. I hate both. This would-be-smart psychology makes me sick; it's so impertinent, digging round inside people and saying why they did things, by what law of mind they came to such and such, and making hideous false statements, and yanking up all the sex problems, the dirty side of everything. They claim they are being real and natural, going back to the primitive. Animals are simple and *decent* with their sex. Things happen naturally and just *are*. It's all simple and straight, but we—ugh!—we've fouled it all . . . dirty books, filthy cinemas, muck everywhere.

Friday, December 5th
So, that devil's job, my pottery exhibition, that annual Christmas horror of mine, is over, and badly over. Scarcely anyone came,

though there is usually a throng and good selling. This year was just a scattering over two afternoons and two evenings. The work was interesting and made a good show, too. Last show I'll give. How I loathe standing round on one leg, showing off the stuff and having everything picked over! I was so exhausted I spent most of the next day in bed too tired to paint or even think, though I must hurry up with my Baltimore canvas.

Mrs. Spier came from Seattle for seven days. She was there for the opening and said there was a great division over my stuff. People were either decidedly for or against it. Some thought it crazy, said they had never seen Alaska look like that. Well, it wasn't Alaska. Others were thrilled. Since, I have received two letters. Miss Rhids writes with warm congratulations and thinks I've come on a bit in the last few years. Mrs. Spier gave a talk on North West art. She says it is creating a great stir in Seattle art centres. Letter from Hatch. He says no one comes and goes without saying *something*, which is satisfactory. He also says Royal Cortissoz gave me three sentences of slanging in *The New York Times*, which is a boost as he is the conservative leader and considers most contemporary artists beneath contempt altogether. Hey, ho! What does it matter? Get busy, old lady, and grind away. As L. H. says, if we keep right on something is bound to happen. I wish he'd write. His letters always help me when I feel a bit downed. Last night I dreamed of Sophie. She had a motor and was quite a swell in a chiffon dress. I looked at her wondering but somehow I knew she was the same old Sophie underneath and I loved her still.

Wednesday, December 31st
Only half an hour left of 1930. I finished Flora's book, *New Art of Lawrence Atkinson*, and found lots of things to remember and digest. I love his abstracts. I feel there is very much in abstraction but it must be abstraction with a *reason*, that is, there must be an underlying truth—something—the pith or kernel, the inner essence of the thing to be expressed. If that doesn't speak then it's a dead abstraction without cause or reason for existence. This coming year I must work harder, must go deeper.

Sunday, January 11th, 1931

No word from Hatch about the Seattle show. I don't feel it has been a success at all. At least it waked them up. That's something. Hatch did not boost it in any way, that's plain. Still, it did me good to have to rattle around and work and get ready for it. The fact that it fell flat was good for my conceit. If the work had been big enough—hit the bull's-eye—people would *have* to acknowledge it. It missed. But oh, how can we get "it," the great universal language that everyone understands, the thing down deep that we all feel? Oh, the lazy minds and shrinking hearts of us who shirk the digging grind! Our blind old eyes don't see and our souls lie flat on the earth, too dead to soar up, up into the place that Lawren Harris calls "Where all the universe sings." Oh, that lazy, stodgy, lumpy feeling when you want to work and you're dead! Is it liver, I wonder, or is it old age, or just inertia, or something from which the life has gone forever, that just belongs to youth?

Monday, January 12th

W. Newcombe has been spending the evening. Lord, what a lot he knows! I feel my knowledge superficial when I talk with him. My aims are changing and I feel lost and perplexed. I've been to the woods today. It's there but I can't catch hold.

Thursday, January 15th

Had to clean a second-hand gas stove for Mrs. Howell's flat. Wahah! I phoned Edith Hembroff today but her mother told me she was still away. Poor kid, her two canvases for the Canadian Exhibition were rejected in Vancouver as too French. Mrs. H. said she would like to own a canvas of mine as she was sure some day they'd be unobtainable. What bosh! I got Harry Lawson to fix my will with Lawren Harris as joint trustee with Mr. Newcombe.

Sunday, January 18th

I have done a charcoal sketch today of young pines at the foot of a forest. I may make a canvas out of it. It should lead from joy back to mystery—young pines full of light and joyousness against a

background of moving, mysterious forest. Last night I dreamed that I came face to face with a picture I had done and forgotten, a forest done in simple movement, just forms of trees moving in space. That is the third time I have seen pictures in my dreams, a glint of what I am striving to attain. Perhaps some day I shall get things clearer. Every day I long for the woods more, to get away and commune with things. Oh, Spring! I want to go out and feel you and get inspiration. My old things seem dead. I want fresh contacts, more vital searching.

Tuesday, January 20th

I have been to the woods at Esquimalt. Day was splendid—sunshine and blue, blue sky, and two arbutus with tender satin bark, smooth and lovely as naked maidens, silhouetted against the rough pine woods. Very joyous and uplifting, but surface representation does not satisfy me now. I want not "the accidentals of individual surface" but "the universals of basic form, the factor that governs the relationship of part to part, of part to whole and of the whole object to the universal environment of which it forms part."

Wednesday, January 28th

For the first time in two months the pendulum has begun to swing. I was working on a big totem with heavy woods behind. How badly I want that nameless thing! First there must be an idea, a feeling, or whatever you want to call it, the something that interested or inspired you sufficiently to make you desire to express it. Maybe it was an abstract idea that you've got to find a symbol for, or maybe it was a concrete form that you have to simplify or distort to meet your ends, but that starting point must pervade the whole. Then you must discover the pervading direction, the pervading rhythm, the dominant, recurring forms, the dominant colour, but always the *thing* must be top in your thoughts. Everything must lead up to it, clothe it, feed it, balance it, tenderly fold it, till it reveals itself in all the beauty of its idea.

Lawren Harris got the $500 award from the Baltimore show for that lovely stump thing. I am so glad he got the recognition. He so richly deserves it and doesn't get half enough. He is always so modest.

A picture does not want to be a design no matter how lovely. A picture is an expressed thought for the soul. A design is a pleasing arrangement of form and colour for the eye.

Sunday, February 1st

I worked all afternoon, first on "Koskemo Village," X. 1., and then on X. 2., "Strangled by Growth," which is also Koskemo (the cat village). It is D'Sonoqua on the housepost up in the burnt part, strangled round by undergrowth. I want the pole vague and the tangle of growth strenuous. I want the ferocious, strangled lonesomeness of that place, creepy, nervy, forsaken, dank, dirty, dilapidated, the rank smell of nettles and rotting wood, the lush greens of the rank sea grass and the overgrown bushes, and the great dense forest behind full of unseen things and great silence, and on the sea the sun beating down, and on the sand, everywhere, circling me, that army of cats, purring and rubbing, following my every footstep. That was some place! There was a power behind it all, and stark reality.

Wednesday, February 4th

Lizzie, Alice and I went to hear the Seattle Symphony. First time in years we have been out together. It was delightful as we sat there unanimously enjoying it. I couldn't help wondering why it was that we could all meet and be lifted up in the music while had it been a picture exhibit we'd have had no shared sympathy at all. Has music something art lacks? The new art does lift one but so few understand. They refuse to be lifted. They will not go beyond the outer shell. They want the surface representation; the soul behind it they do not want and cannot feel. Surely we artists must fail somewhere. Why can't we lift the veil and reveal the soul if the musician can? Is the eye more earthy than the ear?

Yesterday Mrs. Spier came to speak before the Canadian Club on the Indians of the West Coast, and spoke well. She touched on their religion, secret societies and folk lore. She had supper with me and we talked much. I told her I felt my Seattle exhibition had been a failure. She said it had meant more than I knew and had "stirred and caused discussion." It was what they needed. I said I felt my work

had moved into a different phase and was of no more interest to the anthropologist. Her reply was that it meant more to them than I thought. They felt I was getting at the spirit of the people more. "I think perhaps you don't realize yourself," she said, "how steeped in the Indian you are, how saturated with the feel of him." I am glad she said that.

I have started a new canvas, X. 3. I have hankered after a go at it for long. Funny, subjects I have really felt give me no peace till I get down and search into them. They call to me and will not let me rest till I have brought them out and wrestled with them, dug into my memory and lived them over again. Some that were only felt superficially don't worry me at all. I'm through with them.

I have started to write "The Nineteenth Tombstone" again. Shall I succeed in getting it over this time, in making it human and real and in realizing the Indian element?

Thursday, February 5th
Put in a good day's painting below the skin. Got the Cumshewa big bird well disposed on canvas. The great bird is on a post in tangled growth, a distant mountain below and a lowering, heavy sky and one pine tree. I want to bring great loneliness to this canvas and a haunting broodiness, quiet and powerful. "Strangled by Growth" is giving much trouble.

Sunday, February 22nd
Yesterday we went to a dance and potlatch at the Esquimalt Reserve. Stayed from 8 to 11:30 p.m. It was *grand*—the great community house and smoke holes both pouring sparks into the sky, and the rhythmic victory of tom-toms, the inky darkness outside, then the sea of faces—Indians seated on benches in tiers to the roof, many of them with painted faces, two enormous fires which were fed fast and furiously by the young men with huge pieces of cord wood. The different reserves were all allotted places.

March 19th
The earth is soaked and soggy with rain. Everything is drinking its fill and the surplus gluts the drains. The sky is full of it and lies low

over the earth, heavy and dense. Even the sea is wetter than usual!

I want to paint some skies so that they look roomy and moving and mysterious and to make them overhang the earth, to have a different quality in their distant horizon and their overhanging nearness. I'm still on Indian stuff as it's too wet for the woods, but, oh joy, spring is coming, growing time for the earth and all that is therein. The papers are full of horrible horrors and the earth is so lovely. Money and power, how little either counts!

Mrs. Pinkerton wrote of "In the Shadow of the Eagle." It must be rewritten. She says it is so very bad in parts and so very good in others. My brain is very lazy. I have much trouble with it.

April 17th

Last night I went up on Beacon Hill and rose into the clouds. Everywhere was beautiful, full of colour and life. There were bulging clouds and little fussing ones, light and shadow clouds and blue, blue sky between. The broom was a wonderful green. The sea, too, was mysterious and a little hazy. There were two bright spots of gold peering through a black cloud and sending beams of light down. I thought they might have been God's eyes. Tonight it was all different, so bitterly cold, and hard, angry-looking bunches of cloud, and everything beaten-about and sallow-looking and mad. One didn't want to linger but get back to the fire.

Goldstream, June

I walked in the woods tonight among the cedars and the rain and it was heavenly sweet. There were just a few birds, my dogs and I. The rain dripping softly, the trees hanging low with the weight of the wet. Birds for the same reason flew low and heavily. The smells kept down too and were earthy and very sweet. The rain had beaten the bushes across the path and the stream was noisy and swollen.

My work today was not good. Perhaps the weight of the damp atmosphere was upon me too.

June 17th

I am always asking myself the question, What is it you are struggling for? What is that vital thing the woods contain, possess, that you

want? Why do you go back and back to the woods unsatisfied, longing to express something that is there and not able to find it? This I know, I shall not find it until it comes out of my inner self, until the God quality in me is in tune with the God in it. Only by right living and a right attitude towards my fellow man, only by intense striving to get in touch, in tune with, the Infinite, shall I find that deep thing hidden there, and that will not be until my vision is clear enough to see, until I have learned and fully realize my relationship to the Infinite.

June 30th

Find the forms you desire to express your purpose. When you have succeeded in getting them as near as you can to express your idea, never leave them but push further on and on strengthening and emphasizing those forms to enclose that green idea or ideal.

September 28th

Got a new pup. He is half griffon. The other half is mistake.

November 3rd, 1932

So, the time moves on, I with it. This evening I aired the dogs and took tea on the beach. It had rained all the earlier day and the wood was too soaked to make a fire, but I sat on the rocks and ate and drank hot tea and watched the sun set, with the waves washing nearly to my feet. The dogs, Koko, Maybbe and Tantrum, were beloved, cuddly close, and all the world was sweet, peaceful, lovely. Why don't I have a try at painting the rocks and cliffs and sea? Wouldn't it be good to rest the woods? Am I one-idea'd, small, narrow? God is in them all. Now I know that is all that matters. The only thing worth striving for is to express God. Every living thing is God made manifest. All real art is the eternal seeking to express God, the one substance out of which all things are made. Search for the reality of each object, that is, its real and only beauty; recognize our relationship with all life; say to every animate and inanimate thing "brother"; be at one with all things, finding the divine in all; when one can do all this, maybe then one can paint. In the meantime one must go steadily on with open mind, courageously alert, waiting

always for a lead, constantly watching, constantly praying, meditating much and not worrying. Walt Whitman says:

Say on, sayers! sing on, singers!
Delve! mould! pile the words of the earth!
Work on, age after age, nothing is to be lost,
It may have to wait long, but it will certainly come in use,
When the materials are all prepared and ready, the architects
 shall appear.

I swear to you the architects shall appear without fail,
I swear to you they will understand you and justify you,
The greatest among them shall be he who best knows you,
 and encloses all and is faithful to all,
He and the rest shall not forget you, they shall perceive
 that you are not an iota less than they.
You shall be fully glorified in them.

(*Song of the Rolling Earth*)

So—no matter if we are not to make the goal ourselves. All our work helps us to accumulate material for the great final structure. Our business is to do our own small part with absolutely no thought of personal aggrandizement or glory.

November 12th

Go out there into the glory of the woods. See God in every particle of them expressing glory and strength and power, tenderness and protection. Know that they are God expressing God made manifest. Feel their protecting spread, their uplifting rise, their solid immovable strength. Regard the warm red earth beneath them nurtured by their myriads of fallen needles, softly fallen, slowly disintegrating through long processes, always living, changing, expanding round and round. It is a continuous process of life, eternally changing yet eternally the same. See God in it all, enter into the life of the trees. Know your relationship and understand their language, unspoken, unwritten talk. Answer back to them with their own dumb magnificence, soul words, earth words, the God in you responding to the

God in them. Let the spoken words remain unspoken, but the secret internal yearnings, wonderings, seekings, findings—in them is the communion of the myriad voices of God shouting in one great voice, "I am one God. In all the universe there is no other but *me*. I fill all space. I am all time. I am heaven. I am earth. I am all in all."

Listen, this perhaps is the way to find that thing I long for: go into the woods alone and look at the earth crowded with growth, new and old bursting from their strong roots hidden in the silent, live ground, each seed according to its own kind expanding, bursting, pushing its way upward towards the light and air, each one knowing what to do, each one demanding its own rights on the earth. Feel this growth, the surging upward, this expansion, the pulsing life, all working with the same idea, the same urge to express the God in themselves—life, life, life, which *is* God, for without Him there is no life. So, artist, you too from the deeps of your soul, down among dark and silence, let your roots creep forth, gaining strength. Drive them in deep, take firm hold of the beloved Earth Mother. Push, push towards the light. Draw deeply from the good nourishment of the earth but rise into the glory of the light and air and sunshine. Rejoice in your own soil, the place that nurtured you when a helpless seed. Fill it with glory—be glad.

November 16th

A wire from Brown asking three watercolours for the Royal Scottish Watercolour Society. I am glad because maybe it shows that Brown feels kindlier towards me and also sees he cannot get me through Vancouver. My watercolours are not so good. I have none spot fresh and somehow I cannot feel things done two years ago are yourself today. It is quite possible as you pass through growth that they might get better. You have your ups and downs of inspiration but your work of now, today, should have something that your work of yesterday did not, if you are thinking, if you are growing.

Just come from the Seattle Symphony concert. It was fine and I enjoyed it thoroughly but how I did want to be more spiritually alert to its uplifting! I listened like a dumb beast, as I've seen a cow stop chewing the cud and throw back her ears and listen to music. She knew it pleased and satisfied her, that is all. She slowly swished her

rope of a tail and her four feet remained firmly planted on the solid earth. So I, with pleased senses, sat in the hot, crowded gods and my soul rose no higher than those filthy painted cherubs daubed on the ceiling, wallowing in cobwebs and grime.

"Inspiration is intention obeyed."

December 2nd

To attain in art is to rise above the external and temporary to the real of the eternal reality, to express the "I am," or God, in all life, in all growth, for there is nothing but God.

> Artist, Poet, Singer, where are you going today?
> Searching, struggling, striving to find the way.
>
> Artist, Poet, Singer, tell me what is your goal?
> By listing, learning, expressing, to find the soul.
>
> Artist, Poet, Singer, what are you after today—
> Blindly, dimly, dumbly trying to say?
>
> Aye, Artist, Poet, Singer, that is your job,
> Learning the soul's language, trying to express your God.
> (M. E. Carr)

Half of painting is listening for the "eloquent dumb great Mother" (nature) to speak. The other half is having clear enough consciousness to see God in all.

Do not try to do extraordinary things but do ordinary things with intensity. Push your idea to the limit, distorting if necessary to drive the point home and intensify it, but stick to the one central idea, getting it across at all costs. Have a central idea in any picture and let all else in the picture lead up to that one thought or idea. Find the leading rhythm and the dominant style or predominating form. Watch negative and positive colour.

January 25th, 1933

I've been figuring out with myself how it is I hate write-ups. Someone always sticks them under my nose. I figure thus: people here

don't like my work, it says nothing to them, but they like what is *said* about it in the East. In other words, they like the "kick up" not *it*. That's the hurt.

What do I want out there in that open space of sea, bounded above by sky and below by earth, light, space? All space is filled with God, light, love, and peace.

January 26th

What is beauty?—God. What is that vital thing, in ugly as well as lovely things and places, the thing that takes us out of ourselves, that draws and attracts us, the unnameable thing claiming kinship with us?—God, the divine in us calling to the divine in all else, the one essence and substance.

January 27th

The sunset was grand after a wet day. The dogs and I walked on the shore. Your eye ran across level green expanse of water fretted and foaming on the beach and rocks. Serene. Far out it ended mistily in pale space line, then rose to a sky full of low soft clouds with the domed blue above.

The People's Gallery scheme is over for the present. It was a good idea and I am convinced put for some purpose into my mind. I went ahead as far as I could; then it came to a *cul de sac*: no money, no help, no nothing but to let her lie by and sleep and some day she may revive. I don't know now. My energies are centred on the cliffs and sea. Have made six paper sketches. Looked them over today— too stodgy, just paint, not inspiration. I must go out and feel more.

In working out canvas from sketches, the sketches should convey the essence of the idea though they lack the detail. The thing that decided you to attempt that particular subject should be shown, more or less. Take that small sketch home and play with it on paper with cheap material so that you may not feel hampered but dabble away gaily. Extravagantly play with your idea, keep it fluid, toss it hither and thither, but always let the *idea* be there at the core. When certainty has been arrived at in your mind, leave the sketch alone. Forget it and put your whole thought to developing the idea.

Empty yourself, come to the day's work free, open, with no pre-

conceived ideas, no set rule of action, open and willing to be led, receptive and obedient, calm and still, unhurried and unworried over the outcome, only sincere and alert for promptings. Cast out the personal, strive for the spiritual in your painting. Think only of the objective. Desire only that the consciousness of the presence of God may show and speak, not as accomplished by you, not as your work, not as having anything to do with you, but being only a reminder and an explainer of the manifested Father, the Christ. You yourself are nothing, only a channel for the pouring through of that which *is* something, which is all. Your job is to keep that channel clear and clean and pure so that which passes through may be unobstructed, unsullied, undiluted and thus show forth its clear purity and intention. Strive for this thing, for the stillness that should make it possible. Do not let it be a worried obsession causing your life to become a struggle and turmoil but let go that the spirit may work in calm and peace. Learn by listening attentively, be aware of your aliveness, alert to promptings.

June 7th—Pemberton, B.C.
I left home on May 15th and went to Brackendale first. I was accompanied by Koko, who simply could not live without me, Tantrum, who must learn the job of "Mom-minding" while I am sketching, and Susie, the rat, whom no one would look after during my absence so must of necessity come along. I had the usual paraphernalia of sketching, made as light as possible but still heavy as one's heart in great affliction, the dogs, each in a cosy box, and Susie (after an obstreperous scene in which she romped out of two containers) finally settled in a rolled-oat carton cut down, this tucked in my hand bag. And so we got to Vancouver, got to Squamish, got to Brackendale, along with vast quantities of prospectors going to the mines with their packs on their backs. I rejoiced that their packs were even worse to behold than mine.

Lil met me and we travelled to her farm. How the kids had grown! Jolly bunch. What a tumble-up the farm was! Young chickens, rabbits, bees, children, washing, cooking, picture puzzles, picture painting, post-hole diggers, wire netting, shovels, brooms, school books and bags, lunch pails, clomping up and down stairs of hob-

nail boots, groan of kitchen pump, dash of churn, hum of cream separator, and other sights and sounds and smells. And Lil's voice roaring above all the hubbub, first at this one, then at that. And trips in the truck, and walks in the rain, and splashing through puddles, and watching for the clouds to pass, and dashing out to sketch. And finding to my great joy that Sophie was in Brackendale, and Lil asking her and Frank to lunch, and her sister and the child coming too, and the happy, comfortable time we all had, and Sophie so much to me and I so much to Sophie, and the enjoyment of the good food Lil provided. And Larson coming in and talking to Frank about his boat that he had made by himself and come to Squamish in, which ended in Larson buying the same next day, to the joy of all parties. And how we all trooped down to the river to see and try the boat, and the little boys so pleased, and David and Donnie each taking her out alone, and my naming her the *Waterlily* after Lillian.

Then the goodbyes and the sore, sore heart in me because Koko had failed so for the last week, and how I prayed that he might die, being so full of years and feebleness, and the last night how he struggled for breath but in the morning was stronger and better. Then Larson running back for the mail and getting five letters, one from Bess and one from Lawren, always welcome, besides the home ones.

The settling down in the train with the creatures comfortably arranged for and my eye all agog to absorb scenery. Mountains towering—snow mountains, blue mountains, green mountains, brown mountains, tree-covered, barren rock, cruel mountains with awful waterfalls and chasms and avalanches, tender mountains all shining, spiritual peaks way up among the clouds.

Seton and Anderson lakes, shut in by crushing mountains. A feeling of stifle, of being trapped, of oppression and depression, of foreboding and awe. The train slowly crawling along the lake side on the trestled ledge.

Then Lillooet at 8 p.m. The dull hotel where I must wait for my room till the proprietress had had her greasy hair curled and fixed. A tiny, drab, inconvenient room, and my beloved Koko very feeble. All night I tried to soothe him but he was restless and unhappy. I knew in my heart, and shuddered at, what I must do in the morning

35

for I loved the blessed old pup, and now was the testing time of that love. I left Tantrum in my room and, with Koko in my arms, hunted Lillooet for a vet. There was none, nor a chemist, only a foolish boy doctor who was not oversympathetic. It was 10 o'clock before he was in his office. He said it was pneumonia and heart but he knew nothing of dogs or dog diseases, had no chloroform, and was afraid of strychnine. He agreed that it was cruel to let him go on suffering and suggested a bullet; there was a constable at the police office. Oh, the awful misery of that walk of a few blocks to ask for a bullet for my blessed pup to whom guns and all pertaining to them were horror! Koko's eyes were hardly off my face. He would throw back his head as he lay in my arms, and his beautiful, loving, trusting eyes would look straight into mine with absolute faith. How could I fail him? I did not. It was nothing to a dog who had travelled so much to be put in his cosy box, carried in the constable's car across the river. Just a little second. He had no fear or anticipation. A prisoner whom the constable had with him dug Koko's grave beside the roaring river. I went up to my room and cried bitterly.

Fourteen years of devoted love. Ah, little Koko, you are not dead. You have given up that little quaint brown body, but the essence of you, all your love and sweetness and loyalty are not dead, only gone on somewhere to grow some more. Will that which was you and that which is me come together sometime, somewhere? I am very thankful, little dog, for the years of joy we shared. I do not grudge you your rest for you were very tired. Young Tantrum seems so immature and foolish but he will grow. I must have patience with him.

So I plunged into work. Oh, these mountains, great bundles of contradiction, hard, cold, austere, disdainful, remote yet gentle, spiritual, appealing! Oh, you mountains, I am at your feet—humble, pleading! Speak to me in your wordless words! I claim my brotherhood to you. We are of the same substance for there is only one substance. God is all there is. There is one life, God life, that flows through all. He that formed me formed you. Oh, Father of all, raise my consciousness to that sense of oneness with the universal. Help me to express Thee. Do Thou use me as a channel, help me to keep myself clear, open, receptive to Thy will. Open my understanding and make my eye to see and my ear to hear. Let me not fuss and fret

at my incompetence but be still and know that Thou art God.

I stayed five days at Lillooet and then came on down to Seton. Seton and Anderson lakes used to be one till a mountain sat down in its midst and divided it squarely amidships, leaving each lake eighteen miles long. The Durban's stopping place was full of prospectors coming and going in a steady stream, men seeking for gold, strong men, glad to get away from city fuss into the great open, to shoulder their packs, make themselves into beasts of burden, struggle up the stony, steep mountainsides, enduring hardship, cold, hunger, tiredness, always with that gold god ahead, planning their lives when they would find the gold, and building airy castles for themselves, and wives, children, aged parents, and who-not, generous in their imagined affluence. Then, when they do not strike it lucky, collapsing like burst bubbles. Some, not having the courage to face those at home who they bragged to, end it with a bullet. Others will come again next year and the next. Others will stake unworthy claims and bamboozle some poor fool to buy them.

The Durban House at Seton looked like an erupted volcano. Specimens of rock everywhere, on tables, shelves, seats, verandahs. Men pounded them in mortars, making horrid noises, and washed them in pans, making sloppy the porch. They did up bundles and parted them. They carried little canvas sacks full. Indians brought ponies with pack saddles to the front and outfits with frypans, blankets, grub, and always the axe, pick and shovel; loaded the beasts till only their ears and tails were visible. The Indian superintended, then the laden beasts, tied in a string one behind the other, started up the trails. You met them a few days later wearily returning, empty of their packs, the Indian cheerful—he had his money safe in his pouch, no digging for gold for him!

One boy had brought an old friend down in a coffin, returning him to his wife in Vancouver. Disheartened, so a bullet in his brain. The boy had had it all to see to, broke the shack door open just as the gun went off. He had had to make the poor body decent, to help make a coffin, to get others to help him carry him one and a half miles down the rough trail, to make arrangements. For he had known this middle-aged man since he himself was a boy of sixteen —he had been to him like a father—and the poor suicide had left a

message that he was to take his body down to Vancouver to his wife. There were circles round the boy's eyes. He talked incessantly at dinner (there were only the two of us that night) and he played the piano and was restless.

The boy told me of the inside of the big Pioneer mine and I wondered how they had the grit to go down into the blackness, to sink down, down that awful shaft on a lift—only a platform, no cage, no sides. If anything went wrong with the lift there were ladders perpendicular up the sides of the shaft—their only way of coming up—a ladder of certain length, then a plank to rest on, another ladder and a plank, and so on and so on, and that awful, awful black hole if one slipped or got dizzy. The telling sickened me. If a man's light went out he must stand perfectly still and shout. He said the blackness was different from any other, a smothering density you could feel. This boy's job was to set and fire the blasts. It must be done with exact precision and remembering acutely which was which, then the lighting and the mad rush to get away, far, far as possible. The succession of concussions that split your ears and knocked you down. Oh, is there any gold in all the world worth all that?

Everyone got up early at the Durban. The walls were so thin you heard the sighs and yawns from 5 a.m. The men washed in the open hall, I in my room, so it was befitting I should be the last to go down the hall to breakfast. I usually did that at 7 or 7:30. There were seldom the same men for two days. I, being the one woman, wielded the maternal teapot. Everyone loved Tantrum and had a smile for or at him.

Today I moved on to Pemberton and it is pouring rain.

June 10th—Pemberton
Here we are. Three days at Pemberton have passed already. It is beautiful and exhausting. First day they told me of a walk. Said it was four miles. It proved to be six and I got home exhausted and mad, also late. Today I went up Harvey Mountain, supposed to have one of the grand views. They said it covered all the peaks. I expected a glorious panorama and to walk five miles. I crossed three railway bridges, beastly things, scuttling over them lugging Tantrum and

all my gear, counting my steps and reckoning each one aloud to Tantrum. I met two patrollers and stood on edges of track to let them pass. The mountains glorious, tossing splendour and glory from peak to peak. Yesterday there was fresh snow. They are half white and half navy blue and the beastly, treacherous Lillooet river snakes through the willows and meadows. I don't like these rivers. They are oily smooth and swift but swirling, with mean currents and whirlpools. You feel as if they asked you sneakily and stealthily to fall in and be swallowed, swept away swiftly to nothingness. There is meanness in their muddy green-grey water and shelvy sand banks. I never go to the rivers about here or want to look at them or hear them.

Well, after miles and miles along the tracks, I climbed the waggon road to Harvey Mountain. At the summit I sat to rest and made a sketch. The view was certainly fine in a middling way but not all the wonder they raved over, so I supposed this was only the beginning and the trail went up from there. A boy came along on a bike with a bear skin, still newly wet, in a sack. He told me he had just shot the bear. It had been fighting and was in a mean temper. It turned on him so he had shot even though it was off season. I asked about the trail and he showed me where it started up a few rods away, and off I started, on and on and on. It got worse and worse, perpendicular, stony, ghastly. Still I struggled on. From the amount of bear spoor there must have been millions about. It was fresh. Would I meet one? Would it be ugly and attack? Surely, I thought, this is a queer trail to set a woman of sixty off on alone.

There seemed to be no top. I plunged into valley after valley, spooky, silent, grey places. Tantrum heeled splendidly, but he looked into the forest and growled. The mosquitoes were the only life except one startled hawk. I felt as if bear eyes were peeping in all directions and as if my back hair might be clawed and the hot snorting breath of a beast might suddenly touch my ear. But I hated to be a slacker and turn back so I toiled on. Evidently no one had been there recently for trees were across the way. It was very stony, mostly a sort of stony ditch and steep gully. I reached a place where the trail stopped, was lost in undergrowth, and dipped into another valley. I tied my handkerchief to a tree and scouted round for a trail.

There was no light showing, as if I was near the top. I'd had enough. Slowly I retraced my steps, counting myself a slacker, but to be lost on that mountain in a regular bear "rancherie" did not seem good enough to risk.

Some way back I had noted a bare bluff, so I tore paper and marked bushes and, leaving a trail, I climbed up. The view was good but the place creepy in the extreme. I ate and took out my sketch things. I was too tired and too creepy to work or to rest. The dog stared into the forest and growled and barked. "I'm getting out," I said and, consigning my informants at the hotel to hot places, I started the descent and kept going without pause. Somehow I missed the trail. When I got to the road again it was in totally different country; however the track was there, so I knew I could make Pemberton by walking along it far enough. I could have kissed the beastly bridge, it was so good to be sure where I was.

When I limped into the hotel kitchen they were appalled. "My goodness," said the daughter, "you'd got to the top that we meant, when you 'started' on the trail. You must have got on the old McCulloch trail up to an old mine. Why, I wouldn't dream of going up there without a man." Counting that awful climb, I must have gone nine or ten miles. I ache dreadfully.

The Elephant
1933

July 16th

Once I heard it stated and now I believe it to be true that there is no true art without religion. The artist himself may not think he is religious but if he is sincere his sincerity in itself is religion. If something other than the material did not speak to him, and if he did not have faith in that something and also in himself, he would not try to express it. Every artist I meet these days seems to me to leak out the fact that somewhere inside him he is groping religiously for something, some in one way, some in another, tip-toeing, stretching up, longing for something beyond what he sees or can reach.

I wonder will death be much lonelier than life. Life's an awfully lonesome affair. You can live close against other people yet your lives never touch. You come into the world alone and you go out of the world alone yet it seems to me you are more alone while living than even going and coming. Your mother loves you like the deuce while you are coming. Wrapped up there under her heart is perhaps the cosiest time in existence. Then she and you are one, companions. At death again hearts loosen and realities peep out, but all the intervening years of living something shuts you up in a "yourself shell." You can't break through and get out; nobody can break through and get in. If there was an instrument strong enough to break the "self shells" and let out the spirit it would be grand.

I ought to descend to the basement and do out a tub of washing but I am so woefully tired I shan't. It's been very hot for two days; now the wind is up doling out bangs and smacks with a lavish hand. The roses are protesting—only the young strong ones can stand it,

41

the old tired ones flop to the earth in soft, tired twinklings.

A nice elderly couple called on me today to show me their griffon and to see mine. Theirs was O.K. but my four somehow were finer. They obeyed and there was a wise sweetness to them the other fellow lacked. During tea in the garden with the beasts the old lady said, "Are you a sister of Emily Carr, the artist?" "I am her." They said they *loved* pictures and would like to go up to the studio. Their tastes were conservative. I knew that because they told me of a lovely painting of flowers by *me* in the Vancouver Gallery. It was not mine. I knew whose it was and so what they liked. So we clambered up the stairs. They edged in past the litter and fell to talking of the studio to gain time. They spoke of their lovely old watercolours and beautiful photographs. Then I produced some canvases. They were a sweet, honest old pair and they said what they could with cautious sincerity. They are coming to fetch me to see theirs. So be it. *I* shall be in the same box wondering what to say.

July 17th
Bess and Lawren think over-highly of my work. Of course I'm glad they think there is something in it other than smearing on of paint, but I feel a little hypocritish too because sometimes one lets the mundane sweep across their work, the earthy predominate, and the spiritual sleep. Bess's letter was fine. I don't follow all the theosophy formula but the substance is the same as my less complicated beliefs: God in all. Always looking for the face of God, always listening for the voice of God in Nature. Nature is God revealing himself, expressing his wonders and his love, Nature clothed in God's beauty of holiness.

July 20th
Tomorrow there is to be a fool fuss presenting my picture "Kispiax" to the government. I'm not going to the affair in the buildings but have to appear at a pink tea at the Empress. Why can't those who collected and got the thing say, "Here!" and the Government say, "Thanks!" and the janitor hang it on the wall? And why must one drink tea at the Empress on the occasion? But then poor little Edythe has had a job collecting for the thing and I guess she will enjoy being

tea-ed. I wonder why being confronted with my work in the face of the public always embarrasses and reproaches me so terribly. Is it because there is dishonesty or lack of sincerity in the work, something that doesn't ring true, a lack of integrity in my presentation of the subject, or is it a sort of reaction arising from the perpetual snubbing of my work in my younger days, the days after I went away and had broken loose from the old photographic, pretty-picture work? Gee whiz, how those snubs and titters hurt in those days! I don't care half so much now, and yet those old scars are still tender after all these years.

July 22nd
They did it and the Government took it and it all went off quite well, they say. I went to the tea party and felt a fool when I was congratulated by some fifteen or twenty tabbies. Edythe was so sweet and pretty and cool. I loved her. And Professor Fred did his part nobly. Edythe and Fred came to supper with me later, a splendacious curry in the studio. I received $166 for my "Kispiax Village" and felt very wealthy. So that's that.

July 23rd
Dreams do come true sometimes. Caravans ran round inside of my head from the time I was no-high and read children's stories in which gypsies figured. Periodically I had caravan fever, drew plans like covered express carts drawn by a fat white horse. After horses went out and motors came in I quit caravan dreaming, engines in no way appealing to me and my purse too slim to consider one anyhow. So I contented myself with shanties for sketching outings, cabins, tents, log huts, houseboats, tool sheds, lighthouses—many strange quarters. Then one day, plop! into my very mouth, like a great sugar-plum for sweetness, dropped the caravan.

There it sat, grey and lumbering like an elephant, by the roadside —"For sale." I looked her over, made an offer, and she is mine. Greater even than the surprise of finding her was the fact that *nobody* opposed the idea but rather backed it up. We towed her home in the dark and I sneaked out of bed at 5 o'clock the next morning to make sure she was really true and not just a grey dream.

Sure enough, there she sat, her square ugliness bathed in the summer sunshine, and I sang in my heart.

Now she's just about fixed up. She has no innards, that is works, so I'll have to be hauled. I've chosen the spot, Goldstream Flats, a lovely place. I'm aching to be off but not yet as nobody wants to go with me. I've asked one or two. I thought it would be nice to have someone to enthuse to, just for the first trip. With one accord they all made excuses except Henry. Poor Henry, who has lived twenty years and only developed nine when sleeping-sickness overwhelmed him and arrested his progress, like a clock whose hands have stuck though it goes on ticking—Henry *wants* to go along.

I wonder who went with me in the dream caravan. I do not remember but I was not alone. Maybe it was Drummie. No, Drummie was before that. We were only pals when I was a wee girl and I do not remember that he ever was anywhere except in our big garden. He was a dream pal and I used to ride all round the garden with him on a dream horse. There was one overgrown corner. Rocket ran riot there, all shades of it from mauve to purple, and white butterflies hovered amongst it in thousands and the perfume and the sunshine made things woosey. Drummie seemed to come most to that corner. I used to trot like a pony up and down the gravel walk; the rocket was as high as my head. The dream horse and the dream boy and I all talked and had a splendid time that nobody ever knew about except ourselves. I do not remember ever seeing Drummie's face. That was an unimportant detail. Where the name "Drummie" came from I have no idea. Sometimes since, I have wondered if it was some small boy's spirit that really did come to play with me in the old garden. It was a wonderful enough old garden to produce anything, with its flowers and fruit trees and berry bushes and the round tadpole pond where you dipped them into the old iron dipper that the chicken food was measured with. There was a stone paved walk to it with hurdles across to prevent the cows getting mixed when they went to drink. You stood on the hurdles and saw the upside-downness of the daffodils and primroses, the trees, our faces and our white pinafores, and the ducks swam serenely over their double, perhaps finding them as companionable as I did my Drummie dream boy.

July 25th

I have been to a wedding—my sister's little maid—such a pure, high, sweet little soul, an adopted daughter of a chimney sweep. The sweep and his lady shone by soap suds. His skin was so clean and so red it looked as if it had been burned. His lady was in blue with an immense sweet pea bouquet, pink, upon her ample bosom. The little church was filled. A man, middle-aged and "middle" in every other way, muddled in an inharmonious way over the harmonium. Another middling person sang a solo, bellowing the words, "love" and "dear," with suitable volume.

Nearly everyone in the audience had a child. The small ones howled and the big giggled. The parson was a stick as he squeezed from behind two small panels serving as a vestry followed by two shy boys, the groom and his man. Then the old boy at the harmonium fell upon the stops, pranced his big hands over the keys, out squeaked the wedding march and in came the bedecked little flower girls and the bride, white and pure and lovely. How such a lily could have grown to womanhood in that sooty family is a marvel. So all-good, standing there, taking her marriage vows before God, high in her ideals of womanhood and matrimony, giving the whole of her sweet self to the man she really loved, prepared to face life with him on $30.00 per month and love. Bless the child. He is a lucky boy to have won that pearl.

I was looking at a picture, a weak watercolour, a present from a friend to a friend, and trying to sum up why the thing, which was a fairly good surface reproduction of the scene, was so unconvincing and awful. The painter just had not experienced the thing he represented. The objects, water, sky, rocks, were there but he hadn't felt that they were big or strong or high or wet.

I want my things to rock and sway with the breath and fluids of life, but there they sit, weak and still, just paint without vitality, without reality, showing that I myself have not swayed and rocked with experiencing when I confronted them. It was but their outer shell; I did not bore into them, reach for their vitals, commune with their God in them. Eye and ear were dull and unreceptive to anything beneath the skin. This great mountain might be a cardboard stage set, not an honest dirt-and-rock solidity of immovableness. What

were those infinitesimal trees and grass and shrubs? Pouf, the wind sways them, the fire burns them and they are gone! But the mountain bulk! Ages it has stood thrusting its great peak into the sky, its top in a different world, changed in that high air to a mystic wonder. It is praying to God. God throws a white mantle over it and it is more unearthly than ever in its remote purity, yet its foundation sprawls with solid magnificence on the earth.

July 27th
Oh, these mountains! They won't bulk up. They are thin and papery. They won't brood like great sitting hens, squatting immovable, unperturbed, staring, guarding their precious secrets till something happens. At 'em again, old girl, they're worth the big struggle.

July 28th
A long spiel in the paper tonight, my name figuring in the headline —quite unnecessary. I am mentioned in connection with two water-colour exhibits now travelling abroad. Why then do I go to bed heavy and heartachy? Write-ups depress me horribly. I feel as if somebody was making a mistake, especially after a day of wrestling with that mountain. The dismal failure I have made of it makes my spirit sick and bedraggled. I must get that lifting strength, but how?

The women's clubs are sending "Vanquished" to Amsterdam for the Convention of the Confederation of Women Something-or-Other. Three women selected it today. Goodness, when I brought it out I felt maybe I'd gone back since I painted that three or four years ago. I believe it *is* stronger, and my heart is sick. Perhaps I'm approaching my dotage and my best is done. Oh, I must look up and pray!

I have wiped out the village at the foot of the mountain. Now I shall paint the little cowed hollow that the village sits in and maybe toss the huts in last of all. It is the mountain I *must* express, all else subservient to that great dominating strength and spirit brooding there.

July 29th
Oh, my mountain! I am like a tiny rowboat trying to tow it into port and the sea is rough.

46

July 30th

I have contraried my usual custom and ignored my painting this whole Sabbath. The day was perfect and the garden delicious; so the dogs, monk and I sat there and *lived*. Lizzie came to supper, and Henry who was alone tonight. I read Fred Housser's *Whitman to America*. It's wonderful, a splendid book to nourish the soul. Fred knows his Whitman and Whitman knew life from the soul's standpoint. What glorious excursions he made into the unknown! He wrote, "Darest thou now, O soul, Walk out with me toward the Unknown Region, Where neither ground is for the feet, nor any path to follow"; and he *dared*. We, Henry and I, went to the beach after and lit a fire and watched the moon rise across the water. There was absolute peace down there.

Oh, today I am akin to the worm, the caterpillar and the grub! Where are the high places? I can't reach anything, even the low middle.

The sketch should make the mouth water, but the finished picture should fill and satisfy with a sense of completeness. My sketches move people, not my pictures. I'm a *frost*!

August 7th

Two visitors today, one male, inflated and bloated with conceit like a drowned pup, one female, a writer, rather interesting, the mother of a fifteen-year-old boy yet ogling the "bloated pup" as if his sex made him *wonderful*. I toted out canvases and took the opportunity to scan them closely for any sign of falling below par. They do; they are indefinite and weak. I have wrestled again with my mountain. It is much like a great corsetless woman or a sitting pillow. I wish I could sit before it again and realize it fiercely, vitally.

I am happy. At last I have found a use for those fool newspaper write-ups I detest so. I found it in the Lunatic Asylum. I went out to Wilkinson Road Mental Home to see Harold. He was unusually clear-headed and happy. He gets the keepers and patients to cut out any notes about my painting and hoards them and rejoices over them. "I just danced round the ward for joy when I read they'd sent

47

your picture to Amsterdam," he said. "Oh, I was so glad." Poor lad, he begged me to do him a sketch of Kispiax Village where he lived with the missionaries. It is amongst his poor bits of treasures. He has ceased fighting against the bars now and is happy and contented. They let him come with me into the grounds today, first time he'd been outside in months. We sat on a bench in the shade and I unpacked my bag—such things as one would take to a child, and he near forty, apples and lavender from my garden; chocolate and a cake of sweet soap and a pencil for his child's side, cigarettes because he is bodily an adult. We fed the bear chocolate. It was very hot, with a lovely little breeze. No wonder the man-boy was so happy outside the bars for a brief spell, his poor clouded mind fluttering back and forth over memories of when he was free. It is worth a whole lot to see his face light when the keeper brings him in and he ambles forward on his misshapen feet with both hands outstretched to me in welcome.

August 12th
Fred Housser's *Whitman to America* is absorbingly interesting and wonderful to me. It clarifies so many things. Integrity has a new meaning for me, living the creative life seems more grandly desirous (opening up marvellous vistas) when one is searching for higher, more uplifting inspiration, when one is listening intently for what a thing is saying and for the urge of life pouring through all things. I find that raising my eyes slightly above what I am regarding so that the thing is a little out of focus seems to bring the spiritual into clearer vision, as though there were something lifting the material up to the spiritual, bathing it in the above glory.

Avoid outrageousness and monstrosity. Be vital, intense, sincere. Distort if it is necessary to carry your point but not for the sake of being outlandish. Seek ever to lift the painting above paint.

I thought my mountain was coming this morning. It began to move, it was near to speaking, when suddenly it shifted, sulked, returned to obscurity, to smallness. It has eluded me again and sits there, mean, puny, dull. Why? Did I lower my ideal? Did I carelessly bungle, pandering to the material instead of the spiritual? Did I lose

sight of God, too filled with petty household cares, sailing low to the ground, ploughing fleshily along?

August 19th

My van elephant is now a reality. While she sat there in the lot she was only a dream shaping itself. She was bought so suddenly after long years of waiting. It is two months from the morning that I got out of bed at 5 a.m. to peep out of the studio window and see if she was really there in the lot beneath. Then came all the fixings, meat safe, dog boxes and monkey-proof corner. And when she was ready, equipped in full, the hauler came and said that it was impossible to get her out of the lot because she was too low, and he was horrid and I was mad. "Well," I said, "if the man brought her 3,370 miles across the Rockies, surely she can be taken twelve miles to Goldstream Flats." And she was, but not by that old fool. The third who inspected ventured. The family sat on the creature crates and watched the tugging, heaving and wrenching. Sweat and cussings poured! Poor rat Susie was aboard and must have got severely jerked. The lid was off her box when we got there but Susie sweetly asleep within.

Henry and I and the animals drove in the truck. Whew, it was hot at the wood yard! The jacking-up blocks weren't ready. Then we stopped for the tires to be winded. We lumbered right through Government Street. Mercy, it was hot! And the delays were so numerous I patted my wallet and wondered if she was fat enough but they only charged the original $3.50 agreed upon. I was so thrilled that I "coned" and "ginger-popped" the man liberally when we got to the pop shop on the Flats.

It wasn't the spot I had picked, but the Elephant found it to her liking. The Elephant is a grand sitter but a heavy traveller.

Henry went all to pieces when we got there, not a steady nerve in his body. He hopped and wiggled and shook and stuttered. I ran hither and thither getting blocks and bricks and stones to aid the man in hoisting the Elephant off her tires. It was almost 5 p.m. when he left. The Elephant had chosen a favourite cow spot and much raking was necessary. This was accomplished with the aid of a row of rake teeth absolutely devoid of a handle. Everyone on the Flats

49

collected to see us unpack, the monkey, of course, being the centre of attraction. The tent fly tormented me but I got it stuck up at last unaided. I made up the beds and prepared supper. Black fell down among the great cedars before I was nearly out of the mess.

Neither of us slept. I could hear Henry groaning and tossing under the tent. The creatures were all in the van with me and very good. The monkey is housed in a hollow cedar tree, cuddled into its very heart. Surely I have at last found her a habitation she *cannot* wreck. She'd have made matchwood of the Elephant. I ship-shaped up next morning and we are spick and span, very comfortable and very happy. Henry's nerves torment and wrack him a little less. There's a great peace under these magnificent cedars and the endless water sings its endless sound not a stone's throw off. I've made a range to rival any "Monarch" or "Canada's Pride" ever invented. The ingredients are a piece of automobile frame, the leg of a stove, a pile of rocks, scraps of iron, tin and wire, and parts of a gridiron. It's a peach!

Last night we slept like babies. Each creature has dropped into its own niche. The spirit of freemasonry and intimacy among us all is superb. It's wonderful to watch the joy of the pups playing tag among the cedars. There is a delicious little breeze humming among the leaves without bluster or vulgarity. Today I love life, so do the four dogs, the monkey and the rat. And poor Henry; this must make up to him a little for all that he hasn't got in life.

Last night when the pop shop was shut and everyone was in bed I slipped into a nondescript garment and tumbled into the river. It was wonderful. I lay down on the stones and let the water ripple over me, clear, soft water that made the skin of you feel like something namelessly exquisite, even my sixty-year-old skin. When I had rubbed down and was between the sheets in the Elephant's innards, I felt like a million dollars, only much cleaner and sweeter and nicer. The precious pups were asleep all round, and rat Susie, Woo just outside the window in her hollow cedar, Henry in the tent lean-to. The cedars and pines and river all whispered soothingly, and there was life, life, life in the soft blackness of the night.

Today is wonderful again. Henry has found companionship with the pop lady's small boys. They are playing ball, all laughing, which

is good, for at breakfast he was troublesome and morose. Woo has bathed in the river and is exploring the underneath of a big tree root. I am preparing a stew on the "Monarch" range.

Sunday, August 20th

Oh, today is awful! They started early this morning—the Public. The beautiful cedars are dim with dust, the air is riled up with motor snorts, dog barks and children's screechings. The Elephant is beside the public road. For every two feet that pass, kicking up the dust, one nose, two eyes and one gaping mouth are thrust into the caravan. Every party has one or more dogs, every dog has many yaps. One picnic party with a dog contemplated settling on top of my camp. I suggested that it was rather close and there was the whole park. The woman was peeved and said, "But that's the spot I like." Finally she moved very grudgingly by. Woo is very smart. She has betaken her little grey body among the roots in the bank where she does not show, so no one notices her and I am not bombarded. The dogs are shut in the van and are weary of the public. I've had visitors myself for two days.

Henry is better today, looking quite smart and happy. His sister came out and I got a letter from Fred. He talks about his Whitman book. I do want it printed so I can have a copy for my own eye, to line and score and study and make my very own. Just reading a thing over two or three times doesn't do that. One has to go back and back to bits and points. I'm slow as snails at absorbing.

The sun has left the Flats. It is not even visible on the mountain for the smoke of forest fire is all about. Night will be here soon. Even now the folk are piling into motors; snorts and dust clouds are increasing. Two Boston terriers that have been tied up all day are worn out with squealing and only give piercing wailing, yelping whines at intervals. Mrs. "Pop Shop" has subsided into her wicker chair on the platform behind the pop booth. She is very fat and billows all over it. I can see the tired sag of her fat from here. I haven't heard one person, no child or anyone, laugh today. They rush and tear to get, but don't stop to enjoy the getting. I'm longing to paint. Why don't I? I must go into my closet and shut the door, shut out Henry and camp cooking and visitors and food and drink and let the

calm of the woods where the spirit of God dwells fill me, and these ropes that bind my hands and the films before my eyes fade away, and become conscious of the oneness of all life, God and me and the trees and creatures. Oh, to breathe it into one's system deeply and vitally, to wake from sleep and to live.

August 31st

A wet day in camp. The rain pattered on the top of the Elephant all night. Mrs. "Pop Shop" and I went for our nightly dip in the river. It was cold and took courage and much squealing and knee-shaking. Neither of us has the pluck to exhibit the bulges of our fat before the youngsters, so we "mermaid" after dark. I dare not *run* back; the footing among the cedars is ribbed with big roots. One's feet must pick and one's eyes must peer through the dim obscurity of the great cedars and maples. Once inside the Elephant, scrubbed down with a hard brush and cuddled up to a hot bottle, I thought I loved the whole world, I felt so good. But last night as I stood in my nightie and cap, a male voice made a howl and a male head thrust into the van. Well, all the love and charity fled from my soul. I was red hot and demanded his wants. By this time the dogs were in an uproar and I couldn't hear his answer. Finally I caught, "Can I get any bread?" "No," I replied tartly, "The shop is shut out there." He disappeared in the night and then I felt a beast and ran to the door to offer him what I had in camp but he had vanished, swallowed up in the black night. I might have been more tolerant, but I hate my privacy being torn up by the roots. I thought of that one word "bread" every time I awoke.

At 6 a.m. we got up and climbed the mountain to a nursery garden. The little woman was a wonder—five babies under five years and yet she was smart and active. By 7:30 her house was all in order, baby washed and being fed. She is the kind who ought to have a family; they don't annoy or worry her. The whole place spoke of thrift and contentment. I did admire that woman and family.

September 5th

It started to rain last night and has rained all day. I packed Henry off home because his shelter was too slim. Anyhow he has had two

good weeks. I had spent all day rearranging the camp for rain and snugging it up. I moved the "Monarch" range up close in front of the awning. The great cedar hangs over it and sheds off the rain. Woo in its innards is dry and cosy. She loves her cedar home. The woods are delightful in the rain, heavily veiled in mystery. They are delicious to *all* the senses but most to the smell. An owl came and sat on my cedar beside the fire. How I love it when the wild creatures pal up that way! The van is cosy, come rain, come shine, and all is well. Now Henry is gone I hope to try and work. Perhaps it wasn't Henry; maybe it was me. I care much too much for creature comforts and keeping the camp cosy and tidy. It seems necessary, especially with all the creatures. Mrs. Giles, the nursery woman, said that when her small boys went home and reported that there was a lady in the Flats in a house on wheels, with four dogs, a monkey and a rat, and a hopping boy, she thought it must be a section of a circus or travelling show. They also reported that when they came into my camp I chased them all off with a broom. I believe I was considerably tormented that first morning. How different you sound when described to what you feel!

September 7th

This is my first real day in the van. I mean by that the first day I have risen a tiny bit above the mundane. At 6:30 a.m. I looked from my berth in the Elephant and saw the sun faint but hopeful on the tipmost top trees of the mountain. Mount Finlayson is on one side of us and a nameless sheer rocky cliff on the other. The Goldstream Flats are a narrow lowness where Goldstream babbles its way out to the Saanich inlet on Finlayson Arm. The sun gets no look-in for several hours after rising and winks a goodbye to us long before he has finished his daily round.

The four dogs burst like fireworks out of the van door at 6:30. At seven I followed and we took our dewy walk in the woods. Then some washing, dried on the camp fire which made my undies look and smell like smoked fish. I got to work, with my things for the first time all comfortably placed about, everything to hand. I made a small sketch and then worked a larger paper sketch from it. The woods were in quiet mood, dreamy and sweet. No great contrasts of

light and dark but full of quiet glowing light and fresh from the recent rain, and the growth full, steady and ascending. Whitman's "Still Midnight"—"This is thine hour, O soul, thy free flight into the wordless"—sang in my heart. I've a notion, imagination perhaps, that if you are slightly off focus, you vision the spiritual a little clearer. Perhaps it is that one is striving for something a bit beyond one's reach, an illusive something that can scarcely bear human handling, that the "material we" scarcely dare touch. It is too bright and vague to look straight at; the brutality of a direct look drives it away half imagined, half seen. It is something that lies, as Whitman says, in that far off inaccessible region, where neither ground is for the feet nor path to follow.

I do not say to myself, I will do thus or so. I leave myself open to leads, doing just what I see to do at the moment, neither planning nor knowing but quietly waiting for God and my soul.

September 8th

Oh, what a joy morning! Sun blazing, whole woods laughing, dogs hilarious. Camp all in order, calm radiance everywhere. What a lucky devil to have an Elephant and browse among such surroundings! The monk in her warm dress is sitting in the sun, replete with satisfaction. Susie the rat's pink nose keeps popping out from the front of my jacket. Her whiskers do tickle! Susie's heaven is right under my chin. There, I believe, she finds life complete, except maybe she hankers for a mate. Maybe I ought to provide one but they are so populous.

I had thought this place somehow incongruous, the immensity of the old trees here and there not holding with the rest but belonging to a different era, to the forest primeval. There is no second growth, no in-between. It is too great a jump from immensity to the littleness of scrub brush. Today I see that I am what Whitman would call "making pictures with reference to parts" not with reference to "ensemble." The individual mighty trees stagger me. I become engaged with the figures and not the sum and so I get no further with my reckoning up of the total. Nothing stands alone; each is only a part. A picture must be a portrayal of relationships.

Later

Such a terrible loneliness and depression is on me tonight! My heart
has gone heavier and heavier all day. I don't know any reason for it
so I've mixed a large dose of Epsom Salts, put my sulky fire, which
simply would not be cheerful, out, smacked the dogs all round for
yapping and shut myself in the Elephant, although by clocks I should
not be thinking of bed for three hours yet. This is the dampest spot
I was ever in in my life. The bed, my clothes, the food, everything
gets clammy. I burst two hot bottles two nights running. I took a
brick to bed the next night; too hot, set fire to the cover. Tonight I
invented a regular safety furnace. I put the hot brick into an empty
granite saucepan with a lid on. It is safe and airing the bed out
magnificently. (One thing that *did* go right.)

I made two poor sketches today. Every single condition was good
for work, but there you are—cussedness! What a lot I'd give tonight
for a real companionable pal, male or female, a soul pal one wasn't
afraid to speak to or to listen to. I've never had one like that. I expect
it is my own fault. If I was nice right through I'd attract that kind
to me. I do not give confidences. Now look at Mother "Pop Shop."
There she is in her tiny shop doling out gingerpop, cones, confidences
and smiles to all comers. Let any old time-waster hitch up to her
counter and she will entertain him and listen to him as long as his
wind lasts. Tonight one was there a full hour and a half. She has
nothing to sit on at the counter. She's awfully fat and heavy but she
lolls with this bit of fat on a candy box and that bit on a pop bottle
and another bit on the cream jars and the counter supports her
tummy while she waggles her permanent wave and manifold chins
and glib tongue till the sun sinks behind the hill and her son whim-
pers for supper and the man has paid his last nickel and compliment.
Then she rolls over to the cook stove complaining at the shortness
of the day. Does she get more out of life by that sort of stuff than
I do with my sort of stuff? I wouldn't change—but who is the wiser
woman? Who lives fullest and collects the biggest bag full of life?
I dunno. . . .

September 9th

All is fine today, unbeatable weather, no campers, no rubbernecks,

no headache, nothing but peace. I worked well this morning and again before dark and felt things (first ideas) then drowned them nearly dead in paint. I don't know the song of this place. It doesn't quite know its own tune. It starts with a deep full note on the mighty cedars, primeval, immense, full, grand, noble from roots to tips, and ends up in a pitiful little squeak of nut bushes. Under the cedars you sense the Indian and brave, fine spiritual things. Among the nut bushes are picnickers with shrieking children bashing and destroying, and flappers in pyjama suits. And there are wood waggons and gravel waggons blatantly snorting in and out cutting up the rude natural roads, smelling and snorting like evil monsters among the cedars. The Indian used the cedars, shaped beautiful things from them: canoes, ropes, baskets, mats, totem poles. It was his tree of trees. The picnickers mutilate them with their hideous initials, light fires against them, throw tin cans and rubbish into their hollow boles, size up how many cords, etc.

Sunday, and I've straddled over it somehow. At home I can't get enough of its peace. Here I get too much of its pests. Mrs. "Pop Shop" has gone and Mrs. Hooper has come. Curls and undulating curves of fat give place to mannish crop and straight up-and-downishness. The little pop shop has starched right up—positive. The negative slop of the other personality has melted away. She has brought two guns and a dog. "You holler," she said when I told her of two undesirable youths who came to my camp and ordered supper, "and I'll pepper a load of shot about their feet."

After all the motors had departed and it was black among the cedars, a car drove in past my van to a delightful opening among the cedars. They picnicked, a young middle-aged man and wife, a boy and two liver-and-white spaniels. I watched them a long time. They were so happy. They spread rugs and supper in the light of the "car" and ate and chattered. What a nice memory for the boy when he grows up! They were all intimately close, the man, woman, boy, dogs, trees. As they drove out they stopped by the stream. Of course, as is the way of all young things, the boy would want a drink just to prolong the goodness a bit. Can't I remember myself, when all protests were useless to postpone bedtime, asking for a drink?

Woo has been very ill today. Somehow or other she contrived to help herself liberally to green paint off my palette. It's two years since her orgy of ultramarine. I've washed her outside and inside, made her a new dress and pinafore because she was sick all over the other. Her trust in her "ole Mom" is wonderful. She lay in my lap while I poured Epsom Salts down her and washed out her cheek pockets. She was dreadfully ratty with the dogs who probably jeered at her tummy-ache. She was still meek and woebegone when I tucked her up in her hollow cedar but I think the worst is over. Her stomach is a marvel.

No work today. How could one address oneself to upstairs thoughts with sick monkeys and motorists scattered every old place? The dogs also have been devilish.

Do not forget life, artist. A picture is not a collection of portrayed objects nor is it a certain effect of light and shade nor is it a souvenir of a place nor a sentimental reminder, nor is it a show of colour nor a magnificence of form, nor yet is it anything seeable or sayable. It is a glimpse of God interpreted by the soul. It is life to some degree expressed.

September 12th
Homesick—that's me tonight. The cold clammy dark of this place is on me. Tomorrow I shall go out searching for winter quarters for the Elephant. I went up the mountain to see Mrs. Giles and her babies today. It seemed so light and high and clear up there. I sank down into our valley at about six o'clock. It was dusk. Mrs. Hooper thought I was lost and said that the dogs had howled. It was pot-black night long before they were fed and seen to. Such a blackness! It is like being blindfolded with a black rag, and when you light your lamp and fire it seems to make things worse and spotlights you to all the hobos, wild beasts, villains and spooks. I made myself cook some supper and retired to my van and ate it. It's time I was home. It's a dark, desolate winter place. The Elephant stands alone. Mrs. Hooper's little stand is a block of stumps and roots and hollows away and her living quarters are in behind at the back. Her light doesn't show. I suppose I'm a coward. I am not afraid exactly but it's creepy.

September 14th

I have found winter grazing for the Elephant after much tramping. It has settled in to pour. Mrs. Hooper supped in my camp and by the fire we sat long, talking. There is a straight-from-the-shoulderness about her I like. She does what comes to her hand to help people— reared a worse than parentless girl, looked after and helped old poor sick women. Through her conversation (not boastfully) ran a thread of kindness and real usefulness. I feel wormy when I see what others do for people and I doing so little. I try to work honestly at my job of painting but I don't see that it does anyone any good. If I could only feel that my painting lifted someone or gave them joy, but I don't feel that. I enjoy my striving to express. Another drinks because he enjoys drinking or eats because he enjoys eating. It's all selfish.

The rain is thundering on the van top. The creatures are all folded down in sleep, the park blackly wrapped about in that dense dark. There is a solidity about the black night in this little valley, as if you could cut slices out of it and pile them up. Not a light anywhere. The stream gargles as if it had a perpetual sore throat. A car passes up on the Malahat highway with a swift flash of light on this and that up above us and is gone like an unreality.

September 16th

After living for a whole month, or thereabouts, in a caravan and then to return to a two-storey house with six rooms all to oneself makes one feel as if one had straddled the whole world. The Elephant is bedded down opposite the Four Mile House in a quiet pasture. It is hard to settle down. The house feels stuffy and oppressive but the garden is joyful. The trees are heavy with near-ripe apples and the autumn flowers plead for yet a little sunshine so that they can mature their late crop. The rain is drooping them heavily. Woo is still in her summer residence, defying the World, the Flesh and the Devil with hideous faces. The dogs who were so delighted to go away are now tickled stiff to come back. And Susie? To her the studio is splendid and to roam free among its litter is the tip top of life.

I have uncovered "The Mountain." It makes me sick. I am heavy

in spirit over my painting. It is so lacking. What's the use? Sometimes I could quit paint and take to charring. It must be fine to clean perfectly, to shine and polish and *know* that it could not be done better. In painting that never occurs.

Oh, I am frightened when I look at my painting! I have had some back today from exhibitions and see it afresh. There is nothing to it, just paint, dead and forlorn, getting nowhere. It lacks and lacks. The paint chokes me and I ache. Better eat paint like the monkey and make my body sick than dabble my soul in it and make that sick. A dose of salts fixed her body. What can I take to fix my soul? It is sick and aching and heavy. Be still. *Be still*. Fretting and forcing don't get one anywhere. I've gardened and washed blankets today and done them well. That is apparently my level. The work I did at Goldstream Flats is a fizzle, not one uplifting statement, only muddled nothings. And yet at times I thought something would come through and there are some thoughts in it to work out.

"Missing you a long time. I now write to invite you to my exhibition of art." So wrote little Lee Nan. He is a Chinese artist. When I had the exhibition trying to start the People's Gallery, he was much disappointed that the gallery did not go through. His exhibition was in an old brick store in Chinatown, 556 Cormorant Street. It must have taken some courage. His cold, moist little hand, as I shook it, said it did. (He once tried to join the Arts and Crafts Society and was refused because of his nationality.) His work is good and he knows it and loves it.

He had a room full of his paintings. The big double door was open and the shop window was hung with green cotton curtains, truly Chinese. He had covered the brick wall with a thin wash of white but it was still a brick wall, no delusion. There was an organ in the room and a box in a corner draped with a black and white oilcloth. There was a gay bunch of flowers on it and a little new exercise book in which the guests wrote their names, the Orientals on one side of the page and the whites on the other. There were not many signatures.

Lee Nan met each guest and said a few words. His English is very difficult but his face beamed with nervous smiles. I love his work.

It is simple and sincere and very Oriental. He bookkeeps in a Chinese store and has not a great deal of time to paint. His subjects are mostly birds and flowers with a few landscapes. They are mostly watercolours. The birds live and are put into their space just right. There is a dainty tenderness about them and one is not conscious of paint but of spirit. As I stood by little Lee Nan something in me went out to him, sort of the mother part of me. I wanted to shield him from the brutal buffets of the "whites" and their patronizing. ("Quite good for a Chinaman, aren't they?" they say.) "Did you send many invitations?" I asked. "Oh, yes," he said and stopped to count. "I sent seven." I could imagine the labour those seven neat little half-sheets had cost. I have telephoned a lot of people, including two newspaper women. I hope they give him some write-ups. It would please him greatly. I and my work feel brutally material beside Lee Nan and his. I asked the price of a sketch. "Oh, I don't know. Who would want it?" he replied.

I went again to Lee Nan's exhibition. Not one of the old sticks I told about it, who thanked me so smugly and said they would surely go, has been. A great old fuss there'd be if it was someone in *society*. Lee Nan was smilingly cheerful. He expects so little. He has sold three sketches and thinks that the people will come by and by. He would like me to teach him. I feel more that I would like him to teach me. He has what I lack, an airy, living daintiness, more of the "exquisite" of life. There is a purity and sweetness about his things, much life and little paint. How different the Oriental viewpoint is! I should think we hurt them horribly with our clumsy heaviness.

It's frightfully difficult being a "good" landlady. You've simply *got* to keep the place decent, and so many tenants are indecent and if you say anything at all, you are a "beastly, cranky old landlady." It should be perfect balance of both parties, but it is not. Some of them have no self-respect at all. Dirty milk bottles in front windows or doors, underwear on front porches to sun, unmade beds in the afternoon in front of open doors, minor indecencies of all sorts, regular cut worms that nibble all your joy sprouts. I suppose I should be thankful that they are quiet ones at present, but they are

such a really drab lot. No one laughs or sings or whistles or enjoys the garden. They are mouse-quiet so that you don't know if they are in or out. That's all right, but it's like a morgue full of corpses. They're not alive. Every one of them said how *good* it was to hear the dogs home again and me youlping at them. They're a lot of inanimate, mincing ninnies. I have had the other sort too, deafening rowers with squalling babies and radios and pianos, door slammers and heavy foots. I wish, oh I do wish, someone *really* nice and companionable would come, a friend person. Thank the Lord for dogs, white rats and monkeys. They, at least, are stable. Their love springs don't dry up but bubble on and on right to the grave and after.

I am painting a flat landscape, low-lying hills with an expanding sky. What am I after—crush and exaltation? It is not a landscape and not sky but something outside and beyond the enclosed forms. I grasp for a thing and a place one cannot see with these eyes, only very, very faintly with one's higher eyes.

I begin to see that everything is perfectly balanced so that what one borrows one must pay back in some form or another, that everything has its own place but is interdependent on the rest, that a picture, like life, must also have perfect balance. Every part of it also is dependent on the whole and the whole is dependent on every part. It is a swinging rhythm of thought, swaying back and forth, leading up to, suggesting, waiting, urging the unworded statement to come forth and proclaim itself, voicing the notes from its very soul to be caught up and echoed by other souls, filling space and at the same time leaving space, shouting but silent. Oh, to be still enough to hear and see and know the glory of the sky and earth and sea!

September 26th
Little book, I have toiled all day and caught nothing. It's the mountain again. There's nothing to it, just a fritter of nothing like a foam sauce and no pudding to go with it. I say to myself, "Lie down, old girl. Be quiet. Relax. It will never come if you fuss. Leave it. It is not your affair. It may never come but it may be a stepping stone to some other thing better."

I have been mounting paper sketches for the Edmonton Exhibi-

tion. I am not quite sure if it is a good thing to exhibit sketches—thoughts. Then I think that maybe it won't do *me* any good but maybe it will give some other person an idea that will be way ahead and go much further than mine, and that *would* be good. It's the *thing* that matters not who does it. To glorify and express the supreme being, that is *all*.

September 30th
Little book, I'm tired, bodily and mentally. I've had a visitor for three days and to one who lives much alone a visitor disturbs and exhausts. Superficially we had quite a lot in common, interiorly little. Does one ever have interior friends? I doubt it. When my work was surface smattering she liked it extravagantly. Now when I am trying to dig deeper she shies at it. She is pleased at any recognition I receive but it is for the sake of the "I told you so" of the old work when she liked it and folk ran it down, not for the sake of any growth there is in it. That is what hurts. People don't care about any development or growth, most of them anyway. I don't care a whoop for myself (it means nothing) but that I am not making them see further into the thing I am after hurts.

They have asked for two exhibits for Edmonton. When the man came to see me in summer I was all "hedgehogged" up in bristles and prepared with No. But he was so nice. He told me of the many Alberta people stuck out there on farms. Their ideal was to finish life out at the coast after they had grubbed out a fortune on their prairie farms, toiling through heat, cold, blights and blizzards, with the thought of the mild coast climate, the sea, the trees and gardens always before them. Now, with the long-continued badness of things out there, and snowed under in debts, they have settled in dumb despair to finish out there. He said they were knife keen on seeing and hearing anything to break the dull monotony. The Carnegie Extension were doing a lot in spreading round exhibitions, borrowing here and there. He said the exhibition would be crowded, people driving miles, and great appreciation shown. When he said all this my bristles all fell and I felt glad, proud to contribute a wee bit. I promised him two exhibits, one oils—he wanted them for the university—and one my paper sketches for the people. I have them

all mounted now and can honestly say they are quite an exciting exhibition, rough and unfinished but expressing, a little.

October

I have just had a surprise and a great joy. My sister Alice came to see the sketches and they really moved her. She went over and over them for a full hour, changing them about on the easels, sorting and going back again to particulars. And she repeated several times, "They're beautiful. No that's not quite it. They're wonderful." And she kissed me. I felt stuffy in the throat and foolish but that meant more to me than three columns of newspaper rot.

Two artist photographers came to the studio today. They were very enthusiastic over my work. Said it was individual and I was getting something. Am I? I've worked happily for a week grinding at some of my long commenced canvases. I think some of them are waking and beginning to move a little. It's vastly interesting. I'm a lucky devil to be as free as I am: home of my own, studio, no money but as long as I can keep clear of debt I don't need much except paints. If it wasn't for the infernal repairs always bobbing up!

I have written hard all day reconstructing my story "The Heart of a Peacock." It was the first of my animal stories and very weak and sentimental. I changed the angle somewhat. I think it sounds better now. I got so excited!

Little Lee Nan also came to see the Edmonton sketches. He sat Chinawise on his heels, spread the sketches on the floor and studied them seriously. I felt more sympathy and understanding from him than from all the other "locals" put together. His Chinese hands were expressive, pointing, indicating and swaying over the sketches. His English is broken and obscure.

Max Maynard and his wife came in later. Max picked on footling unessentials, harping on the misplacement of one small hut. He ignored the forty-five other sketches while he rasped and ranted over that one little hut. He says that women *can't* paint; that faculty is the property of men only. (He is kind enough to make me an exception.) He tells me he only comes for what he can get out of me but he goes away disgruntled as if I'd stolen something from

him. Sometimes I think I won't ask him to come over any more but if he can take anything out of my stuff (and he does use my ideas) maybe it's my job to give out those ideas for him and for others to take and improve on and carry further. Don't I hold that it is the work that matters not who does it? If we give out what we get, more will be given to us. If we hoard, that which we have will stagnate instead of growing. Didn't I see *my* way through Lawren? Didn't I know the first night I saw his stuff in his studio that through it I could see further? I did not want to copy his work but I wanted to look out of the same window on to life and nature, to get beyond the surface as he did. I think I can learn also through Lee Nan and Lee Nan thinks he can learn through me, light and life stretching out and intermingling, not bottled up and fermented.

October 5th
Oh, that mountain! I'm dead beat tonight with struggling. I re-painted almost the whole show. It's still a bad, horrid, awful, mean little tussock. No strength, nobility, solidarity. I've been looking at A. Y. Jackson's mountains in the C.N.R. Jasper Park folder. Four good colour prints but they do not impress me. Now *I* could not do one tenth as well but somehow I don't *want* to do mountains like that. Shut up, me! Are you jealous and ungenerous? I don't think it is that.

October 6th
My mountain is dead. As soon as she has dried, I'll bury her under a decent layer of white paint and top her off with another picture. But I haven't done with the old lady; far from it. She's sprawling over a new clean canvas, her germ lives and is sprouting vigorously. My inner self said, "Start again and profit by your experience." Oh, if I could only make her throb into life, a living, moving mass of splendid power and volume!

Trip to Chicago
1933

October 9th

A letter from Lawren telling me of his visit to the Chicago World's Fair, setting up within me the awfullest ache of longing to go and see for myself the picture exhibition. It must be comprehensive and wonderful. To be on the same continent and not to go to see it seems a shame. I wouldn't care about the rest if I could see the pictures. What an education! Well, if it was necessary for my soul's fulfilment I would see them. Maybe I've got to plough along alone and find my own way, going straight to God for knowledge and instruction. I'm not going to grunt anyhow.

Direction, that's what I'm after, everything moving together, relative movement, sympathetic movement, connected movement, flowing, liquid, universal movement, all directions summing up in one grand direction, leading the eye forward, and satisfying. So to control direction of movement that the whole structure sways, vibrates and rocks together, not wobbling like a bowl of jelly.

October 14th

Things have to be in Toronto for the first group of twenty-eight by the 25th. Only three days more to pull them together. Yet knowing that, perhaps because I knew that, I chucked all to the winds and went to Beecher Bay with Phil. It was splendid. We built a fire, ate tea on the beach. Four little tiny beaches made by jutting rocky points with round, flattened trees and wind pouring up the ravines. Groups of small trees scuttling together in hollows, and frail wind-broken shacks—such glorious shades of weathered boards. Pine

trees and grey sea and sea gulls and glowing russet-red bracken. All lovely, forsaken, free and wild. Got home to my ravenous dogs at seven o'clock. I took a long straight look at my canvases.

I think we miss our goal very often because we only regard parts, overlooking the ensemble, painting the trees and forgetting the forest. Not one part can be forgotten. A main movement must run through the picture. The transitions must be easy, not jerky. None must be out of step in the march. On, on, deeper and deeper, with the soul of the thing burrowing into its depths and intensity till that thing is a reality to us and speaks one grand inaudible word—God. The movement and direction of lines and planes shall express some attribute of God—power, peace, strength, serenity, joy. The movement shall be so great the picture will rock and sway together, carrying the artist and after him the looker with it, catching up with the soul of the thing and marching on together.

Don't cultivate parsons out of their pulpits. They are very disappointing. Let them step up in the pulpit and stay stepped up. It is best for them and you and ideals. I asked one to supper tonight and to see my pictures after. He enjoyed his supper enormously and the pictures not at all. I had hoped he would see a little in them. Down came my hopes, bang! smash! The further back to my old canvases I got the better he liked them, just skin-deep pictures, full of pettiness and detail. "There's such lots in them," he would say, "so much detail." That pleased him while the struggle for bigness, simplicity, spirit, passed clean over his head, only meaning bareness, lack of interest to him. "I don't want to see any more," he said at last (I had only brought out about one dozen) and, pointing to my totem mother, "I'd hate to dream of her." Oh, those that gab about beauty and can't see it! Another can be ungodly and all that is bad, and yet beauty can just hoist him up easy as a steam winch. We are queer. "To know the universe itself as a road, as many roads, as roads for travelling souls."* If the terminus of all roads is God, what matter which road we take? But hail your fellow travellers from a distance. Don't try to catch up and keep step. Yell cheerio across the fields,

*Walt Whitman.

but stick to your own particular path, be it paved or grassed, or just plain old dirt. It's your path and suits your make of boots.

October 17th

The mountain is finished, and the Brackendale landscape and the tree with moving background will be coffined tomorrow and away. They ought not to go out as pictures, finished. I feel them incomplete studies, just learners not show-ers. Will I ever paint a show-er, forgetting the paint and remembering the glory? I will not berate them. I have wrestled with them honestly, now I put them from me and push on to the next, carrying with me some bit of knowledge and growth acquired through them—on, up! Oh, the glory of growth, silent, mighty, persistent, inevitable! To awaken, to open up like a flower to the light of a fuller consciousness! I want to see and feel and expand, little book, you holder of my secrets.

October 18th

I gave a birthday dinner party. Of the four guests one was a vegetarian, one a diabetic, one treating for biliousness, and the remaining one a straightforward eater. I cooked all afternoon to pacify the vagaries of each and it was a good supper but I hated food-stuffs as I dished up the messes. We three old sisters make much of our birthdays, meeting at one or the other of our houses, exchanging visits and gifts and sitting round fires to talk. Alice starts in October, Lizzie follows in November and I end up in December. Only three of us left. We are particularly free of outer relatives, cousins and things. Alice usually carts along a mob of other people's offsprings, her boarders, and Woo and the dogs and Susie join the circle if the party is at my house. They have inaudibly accepted Susie now. That is, they don't hysteric when she cavorts round under their chairs.

I'm going to Chicago to see the art exhibition first and foremost and the Fair incidentally. Both Lawren and Bess have written of it and say it's grand and I'm wriggling with thrills. The art of all ages collected together, the old thoughts and the new thoughts hobnobbing on the walls, saying to each other, "We are all akin and not so different either." I wonder what they will do to me. I hope they'll

speak plain, the old ones and the clever ones and the holy ones. As always, I go alone. Funny, it seems it must always be so. I'd love an *understanding* companion. Otherwise I'd sooner be alone. It teaches one things. The girls are quite keen and enthusiastic over my going and the railway fares are ridiculously low, so low it would be trampling on Providence not to take advantage. I'm dreadfully busy making clothes and safe dog pens, cleaning stove-pipes and generally arranging. I used to think the world couldn't wag if I wasn't right here running my house. That's silly, fancying oneself so important and growing into a congealed stagnator instead of living and moving and seeing.

Such sewings, carpentering, basement cleanings, shoppings! I got my ticket and moneys, silly little bank notes smaller by half than ours, and had my coat cleaned and boots soled and bought a hat warranted to be uncrushable, unspottable, uncomfortable and entirely travel proof. I've made a beautiful dress, a passable petticoat and two impossible bloomers, and had my shoes poked out in bay-windows over my worst corns, and made a comfortable pen in the basement for the dogs during my absence. Nobody wants Susie to care for, poor lamb, and she's so easy and loving and sweet. I don't think I'd better take her along, though I'd like to. The ticket man has written things all over my envelopes of tickets and things in a hand so small it will take three telescopes and a microscope to read it all. I always get a giddy head when they shoot rates, fares, prices, time tables, and directions at me. I earnestly pray the sea will be calm because I cross to Seattle on the little *Iroquois* boat.

S.S. Iroquois, October 30th
It's one grand and perfect day for a starter. I left at 9 a.m. for Port Angelus. Won't get to Seattle till 4 p.m. We (me and the gulls) have the deck to ourselves. Gulls don't wear trousers; their naked legs stick right out of their waistcoats. They are mostly young, with spotty pinafores and smudged faces showing their grown-upness is on the way. The old ones look so smooth and white and adult, the unwinking clear grey of their eyes fearlessly splendid. The whole round of the upper back deck is a solid row of sitting gulls, hitch-

hikers, and no two of them have the same expression. The rail is too rounded for the comfort of their heel-less webbed feet and they keep slithering and changing places in the row and squawking about it. As soon as they are settled a steward flaps something and then it's all to do over again.

I don't know if I feel more like a princess or a convict, I'm being taken such care of. Archie, the ticket-agent, has encircled me with care-keepers and looker-out-fors; must have thought I looked a bit old and unstarched for travelling. He saw me off himself, wrapping me in the Purser's care.

It's awful to see the ticket man flip the yards of tickets that cost so much into his pocket and give you a mere scrap of paper in return, though it is nice to be relieved of its responsibility. I simplified my rather intricate system of keep-safes to one central pocket attached round my waist with a corset lace, pinned to my petticoat with a stout safety and covered decorously by my skirt. I hope I shan't lose things. I have everything tied on and the untieables poked down my front till I look like a pouter pigeon. But I am so lost a person things just wilfully hide.

Later

It is raining at Paradise, Montana, and the clock has jumped nearly an hour. It's pretty—rolling hills and farms. There is a funny kind of pine tree that changes to a gold colour—so astonishing. I like Montana. It would be lovely to ride and ride and ride on a dear companionable pony, on and on and on. The hills look like soft shaded velvet.

Wonderful skies towards dusk—deep, billowing clouds walloping across the sky. There is snow on some of the mountains, newly fallen. The little towns look so old and battered, and forlorn and forsaken. Very little life is visible and many houses are broken-windowed or boarded up. Oh, it is a vast, lonesome country, lean and unprofitable, with bitter cold and torturing heat, a place to teach me courage and endurance. I wonder if I have ever experienced it in a past incarnation or shall I yet in another? Night has shut down just before we come to the grandest part and dark will be on the Bad Lands that I wanted to see.

October 31st

Here's yesterday's tomorrow and we are rushing on and on and on, eating up space, passing through what are queernesses to my Western eyes. Occasionally, a minute of keen, pure air that cuts like a knife as one clings close to the car step for fear of getting left. Mercy! What would one do? I guess *our* West is just grand. What these people have to put up with, being fried and frozen, parched, blown to chaff! Even the telephone poles are blown bent. The little water is brackish and there are ugly scars of burnt along the grass. Just one thing I love—its space. The sky sweeps round in noble curves and deigns to come down, down even below the earth. At first I thought it was the sea in the distance, but no, it's just the sky swooped down below the brown, rolling hummocks, making you feel the earth is floating in the air, wrapped about in it. If you could be under the earth it would be there too.

Last night the train bumped scandalously as though we were being hooked on and off the engine every few blocks. At every bump some monster shouted, "Wake," and I waked and stared straight at the sky with its high bright moon and clouds rolling and stretching out sublimely, and here and there a patch of blue with a star winking in it. The quiet brown earth, solid and sullen, seemed as if the liveness of the sky was trying to wake it up and couldn't, as if it was disheartened and sad. Poor earth, what does it want? For it can't stop growth. But the blizzards and the hail strike it, its crops are tortured by thirst, the farmer throws down his implements and leaves it to itself. Surely something will wake it all some day. After aeons of time it will come into its own and the empty, forlorn houses will have curtains and smoking chimneys, and its yawning weariness will be all cheered up and sing. I watch and watch till I fall asleep. It's all so new and interesting. I like being alone; things talk plainer so.

There is a cackling woman opposite *en route* to bury Mamma in Wisconsin. She doesn't seem depressed though she wonders if she will feel just like taking in the Chicago Fair the day after. Her heart is gummed shut around her superlative husband and her super-superlative daughter whom she left behind, but she sure brought along a waggling tongue. I don't wonder she has stomach trouble;

her tongue *must* neglect her organs—it's so busy elsewhere.

There are no hummocks now. The earth is flat, not a bump except for an occasional pile of chaff, the thresher's leavings. I wish I could express that sky and space.

Oh, it gets worse and worse! It has gone so flat and thin looking. It's new ploughed mostly, and black or dead brown. Out there in the miles of flatness is a cemetery. I did not know the earth could look so thin and poor and hard. Our engine smoke rolls low over it, crushed down. I think I'll read Whitman to cheer up on.

November 1st
Chicago tomorrow and the pictures! What will they teach me? Oh, I pray I may be receptive to what there is for me. I have just read Fred Housser's letter thanking me for the sketch I sent. It came as I left home. I read it once and put it away quickly for fear of growing vain and smug. I'd so hate to be that. I have so much to learn and fall so short. I do hope the Chicago pictures give me a boost. It's so long since I've seen other people's thoughts, and my own seem wearily me-ish.

This morning it is clear and glorious—flat country, with prosperous looking farms and satisfied cattle, pigs and chickens, and vast fields of cornstalks and windmills and decent fencing, and old-fashioned houses with one-peak gables and fat barns. I suppose it's Wisconsin. There is sun and haze and a nip of frost.

Chicago, November 2nd
I'm here, and oh, the awfulest blow, the pictures aren't! They closed on the 30th! Oh my, oh me, I did so badly want to see them! I feel like going straight home and bawling. I'm going to wash and then go up and beat my head on the stone doors of the Art Institute.

Later
It's true—there's nothing to be done about it. It closed only last night. I left an order for a catalogue. They had none but will send one on when more are printed. I feel as if someone had hit me and I want to cry horribly. Now I suppose I must see the Fair, though I haven't much heart for it. It doesn't seem to matter.

Night

Spent about six hours of weary tramping from building to building and did not get one kick. The workers looked so utterly jaded and weary of the sham, for it is a sham right through, tawdry make-believes. The real things, the flowers, bushes, trees and shrubs, can't stand it. They are dried up and dead and knocking their bare, crackling limbs on the hollow plaster walls. Nobody laughs. They try to force souvenirs on you and turn peevish when you don't buy. I came home wet and cold to the Y.W. and sat in my room and snivelled dismally in self-pity.

Why, why, why must I always stand alone in my work, away from other artists, away from seeing other worthwhile work? Now I'll take my brine-pickled eyes to sleep. Maybe tomorrow they'll be clear enough to see something else besides that gallery door slammed on my nose.

November 3rd

I received a letter from Lawren. Knowing I was *en route* and the show over, he'd telegraphed, but too late. He told me to go see the director but it was no use. I did but he was hedged in by a hedge of old secretaries, regular cacti, their spikes spearing every move. I footed it to the Field Museum. The Natural History is grand, so beautifully mounted, intensely interesting. The museum is gigantic. If only one was provided with legion eyes and could toss one in every hall to do its work, collecting them as you came out, how grand it would be!

Hall of Science overwhelming; very excellent and noble but disgusting. All diseases exposed, microbes and medicine. I sat down to rest and found a movie of the first operation under anaesthetics. When the victim began to writhe I fled. Next I got mixed up in the bladder diseases, then tuberculosis. Pigs' lungs, cows' lungs, rats' lungs hanging in a row made me sick. Then came the microbe family and the toxins. Finally I arrived at human embryology. Should I or shouldn't I? I went in and it was beautiful. The little unborn babies in bottles were beautiful—such character and pathos and reality; no two alike. They looked so wise and unearthly! Yes, I loved the babies.

November 4th

It doesn't matter about the pictures really, not a bit. What I am looking for I must work out for myself. It is between God and me. Laziness made me desire to look at the pictures of others, to try and pick up short-cut recipes that others have used to get what they desired to express instead of going straight to the thing itself, to stand before it meek and silent, feeling deeper and deeper and more intensely till its life throbs and vibrates through you, till the inaudible words of the earth, God's words, speak to you and tell you what to do, how to express.

Chicago is as windy as Victoria. Went to Marshall Field's. Huge place, floor after floor. When you roll up your eyes from the shop's middle the landings go clean to Heaven and then some. I did a little shopping. They tried my corsets on right in the eye of all Chicago (over my clothes of course) and I was embarrassed. The shop women are very courteous and helpful, the young girls so bright and attractive and anxious to help, and "please" and "thank you" when they hand the parcel and wish you goodbye and hope you'll enjoy your purchase. I hope, indeed, I shall enjoy the corset but am doubtful.

Now for more fairing. I'll tidy up that job before I do up Chicago.

Later

I've finished the Fair, that is I think I've got all I want. The nights are so bitter and cold, it's time it closed. First I went to the Aquarium and that was enchanting. It is not in the Fair grounds and is real— solid, alive, beautiful. The fish are magnificently staged and their colour and shape and markings and grace are subtle and superb. They have dignity and intelligence and marvellous beauty. It is real joy to watch their movements. The place is all dim and mysterious, long corridors with tanks sunk in the walls, beautifully lighted from above. No two fish, even of the same species, have the same expression. It's wonderful to contemplate that infinite variety of creation.

Out into the bitter blast again and into the Fair. I went here and there. Every nose was redder than the next, except the ones that were purple. The little sham lake puddles were all aboil like angry little oceans, and the fountains slopped over and blew against the disgusted passers. Flag ropes flapped, sign post directors creaked and

groaned, and the dead trees rattled their bones and shivered, but not so badly as the poor souls in the Morocco Village. They looked the acme of all misery, done up in blankets and coarse overshirts, clinging feebly to life and tightly to their prices, and how folks haggled! The Chinese place was the same, and the Belgian. In the *Christian Science Monitor* hall they were snug and warm. In the Hall of Religion I heard a first-rate talk by a Mormon on their beliefs. He was so convincing and sincere I nearly turned Mormon. Then I saw Firestone tires created from start to finish, and the outside of Byrd's ship and his Husky dogs in kennels, and medieval monsters in caves with horrid smoke and abominable bellowings, heads and tails that moved and eyes that glittered electrically. I did not think much of that lurid show.

Then I came to the Streets of Paris and paid 10c. and went in. It was pretty and well got up and realistic but the undercurrent was dirty and I was glad to go out. I was sorry for the half-naked, shivering girls and hated the vulgar, coarse men who exhibited them. The wind must have tortured their nakedness. They were blue and wretched under the paint. Then, last, I crossed over, paid 25c. and saw the babies in the incubators. They looked cute and cosy, the only warm life in all that three miles or whatever-it-is of bitter blasts, kings and queens in their own right, completely indifferent to the passing show. I could almost willingly have shrunk myself into an incubator and started life all over again.

My one extravagance is a taxi home. When you are not sure of the way and your feet are aching blobs, it's glorious to wave a yellow cab like Cinderella and her pumpkin and be whirled off to the spread wing of the old Y.W.C.A.

Sunday, November 5th
Too late for breakfast so had it round the corner, better and cheaper. Bitter wind still persists and the sky heavy. Inside you suffocate; outside you freeze. What is one to do? Stand in the doorways and be batted by both? It is not hard getting round; the traffic is not dense and the police kind and courteous. I have not boarded a streetcar yet. Somehow I shrink when they come near and go on footing it. I must be very animal and earthy because I love the earth; it's so dependable. I can't trust machines. All machinery to me is terrifying,

with an inexorable determination about it, cruel and bloodless. Yet I've heard men who love engines talk about them as if they were human. "Why," said Bert Fish, who ran the lighthouse at Friendly Cove, patting his well-kept engine lovingly, "She's like a baby. She tells me at once when anything is wrong. There's a different sound that tells you at once." I wish I could feel that way. I wonder how many incarnations it will take to grow strong and wise and get away from one's cabbage state.

I went to the Unity Centre which is no bigger than ours at home though not quite so simple. Miss Edith Reynolds gave a fine talk and a lot of it fitted in with my big disappointment of this week. I know that it is all right—working out fine. All resentment has gone. On the way home I dropped into the Institute to see the Blake engravings again. Blake knew how!

Chicago streets looked Sundayish. Mr. Ford's motor wasn't turning bottom up but sat demurely in the window. The doll in the candy shop wasn't dancing. Only the United Airways nose or tail (I don't know which it is) waggled round and round, a newer invention and therefore further removed from godly ways, I suppose. Finally I got up the courage to enter a bus, after many enquiries as to which. It was one of those skyscrapers with a tin stairway that makes you feel as one must have felt when perched on one of the first one-wheel, high bikes of the dark ages. The lake looked furious, with high, dirty-brown waves as if the bottom was on top, a shake-the-bottle effect. Lincoln Park is spacious and the zoo very fine. I wanted to hug the lions and tigers and comfort them. Such glorious strength and vitality to be crowded in by bars while the great wild spirits of them walloped out, bursting through space, out, out to their jungles and their freedom!

The monkeys don't mind; they see the funny side of life and enjoy investigating anything strange and new. As long as they can play and show off and tease each other and get what they like to eat, all the rest is made up for. They *enjoy* humans, life's a jolly game of investigation. The big chimpanzees and orangoutangs, gorillas, were very human, so despairing, bored with life and mostly alone. Two red orangoutangs sat in adjoining pens leaning either side of the same door. They wanted each other's society awfully and kept up a series of rapping to each other with their hairy, human hands—

doubtless in code. The gorilla reclined on his elbow with crossed eyes, like a lazy old man on the park grass, and regarded the people indifferently. I wonder what he thought of us—very little I imagine.

Monday, November 6th

I have been to the ticket office and I may be able to change my ticket to return home via Toronto and the C.P.R. I do hope so. I'm nearly full of Chicago. I went into two picture shops and stood and looked into awfulnesses. They seemed pitiful. I saw the poor starved soul trying to express something, just the surface, trying, wanting, but unable to see or feel or express. But isn't it something that he wanted to do something, a beginning? So those who are further along than I am must feel about mine. We can't paint till we can see and feel into our subject, experiencing it. There are no short cuts. The matter rests between God and your own soul. Another's thoughts are not ours and to copy them gives us no growth. Our own expression is as subtle as the difference of expression on the face of each fish in the aquarium. Some will say a fish is a fish. No, a fish is an entity and is its own self.

It is dark today, brooding and oppressed. The lake looks cruel, bottomless and hard. The wind has dropped and Chicago is still and sullen. No letters from Toronto or elsewhere. I did expect to hear today. My first letter to them was posted Thursday. Drat the mails! Or don't they love me up there any more and are indifferent alike to my woes and to my coming? Bess has reason to know me for a spit-cat and Lawren will be up to his top hair in the exhibition and too busy to think of old me at all. Emily, don't you know by now that you're an oddment and a natural-born "solitaire"? There is no cluster or sunburst about you. You're just a paste solitaire in a steel claw setting. You don't have to be kept in a safety box or even removed when the hands are washed.

Tuesday, November 7th

The Lord be praised! I leave Chicago tomorrow at 9:15 a.m. I have felt bouncy ever since I made up my mind at 3:30 to migrate. I do look forward to seeing those dear folk in Toronto and their pictures, and to some inner talks about all the best things. I expect I shall only

be able to sit like a bell without a tongue and just make a note if someone kicks me. I don't get much chance to talk to people out home about the real things, so I have no words. I want to hear Bess, Fred and Lawren talk. What a selfish brute I am! I want to get and I have so little to give. I'm afraid to give out the little I have got, afraid of mixing things up and putting them wrong and being laughed at.

Wednesday, November 8th
No letter from Toronto but I am off and it's good to leave Chicago. The ground is white and frosted. Oh, I do look forward to seeing the Toronto folk. I do wish I had heard, but I think Bess wants me. Goodbye, great station and apartment blocks and the university. Goodbye, blunt-towered churches who do not use your index finger but point to Heaven with your thumbs. Soon it will be country fields and space.

I like to travel alone, to sweep along over space and let my thoughts sweep out with it. They seem to be able to go so far over the open, flat spaces that run out and meet the sweep of the sky and the horizon like body and soul meeting, the great sky illuminating the earth, the solid earth upholding the sky. Snow falls intermittently and the earth is like a woman who has fixed her face badly. There are mud icicles hanging under the motors. The railroad and the motor road lie parallel and close.

November 10th
Noon. I'm there! Bess and Fred met me and were so gloriously kind.

Bess gave a lovely party, mostly artists but all were doers of things and thinkers. The room was not only full of them but what they did was there too. I knew a lot of them before and those I didn't I do now. They were all so awfully nice to me. I loved every one. It's a rare thing to be in a company of doers instead of blown-out air cushions. At home I want to sneak off and yawn but this party lived.

November 17th
One week and two days have passed. Every minute has been splendid, too full of living to be written down. I have had a long talk with Fred and Bess, wanderings in those far-off regions where neither ground is for the feet nor path to follow. I have had long talks with

Lawren in his studio, unashamed talks from the naked soul, a searching for realities and meanings, the beautiful pictures gleaming all round, calm, inscrutable notes and glimpses of the between places where the soul penetrates and the body does not, where sex, colour, creed, race do not enter.

Lawren's studio is wonderful, all quiet and grey, nothing unnecessary. There is equipment for painting, equipment for writing, a roomy davenport and peace; that's all. It is a place to invite the soul to come and gather the riches of thought, and ponder over them and try to express them, an orderly place of an orderly mind. I'm glad, glad, glad that I have these rare privileges and that I am able to talk straight and unafraid. One can't do that with many. Just with Fred and Bess and Lawren can I let go like that, throw away the shell, escape for a brief spell to a higher place of thoughts and ideals. Three times I had this experience. Now I am going home happy, contented, equipped for further struggle.

There was a rounded-out completeness about this visit—nine days of refreshing content spent with those toddling along the same path, headed in the same direction. And I was one of them. They accepted me. My own two pictures (they did not hang the third) were very unconvincing hanging there. To a few people they spoke, saying nothing but hinting at a struggle for something. My frames were shocking. Bess complained bitterly of that. But no frame, however rich, could have helped. An empty cup is an empty cup, though it may have a fine gold rim. Yet strangely I am not cast down. I can rise above the humility of my failure with an intense desire to search deeper and a blind faith that some day my sight may pierce through the veils that hide. I know God's face is there if I keep my gaze steady enough. Everybody must work. Not only wrestling but tuning in.

Yesterday we went to tea with a little Russian lady artist. Quite a number of other artists were there—Mrs. Adaskin, a pianist and wife of the violinist, Mrs. Harris, Betty Hahn, the sculptress, and many others. One night we went to dinner with Isabel McLaughlin. She has a beautiful flat, modern and severely beautiful. It was in a high building and you looked out over the lighted city. The furniture was modern and very attractive. She's a painter. After that we went to hear Kreisler. At first I did not enter in. I remained solidly on my

seat regarding the elderly man with the sad face. He had a shock of iron-grey hair and legs not perfectly straight, and he wore a heavy gold chain. Through the middle of the programme I became more clearly conscious of enjoyment but he did not lift me from the earth. I suspect I am not deeply musical. Shall I wake to it in this life or wait for some other? Bess was awake to its beauty and thought it grand.

Bess gave a great tea for me on Saturday. I knew many of the people from my last visit and there were a few new ones. Oh, they were so kind and so good to me! They made me feel one of them and not a stranger from the far off West.

All that morning I had felt awful. The day before I had talked long with Lawren. We discussed theosophy. They are all theosophists. I know there is something in this teaching for me, something in their attitude towards God, something that opens up a way for the artist to find himself an approach. We discussed prayer and Christ and God. I didn't sleep well and woke at 5 o'clock the next morning with a black awfulness upon me. It seemed as if they had torn at the roots of my being, as if they were trying to rob me of everything—no God, no Christ, no prayer. How can I ever bear it? I ached with the awfulness of everything and cried out bitterly. I had thought I might get some light but I was stiff with horror. I was soul-sick. Bess and Fred saw and were merciful.

Bess left me at the Gallery where Arthur Lismer had classes. I tried to throw myself into the work. When the guests arrived for the party I made an awful effort, and succeeded, but it was there in my heart below. We spent the evening alone talking and reading and discussing the party till midnight and as I said goodnight Fred asked, "What's ailing you, Mom?" He looked so kind and honest and I knew Bess was sympathetic so I told them about things. Fred talked on till 1 o'clock. He's a splendid explainer. He cleared up lots of things I'd got all wrong and I went to bed happier and slept.

At the party Lawren asked me to come to his studio and have another talk on Monday. Between the two of them I saw clearer and the black passed over. Yes, there is something there for me and my work. They do not banish God but make him bigger. They do not seek him as an outsider but within their very selves. Prayer is

communion with that divinity. They escape into a bigger realm and lose themselves in the divine whole. To make God personal is to make him little, finite not infinite. I want the big God.

November 18th

On and on and on gliding through space, going through fine and bad, cold and mild weather. The pigs are rooting happily in the soft earth and a breath or two later the boys are skating on the Mississippi River. The trees are powdered with fresh snow. Farmers haul late grain over muddy roads. A woman comes out of her cottage with a great pail. We, as we pass, are nothing to her; the pump in the yard is her goal. This great flat country is all backyard. There are no hollows to hide the unsightly things. Rubbish is heaped in full sight. Back doors are exposed in all their "back-doorness." No friendly, protecting fence surrounds the house. Posts and wire are about the fields. The land lies naked to the eye. Only that which is enclosed by the houses' four walls remains to themselves. Other than that is public property, open to the eye of the world and to storms. Only when black night comes is there hiding or secrecy. Yet there is a baffling, open mystery, greater perhaps than our own forests where the mystery comes so close you can almost touch it. Here you go out to meet it. There it comes to you and envelops you. This open land reeks of the sweat of man's toil. That forest knows nothing of toil and sweat; it is unsubdued. If they cut the forests they grow again, covering the scars quickly with new growth which again hides and shrouds its mysteries. Man can't keep up with its growth. Does he stop his blasting and sawing even a few months, it is hushed back into hidden mystery. But this land, year after year, lies open and ready for man's planting. It is servile to man. The West is servant to no one but growth only.

Last Sunday evening Lawren Harris lectured in the Theosophy Hall on war. It was a splendid lecture but terrible, one of those dreadful things that we want to shirk, not face. He spoke fearlessly about the churches and their smugness, and of mothers offering their sons as sacrifices, and the hideous propaganda of politics and commerce exploiting war with greed and money for their gods while we stupidly, indolently, sit blindfolded, swallowing the dope ladled out

to us instead of thinking for ourselves. His lecture was mainly based on two recent books, *No Time Like the Present* by Storm Jameson and another I forget the title of. The preparations for war are fearful beyond belief. It took some courage to get up and tell the people all that awfulness.

The weak sunshine is throwing long, long shadows. I wish I was like a doll that can sit either way. I used to love to make mine sit with their back hair facing their laps and their hind-beforeness ridiculous. I loved to make my dolls look fools to get even with them for their coldness, particularly the wax or china ones. I loved the wood and rag much best. The wooden ones rolled their joints with such a glorious, live creak and the rag ones were warm and cuddly. But none of them could come up to a live kitten or puppy.

Valley City! How can it be called that? It takes hills to make a valley. Oh, I see it is unflat before and behind, though not so much but that the tombstones can peep over. Poor deads, I wonder if that is the highest they ever get. One last burst of sunshine is over the fields, gilding them. Our smoke is rolling behind in golden billows. There's a golden farm and a windmill and a golden cow and horse, but the richest of all in goldness and shameless shamming are the stacks of straw and chaff. The turkeys have gone to bed on top of the barn roof, up above the icicles. How uncosy! It's getting so near Christmas that perhaps they've lost heart and think any old roost will do, poor dears! I'd rather barn roof and icicles than roasting pan and gravy myself. Life is very full of opposite contraries.

November 19th

8:00 a.m. Montana, and the grandest kind of morning. The night was also grand. I was awake a lot. I think every star in the universe was out and was newly polished. The sky was high and blue and cold and unreachable. I'm glad I know now that that is not where we have to climb to find Heaven.

I like Montana, the going and coming of it and its up-and-down-ness. Lovely feelings sweep up and down the rolling hills getting tenser as they rise, and terminate in definite rather defiant ridges against the sky. The sky itself does wonderful things, pretending to be the sea, or to be under the earth, and to be unreachably high. It

loves to wear blue and to do itself up in little white pinafores and flowing scarves of many colours, and to tickle the tops of the mountains so that they forget about being rigid and defiant and seem to slide down the far side as meek as Moses. There's lots of cattle, heavy, slow-moving, bestial, black or red, with white faces and shaggy coats. The foolish square calves pretend to be frightened of our train. Bluffers! Haven't they seen it every day since they were born? It's just an excuse to shake the joy out of their heels.

Livingston, and my feet have touched Montana. I've smelt and tasted it, keen, invigorating. Things here are much propped up and reinforced. There are myriads of clothes-pins on all the lines. I suspect the nippy wind of this morning is not unusual. We have gone through the Bad Lands in the dark again.

Logan, Montana. I should not like to live here. The hills are clay-coloured rock with scrubby, undernourished trees. Lightning balls are on any houses of size.

The mountains are higher now, barren and a little cruel. I feel in my bones there will be beastly black tunnels soon. Nearly every house has a dog—no kind, just a leg at each corner. It's Sunday and children and elders are doing things, playing, riding, driving, looking over cattle. There are a few out in automobiles, and one complete family is setting out for church with their books under their arms, and conscious of their best. There are magpies and pheasants and rabbits, occasionally flocks of turkeys and beehives. Tomorrow we will reach the far West. Gee, my back aches!

I was in the diner when we came to those great plains before you get to Butte. We had been climbing for some time and were high up on queer mountains of odd-shaped boulders thrown together in masses. The train wound in and out among them groaning horribly as it took the curves. Down below was a vast, tawny plain with long winding roads and a few horses and cattle. Your eye went on and on and slowly climbed the low distant brown hills. I never saw anything like it before. It was not a space of peace but rather of awe. It seemed a great way before we saw queer built-up places and great mounds of slag, and scarred mountains with their bowels torn out and reservoirs and towns, and queer mining erections and cars of ore, all the ruin and wrack of man's greed for the wealth of the

earth. We circled the great plain and went on through sagebrush. There would be a wonderful wealth of material for a certain type of painter here. Stunted little black trees and black cattle are scattered among the hills, and you can't tell which is one and which the other.

It has happened in the last half hour while I was asleep. I do not know it by the map but in my own self that the East is past and the West has come. As we came down from the hills the trees thickened. Heavy fog has shut down and all we can see is the dim ground and tree roots—everything else washed out.

I have been reading "Song of Myself" by Walt Whitman. I am very tired. I think we of the West are heavier and duller than the Easterners. The air is denser and moister, the growth more dense and lush, the skies heavy and lowering. (My hair is all curly on the edges with damp.) Might not all this affect us too?

We will arrive in Seattle at 8:30 a.m. tomorrow. I should be home by 1:30 if I connect. Beloved West, don't crush me! Keep me high and strong for the struggle.

November 20th

All night the demon monster has been rushing us into the West in a series of rough jerks and bumps, as if we lagged and it bullied. It is all West now, no trace of East left—low sky, dense growth, bursting, cruel rivers, power and intensity everywhere. I think it is a little crushing and then I note the fine trees, how straight they grow, not one kink or swerve in a million of them, plumb straight.

Now I am on the boat. Here's a corner of the lounge where I can perhaps sleep away the time or part of it. Funny thing, there was not a moment to be lost on the train. I looked intently always. But the boat is different, just water and more water, and sky galore, and snatches of land here and there, but vague and not intimate. How queenly this ship is after the snorting bumpity train! But the sea is restless. It has not the calm pushing growth of the earth.

Victoria (night)

Everything at home fine. Hot welcome from tenants, sisters and beasts. Jobs piled hat high from front gate to kennels. I'm glad I went; it was a joyful affair.

83

Moving Forward
1933-34

November 28th, 1933

Yesterday three of the Hart House quartette came to see me. (They gave a splendid concert in the Empress on Thursday night.) Mr. Blackstone and Mr. Hambourg came in the morning with Miss Bicknell, but Harry Adaskin came at 2 p.m. for a real visit and talk. We plucked the easy chairs off the ceiling and got to it right away. We discussed theosophy and our work and justice and God and prayer. He told me about his new violin. It means everything to him. It is lovely to see how much. We went through my canvases and sketches. He said he liked my things in the show in Toronto and that they were always fresh and inspiring, and a different note from the Eastern material and he thought I was expressing the West and that all made me very happy. He stayed to supper. Lizzie came, found out he was a Jew by birth, filled him to the hat with British Israel and they got on fine. He is a dear boy, sincere and sweet right through. When he left he took both my hands and said he had had such a happy afternoon and he stooped and kissed first one of my hands and then the other. I loved the sweet way he did it and I felt another friend added to my beloveds in the East.

Oh weary old me. Did the household round of little nothings inside and out in the sodden garden and noon was upon me before I was aware the day was fully started. Then painted till 4 p.m. and dark—one of the Goldstream Flat studies—working steadily and sanely—not very tip-toey. Then took a long walk along the shore and back through the little wood in the dusk with the four dogs.

The dear old park is plucked and foolish now. The straggle of trees have lost their mystery, and the dense places where we hunted lady-slippers and felt we were right in the forest as kids. Now you cannot hide from an electric light blinking like the eye of man. The grass is muddy and turned up by football games. Just the sky is unchanged. Thank God they can't mutilate and modern-improve that. It was low tonight, bulging with wet, dropping to the horizon and then some, so that it smudged over the cold grey sea, and the gulls hurried east. The dogs were uproarious. They think about that walk all day, but they are patient. At 4 o'clock their moist noses and red tongues are a-waggle for supper but that is second to the walk. Yet, were they loose they would not go a step without me. The walk and I are *one* joy.

What hind-before topsy-turvy beings we are! Always trying to unwind the ball from the wrong end and getting in horrible snarls, starting to write from the tail end back and to paint the outside of our pictures before constructing the skeleton inside. Have you ever rubbed your cheek against a man's rough tweed sleeve and, from its very stout, warm texture against your soft young cheek, felt the strength and manliness of all it contained? Afterwards you discovered it was only the masculine of him calling to the feminine of you—no particular strength or fineness—and you ached a little at the disillusion and said to yourself, "Sleeves are sleeves, cheeks are cheeks, and hearts are blood pumps."

December 1st

A heaviness descended upon me this afternoon, a great, black foreboding cloud. Why? I cannot shake it. Are those I love worried or in trouble? I cried far into the night. Why? How should I know? Just a great wanting, a longing to know and understand which way.

I have looked at the catalogue of the pictures in Chicago that I did not see. What is the test of a picture? Not form or colour or design or technique. It is intensity of experience and feeling, the existence of the thing *spiritually*. If the spirit does not speak, nothing has been said even though the surface forms clamour and clank. If the small, still voice of reality cannot be heard above the hubbub of

objective seeing, the picture is a blank nothing. Oh to realize that intensity! It is of the soul. Oh God, give it to me! It is mine already deep within, but asleep. How can I wake it? Oh, how?

Work has gone well today. I entered into the spirit of it and am tired but happy. Fred offered to look over some of my stories. I got out a great bunch last night and must tackle some of them and try and shape them. I believe it is in me to be able to, but they don't come, and the construction, grammar and spelling! Just like the paintings—thoughts but no orderliness of mind. Pull up, old girl, and remember the "pact"—I *can*, I *shall*, I *will*.

December 7th

You need not expect Lawren Harris to do your thinking for you. He suggests—leaves you to ask questions if you are interested— answers them patiently and fully—then gives you, as it were, a gentle push-off and leaves you to think things out for yourself. That's *real* teaching.

December 8th

Remember, the picture is to be one concerted movement in a definite direction for a definite purpose, viz. the expression of a definite *thought*. All its building is for that thought, the bringing into expression and the clothing of it. Therefore if you have no thought that picture is going to be an empty void, or worse still, a confusion of cross purposes without a goal. So, old girl, be still and let your soul herself find the thought and work upon it. She alone understands and can communicate with her sister out in nature. Let her do the work and, restless workers, running hither and thither with your smelling, looking, feeling, tasting, hearing, sit still till your Queen directs but do not fall asleep while you wait—watch.

I have just come off a three days' starve and feel fine. We eat too much. It is my cure for neuralgia and such-like pains. Orange and grapefruit juice only for three days. How clean and easy one feels after, gay as pyjamas on the line on windy wash days. Yet the weakness of me puts it off, making every excuse before starting in. When started I generally stick.

December 12th

Emily Carr, born Dec. 13, 1871 at Victoria, B.C., 4 a.m. in a deep snow storm, tomorrow will be sixty-two. It is not all bad, this getting old, ripening. After the fruit has got its growth it should juice up and mellow. God forbid I should live long enough to ferment and rot and fall to the ground in a squash. I have been having supper with Mrs. Stevenson. It is her birthday today—eighty-six. She is wonderfully able but complains a good deal of rheumatics and loneliness. I think then I should want time alone to rest, meditate and prepare for the change. I am twelve years older than my mother was at her death. I do not think we shall meet those others as we left them. I do not think we shall know each other in the flesh, only in the spirit. It will be those who have been akin in spirit here, more than akin in the flesh that will meet and rejoice together.

Visitors to the studio. Some from Montreal and others, English, from Cobble Hill. The Easterners take art more seriously (effect of Group of Seven influence). The English rile me—hard, dictatorial, self-satisfied. Nice enough people but my heart goes not out to meet them. All the doors of my inner self are shut. I entertain them in the front hall and put the clock on a little to hasten their departing. I don't want to go into their best parlours and sit down any more than I want them in mine. I let the rat out hoping they'd be scared and quit quick but they loved her and stayed longer to play with her.

Went last night to "New Thought." Dr. Ryley from the States expounded on the spiritual mystery of Christmas or birth of Christ in the soul. Oh goodness gracious! What is one to *believe*? Everyone thinks he is right and runs down the other fellow's religion and extols his own. God, God, God. That's what we all want, to get a nearer and better understanding of God. Today I wrote Lawren and told him I couldn't swallow some of the theosophy ideas I had to be honest. Couldn't let him think I was wholeheartedly in tune with it, when I am not. I do see the big grandness of much of it. It's their attitude toward the Bible I can't endorse. It's awful to have your holy of holiest dusted with a floor rag and a stable broom.

December 19th

Been out to the asylum to see Harold. The place was in an upheaval for their Christmas concert. Harold and I sat on two straight wooden chairs just inside one of the ward doors—eleven plain little iron beds, flat and immaculate, with little square pillows. No other thing in the room but those eleven beds a foot apart with a two-foot aisle down the centre, between each row, bare, clean floors.

You go through three padlocked iron grated doors. The windows are barred. The stairs are all iron cage work. A helper paces the corridor or sits in the room always. They like me and always seem glad when I come and there is a happy feel in knowing you have brought a wee glim of sunniness into that grim place. I jolly Harold and he is quite merry. We talk of all the Indian villages we both know and of animals which we both love and I take an interest in his work, polishing the brass spittoons. And he is fearfully interested in my painting. He hoards up every notice that ever appears in the paper about it. His pockets are stuffed with my letters and press notices. The worst bore is when he reads my *own* letters aloud to me. How I wish then I had not made them so long-winded!

Now all the jobs are about done up. Parcels for the nieces are bought or made and packed and posted. The candy-making orgy is over for the year. Cards posted, cemetery holly wreaths made. Maybe tomorrow or next day I can paint a little. There was a piece in the paper about my picture that the women's clubs sent to Amsterdam. The critics had dubbed it the only one in the collection showing spirituality. Oh, if it really *were* a "spiritual interpretation." Will my work ever really be that? For it to be that I must myself live in the spirit. Unless we *know* the things of the spirit we cannot express them.

Christmas Day, 1933

That's over. We've turkeyed and mince-pied and exchanged gifts and feasted each other and kissed all round and written and received mail sacks of letters. They have charity-ed and Sunday-School-treated and heard services radioed from Bethlehem and admired church decorations while I cleaned and stuffed turkey, made ginger-beer and candy and pie and cemetery wreaths and done the menial

family jobs, and now it *can't* happen again for twelve whole months and I'm mighty glad. I painted a little this afternoon. I walked along the cliff yesterday with the dogs. The heavy rains have washed down whole banks. They've slithered and sat low and left bare clay scars, slimy, unbeautiful. I must get out there and study and absorb; realize space and eternity out there.

December 28th

Oh you half-thoughts that come tantalizing and eluding! Why do you tease so? Why not come and *stay*? This Hide-and-seek business tires one. Do you say, "If we showed ourselves too plainly the game would be over; you would cease to seek"? Perhaps. It's the same always—people, places, pictures, reading. The same thing. I suppose Lawren would call it "Law." When you are dimmest and not really looking you see clearest. You can't put the "dimmer" on yourself. It is just there at times. When it's there your memory works in a different way. For instance in reading you won't remember a single *word* but inside you remember the meaning or a glimpse of it. You couldn't put it into words or explain it to someone else. In painting you don't see the woods or whatever you are looking at but something else bigger and more vital. In people, you do not see nor can you afterwards recall their features; their faces do not exist. What you know and love is way in back, in their souls. I know that Bess is beautiful and serene. I know Fred's smile. I know nothing about Lawren's face, can't remember one feature—yet I know him best and love him best. I do not remember Harry Adaskin's face.

The spirit and its vehicle, or manifested body, must work together, through each other, for perfect realization. What would be the good of a carriage with no *go*? What would be the good of the *go* with no carriage to sit in? The body must not be ignored and the soul must not be ignored—a third thing must be born of the two. I cannot name the thing and all the books can't and I do not think it needs a name. A name would spoil it, would be too crude for such an elusive—spirit? being? thing? Even a thought is too hard and

material to press upon it, though sometimes it travels in thought. When you go to pick it out of the thought, separate it, clothe it in definitions, it has gone—lifting up beyond, just out of your reach—and left you empty.

Do you know the exquisite, self-respecting, firm feel of a mended garter and taut stockings that have slopped down your calves from a broken one? Well, that's the same feel you get from a good *honest* day's painting after a period of impossibility.

December 31st
Express, express, express, lead up and on through the picture. God is trying to get through, trying to speak. Swing the thought through the whole, no abrupt disharmonies, transitions. A bird flies straight with ever-flapping wings till it has reached its goal. Then it is finished and rests till the next idea of action comes to it and away again to a fresh goal, forgetting its last flight. Only its wings are kept strong and ready by every flight.

11:30 p.m.
A few minutes more and the New Year will come. The present moment, that's all we have. This looking forward and looking back is unprofitable. I have done? I will do? No, I AM DOING.

I have been to my two sisters'. Oh, how little our real lives touch! We love each other dearly. I can't imagine life without them; it would be one awful blank. They are so good and so unselfish. Yes, we are jig-saw puzzles with the pieces mixed. We don't make one picture. Was it accident we all came in one family? Nothing is accident; we needed each other. Will we be together in the next incarnation? We are each so utterly different—lives, aims, outlook. Bless them, bless them! God bless us all and make us all more understanding in 1934.

January 5th, 1934
I worked well today, painting with vitality and intention. In consequence, am tired and glad.

January 16th

Here I am, little book, having neglected you for some time. I have written to Lawren twice, so that does you out of your little spiel for I work it off on him instead of on you. It's all the same as long as you can get it off your chest, only it's easier when there is flesh and blood at the other end and, more than that, an answering spirit.

I heard from Gerhardt Ziegler yesterday and was so happy, for the last time he wrote he was very near death, but he is better now after much suffering. Poor boy, he has a beautiful mind. If all Germans were like him—he has altered my whole attitude towards Germans. Oh, we are all bad and all good. If we could only all meet on our *good* planes! Gerhardt says there's a little bit of me over there in South Germany in his garden, the little bit he took back in his heart of me. I'm glad; I like a little bit of me to be over there in that land of strangers. I too have that little sprig of German niceness in my heart's garden here in B.C. which he brought and left with me. We were both looking perplexed, and poor Klaus too, that day up the Malahat, where we drove in their travelling van, and picnicked and talked of all these things and read Walt Whitman aloud. Little Koko was there too. Now Klaus and Koko have gone on to other places to grow but we have more here to learn first.

My six pictures came home from Ottawa yesterday, returned without thanks, no praise, no blame. Wish Brown had said something even if it had been bad that would have put my back up. Nothing hurts like nothingness. A flat, blunt weapon gives the deepest, most incurable wound. I look at the pictures and wonder are they better than my present-day ones—this year's? I don't know but I do not *think* they are. I think they have better colour and perhaps more strength but any shapely or fine-coloured object can be pleasing. (Not that Mr. Brown did find my pictures pleasing; apparently the reverse.) But as I look at my big forest I find a lack of life—the essence. If manufactured materials were heaped together in a good light and pleasing folds wouldn't they do just as well? That is not what I want—the thing I search for. They lack that vital understanding thing, which must grow and develop and unfold in you yourself before it can come out. That something must be realized and experienced in your own soul before it can possibly be

expressed by you. So I heap the pictures back in their room, not ashamed, regarding them as the under-crop that is to prepare the soil for a finer one—dig them in for manure. Don't sit weeping over your poor little manure pile, but spread it and sow a new crop on top and the next one will surely be richer for it.

I went to hear Raja Singh's lecture on Gandhi. Singh is a Christian Hindu, educated and vital, big, broad and spiritual. Gandhi is *not* a professing Christian but he lives it. There was no mean, petty narrowness so often visible in Christian missionaries and preachers. The man was big. When he got through you loved him and Gandhi both.

Jack Shadbolt and John MacDonald wrote from New York. They want me to have some pictures of my pictures taken and send them over there in the hopes they can persuade one of the galleries over there to stage an Emily Carr exhibition. I refused. It is not practical and I do not want that thing, publicity. I want work. I do not think for an instant they would want my stuff anyhow and oh, the worry and trouble! No thanks.

January 18th
I asked Raja Singh to supper and Willie Newcombe and Flora Burns to meet him. Somehow I wanted to ask him into a Canadian home that wasn't a parson's. He is a most charming man, vital, intense. He phoned at 5:30 to say he was just in from a meeting and would be along shortly after six. I gave him minute directions and got my dinner all cooked. The others came and I sent Willie out to hunt the Raja. A perfect deluge of rain came suddenly. Willie found the Raja wallowing through it in the black, completely lost. When he accosted him he thought Willie was a holdup man. Well, you never saw such drowned rats! The Raja was hatless and had no umbrella. His black hair hung down in dripping ringlets like a wet spaniel's. We got his coat off and shook it. His pants were soaking from the knees down, and his shoes. I suggested he take off his shoes, but his pants! I offered to go below and borrow a pair but he wouldn't hear of it, so I got him a towel and he dried his hair and we had supper and were very merry over it all. He brought some interesting photos.

He will come and visit me some afternoon he says and I hope so, for I like him—so in earnest and no prig, but splendid, big and doing something. He works with Eurasians, not-wanted children of low caste Indians and white men, often Oxford and Cambridge men. They have to fight to get the children; the women want them to sell for prostitutes. They move them right away to a colony by themselves. When they are grown, they are given free choice, not coerced religiously or any other way, but left to be individuals, with the ideal before them of making a fine contribution to India and of being looked up to, not down on. He says their brains are splendid. They will make a fine, new race. That is real missionary work.

January 25th
I have heard two more lectures by Raja Singh, and today he has been in my studio from 10:30 to 1:45. He is fearless, earnest and grand. We talked of many things. Everything in him centres on Christ—being consecrated to Christ, opening oneself to become a channel to be used by Christ. He has a child-like, simple faith—no sect, no creed, no bonds but just God and Christ.

January 29th
I have said goodbye to the Raja. He's splendid. I heard him eight times and I am so glad he came here—I can't tell how glad. My whole outlook has all changed. Things seem silly that used to seem smart. I have decided to take my stand on Christ's side, to let go of philosophers and substitute Christ. I wrote to "Uncle Raja" (that's what his Eurasian children call him) and he gave me a beautiful "May God bless you" as I took his hand and said goodbye tonight after the lecture on Mahatma Gandhi. Oh, I do want the kind of religion that he offers—it is verily of Christ. As he lectures you lose him; it is God speaking. His great clear voice, rich and carrying well, rolls out uttering fearless truths, sincerity, conviction. The man is surely inspired; the vitality he puts into it is not human. From his fingernails to his toe tips and right up through his Indian black hair, it is life exultant. He is radiant. When it is over, great beads of sweat are on his forehead. He wipes his face and his human body sinks into his seat and he covers his face with his hand and I

know he prays then. His invitation to pray is so simple, just "Shall we bow our heads in silent prayer?" And after a few full, live moments he begins, deep and quiet, "Our loving, holy, Heavenly Father" and the few simple sentences take you right in front of God. Oh, this is live, vital religion. The theosophy God and philosophy are beautiful but cold and remote and mysterious. You circle round and round and rise up a little way so that your feet are loose but there is beyond and beyond and beyond that you never could reach. God is absolute law and justice. But here a live Christ leads you to God, and the majestic awfulness is less awful. Tonight he interpreted the life of Mahatma Gandhi, brought out all his nobility and greatness, and spoke so lovingly and understandingly of his weakness as if he was speaking of his own father that he loved.

I love to be blessed by good ones. Now there is one more added to the remembrance garden deep in my heart—Uncle Raja. Down in my garden is neither creed, nor sex, nor nationality, nor age— no language even—there is just love. Only those who have touched my inner life, my soul, do I plant down there. No matter how intimate I have been with them they cannot get into that place unless that mysterious something has happened between our souls.

I have written to Lawren and told him about things. I think he will be very disappointed in me and feel I have retrograded way back, fallen to earth level, dormant, stodgy as a sitting hen. I think he will hardly understand my attitude for I have been trying these three years to see a way through theosophy. Now I turn my back on it all and go back sixty years to where I started, but it is good to feel a real God, not the distant, mechanical, theosophical one. I am wonderfully happy and peaceful.

Last night I learned that dreadful, horrible thing about poor Lizzie. I am glad she has told us and asked us to help. She is such a good soul! I just can't bear it. Those are the places Christ helps. He did last night.

God, God, God! Oh, to realize so completely that you could utterly let go and passionately throw your soul upon the canvas.

February 7th

Fred's crit is fine, and kind too. He was honest with me and, oh

goodness, how few people are! It's a compliment when people don't think you want "eye wash," as Fred calls it. He says there's too much *me*, too much *originality* (I suppose he means *striving for effect*, I did not know I had done that). I'll at them again and try and unify and concentrate and build to a pyramid and unhitch my horse and put him before the cart and cast out *me* and seek to find expression for the wordless subtlety of the beasts. He says I must live and experience my stuff. Heavens! I thought I did. They swamp me at times but I haven't got connection between the thing and its equivalent in words.

The snapping of this theosophy bond will make a difference to my beloved friends in the East. They all do so believe in its teachings. I wonder if it will cut me completely adrift from them. But I am glad to be back again and have peace in my heart. Alice is much interested in the Raja's message also. That and this dread thing hanging over Lizzie is bringing us closer together.

February 12th, 6 a.m.
I woke with this idea. Try using positive and negative colours in juxtaposition. Complementary are negative to positive. Try working in complementaries; run some reds into your greens, some yellow into your purples. Red-green, blue-orange, yellow-purple.

I have decided to do what I can to give practical enjoyment with my painting, when anyone who can't afford to buy but *really* enjoys one, to give it freely. I have given one to the Houssers, to Harry Adaskin, to Harold in the asylum and also one to his friend, to make Harold happy, and one to Lee Nan as a New Year's gift and one to Gerhardt Ziegler in Germany and am sending two off to Mr. Hatch. He wrote he never thought women's work (painting or writing) serious or strong but he excepts me and a few others. Edythe, Jack, John and Fred all say my work is better than the American work in New York. I do not agree. I don't want to be mean and snippy but I don't think they know. I must get a hustle on and make time. Not a brush stroke today—painted stairs, cut down a pear tree, went to town to see Lee Nan for his New Year, fixed my sketch-keeper under the table—a million little chores. But

95

I am *hedging*, not facing the problem before me—how to express the forest—pretending I must do this and that first, and indeed things must be done some time, somehow, but the other should come *first*; it's my job. It's much easier to dig the garden, clean the basement, paint stairs, than paint to express subtle interior things. I let myself follow the path of least resistance and shirk delving down to the bottom of my soul. I wish someone would spank me and set me down hard so I'd cry and be good after. The woods begin to tease me these fine early spring days but I can't go yet and the winds are bitter cold.

Dr. Wells of Edmonton came and was apparently interested. He stayed an hour and a half. He said, among other things, that Eric Brown does like my work and considers me one of Canada's serious workers. That being so, why does he sniff so at what I send over? He treats me very queerly, ignores my stuff, looks the other way and doesn't hang it. It's funny that my work doesn't speak out of its own dirty old studio. Dr. W. declared the things I sent to Edmonton were not the same he saw here. They *were* those very same. Lawren said his always looked so much better in his studio. Seems to me his look pretty fine out too but my own out among others make me *sick*. They look awful. It's pretty rotten painting like that for you can't send your studio forth with the pictures, to background them. Good work should tell out anywhere.

I worked well today, carrying out what came to me the day before as I woke, about painting in primaries, using positive colours with a few negatives for rests between. I felt my canvas pretty stirring. It did not seem like "guidance" because it seemed too giddy and violent a method to come from God. All the same I did not dare to refuse and went ahead. Something is needed to wake me; I've got pretty stodgy and negative in colour.

I wonder if I should open the studio to the public for two days. There are many who are kind to the work. I think somehow perhaps I should. It *might* help someone. I don't like it but it's my job, perhaps. Gee! I want those woods to go whiz-bang and live and whoop it up with a vim. *Not* vulgar, blatant see-me-do-it, but joyous, irrepressible, holy, glorying uplift to God.

February 16th

I have had a long, fine letter from Lawren. How could I ever have doubted his friendship and thought that when I told him about having gone back to Christianity our ways would more or less part? He is glad I have found inner light and blesses me harder than ever. I am so glad! I want to struggle ahead like thunder now and, after all, the struggle is being still—not slack, but *still* and *alert* for any leads that may come through, and, like poor Mary, ponder them in my heart. I like the Virgin Mary; she was not a blabber.

February 18th

Went to early communion at the Cathedral this morning (8 a.m.). I couldn't help noting how melancholy all the people looked. They clasped their hands and looked straight down their noses as if something awful had happened instead of being grateful and glad in their hearts. I can't think that holiness means unhappiness. Seems to me real holiness should mean lasting happiness. That's the kind I want to get hold of. That's the kind of holiness I want to come into my painting too—praise, every bit of nature praising God. In *The Sadhu*, lent me by Raja Singh, he is describing Heaven as seen by him in an ecstasy. He says, "Everything, even inanimate things, are so made that they continually give praise and all quite spontaneously." That is a wonderful thought, and here in a minor way they may be doing the same thing if we were sufficiently spiritual to see it. That seems to me to be the real meaning of art. If we could see and express that one thing only. But that could only be attained by living a pure spiritual life and by constant prayer and communion with God as one works. This is difficult. So many evil, selfish or vain thoughts come into the mind even in the midst of painting— grouches and grudges. One can not always sing in his heart while he works but a singing heart, I am convinced, and the mixing of joy and praise with the very paints, as well as the ideals and inspirations one receives, and the forgetting of oneself is the only way. Those old religious painters lived in their religion, not themselves. Our B.C. Indians lived in their totems and not in themselves, becoming the creature that was their ideal and guiding spirit. They loved it and were in awe of it and they experienced something. We must

97

have awe and reverence but above all *love* of God, if we want to express his creation.

I have been reading the life of Vincent Van Gogh—poor chap, so strong and so weak!

Just came from a lecture on the history of art. Went sound asleep in the middle. Met the lecturer at dinner first. Conscientious stuff but not thrilling and too long-winded. Slides were good. What those men got into their work was astounding—knowledge of power and the something underneath. Makes us poor, puny present-dayers look pretty small, and cheap as tooth-picks. Look at their thoughts and their draughtsmanship!

My canvases came from Toronto yesterday. Took $7.40 to pay express, which leaves me $1.40 to live on for one week and buy dog meat as well. What's the good of sending to exhibitions? First I sent to get the crits of the men in the East, which were helpful. Now they don't give me any. Why? I got *nothing* this time. Two people, neither of them artists, caught the meaning. One of the mountain and one of the tree. Just two people. Is that all I gave? It's rather disheartening, this painting. Is it useless and selfish? Or is it my job, with a hidden meaning for myself and others? I don't know. The pictures look so much better in their own studio! Now, at home, they seem to mean a little; in Toronto they looked poor, mean and awful. I am digging into housecleaning and gardening. Spring is bursting but the wind cuts like ice.

February 28th
I have finished the "Cow Yard." I think it's better than the rest. I've put all I know into it, lived the whole thing over, been a kid again in the old cow yard, fished for tadpoles in the pond, felt the cow's slobber on my hand, roasted potatoes in the bonfire, scuttled past the "killing tree." I get so worked up over my funny creature stories, then once they're finished, I'm done with them completely, don't make any use of them nor have the courage to *try* a market. I've never tried one yet. I'm sure no one would take them. Still it's feeble not to try. I like the "Cow Yard." It's honest and every incident is true.

March 2nd

I read the "Cow Yard" to my two sisters. What a much worse ordeal it is to read or show your own work and your own self to your own people than to the rest of the world! Why, I wonder. They smiled a few anaemic smiles as old episodes brought memories of the old cow yard and both said, "Very good" in a wishy-washy way when I had finished, then went on with their work and did not allude to the story again. *Could* that mean interest? They simply did not see anything in it. Lizzie said, "I wonder if you couldn't get it into a child's magazine." Alice said, "I'd like to see it in print." Neither of them understand the sweat and thought and heartaches that go into painting a picture or writing a story. They want just some surface, sentimental representation. I did sweat over the "Cow Yard," trying to show the cow yard's internals and the big lessons of life to be learned there but I guess I failed entirely. It was never intended for a children's story. I was trying to show life. Well, chuck she goes into the failure drawer, done with. What a houseful of failures I have, to be sure! That's that! What next?

Life, life, life, why are you such a huge, big Why? Why can't we all talk one language and understand each other? I really *do* feel a deep interest in both my sisters' work and what goes on in their lives, as far as they let me. Mine does not seem to interest them in the least. The dogs are much more interested in my doings, even Susie is. Now, this is despairing and it won't do and it is busting the "contract." I've got to keep my courage up and remember the Sadhu's prayer, "Graciously accept me and, wheresoever and whensoever Thou wilt, *use me* for Thy service." That's all that matters.

I don't want that fluffy stuff. Better that they should be indifferent than that. I suppose it's sympathetic understanding one craves. When I read the "Cow Yard" to Flora she discussed every bit and chuckled away over the incidents and I felt like ginger ale just opened. Now, after reading it to Lizzie and Alice, I feel like the dregs left in the glasses next morning.

March 3rd

I've been thinking. The girls did not care for the "Cow Yard" be-

cause they never really cared about the real cow yard. It didn't mean anything to them in itself. It was just a place where creatures were kept. They weren't cow-yard children. How could they get the feeling of it? All the same, *I* was the one that failed; I did not make the meaning plain.

March 5th
Lizzie came in. "I've brought you a book so you can get the address to send the 'Cow Yard' to. It's *Short Stories by Ella Wheeler Wilcox.*" It was by Mary E. Wilkins and published twenty-two years ago in Edinburgh. She said, "I wish you'd change the name. 'The Barn Yard' or something else would be better I think." "But," I said, "the whole point would be gone. It's the *cow* yard. The cow is the centre of the whole story; it's built round her." "Well," she insisted, "'The Barn Yard' would do as well and sounds better." Oh, didn't I make my story clear even on that one point?

March 6th
It's a help to sing to your picture while you work. Sing that canticle, "O, all ye works of the Lord, bless ye the Lord. Praise Him and magnify Him forever." I am trying to get that joyous worshipping into the woods and mountains, the work of the Lord. I'm glad I have a lonesome studio with no one to hear but the dogs and Susie—and God.

I have begun the crow story. It is to be done mostly by conversation—people discussing his merits and demerits—little direct description.

March 7th
There now! It doesn't pay to try to be nice. Mortimer Lamb asked to come to the studio and I said, "I will try and be decent and amiable and helpful to him." So I tried and I rattled out millions of canvases and sketches, which is hard, tiring work. Result—"I *have* enjoyed myself so much. May I look in *again* before I leave," says Mortimer. He's all keen on having an exhibition of my stuff in London. (They'd never accept it.) "It's a shame to think of you stuck out here in this corner of the world unnoticed and unknown," says he. "It's exactly

where I want to be," says I. And it is, too. This is my country. What I want to express is *here* and I love it. Amen!

Oh, I'm a lazy woman. To *paint* one must make the *supreme* effort. I mean the effort of emptying oneself, the effort of abandonment. But one goes out and dreams and *drifts* instead of absorbing. Heavens! What a lot of stuff these people pour into my ears! It doesn't harm me any, for the simple reason that I don't think they *know*. If I did think they did I might get chesty. Nobody knows any other body's struggles. Oh, that great, big, huge, enormous something supreme that my stuff lacks so entirely, that oneness and unity, the thing that lifts one above paint, above rot, that completeness! I think if one could find that they would stand face to face with God. How could one ever hope to be holy enough to paint that way?

March 8th

Out on the cliffs sketching for the first time this year. It was unbelievably good, sunny and warm. Protected by the bank from the north wind, I put my "whole" into it—sky and sea. Came home and built a big paper sketch from the small, got quite a sweep and swirl to the thing and lost it again. Will whack again tomorrow. Very happy all day.

March 9th

Dear Mother Earth! I think I have always specially belonged to you. I have loved from babyhood to roll upon you, to lie with my face pressed right down on to you in my sorrows. I love the look of you and the smell of you and the feel of you. When I die I should like to be in you uncoffined, unshrouded, the petals of flowers against my flesh and you covering me up. As a baby it seems I loved to roll and grovel on you. My mother told a story. A small boy and she were comparing babies. My mother seemed to be coming out on top; her baby was a girl, his a boy; hers was fat, his lean; hers sweet-tempered and healthy, his lean and fretful. Then he found wherein his beat Mother's baby all hollow. "Anyhow, Mrs. Carr," he said, "my baby's the *cleanest*." I, toddling and tumbling in the garden, was earth-coated, his baby was spotless in his pram.

Another time I remember my brother-in-law trying to pay me a compliment on my return, grown-up, from the Art School. "Quite a young lady," he said. "Not such a smell and flavour of Mother Earth about you." Oh, Mother Earth, may I never outgrow the wholesomeness of your dear smell and flavour!

I have been entertaining a woman who has been giving a course of lectures on the history of art. Oh, what a dull woman! It was like trying to make merry with a stone crusher. She is not an artist, only a book-learnt lecturer on art. She drones on nearly two hours. As soon as the lights go out for the slides you hear a gulp of relief go round and the chairs creak gently as relaxed bodies settle to sleep. I don't know one soul there who doesn't sleep through the latter half, and such a blinking when the lights come on! Well, she got even with me by the corpse gaze she gave my pictures. I have never showed to a dumber. It was awful! If she'd only said, "Damn! They're awful!" I'd have been so thankful. She evidently hated them. Wonder what she'd have said to today's and yesterday's sea sketches. They're pretty wild and I hope lived a little before I loaded on paint and strangled the life out. Will I ever learn the art of developing the vision without killing it? Oh, the things waiting down there to be expressed and brought forth in gloriousness!

March 18th
Ah, little book, I owe you an apology. I've got to like you despite how silly you seemed to me when Lawren suggested I start you. You help me to sort and formulate thoughts and you amuse me, which is more than housecleaning does, and that is what I have been doing for the week. Well, it's all in the day's march, but the housecleaning march is bad, uphill going, stony, grim, and grimy, and nothing so unflinchingly and brutally tells you your exact age.

Three women from the Business and Professional Women's Club came out to select the picture I told them they could have to hang in their clubroom. Two stiff-backs came, just. I could feel them bristle as they entered the studio. I asked what space they had and what sort they wanted. One of them said, "I like your Indian" (an old, old man). Well, I brought out some. Nothing suited. They

sniffed and stared and stared and sniffed while I felt helpless, irritated. A third dame of selection was to come later. Well, I fumbled round the canvases trying to see things with their eyes, and couldn't. My stature simply isn't business profession. However, No. 3 came duly and pretty quickly sorted out her likes and the others' dislikes. They took the despised "Mountain" which the Easterners saw nothing in. Gee! I wrestled with that mountain and I'm not through with "it" (the subject) yet.

Yesterday Phil took me on a van location hunt. We found one I like greatly, the Esquimalt Lagoon. Wide sweeps of sea and sky, drift galore, and hillside and trees, and great veteran pines. It will be some time yet before I can go. We looked in *en route* to see the Elephant and jacked her up higher. The dear beast looked O.K. It was the lovely time of day and the Lagoon and woods were at their best—mysterious, the material dormant, the spiritual awake. I *think* I could paint there.

March 20th

I sailed up the church aisle Sunday late, so as to avoid the obnoxious soloist, and got there just in time for her solo. Then we had a hymn and as I looked down at my book I discovered great splotches of whitewash on the sleeves of my coat. Then I further discovered I had gone to church in my *very worst* yard coat—whitewash and paint all over and two holes in the back as big as oranges and the lining hanging out. I laughed right out—I couldn't help it—and caught Mr. W's eye. He was holding forth and I suppose he thought I was laughing at him. Nothing for it but to sit it out. I got out during the last hymn, fuming. It's too bad to wear even to the beach. A big worsted loop keeps it shut at the neck. I'm fed up with that church somehow since they amalgamated—too much repetition, too much music (or noise rather). The pianist BANGS and the soloists shriek, too many flowers stuck all over the platform in all sorts of vases on footstools, jazzy lace curtains with horrible zigzag patterns, and Mr. W. so tickled and smug—at getting the job and a salary, I suppose. He tells the same old stories by the yard. His voice is like the gramophone needle scraping blank. I guess it's time I moved on. But where? I'd "sit under" the Dean but I can't hear one word in

the Cathedral. Most of the parsons just chew words. *If* there is any juice to their performance they swallow it. It's me that's wrong, I guess. I want Christ's teaching and living, not church dogma and doctrine. I wonder why Raja Singh did not answer my letter. Somehow I'm afraid he's in trouble or sickness because he's very polite and it needed answering.

They came and got the "Mountain" today. I was ungracious and did not ask them in, said I was housecleaning and hauled the Mountain to the door. Goodbye, old Mountain. How will you like the "Business and Professional" eye? Will they be kinder to you than the "Grange" eye, or even worse?

March 26th

Heavy today. Such a weight upon me. Weather grand—several hours' good rain, and the earth, flowers, birds whooping it up and rejoicing in mellow deliciousness. I did a fair sketch this morning, too. Am working intensively this week. I make a sketch one quarter size, loose-knit and superficial but *observed*, bring it home and make a full-sheet one (oil on paper). I try to take it further than the small one and express all I know of that particular theme and the purpose of the sketch to wake and enter the place of it. What I am struggling most for is movement and expanse—liveness. By George, it's *living* out there on the Beacon Hill cliffs. I'm a lucky devil to live near that wideness because it gets increasingly difficult to urge myself to the effort of setting forth on longer journeys for material. Weariness and rheumatic joints try to down me and I have to flog my spirit to rise and fly over them.

March 27th

I got a letter today that pleased me greatly. It was from Smith's Falls, about a picture exhibit, that one of mine was in. She says, "We have had a glimpse of British Columbia through your eyes and want to thank you. We know the B.C. woods and it made us homesick. Undoubtedly many did not understand your picture, not knowing the almost tropical growth of B.C. We, my husband and I, have lived in it, climbed in it, camped in it and found it just right. Accept our sincere gratitude." That's worth a lot of struggles, the

kind of praise that thrills and makes you tingle to go on, to think you'd made someone feel. How different to those beastly empty write-ups, varnishing the "you" and ignoring (or worse) the thing you're struggling for.

March 31st
Did Good Friday penance—went to see Harold at the insane asylum. He is writing an autobiography and spent the hour and a half of my visit reading it to me. It is wonderful, quite good in spots and wild romance in others—things he has got from stories he's read or heard but that never happened to him. Still, it keeps him busy. He kneels and writes at a chair. The other patients laugh at him and steal his papers away. However, the attendants seem quite interested and keep his book for him. I took him a fresh supply of scribblers and pencils. He is intensely occupied with his story, just as thrilled as I was with the "Cow Yard." "The trouble is, I don't get enough time," he says. "You see there is my work [the polishing of the brass spittoons] in the morning, and I help set the tables." Then he kneels to the chair, with his white face and damaged forehead bending low over the seat and his misshapen feet thrust out behind and his poor dull brain rummaging among his confusing memories of happenings and readings. "You see," he told me half a dozen times, "I want to do this thing thoroughly and put down the whole truth—only the truth." When he read, his whole being went into the thing. When he described the cattle round-up in the Nicola he made the calls of the cattlemen with terrific gusto. New paragraphs were frequently started, "I Harold Cook, author of this book." It is all written in a fine, neat hand. Sometimes it takes him very long to find his words and spelling in his dictionary. Sometimes the patients help him.

He wouldn't let me go, asking me about its publication, clinging on to my hand, the keepers waiting. "Look here," I said, "I'll get shut in and you'll miss your supper," and finally got out. He has been writing it for several months now. Well, at least it means that the poor, muddled brain fretting over captivity has been released for spells into the freedom of memory and imagining. No bars of asylums or jails or poverty and sickness or any devilishness whatever can arrest the flight of our imaginings nor hide from us what is

stored in our memories. This bit of rummaging in my own memory, probing and clothing the ideas that come to me about the creatures I have had and known and loved—what a joy and unfolding of many things it has brought to me! What matter if they are never printed or heard of or seen? Maybe they've helped to develop some unexplainable thing. Anything worth while is bound to burst out, but we don't know how or when or where. Hidden away in a drawer they may have done something, even if it's only developing me so that I may help others by *understanding* them better. I certainly can enter Harold's joy in his biography far deeper than if I had never tried writing myself. Funny world.

April 1st—Easter Sunday

I went to Early Celebration at the Cathedral. It was full—men and women all "remembering." It was cold and wet and early and the flowers through the park were trying to bear their burdens of rain and hold themselves up from the mud. The church was full of lilies and daffodils. I took communion in the side chapel. The little Chinese curate passed the cup. I like being served from his hands. There is something specially spiritual about the Orientals. Their slender hands touch beautiful things so reverently. Our British hands are large, practical, useful appendages, but they are ugly, clumsy, uncouth. They are not reverent and tender of the touch of loveliness.

One feels aged in the Cathedral. It is impossible to hear and hard to see. I don't try to any more. I just sit and "feel" God, just try to get close and let the words go. The Cathedral is very new and, because it is, it tries to pretend age. The decrepit, old, and lame attend, decent and uninteresting spinsters, and "h"-less, Old Country families that stick like limpets to the rock of the "Church." And, oh the headgear!—postscripts tagging on to the tail of Queen Mary.

April 4th

I woke this morning with "unity of movement" in a picture strong in my mind. I believe Van Gogh had that idea. I did not realize he had striven for that till quite recently so I did not come by the idea through him. It seems to me that clears up a lot. I see it very strongly out on the beach and cliffs. I felt it in the woods but did not quite

realize what I was feeling. Now it seems to me the first thing to seize on in your layout is the direction of your main movement, the sweep of the whole thing as a unit. One must be very careful about the transition of one curve of direction into the next, vary the length of the wave of space but *keep it going*, a pathway for the eye and the mind to travel through and into the thought. For long I have been trying to get these movements of the parts. Now I see there is only *one* movement. It sways and ripples. It may be slow or fast but it is only one movement sweeping out into space but always keeping going—rocks, sea, sky, one continuous movement.

April 5th
Lawren asked if he could see the "Cow Yard" so I posted it today. He will pass it on to Fred.

I am trying chalks. Hang! Why don't they invent a good sketching material? My oil and paper are fine but the oil paints are such a nuisance to carry. But it's a dandy method for five finger exercises in the studio. I've learned heaps in the paper oils—freedom and *direction*. You are so unafraid to slash away because material scarcely counts. You use just can paint and there's no loss with failures. I try to do one almost every day. I make a sketch in the evening and a large paper sketch the following morning—or vice versa.

April 6th
Just come from the last lecture on art. This afternoon there was a tea for the lecturer—old women like me, very dull—refreshments drab and uninteresting. After the lecture tonight there was a reception at the Business and Professional Women's Club—mixed ages, vivacious old and stodgy young—peppy sandwiches and snappy cakes—lots of chatter. What's it all about, this art? We've had the *reason* for the way each man worked. We've had the viewpoint of each man. We've had the thoughts of each man. We've had the man turned inside out and the work turned outside in, and how much of it is true? Who of us *knows* just *why* we do what we do, much less another's *whys*, or *what* we're after? Art is not like that; cut and

107

dried and hit-at like a bull's eye and done for a reason and explained away by this or that motive. It's a climbing and a striving for something always beyond, not a bundle of "rules" or a bundle of feels nor a taking of this man's ideas and tacking them on to that man's ideas and making a mongrel idea and calling it "my own." It's a seeing dimly beyond and with eyes straight ahead in a beeline, marching right up to the dim thing. You'll never quite catch up. There will *always* be a beyond. It would be terrible to catch up—the end of everything. Oh God, let me never catch up till I die. Let me be always feeling up and out, beyond and beyond into eternity.

A friend drove me out to the Lagoon to look, really to tread on and to measure up the camp ground for the van. I think it will do quite well, in an unfenced property near a stream, near the beach, near the road, near the woods. My friend and two boys and my sister and I went. One boy was bilious and miserable, the other boy greedy and dull. My friend and my sister and I chattered surfacely.

It was not a pretty day—fine, but hard and cold. Everything was dressed in its glorious new spring green but seemed to say, "I'm in my new spring finery. Keep at a distance. Don't soil me." The sky was hard and the mountains peaked and clear-cut and the sea steely blue and cold. It was an "English" day, high-brow and haughty. The Lagoon needs the mellow light of sunset to make it human—no—make it God-like. The old longing *will* come. Oh, if there was only a really kindred spirit to *share* it with, that we might keep each other warm in spirit, keep step and tramp uphill together. I'm a bit ashamed of being a little depressed again. Perhaps it is reading the autobiography of Alice B. Toklas—all the artists there in Paris, like all the artists in the East, jogging along, discussing, condemning, adoring, fighting, struggling, enthusing, *seeking* together, jostling each other, instead of solitude, no shelter, exposed to all the "winds" like a lone old tree with no others round to strengthen it against the buffets with no waving branches to help keep time. B-a-a-a, old sheep, bleating for fellows. Don't you know better by now? It must be my fault somewhere, this repelling of mankind and at the same time rebelling at having no one to shake hands with but myself and the right hand weary of shaking the left. Stop this yowl and go to

your story and enter the joy of the birds. Wake the old sail up, hoist it up in the skies on lark songs. Lay the foundations strong and flat and coarse on the croaks of the crows and the jays and the rooks. Fill it with thrush songs and blackbirds, and when the day is petering out wrap the great white owl's silent wings round it and let the nightingale sing it to sleep.

Sunday

I feel I have "sat under" Mr. W. for the last time. I have done with the loud music, or rather noise (about ten or twelve hymns and a horrible solo by a wretched little man with no voice and a bucketful of affectation and a woollen sweater under his jacket which showed all down the front), and Mr. W's monotonous voice, and that queer, hard stare from under his eyebrows out of eyes with no lashes, and the same endless anecdotes I have heard for two years, and the smother of flowers in the junk vases standing on assorted stools, and the pianist in violent blue beating out violent noises, and the long stupid explanation about the silver bowl at the entrance for the collection. The whole thing disgusted me and seemed hard-set and unspiritual. I must not go again. It is not good to feel that way. I feel that Mr. W. has grown pompous and smug and that it isn't what I want and it doesn't get me any nearer to God. Why do all these parsons lay things so dogmatically before the people? They're all alike, all *sure* that theirs is the only way. The road is the same but some tread it in shoes, some in sandals, some in slippers, some in gumboots and some barefoot. Some run and some walk and some sit a lot to rest. God, God, God, we all want to get to the journey's end in time. Fit us with boots to suit our own feet and make us tolerant of the footgear of the rest. I've read "The Snack" over again. It's perfectly *awful*—meaning not clarified, sentences clippy and rough, sense twisted. I'll never, never, never be able to express them. I looked at my six beach sketches, just heavy with paint and expressionless. It is wilting to find yourself out now and again. Your short-comings all jump out at one and b-a-a-a. Maybe if it's true about reincarnation everyone goes through this stage just to prepare for the next, sort of a priming for next time's fruit, and the fellows who are ahead this trip are the ones who get deep priming last.

A man came today and he wanted to know all about modern art—every single thing in one sitting and I am sorry I couldn't explain better. I'm no good at it. I want to give out the little bit I know but I can't find words. I hauled out quantities of canvases and he went away shaking his head. He said he was too old to learn and too busy and he went back to the old, old ones and said he liked those best because he understood them but he wanted to understand the others and he couldn't, and his wife sat and tried to squeeze out feelings over the canvases like you squeeze out icing ornaments on a cake and messed herself and left ungainly blobs and I felt so helpless that I couldn't help them to understand better. Somehow we couldn't catch on to each other's understanding and we were unhappy over it and it was all hopeless, like a wrong key turning round and round in a lock and having nothing happen.

April 12th

Sewing—a necessary evil—and a sketch on the cliffs in the evening. They are very beautiful. It is when the sun has dropped behind the Sooke hills and blobbed yellow and red over everything just before he did it. People generally rave over the red and yellow but I'm in a hurry always for it to get over. Then "it" comes, tender, melting mystery. I love the woods at that hour—no blaring lights and darks to perplex and make you restless with their shifting and sparkle, but that lovely mellow peace so much deeper and richer than sun glare. I shall love the lagoon in the evenings. The woods will darken quickly because of the hill but the grand expanse of beach and sea will hold the after-glow for long. I showed the crow story to a girl last night, read it to her. She did not think it entirely satisfactory. Some bits of description of the crow she liked very much. It did seem rough and jerky as I read it aloud. It needs a lot of cutting up and smoothing, as the thing I'm chasing in it is abstract and very difficult. I'm a bit of a fool to try that indefinite material before I can do definite stuff but those subjects interest me and I *must* try to get it over even if I fail. The trying is well worth while, only it seems so selfish to just go on trying unless one's tries amount to something. Lawren has the "Cow Yard" today. Wonder if he feels it or if it is only oddities like me, the "cow-yard child," who can wallow with delight in cow yards.

Even I did not realize all the joy and sorrow of its deeps till I *wrote* the "Cow Yard." Maybe I've used too many *people* in the crow story. I must think into it deeper.

Be careful that you do not write or paint anything that is not your own, that you don't know in your own soul. You will have to experiment and try things out for yourself, and you will not be sure of what you are doing. That's all right; you are feeling your way into the thing. But don't take what someone else has made sure of and pretend it's you yourself that have made sure of it till it's yours absolutely by conviction. It's stealing to take it and hypocrisy and you'll fall in a hole. Art is an aspect of God and there is only one God, but different people see Him in different ways. Though He is always the same He doesn't always look the same—as the woods are the same, the trees standing in their places, the rocks and the earth, but they are always different too as lights and shadows and seasons and moods pass through them. Even the expression of our human faces changes. So does God's wonderful infinite face, which is beyond all human picturing or even imagining, which hasn't any human thoughts big enough to think it even, but is beyond and beyond and beyond.

If you're going to lick the icing off somebody else's cake you won't be nourished and it won't do you any good, or you might find the cake had caraway seeds and you hate them, but if you make your own cake and know the recipe and stir the thing with your own hand it's *your* cake. You can ice it or not as you like. Such a lot of folk are licking the icing off the other fellow's cake.

April 15th

Am eating today after a fast of seven days and it feels very good inside. I wish I had been brought up to think nothing of food, instead of encouraged to have a palate sensitive to and demanding good eats. I believe those who are reared on short-comings are best off spiritually and bodily. I was reared an earthy child. I remember the spirit in me used to try and look up but the fat earth body sat on it. Now it fights to lift but sixty years of being sat on has flattened it. I have painted today a paper sketch. I tried to say something, to

work out last evening's thought in my sketch on the beach. It spoke a little so I quit for fear of strangling its mite of speech. There's wonderful things out there on the cliffs and over the sea.

Tonight there was the tiniest, delicate new-born moon, needle-sharp at its points and whooped upwards, and the most delicate blue-green-grey sky with warm brownish clouds coming right over the top of you, and cold blue-grey, flat clouds, and the mountain, and the sea, quiet and low grey. How can a human hand dare to feel into that light and space? Only the soul can feel out into its formless realities, too subtle for forms and mediums. Only the soul can cope with it. Only she can feel her way into its fineness.

April 16th

I woke to this dream: I was in a wood with lush grass underfoot and I was searching for primroses and a little boy came. I did not see him, only his bare feet and legs among the grass and I saw my own feet there among the grass also. "What are you looking for?" said the boy. "Primroses." "There are no primroses here," said the boy, "but there are daisies. Gather them." Perhaps what I want most is not for me. I am to take "daisies" instead of primroses.

I washed a wall. While it dried I went to the beach and made a sketch. Came home and kalsomined. While that dried I did my big sketch from the small one and went back and did my second coat of kalsomining. My sketch was half good, a certain amount of light, freedom and space, but not sensitive enough. I need much refining away of clumsiness. Christ said, "I am come that ye might have life and have it more abundantly." Having Christ in one's life should waken one to a far bigger sense of life, far bigger than the sense of life that comes through theosophy, that static, frozen awfulness, sort of a cold storage for beautiful thoughts, no connect-up with God by Christ. At one time I was very keenly interested, thought perhaps it was the way. Now it numbs and chills me. It's so blood-less, so tied up with "states" and laws and dogma, and by what authority?

The beach was sublime this morning—low, low tide that showed things that are most times hidden, great boulders, and little round stones the size of heads, covered with a kind of dried sea moss and

looking like the tops of human heads. The sea urchins squirted at you as you walked and crabs scuttled, and the air and the sea and the earth were on good terms, and made little caressing sounds. The sea kissed the pebbles and the little breeze petted everything and wasn't cold or annoying. As for the earth, she is beside herself with sprouts and so happy. The air and the earth and the sea seemed to be holding some splendid wonderful secret, folding it up between them and saying to you, "Peep and guess. If you guess right you can have it." And you're almost scared to guess for fear of being wrong and not getting it.

I think perhaps it's this way in art. The spirit of the thing calls to your soul. First it hails it in passing and your soul pauses and shouts back, "Coming." But the soul dwells in your innermost being and it has a lot of courts and rooms and things to pass through, doors and furniture and clutter to go round and through, and she has to pass through and round all this impedimenta before she can get out in the open and catch up and sometimes she can't go on at all but is all snarled up in obstructions. But sometimes she does go direct and clear and catches up and goes along. Sometimes they can only go a little bit of way together and sometimes quite far, but after a certain distance she always has to drop back. But, oh, if you could only go far enough to see the beauty of the whole complete thought that has called out to you!

April 22, 1934
Life is so cram-full of disappointments and some are little things that one should not mind at all and often those little brutes seem to cut deepest. I got a letter from Lawren. I did want a good honest opinion on the "Cow Yard." All he said in a three-page letter was one-half sentence: "The Cow Yard is fine. Have only read it once. Will read it again later. Have no criticism to offer." Now what help is that? I know it's fine because I put all my best into it, but I wanted some helpful hints, comments, suggestions, opinions. Shucks! "Not one can acquire for another, not one can grow for another, not one," says Whitman. Plow, harrow, seed your own land with your own hand. Fred gives you a cracking hard crit, lances clean to the

bone, hurts and helps. I wonder what aeons of time will elapse before I hear from Fred. What an impotent devil I am. If one could see things *clearer*. After all, we all stand so *utterly alone* and our only real critic and judge is our own soul. I suppose if we were absolutely straight and honest with our own selves . . . but, there you are, everything's a muddle.

April 24th
A dull tea with a dull woman at the dull Empress. The pups, Tantrum and Pout, the only gay things about it and the conservatory a joy of airy, fairy, gay colour, too exquisite and upstairsy to describe in words, like colour stairways of joyousness leading out beyond earth things. My companion a veritable twist of nerves, jerking, jumping, blinking, mouthing, worriting and religious, clinging to life with every atom of her and telling you all the while how ready she is to "pass on." Oh dear, and me so deaf and straining to hear her muttering and gibberings and not catching things and answering wrong and bringing her home to supper and her swearing she can't eat a thing but a dry crust and tucking in to a good "square" and smacking her lips. And shovelling her home at last, and glad to get to bed, and thanking God fervently that I don't have to live with her. Oh better a million lonelinesses than an uncongenial companion! "Can I see your pictures?" she said and regarded three finished sketches. "Oh, not finished," she said and made no further remark. I told her about the "Cow Yard." She was not the least interested. Nobody is interested in anything these days except themselves and their own doings and thoughts. It's queer; folk *used* to be interested. Now it seems there is too much of *everything* in the world. We're all "overproduced." Everybody *does* everything and there is a surfeit of all things and everyone wants to flap out from the flag pole at the tip top and nobody wants to climb the stairs and, step by step, get used to the higher air. The garden has never been so lovely. The lilacs are a dream, their perfume penetrating every corner.

Two easels stand in the studio and on each is a paper oil sketch of the beach. Unlike my canvases, they have no dust sheets, and I

watch people's reaction. No one gives them more than a passing glance—some not that. There can be nothing in them. They make no appeal. Yet I am keenly interested and I do feel I put more of myself into them, a great deal more, than a year or so back when I was thinking design and pattern and painted more or less from memory of things I had seen. I am painting on my own vision now, thinking of no one else's approach, trying to express my own reactions.

Beach fine today. Wide, wide expanse shimmering off further than one could think. Five middle-aged nuns picnicking—enormous quantities of food and books, black draperies flapping, (Oh, how awful to be swathed and wrapped up in that trailing stuffiness!) silver crosses dangling and glinting in the sunshine. The nuns had a good time. They were very pernickety in their selection of a rock to picnic on. Tried three, flapping from one to the other like dishevelled crows. One sat down and dabbled her feet in the sea. She spread out all her black layers like a sitting hen, so that only the mussels and limpets, who apparently have no eyes, could see her bare skin. She did things with a newspaper. Perhaps she wrapped her feet in it when she immersed them so the he-fish should not see. Anyhow she took her time and the others read a whole library of religious books they'd taken along. They then had an enormous feed and everyone had a bottle of queer pop and tipped the bottles up and drank out of them. The pop bottles looked deliciously irreligious, sticking out of their nun's bonnets.

Two youths sawed logs, stripped to their waists. They oiled the saw a great deal. I guess they enjoyed oiling more than sawing for it was very hot. I brought my thought sketch home and thrilled acutely, putting it on a large sheet. Oh, I hope the brute won't die tomorrow when I load on more paint and struggle. It seems as if those shimmering seas can scarcely bear a hand's touch. That which moves across the water is scarcely a happening, hardly even as solid a thing as a thought, for you can follow a thought. It's more like a breath, involuntary and alive, coming, going, always there but impossible to hang on to. Oh! I want to get that thing. It can't be done with hands of flesh and pigments. Only spirit can touch this.

What's the good of trying to write? It's all the unwordable things one wants to write about, just as it's all the unformable things one wants to paint—essence. It's nearly dawn and I have been awake for a couple of hours. All the birds have started up such a racket. Now they haven't got any words and don't want or need any. All they are impelled to do is to toss praise into space where it mixes up with all the other essences of joy that all the rest of creation is pouring forth, bubbling up and spilling over and amalgamating with other spills-over, and becoming a concrete invisible something of great power. It becomes the something that feeds longing souls food, the something that has burst through its mortal wrappings and is pouring back to its source—God—in praise, a concentrated essence, very strong and very subtle in its strength. Everything is in it: light, perfume, colour, strength, peace, joy, and it has no needs, no special name. A name would weight it and keep it down. It could not have a name of this world because it is of another. One day we will go out and meet it in another world and then we will know its name because we will understand that language. It is a thing that must not be pried and wrenched open but left to unfold. You cannot pry open the dawn. It comes. Day is here now and the birds have come back to the material and are hunting breakfast.

Another week gone and no word from Fred Housser re "Cow Yard." Shucks, Emily, you old fool, when will you learn to be, as Whitman puts it, "self-balanced for contingencies to confront night-storms, hunger, ridicule, accidents and rebuffs like the trees and animals do" and not diddle round as to what this and that one thinks. Make your own soul your judge. Nobody else cares, so why bother them? Search in your own soul and see if the thing is honest and fits your meaning square as you have the ability to make it plain, then quit and don't worry. What does this or that little "do" of yours matter anyhow? It's all for growth. If the soul has gained something by writing or painting it, it is surely worth while. *If* it says something to someone else's soul, that's grand, but our own soul has got to learn the language before it can talk.

A vague artist woman came tonight. She is well-equipped techni-cally and keeps her soul well clamped under and caters to the sur-

face wants of the public, starving her soul that the bodies of herself and family may thrive. She thinks we are here as sort of stop gaps to keep the universe going and sometimes she doubts if there is any afterwards, she says. She asked what set me working this way. I don't know, and more than a dandelion knows why it's yellow. It's just growth, I guess. Lawren's work influenced me. Not that I ever aspired to paint *like* him but I felt that he was after something that I wanted too. Once I used to think, "How would Lawren express this or that?" Now I don't think that any more. I say, "Emily, what do *you* make of this or that?" I don't try to sieve it through his eye, but through mine. She saw many shortcomings but said my sketches stirred her and carried her out. She thought if I *did* find what I was after it would be big. I wonder. I want the big thing but even if it never comes satisfactorily in paint, the trying for it is worth while. There are places that are out-and-out bad in my pictures too.

May 3rd
I have been to Vancouver to be on the judging committee of the Art School Graduates Association for their show, and I have also seen Sophie and I am home again and have kalsomined a large flat, and this all in two days. I thought the work appallingly bad, no meaning to it, no drawing, no nothing except badness. The other judges entertained me at the Georgia with a very poor lunch. However Sophie's visit was satisfactory and happy. She was watching at her window, the curtain drawn back, and her one eye and her toothless gums expressed everything they were capable of. I love Sophie's smile of welcome. It is just as dear, perhaps dearer, now that her countenance is abbreviated by losses.

Movement is the essence of being. When a thing stands still and says, "Finished," then it dies. There isn't such a thing as completion in this world, for that would mean Stop! Painting is a striving to express life. If there is no movement in the painting, then it is dead paint.

Noah's Ark
1934

Noah's Ark—1934
Esquimalt Lagoon, May 12th

And so we're here. Kalsomining, paint washing, preparing the flat to rent, packing and getting here is all accomplished and past. But weariness is also accomplished and present. A mental, physical and spiritual inertia swamps me. I am ashamed, very tired and ashamed of being so tired right through.

May 14th

Spring is crisping up a little. I had a good night and my two-day visitor has gone; a nice little person who loves nature ardently but a little strenuous to be teamed with my old bones. I am more like me now and less like an agitated Mrs. Noah. The creatures are all in their own niches, so good and so happy. One is so obviously their God that it ought to make one careful. If one got to Heaven and found God snappy and cross how awful it would be! This living right close to their adored is Heaven to the beasts. It is very Heavenly, this daisy patch. The old Elephant is sitting in millions and millions of these daisies. They are thick under the van, and growing harder so as to peep out from beneath and are even more lovely, gleaming there palely. The fellows out in the open are straddled out, exultantly staring up at the sun. The others are striving harder, aspiring, working out of the gloom. The dew is still on them though it is noon and it looks like great tears sparkling on their faces. Woo rolls among the daisies with her four hands in the air, playing with her tail. There are immense bushes of sweet briar roses that will be in bloom

soon scattered all over my pasture. The sheep come to the far corner under the trees with their lambs. The dogs keep them from coming too close. A beautiful bird with a lemon yellow breast with a jet black brooch in the middle is under one of the rose bushes feeding a youngster that flaps and squawks. The air is full of bird song and the frogs were croaking right in the awning lean-to of the van, which is hemmed in by a nettle patch. From the van window beside my bed I can see the sea and the stars at night as thick as the daisies by day.

The camp is very comfortable now it's all fixed. The first day was a little awful. We sat out on the pavement outside home waiting for the truck at 7:30 a.m. It did not come until 8:30. The man next door evidently thought I'd been evicted. He kept looking out at the beasts and me sitting round on the deplorable old chairs and at the kettles and the rusty stove pipes and old carpets. We got here around 9 o'clock and I turned out the last year's stuff and cobwebs. The walls looked bad so Miss Impatient had to get busy and paint them. As soon as the inside of the van was all painted up and messy, down came the rain, so everything had to be rushed into shelter. Gee, how I admired Mrs. Noah as I marshalled all the creatures into the van— Woo and the rat and the four dogs! She had ever so many more varieties and the rain battering on the roof for forty days instead of twenty-four hours. But I bet she did not have wet-paint walls to contend with. God gave them warning to get their chores done up before the rain came. So we all turned into bed and semi-slept. The rain came through but did not fall and I was glad of that. It let me get up and have a couple of hours straightening in the lean-to next morning and then it did it again, but I turned round and round in the van straightening as I turned so that when it stopped we were quite straight inside. And just as all was in order, my sister and four others came to tea. I was delighted that all was straight and everyone thought it was lovely. They brought me letters and cigarettes and sweet cake, more than I know what to do with, so that I hope some more come to eat it. A man came Sunday morning and offered me green leaf lettuce which I hate and a woman gave me skim milk.

Now let's see if I am kidding myself about being too tired to work or if it's just laziness about assembling my stuff and setting out. How life does tear us this way and that—what you ought to do and what

you want to do; when you ought to force and when you ought to *sit*! There's danger in forcing but there is also danger in sitting. Now hens know just when they ought to sit. Hens are very wise.

May 15th

The wind kicked up all the horrible ructions it knew how last night. I thought the van would up and fly away on its flaps. The buckets and pans rolled round. Everything inside blew out and outside things blew in till in and out were all mixed up. I sketched on the beach— results indifferent. We tucked into the van but at midnight the gusts were very fierce and I got into boots and came out and un-hooked the flaps and lashed things together a bit and it was better. Rain threatens.

It's fine here. Nobody pesters you. The great wide beach is yours for the taking, its lapping waves and its piles of drift all yours. The roses on the bank, bursting in a riot of cool pink from the piles of deep green leaves, toss out the most heavenly perfume. I love to pass the corner where the spring gurgles up out of the black earth. The roses are so busy there drowning the old skunk cabbages' smells and the birds are applauding us with wing-flappings and such shout-ings. A lovely little couple were down pecking in the black earth. I watched them. He, rusty red about the head, a regular Scotchman. She, quiet grey and very ladylike. They were obviously very attached, keeping close and chatting, not polite he-and-she-manners talk like some married couples, but companionable babble.

There are times out here when one just looks and times when one just listens, and others when one just feels or smells, and there are times when one does all of them at once and others when one is just vacant and nothing works. I believe these times are good too, not to be worried over as savouring of laziness but regarded as times of preparation for development, like a field lying open and fallow and bare.

Oh, the birds! They are as birdy and as busy as they can be in May. Before it is light they are at their singing. Then there's break-fast and the all-day-long job of feeding and teaching the young. Maybe that is why they do get up so early, to have a little quiet to themselves and have time for their devotions. I do not think of birds

as saying anything but only as tossing off the overflow of their joy in being in the few notes that are peculiarly their own. The bird doesn't need many notes because he doesn't know many emotions. When his feelings are bad he does not express them but hides them away somewhere off in the silence. He's noisy and ecstatic over living. Over dying he is silent and secretive. I know now why birds, those perpetual campers, sing after rain.

3 p.m.
The rain pours. I have put us in and pulled us out until I feel like a worn concertina. If it does it again, I shall ignore it and drown. This is our lazy old April's postscript in May. Fool, fool, fool, that is what I called myself to leave a comfortable home to be drowned and frozen, to cope with wet wood and primitive stove and the bucksaw and water lugged from the spring, this pattering through puddles in a cotton nightgown and rainboots and pleading with the wet wood while hunger and hot-drink longings gnaw your vitals. But, at last, the fire began to burn the sticks, the kettle began to boil, the sun began to shine and I began a new chapter.

May
The only dry thing in the whole camp is the water bucket. It's wonderful how one learns to manage to combat and yet work with the elements. I think of Mrs. Noah a great deal: "And Noah went into the Ark and shut the door." When I cosy the creatures into their boxes and take the hot water bottle and shut the door of the Elephant, I feel very safe and able to sauce the elements sitting up in the bunk looking over the sullen grey sea and the old wrecked automobile sitting on the beach among the drift and the drowned daisies who never opened all day yesterday, hiding their golden eyes with cold red fingers, the briar roses sullen and not thinking any more about putting on their lovely pink dresses, and the blackthorn bushes not white round bundles of blossoms but sodden drab lumps. But it's cosy in the van, the rain hitting hard just a few inches above your head and you able to say "Fooled!" as you hear its thwarted trickle down the van sides, and four comfortable snores coming out of the four dog boxes, and Woo's puff, puff and the

soft little tearing of paper, Susie's old maidish preparations for the nests she's always building and never filling. Yes, the van is cosy when it rains.

Sunday

The Morleys spent all day and it was very nice. We ate and talked and I read them "Cow Yard" and "Balance" and "No Man's Land," and they liked them, and out it came, the longing that everyone has to write to express that seething inside that so wants to find an outlet. It is not pride or notoriety or fame people are really after; it's the great longing to grow and to find out what is in oneself and *do* something to bring it into expression.

Camp life is one steady wrestle—with the elements, with inadequate means. One says, "When I have leisure in camp I will do this and that," but the leisure never comes. Indians, those superb campers, had leisure in abundance because they understood; they did not combat. If the wind wanted to come in, they let it and shifted themselves out of its way. If the tide served, they went, if not, they waited. No fussy, hurrying clock to watch, only the steady old sun. If the sun said, "Too hot to work," the Indian did not work. Time was no object and waiting enjoyable. There was no friction so there was peace and they went with nature and nature is quite comfortable if you don't thwart her. My stinging nettle patch is perfectly sweet-tempered if I don't annoy her. I go and come through it with never a bite. I'm not afraid of her.

Oh, this inertia! I don't *want* to work. It blows and blusters and is much nicer sitting in the van than anywhere. I've reconstructed the shelf-table, made a nice little pulpit table with part of the shelf and evened and strengthened the shelf that's left. I love things firm and steady. Now they are. I wish I was as firm and steady. All I've done today is make a good camp stew and learn a piece of poetry, *viz.*

> When He appoints thee, go thou forth—
> > It matters not
> If south or north,
> > Bleak waste or sunny plot.
> Nor think, if haply He thou seek'st be late,
> > He does thee wrong.

To stile or gate
 Lean thou thy head, and long!
It may be that to spy thee He is mounting
 Upon a tower,
Or in thy counting
 Thou hast mista'en the hour.
But, if He comes not, neither do thou go
 Till Vesper chime,
Belike thou then shall know
 He hath been with thee all the time.

 (*Specula* by Thomas Edward Brown)

May 22nd

Oh mercy, how it blows! This place is all superlatives. It blows extremely hard or rains extremely hard or suns until you're melted or all at once until you're giddy. The slop about one's feet is awful. It lies round the van splashing up as you walk—disgusting slop, cold and penetrating. Under the fire is a well of water; the fire sits on a tin tray on top. Sometimes I think I must move on, and dread the expense and bother.

Somehow theosophy makes me shudder now. It was reading H. Blavatsky that did it, her intolerance and particularly her attitude to Christianity. Theosophists say that one of their objects is study of comparative religions and on top of that claim theosophy is the *only* way. It's that pedantic know-it-allness that irritates me. I'm a beast.

Instead of trying to force our personality on to our subject, we should be quite quiet and unassertive and let the subject swallow us and absorb us into it, and not be so darn smart of our importance. The woods are marvellous after the sun has dipped and quit tickling them. Then they get down to sober realities, the cake without the icing. They are themselves, then, like people alone and thinking instead of persons in a throng trying to sparkle and taking on reflection from others. Dear trees, we don't stop half enough to love and admire them.

It is as I said: go with nature and she's easy and delicious. The swamp round the van was awful and my feet in torment, rebelling

at rubber or wet stockings. So off they came and barefoot I paddled through big and little puddles. It's the most wonderful feel. The grass is so soft. The daisies tickle and leave pink and white petals on your naked feet. They never cling to your boots. The earth, even the squelching black mud, kisses your feet as you pass through and the sun is far warmer than shoes. Legs are not so happy. They don't touch the reality, only the air, but they'll get to love the air too. To think how I've fussed over wet feet for two weeks, bucking instead of accompanying!

May 24th
Oh, the misery of living in this slop! The water lies all round the van. I can't stand it. My feet are hideously sensitive to cold, to wet, to unevenness, more sensitive than my hands. Even with thick shoes I feel *everything*. When I had a toe amputated I suffered tortures. The doctor remarked on the extreme liveness of my feet nerves. Underfoot things can do things to my whole being—exquisite pain and exquisite pleasure. There you are. Much easier to have old cowhocks and squelch round in the mire when life is so full of mire. Tomorrow I go into town and command the hauler to drag me up the hill on to the Metchosen Road, high above all the slop. I've seen a lovely place. There won't be beach and open expanse but there will be shelter and the holiness beneath trees, and *dry* grass. So, I moved the stove in under the tent and am warmed with thoughts of dryness. My frog is croaking right in my left ear and a pheasant and a robin are calling. Woo is cuddled up in the sweet briar bush. How do those soft little hands of hers avoid the thorns? I believe we must have been intended to go naked. Rain-soaked clothes don't connect with a common-sense creator and a perfect universe. Drat Eve's modesty complex.

May 27th
Here we are, all settled in Mr. Strathdee's field, dry and happy. The move was awful. I'd have given the van away, with a kiss thrown in, to anyone who'd have dragged her out of the hole. Friday morning I waited, all packed, in great discomfort from 9:30 (the appointed hour) until 11:30. Then the haulers came and drove round

and round the briar bushes, mud and slosh splashing to heaven, but they couldn't get near the van and nothing would work in the bog. Then I ran hither and thither hunting a man to help but there weren't any, so the hauler hauled me and the beasts and junk up and sat us in the field and went to town for help. We sat and sat until 4 p.m. from 12 noon. As I sat there in my wicker easy chair with the two beds, three chairs, stove, buckets, pots, food boxes and all the animals round me, a funny little body grinned along the fence. Every step she grinned harder. Somehow the grin ran along the top fence rail seeming to go along and continue because after she was long past her head was turned behind so that the grin ran back again and met you from the other way. It was such a kindly, enveloping grin! She was a neat little person with glasses on, and carrying many bags, and not any more young. She went past and into the back gate of Mr. Strathdee's place and went through his house and came down the path to my corner. She hadn't heard about me coming to his place and she said, "Are ye having a wee bit picnic, dear?" and she smiled some more in a kind, welcoming way. It did tickle me to think of one solitary soul taking all that clutter along for "a wee bit picnic" all alone. She works in a hotel and comes out Saturdays to tidy up "Brother." She washed and scrubbed; smoke poured out the chimney and mats shook out the doors. Then she trotted off through the woods to see "Sister" who lives in the other direction, stopping at my camp to give me quite a good helping of their family history and to admire the "nice wee doggies" and the "nice wee monkey." Saturday is her one day off so she sets out at 9 a.m. and gets the 11:30 p.m. bus home. Tidies "Brother" and tidies "Sister" by way of rest!

When the old Elephant came lumbering up the hill, I was glad after all that she was mine, but I was very tired and a fair price would have bought her and quit me of camping for ever. But I fell to. Then when I was tucked in bed my spirits hoisted a bit and this morning was so shady and sweet and calm, all the troubles were gone and I wouldn't sell the van for a mint.

May 29th
I am circled by trees. They are full of chatter, the wind and the

birds helping them. Through the sighing of the wind they tell their sorrows. Through the chortle of the birds they tell their joy. The birds are not so intimate here as down in the swamp. There they flew low and sought earth things and dug for worms. Here their concerns are in the high trees. My spirit has gone up with the birds. On the Flats it was too concerned with the mud. I hate to leave camp in the mornings, it is so delicious under the gracious great pines. In the afternoon, when the sun has dodged down and blares forth and gets glaring, red hot and bold, I like to get off into the calm woods. When he has gone, leaving just a trail of glory across the sky which the pines stand black against, it gets wonderful again and presently an enormous motherly moon comes out of the East and washes everything and all the sweet cool smells come out of things, not the sunshine smells of day that are like the perfumes and cosmetic smells of fine ladies but the after-bath smells, cleanliness, fine soap and powder of sweet, well-kept babies. And when you put the van lamp out and lie in the cool airy quiet, you want to think of lovely things. Only sleep is in such a hurry. She has fallen already on the dogs and the monkey and even the rat, and the moonbeams and sleep whisper together, and there you are, helpless as when you lie on an operating table and the doctor is putting you under. You've got to give in; it's no use kicking, so you wonder where you are going and what you're going to see. You wake up once or twice to peep but it only spoils things and looses the thread, so that when morning bustles in your "wake" and "sleep" are all mixed up and vague.

There's the big, hard, cryable disappointments and then there's the horrid little jolts not worth defacing your eyes and nose about, but accumulative, making in the aggregate a tougher, harder, bigger thing to swallow than the big individual troubles that made you cry.

The folk round here kept singing the praises of a certain widow. They just about wept as they told you about all the knocks life had dealt out to her. Her husband had died on her tragically, her son ditto, and now her son's dog. She was, they said, so brave and heroic in her affliction. I began to admire this woman and to want to know

her and when it came to the dog's death, and she seventy years old
and so emptied of all she loved, I looked over my outfit and decided
the lonely widow should have Maybbe who is such an affectionate,
companionable creature. I pictured the widow woman and Maybbe
all of a-cuddle in the winter evening and the woman saying, "What
a comfort this creature is in my loneliness," and the dog creeping
further and further into the woman's heart, wriggling into that
empty ache till their love was all tangled up together. So I set out to
call on the widow and feel the way to offer my gift graciously. I did
not take Maybbe with me because her pups are nearly here and she
looks awful, but I took Tantrum and Pout. I would say, "She's the
mother of these two and she's having more this week but as soon as
they're weaned you shall have her. She's such a companionable
creature and I shall be so glad to know she has a lovely home."

From my camp I had seen the widow's big straw hat bobbing
round her flower garden. Her pinks smelt delicious as I went up her
long, straight path. I introduced myself and asked, by way of excuse,
if she had any eggs for sale. No, she had not. Livestock were such a
nuisance, dragging one out in all weathers. My heart went down
a little. Dogs and cats were not so bad; you could call them. My heart
went up a little. She showed me the pinks and the peaches, and there
was the empty kennel.

"You have a dog?"

"No, he was killed the other day but, oh well, they are a nuisance
anyhow with so many sheep round."

"My griffons don't look at sheep," I said.

"You never know. Another dog may set them off."

We looked at the Canterbury bells and the snapdragons and roses.
The garden was shadeless and very hot. Evidently her feet ached like
mine for we both shifted on to the other foot often. The cottage
looked cool, dark and inviting. I wished she'd ask me in to rest and
cool. We went from flower to flower.

"I must be going," I said finally, adjusting my sketch sack on my
shoulder.

"Yes," she acquiesced. "I can't ask you in because of those dogs.
I never allow a dog in my house."

While I was eating my lunch, a great wind gust blew a canvas chair across the table and smashed the mouth of the milk jug. From then on, the wind got more and more vulgar and violent. I selected the wood behind the hill and I did two sketches but about all they had to say was, "I'm paint" and "I'm canvas," and I went home. At the gate I met all my saucepan lids, the saw and the coffee pot. The chairs all lay flat and the fly hung by one hook. Everything you did not want exposed was and there were whippings, bangings, and topplings going on everywhere. I dared not light a fire but about seven o'clock I did and sat by it with a bucket of water. The grass caught once. I got a pot of tea and a hot bottle, for it was very cold, and I put the fire out with water and cosied the creatures down into their boxes, took food in the van and tucked into bed. No moon-baths tonight. Noisy blackness and quivery shakes as if the Elephant had ague, and tappings and rattlings as if she was haunted. How completely alone each one of us is and yet we are so helplessly atoms of the whole!

May 30th
The elements obviously say, "Hibernate," so I wrap myself round in the van and do so. The wind is keen and raw, it rains when the wind will let it come down. The trees take the wind so differently. Some snatch at it as if glad of the opportunity to be noisy. Some squeak and groan, and some bow meekly with low murmurs. And there are tall, obstinate ones who scarcely give even a sulky budge. The differences make the kick-up even more turbulent than if they all went together. The last two days have been one perpetual cater-ing to the elements. It's cold enough for snow tonight and the wind nips and rain spits. I have written all day on the crow story. Lots of clarifying needed still.

June 1st
Maybbe's puppies have come. All day she was so restless. No nest suited her. I gave her two to choose from, one blanket, one paper. She tore the paper up and was sick over the blanket. She tried all the dog boxes and decided on Tantrum's, which she was barely able to squeeze into. She tried my suitcase and my paint box and finally

had her puppies on the shelf, so I had to rush with a plank to keep them from rolling off, but when she settled to business she was O.K. and has four loud-voiced squealers. And there we are. Something new seems to have happened inside the old Elephant. Maternity is very wonderful. Those four tiny new lives have meaning.

It's a clear, keen morning.

June 3rd
Everything in this part of the world is doing just right today and the earth is beautiful—enough wind, enough sun, enough heat, enough cool. The puppies lie in a sleek, rich-coloured row against their mother, deaf and blind to all about but conscious of the warm maternal closeness of the old dog. Impatience was born in them. They tug furiously at the mother who patiently yields to them her whole being, all she has to give, feeding, warming, cleaning, guarding them. She enjoys their exhausting worry. They are hers and possession is sweet. She lies very content, gathering back the strength she has spent on them so that she may have more to lavish on them. The wonderful instinct of the earth to reproduce and keep things, their own kind, going on. The pups are settling down to the strange feels of the outer world, feels entirely embodied in their mother as yet.

The days fly and the nights too. There is so much to feel and see and hear out in the open. It keeps your whole being alert, drinking in wonders till you are drugged by them, and drift off carried by this smell and that feel and this sound, that colour—out, out, to that which stands behind all these things, God, comprehending all substance, filling all space.

June 4th
Last night I went to hear Raja Singh. At 5:30 I picked up the paper my sister had brought out Saturday. There I saw that he was speaking three times Sunday. I did not know how I was going to get into town but I automatically got ready, shut the creatures up, and had tea and went out on to the highway. I hailed and a nice couple stopped and took me to the very door of the Centennial Church on Gorge Road. The subject was Christ in India. It was an earnest and lovely

address as he always gives. He looked frail and rather far away. One feels those people are much nearer spiritual things than the Western civilization. We have not their mysticism. We are so heavily cluttered with our bodily wants and necessities, our possessions, that we lose sight of the forest in the trees. I felt my life was small and greedy, grasping for the little and overlooking the big. What can we do? I suppose the answer is fill our own niches as full and comprehensively as we know how, fill our own place. When it's full to bursting maybe our limits will be pushed back further and we will have more space to fill. I taxied home and was very glad I went.

King's birthday. All the mosquitoes drank the King's health, literally, in my blood.

June 5th
Sketched in the big old wood. Trees old-fashioned, broad-spreading and nobly moulded, beyond cutting age. There is no undergrowth in that wood, only old fallen branches and wild grass, but mostly moss, very deep and silent, sponging down many old secrets. The other wood, just across the way, is different in type. It has been liberally logged and few giants are left, but there are lots of little frivolous pines, very bright and green as to tips. The wind passes over them gaily, ruffling their merry, fluffy tops and sticking-out petticoats. The little pines are very feminine and they are always on the swirl and dance in May and June. They snuggle in among the big young matrons, sassing their dignity, for they are very straight and self-respecting, but the youngsters always tip and peep this way or that. It is good to work among the venerables and then cross the road and frivol among the infants.

A hot night is following a hot day. Everything that opens in the van is open. I've had a cold bath out in the open with the velvety dark shrouding my nakedness. I wish it was always like that. It's a pure, lovely feel, the real you touched direct by the real earth and grass, and trees and air, all vibrating and live, not dead and senseless like garments. I sketched in the frivolous wood tonight and did a big slice of the crow story in the afternoon.

4 a.m.

The solemn wood is all lit beyond, where the sky glimpses through and sparkles like jewels. That is the sunrise sky beyond. Though light of day has not quite come, the world has on her mystery complexion. Night and day are saying goodbye for twenty-four hours. Night is in a hurry to be gone but day hangs on to him a little. The birds say, "Hurry, hurry." They want breakfast. The flowers want the light so they can unfold and grow. Everything is as ready to wake as it was to go to sleep. Nature is always ready to get along. We are the only yowlers, never quite ready to wake, never quite ready to go to bed, never quite ready to die, never quite anything, always on the road, never quite caught up, always wishing something was a little different. Well, if we didn't we'd be beastly smug. It's wanting keeps us going. The flowers and the creatures are content with routine. We want more. We want progress.

June 11th

Time slips by, quick and smooth. It is morning—it is noon—it is night—it is nearly midsummer. The puppies have more than doubled their size. Their unseeing blue eyes opened yesterday. How hard they are on the mother and yet how she loves them and patiently endures them.

I've worked well the last week, painting and writing. I shall get some surprises by and by for I run the sketches straight into their receptacle in the van. There is no place to exhibit them to myself. When I see them again, I shall have forgotten I ever did many of them and maybe it will be good to see them fresh like that. The first thoughts may speak stronger.

There is a great deal going on here but it is all the still noise of silent growth. There are few man noises, only the rip and snort of the tearing motors, inhuman machine noises, seldom flesh and blood noises. One doesn't connect the bird notes with flesh and blood but rather with abstract things, joy pouring out unplanned, natural overflow, and the wind is always on the sing. The field is full of dandelions, energetic people always doing something, turning their

clear yellow faces this way and that as the sun moves, wagging their heads in the wind, growing fearfully fast and hauling their green caps over their faces at night.

The first time for days that there is not a cyclone raging at this time of day. I have done quite a lot of painting, quite different to work before. Better? Worse? I can't say but I *think* it goes further. I don't know what the Easterners would say and I don't think I care so much now. Their criticisms don't seem to mean anything now like they used to. The last two years they have not been worth having. Mostly they say nothing. I'd much prefer a slating. Probably they find my work gone downhill but I can't honestly say *I* think it has, for I see and strive for something further and am not so concerned with only design. I want depth and movement and find my older work empty. I am anxious now to put this newer stuff up against it and see if it holds. I have no chance here to give it a second look when I bring it in but I have felt that I am getting a little further away from paint. These are only sketches but I am trying to feel out to bigger things. How I shall manage my canvases I don't know. Lawren's sketches are finished, every corner, every detail. They take you to their destination and leave you. Mine don't take you to any destination but I want them to give the desire to get there, to go on and not sit down anywhere *en route*. I want to express growing, not stopping, being still on the move. These subjects are stumps and pines and space. They are difficult to express, but my feeling is if one can see the thing clearly enough the expression will follow. The thing is to be able to apprehend things, to know what we are trying to get at, to know what we see. So many of us open our flesh eyes but shut the eyes of the soul.

There's a torn and splintered ridge across the stumps I call the "screamers." These are the unsawn last bits, the cry of the tree's heart, wrenching and tearing apart just before she gives that sway and the dreadful groan of falling, that dreadful pause while her executioners step back with their saws and axes resting and watch. It's a horrible sight to see a tree felled, even now, though the stumps

are grey and rotting. As you pass among them you see their screamers sticking up out of their own tombstones, as it were. They are their own tombstones and their own mourners.

There is no right and wrong way to paint except honestly or dishonestly. Honestly is trying for the bigger thing. Dishonestly is bluffing and getting through a smattering of surface representation with no meaning, made into a design to please the eye. Well, that is all right for those who just want eye work. It seems to satisfy most people, both doers and lookers. It's the same with most things—the puppies, for instance. People go into screams of delight over them—their innocent quiet look, their fluff and cuddle, but when the needs of the little creatures are taken into consideration they are "filthy little beasts" and a nuisance. The love and attraction goes no deeper than the skin. You've got to love things right through.

When first I got the van I called her the Elephant. She entailed a certain responsibility, seemed a bit unwieldly and cumbersome. You didn't just know how to fit her in. You were, in fact, a little scared of her. Now she's a bully old girl; the scare of her is gone. She's not like an elephant now but like a motherly old hen. Towed out, she meekly squats, fluffs out her flaps on all sides and encloses us. There's always room for another beast and we never seem crowded. Each one has his own particular feather to shelter under. Maybbe's four pups are just right up there in the corner. Woo appropriates her niche, always delighted to cuddle in, screeching for it when she's cold or tired, looking neither to the right nor the left, just diving into her box with a contented chuckle. Tantrum and Pout and Wopper know and love their own places. I guess my bed is the van's very heart. When I am tucked up there I am very content, books on the shelf above my head and the good old coal-oil lamp. My sketches are under the bed, that other pile of thoughts, some good, some poor. When I lie cosy and the wind is howling round outside (for this place abounds in wind) I can peep out the little window beside the bed and feel for all the world like a chick peeping out of the feathers of an old Plymouth Rock. And there's all the lifey smells coming in and out through the flaps—hay and pine

boughs and camp fire and puppies and cake and coal-oil and turps and paint and toilet soap and wash soap and powder and disinfectant and the rubber of the hot water bottle and mosquito oil. They come in and out over the groceries and water buckets standing under the flaps, but the camp fire and the hay and the pine trees are the strongest and compound them all into one sweetness. And the sounds of the trees and the birds that seem so much a part that you can't quite make out if they are in your own head or in the world. And the puffing and snoring of sleep and Susie's gentle tear, tear of paper to make nests. And then some small foot kicks the tin side of the van and the wind tweaks the flap, and sometimes it gets so rough that we let the flaps down and the red hen tightens up, resisting the cold until the sun shines out and shames the wind's rudeness and our flaps are all loosed up again and we poke our heads out. She's a nice old van.

Quite a downpour but what care we, snugged up all cosy under the old tin hen. The rain comes in insignificant little titters on the canvas top with an occasional heavy ha-ha as the big accumulated drops roll off the pine boughs. Susie cavorts round in glee and all the rest snore cosily. I am a lucky woman, I have a brick in a biscuit tin at my feet, and a lovely afternoon's writing before me, and the mystery of the solemn wood to look into. It's a very nice wood but wickedly full of mosquitoes. Perhaps they belong to the mystery. Doubtless they, with their poisonous little pricks, have their place and undoubtedly they enjoy us. Three baby fir trees sit on the edge of the solemn wood and look as out of place as children at a grown-ups' party. Ghost flowers grow in the woods—beauties. I shall take a big clump home. They are mystery flowers.

The wind's been dreadful for two days and two nights. The tent blew down. I was flitting round all night. My smallest pup was very sick. I think the cold wind caught him. He cried and cried. I got in and out of bed, first to locate which pup was wailing and then to wrap him in a woolly and take him into bed. But he wailed in pain. I put bacon fat on his chest, and eucalyptus. Then a great gust came and the tent nearly dragged the van over, so I went out and wrestled

with it. In bed and out of bed, in the van and out, what I had on blowing scandalously, what I had off heaped round, and all in the way. The monkey let out unearthly screeches and Susie tore paper. The dogs in their cosy boxes saw no cause for complaint and snored. That was reassuring.

June 20th

More maddening wind and another sick puppy that wailed all night to the accompaniment of the wind. I just loathe to see it suffering yet at times it looks quite fine. I've done everything I know, which is not much when it comes to such youngsters. I hate to leave it and go out and I hate to sit and hear it wail and I hate to destroy it unless it has to be. These tearing ice blasts sweep across the earth piercing everything. In the lulls it's quite warm. The sun dodges back and forth peeping through rain clouds. The whole universe is aggravating.

I wonder what I have learnt on this trip? I guess it's a matter of infinitesimal daily gain (as long as we are honest over it). We should not expect to drink immense swallows of knowledge but just go out with our eyes and soul open. Clamber, clamber. One does not always plant one's feet daintily when one is covering rough ground.

I am not glad and not sorry to move on. The summer parch is on the earth.

No word from the East. What's the matter with those people? It's over a month since I asked for the return of the manuscript. I guess they had it about three. I try not to think of them but I do because they've become part of my life and it's hard sorting them out and standing square on my own old running shoes irrespective of their opinion and criticisms, and it's good for me. Their crits don't help any more. They're drifting in art and not pushing on. Just because Lawren is not working others think they can't. The group's collapsed and the new group hasn't taken hold. Maybe it's up to us Westerns to wriggle up a bit. No mistake, the times *are* depressing. People simply can't afford the price of transportation to shows. I can't and I work with no idea of exhibit but just to squeak ahead a little.

Hopes and Doldrums
1934-35

June 23rd, 1934
The roof seems low and heavy and the walls squeezing us. Yet the house is enormous after the van. But the van was so much nearer the big outside, just a canvas and a rib or two and then the world. And the earth was more yours than this little taxed scrap which is under your name. I left two little pups out in the solemn wood. It's nice to see my own family again. Yes, it's good to be home.

Mr. Hatch wrote acknowledging the two paper sketches I sent him. He found their vigour and profoundness appealing. Said few people *understand* them. Now I can't see *what* there is to be understood. They are just woodsy statements, no secrets or obscurities beyond the fact that all life is a mystery. Perhaps folk would like a numbered bit on the back: 1. a tree, 2. a root, 3. a grass, 4. a fool looking. Oh life, life, how queer you are!

My new sketches thrill me a bit, sort of exhilarate me when I look at them, and a joy to work on. The job is to keep them up, up, up, to keep the praise in them bursting, rising, passing through the material and going beyond and carrying you with it.

The days are glorious and splendid, and just beyond are all the horrors peeping and jibbering. What can one do? Live in the present day by moment but ready to face squarely what shall come when it does, meantime making the best of the flying moments, using them. I went to hear Mr. Springett from Toronto yesterday. He did as they all do, ran round and round and did not find a finish. That's all any of them can do, Church, Christian Science, Oxford Group, all the

million and one different kinds, various as the flowers of the earth, bearing their different seeds and fruits and scattering them, all with something right in them and some wrong too, pushing and growing to get up above the dirt.

Went to hear Mr. Springett again. He certainly is fine and quite alive. When he starts to speak people sit up. His great hulk heaves itself out of his chair and sort of hurls itself into an open spot on the platform, not behind the reading desk like the other speakers—that would cramp him. Besides he has a bay in front and needs room for his physical as well as his spiritual parson's collar (celluloid I think) round his massive neck, but his chins and things are inside, not hanging over. It's more like a fence than a collar, a tight thing fitted to the throat. This circlet is big enough for a waist belt, big to let all the thoughts that roll up from his heart pour through. He is never still a moment and evidently knows all near objects are in danger for he moves the water jug and the glass and the vase of flowers at his feet and the chair to safe distances, and all the time he is talking hard and unbuttoning his coat and taking his watch out of his pocket and putting it safe and far over on the reading desk. His legs take on a wide straddle and then his arms begin working. They fly up, up unintentionally and big cuffs shoot out from his sleeves and catch on his coat sleeves. This little restriction pulls him up and he wrestles furiously and smashes them back up his sleeves and buttons up his coat again as if he feared they'd burst out that way and all the time his words are pouring out and you can, in a way, feel them striking on people's hearts like water hissing on hot metal. And after an immense outpouring he stops short and says, "And there it is," and leaves it with folk to digest. Then he forgets his cuffs and unbuttons his coat, but before long it all happens over again. People are all het up at the finish and say to each other, "Isn't he fine? Wasn't it wonderful?" And then they go home and eat and sleep and the next day and all the days after it gets weaker and weaker. We're such desperate hypocrites. If we actually believed in our hearts' cores it was *all true*, we'd burst because of its immensity, and everything else would be nothing. We're not really honest or else we're too little to compass it. And everybody says everyone else's way is all

137

wrong and one longs to know. Are all ways wrong or all ways right?

My sketches have zip to them but they don't strike bottom yet. They move some but I want them to swell and roll back and forth into space, pausing here and there to fill out the song, catch the rhythm, to go down into the deep places and pause there and to rise up into the high ones, exulting. Let the movement be slow and savour of solidity at the base and rise quivering to the tree tops and to the sky, always rising to meet it joyously and tremulously. The objects before one are not enough, nor colour, nor form, nor design, nor composition. If spirit does not breathe through, it is lifeless, dead, voiceless. And the spirit must be felt so intensely that it has power to call others in passing, for it must pass, not stop in the pictures but be perpetually moving through, carrying on and inducing a thirst for more and a desire to rise.

July 5th

For years I have been "pillared" and "pillowed" on the criticisms and ideals of the East. Now they are torn away and I stand *alone* on my own perfectly good feet. Now I take my own soul as my critic. I ask no man but push with my own power, look with my own eyes, feeling into and praying always. My only shame is indolence or slovenly smattering over surface appearance instead of quietly and soberly digging and boring beneath.

July 9th

Little book, I started to take a summer school course in short story writing so perhaps I can improve in my treatment of you. I'd like to make little daily incidents ring clean cut and clear as a bell, dress 'em up in gowns simple and yet exquisite like Paris gowns. I have not much confidence in the instructress but anyhow she knows heaps more than I and it's fun to work along with others. It's so long since I worked other than like the proverbial pelican in the wilderness, not since art school days.

July 11th

I am enjoying the short story course at summer school. It's nice to be among the young things and sharpen myself up against their keen brains. I'm the veteran antique among twenty-two. The desks are

built for young things. My big front can hardly squeeze in. I touch back and front. I sit up in the front row because of being deaf. It was horrid when our first things were read out loud. I came first. Mrs. Shaw asked if I'd read my own or prefer her to. I grabbed at her offer. It was so funny to sit and listen to my thoughts coming out of another's mouth, the first time I'd ever done so. We had to write something that had happened, an incident, between the first and second morning of our course. I struck a humorous note and the young things clapped and grinned at times and it helped to start them off with more courage. Some of them were very good but most were frightfully serious. They haven't grown high enough yet to see over the top of life's fence and note the funny things on the other side. One of them asked if I was the painter and grabbed my hand and shook it and asked why I was wasting my time there when I could do the other. Lots of them are school teachers; they sit stiff, their mouths shut tight. There are time-killers and some middle-aged, bravely trying to keep up, and the teacher's son, brought by Mother and a little afraid to let go and expose his depths to the maternal eye.

The wide corridors bustle with youth and fifteen little nuns glide in and out, catching the convent school up to date. There isn't much giddy giggling like old days. There's rather a hard times' sober pushing to acquire more knowledge as bait to hook a job.

July 26th

That's that. A garden party for the short story class (summer school) —between twenty-five and thirty. Every man jack came. The tea was good but *very* simple, only hot biscuits and sponge cake layer with whipped cream and tea. Afterwards I passed round a basket of apples from the tree. The day was obligingly warm and windless so that the cool under the apple trees was welcome. The pups were in good form and the monkey, and the pale green apples bobbed up and down over the tea table. I had blue linen cloths and lots of benches and chairs. Then we ambled upstairs to the studio and there was an awful half-hour when they all stood at the end of the room like a lot of cornered rats, pop-eyed and shocked at the sketches. Nobody knew what to say so there was that awful silence in which one tosses

sketch after sketch on the easel hooks with nervous haste and wants to sink through the floor. Then someone breaks the silence with a horrid, "What's that *supposed* to be?" and somebody else says, "Do explain them to us," and someone else gasps, "Just *where* is that?" and you want to slap all their faces, burn up *all* your stuff and then dig a deep hole, tumble into it and claw the earth over yourself. The world's queer.

Horrid things are in the paper today. Austria up to ructions. Somebody assassinated. Europe trembling and everyone saying, "What's coming?" God alone knows. Gee whiz, I'm tired, mentally and physically.

August 3rd
It's a long week since I told you anything, little book. Here's a secret first. Others might say it was silly. For the second time a soul has kissed my hand because of a picture of mine—once a man, once a woman. It makes one feel queer, half ashamed and very happy, that some thought you have expressed in paint has touched somebody. Today I sold a sketch and gave another, though of my very most recent. They always pick the newest and leave the old frowses. One's glad, in a way, that the recentest should be approved above the older. It looks like progress. One would rather like to keep one's latest, but there's always the hope that there'll be better ones than the latest by and by, so scoot them off before they grow too drab. I'm thirsting to be at it again but the story course has me tied by the arms and legs for another week yet. I've written an Indian story, "The Hully-up Paper." The class liked it.

Miss Richardson of London has been lecturing on teaching children to make pictures. It is interesting. Slum children's work was what she showed. They were lovely, done from the centre of the children's being and belonging to themselves. It's a big thing and very worth while, hoisting them up above convention and tough outsides and giving them the courage to look inside and try to express in paint what they see, the same thing that I am trying to do in my own work. The children are nearer that God-thing and handle it naturally. I come to it in fear and trembling, with a clumsy, self-conscious hand, saying too much, hanging on to the thing too hard

for very fear of it fluttering away. It is so easily bruised and crushed. It wants to hover above, free, not strained, not caged like a captive bird, mad and moping, but free, coming and going between God and you.

August 8th

My story has been selected by class vote as the one to be read at the closing assembly exercises of summer school. I was stricken with horror when I found I had to read it *myself*, and wished they'd chosen someone else's, but now I don't care any more because I want to do honour to the Indians. It's an Indian story—just a simple, tender, old Indian mother. I want to make them love her and feel her Indianness like I want people to see and feel the "Cow Yard" in spite of no plot. Mrs. Shaw doesn't like "Cow Yard" much. Says it's plotless and "maybe she could help me fix it up." I don't want Mrs. S. to fix it. I don't want it to have a darn magazine story plot and set people worrying to unravel it. I just want it to be the "Cow Yard" and make people feel and smell and see and *love* it like I did as I wrote it—blessed old heaven of refuge for a troubled child and a place of bursting joy for a happy one.

August 10th

I did it. It wasn't very awful except that the hall is terrible to speak in. It does horrible things with your voice so that it is a big effort. I had just two wants as I stood there reading: to make my voice carry and to make them see "Jenny" and "Bessy" and "Charlie Jo's little Injun baby." They gave me a lovely bunch of flowers and clapped when I went on and off. This evening we went to the house of one of the students. It was a simple, honest, happy affair. They're a nice set of young things and we olders aren't so bad and all get on together. We sang and played games and had supper with *very good* coffee and I drank two cups and can't sleep. We're going to meet at my studio on October 1st and everyone is supposed to bring a manuscript that they've written between now and then.

August 12th

I haven't one friend of my own age and generation. I wish I had. I don't know if it's my own fault. I haven't a *single thing* in common

with them. They're all snarled up in grandchildren or W. A. or church teas or bridge or society. None of them like painting and they particularly dislike my kind of painting. It's awkward, this oil and water mixing. I have lots more in common with the young generation, but there you are. Twenty can't be expected to tolerate sixty in all things, and sixty gets bored stiff with twenty's eternal love affairs. Oh God, why did you make me a pelican and sit me down in a wilderness? These old maids of fifty to sixty, how dull they are, so self-centred, and the married women are absorbed in their husbands and families. Oh Lord, I thank Thee for the dogs and the monkey and the rat. I loafed all day. Next week I must step on the gas.

August 22nd
We three went on an excursion round Salt Spring Island. A perfect day. All were amiable and enjoyed every bit. Moon across the water on return was superb. It has been in my thoughts all day, silvery ringing space filled with every colour and glorious light, and such peace, the kind of "God" that passes all understanding.

August 23rd
Edythe and Fred came and chose three sketches to send to Gertrude Stein, Paris. Tommy rot I call it! Dear children, they are good to this old woman but I'm sure Gertrude won't bother and she'd think my sketches mediocre.

August 24th
Mr. Sught came and photographed some of my pictures. They looked punk old things as I pulled them out, hey ho! I must do some better canvases. Mr. Checkley came and saw about some sketches for the Willows fair. I guess that's where my things belong—among the sheep and pigs at the agricultural fair. Anyhow I'd rather show among livestock than among the Arts and Crafts Society. Two American women phoned and did not *ask* if they might come to the studio, just said they were coming. Cheek, I call it, not to say, "By your leave." Well that's that, three things off my chest in one day, all a bit nasty. I do wish I could feel *satisfied* just once over my work. It's so faulty and poor. I'm wanting to get out in the woods again.

Sunday, August 26th

The girls came to dinner. We had it on the balcony outside the studio. It was lovely, just we three girls, overlooking the garden. The gladioli and Hadley roses were gay in the round bed. We went down and looked round the garden and saw the roses and the pups. The girls weren't in the hurry they usually are and there was slow restfulness. I like that. The perpetual scurrying to get away to the next thing wears one. Yesterday I sold a picture to Flora. She likes my work and thinks over-highly of it but I love her to have my things. I gave her another so she will have one woods and one calm sea. Flora is very fine in spirit and her life is not easy.

The pups, Caravana and Metchosen, are so cute and so different and so alike and so wise and so foolish all at once. Metchosen takes life with a joyous ease. Caravana has a more suspicious nature and takes life much harder. M. is all "he." C. is all "she."

The last week has been warm with superb nights and whispers of coming fall. I have been on the beach around 7 o'clock in the morning. It's pearly across the sea, not many mountains showing. The cliff's parched, colourless. I said to myself this morning, "What is it I want to meet out there?" It is light and space and inside them, well enveloped in the peace and glory of it, God. "I am pure being in whom all things be." And yet we're always hedging, scared to face squarely, scared to acknowledge the author of our being and go to meet Him and listen to what He has to say. I say to myself, "But I must hurry because the years crowd by so quickly I have little working time left." Fool. Time is God's. You will have just as long as He intends you to have, all the time and all the opportunity He wills. You and your work are not so important as you think. The only thing that *is* important is God, and the trying to see something of Him in everything.

August 27th

Such a day! 7:30 a.m. on the beach cliff, painting—just a light empty sky, a strip of dark blue sea, a wave of mountains and wisp of dry grass. Brought the sketches home and started on a big one of it, not entirely satisfactory but in the right direction. After noon Mayo Tong, a Chinese cook boy, came to see pictures. He was delightful,

so keenly interested and such an understanding person. His remarks and quaint criticisms were most illuminating. He studied each canvas and each sketch deeply. He knew at once the ones he liked. He fell at once for a Goldstream Flats tree thing. "*Why* do you like it?" I asked. "Because it is beautiful," he said, "very, very beautiful and I can go long, far, into it." I put up some of my old ones. "No!" he said. "It is nice but it is still and it is like it is. This one goes like wind coming through it." One wood canvas he liked very much. He said, "I like tree places. That was a lonesome place." He was very courteous and appreciative that I took time to show him things. A nice boy with lots of feeling, the fine sensitive feeling of the East for art. Then Delisle Parker and Mrs. Parker and Miss Dallas from Vancouver. Delisle, just back from Paris, was more than enthusiastic, dubbed some of the canvases and sketches "magnificent." All can see the promise of something in this year's work, something that lifted them and took them out. I am so happy about it. I pray for more wisdom and knowledge and humility and I thank God that my work should stir others and induce enthusiasm in them to make them run off intending to *work*. Then Flora came to tea, and people about dogs, and people about flats, and I'm tired but happy to think that artists from Paris who have been looking out into bigger worlds see something in mine in this small corner.

August 30th
Mr. Parker, direct from Paris, opines that Emily Carr can hold her own with the painters *anywhere* and went from my studio all puffed up with the desire to work himself. Mrs. Parker told me, and she said herself that my new work brought tears to her eyes like solemn music does. That is all very extraordinary. Yet, as I was mounting sketches today I felt so many shortcomings and I believe more and more that one's only real critic, the one that counts, is one's own soul. The true part of one's self knows how far you have fallen short. Oh Christ, keep my ideals *high* and help me to look up above praise or flattery.

I'm having a smash of people in the studio. Why? It's sort of my job. People are kind to me and if my stuff gives them pleasure and helps them to see things a little I am happy.

Oh! Oh! OH! I'm tired. Had a big party, some twenty-five souls, mostly artists, visitors, two Paris, three Seattle, one New Haven, three New York, one missionary, and the rest locals, but with all so recently from the other cities it was quite interesting. I showed millions of mounted sketches and many canvases, and gave them good eats, and got so tired over the last few sticker-ons that I was almost crying. I showed pictures steadily for about two hours. They liked them and said all sorts of things, some silly, some true. It's funny how little I care what they do say. All that "goo" trickles over me and runs down the other side and makes not one indentation. I do not think it is empty flattery. I think most of them *felt* something but it kind of nauseates me. I liked the little Chinaboy's remarks much better, badly expressed but from his heart. Oh gee! I want to get away to the van, away from everybody, out with the thing itself, and just the restful beasts. Tonight when they were all cackling around, my soul just wanted to gather up my heels and away. I ought to be ashamed and so very glad that the sketches spoke to people. I have mounted fourteen new ones.

Oh, I'm sure I wasn't nice, not a bit nice to people tonight. They liked my evening and me in spite of me not because of me. I'm a cat.

September 2nd
People keep saying nice things about my party but the best of all was when Lizzie said *she* enjoyed it and *saw* something in my work for the first time. I was very tickled. Alice liked it too, but she had liked it once before, when I was getting it off for Edmonton. And now I'm off again to the van and keen as pepper to be at it again. I've had a big few days preparing beasts and paint, materials and food and clothes, and typewriter and stories to work on. And I shall forget all about the house and the tenants and bothers and settle down in the van and work. I am very blessed in having it. I have talked to a Jewess today. It was interesting—a different viewpoint. She is sure that Christ is coming very soon to earth. Surely this thing is stirring all peoples and religions.

September 5th. At camp at Mr. Strathdee's, Metchosin Road
It is beautiful, very calm. The forest fires fill the gaps and valleys

with blue. The sky is high. The grass is parched and leaves continually fall down. Time is only bounded by light and dark and hunger. People have welcomed us back kindly. I had four accidents yesterday as a starter—just put a peach in my pocket and sat on it, left the fish I'd prepared at home, knocked the pickle bottle across my glasses and broke them, and broke the van window. The beasts are so happy and I've forgotten all about the grunting tenant. What a grand list she will collect against my return though it doesn't seem to me there are many headings left. She's had moths, heat, floors, plumbing, garbage, rent, dates, door bell, window cleaning, blinds, walls, furniture, neighbours, garden, hot water and noises already—and some I've forgotten.

It falls dark early. Rain has threatened all day and is longed for by those who are fighting forest fires. Mr. S. has been out all day scraping moss off rocks to keep the fire from spreading. He is a most uncheerful anticipator of evil: knows the fires are going to sweep straight for his premises, knows his apple trees won't bear, knows there is a dead sheep smelling and it will get worse and worse, knows my pups will fall into his cistern and be drowned one day and run over the next, and that all the hens have tuberculosis and that the ants will eat his house clean to sawdust!

I have made a sketch—fair. Oh goodness, it's splendid off in the rough land behind here. The wild rose hips are scarlet and the bracken is turning brown russet. The grass is parched silvery, hardened and wired into ripples where the prevailing wind has run over it so perpetually it has stiffened and given up trying to straighten up. The grasshoppers click and tick across the grass, low and heavy, and there are wasps everywhere, and myriads of little sober-coloured birds eating thistledown.

September 6th

I have sat over the fire. It has been dark some time, a wonderful, mysterious not-black dark. The trees are so inexplicably beautiful! I've been thinking about them, how in a way they are better than we humans. They are more obedient to God and recognize him clearer.

They go straight ahead doing what God tells them; they never pause or question; they grow, always moving in growth, always unfolding, never in a hurry, never behind, doing things in their season. God did not give them the right to choose good and evil like he did us so they don't make as big a mess of things. That grand thing, that final choice, is our prerogative, the thing that makes us God's sons and daughters and not just his creation. His spirit is among all the other things because it is everywhere. The woods were very full of it tonight. I think our mistake is trying to humanize the woods to make them conform to us, instead of going out to them in a spirit of recognition of the God spirit among them. Only when we realize our kinship in spirit will we get understanding.

September 8th

Only 7 o'clock when I shut myself in tonight and yet it was dark— practically no sun today. Did a morning sketch and finished yesterday afternoon's. The morning one promised well and fulfilled ill. Little "Wee Bit Picnic" lunched with me, queer little dodger, all fixed up fancy when she comes down the road, till she gets to work on "Brother's" house-keeping deficiencies. Off come her stockings and everything that will take off and she puts on an apron made of three legs of men's overalls—one goes cross ways over her middle and the other pair dangle. When I invite her she refuses and excuses and finally succumbs and comes as she always intended to. She adores Woo who makes faces at her and then turns her back. She has two subjects of conversation, "Brother" and the inadvisability of marrying an "out of work" or anyone who can't keep you as well as you can keep yourself. She was full of the beautiful things an old man left her whose room she attended to at the Empress for three years— seventeen dress shirts, my dear! But he was a very thin old man and "Brother" is so wide the shirts refuse to enclose him. I wondered if the three jean legs that formed the apron were part of the legacy.

It blew terribly last night. Writing won't come these days. I seem too tired at night to apply myself, am reading quite a lot and the days fly. I think the most splendid thing would be to paint so simply that the common ordinary people would understand and see some-

thing of God in your expressing. The educated look for technique and pattern, colour quality, composition. Spirit touches them little and it's the only thing that counts.

September 9th

All the elements have had a hand in today—rain, shine, wind. You have to jump all ways at once to accommodate them. Oh my! Oh me! Life in a caravan in pouring rain with two dogs, two puppies, one monkey and one white rat along! No good imagining a fire for breakfast. I did it on canned heat in a bean tin. The peak of things was when I discovered I'd left my mackinaw out in the rain all night.

September 12th

Only 7:00 p.m. and I'm already tucked in bed. The night is rough and bitter. Everything is closed down and the creatures, like myself, all have an extra blanket. I've typed nearly all day—"The Praying Chair." I think it rather quaint but I don't know; to others it may be silly. It's my own awful longing to possess a dog and of course it's very real to me. How that longing has been fulfilled and what a lot my dogs have meant to me! Sometimes I think I'm not half grateful enough to the creatures. I wonder if my book with little sidelights on their lives will make animals any dearer or any clearer to anybody. I couldn't imagine a world without the love and the interest of them. They put up with you when nobody else will. In your very most hateful moods they still love you.

September 15th

It is glorious weather again with a moon at nights. Sketching full blast. Worked half the day, taking my lunch into the woods. High and blue sky, straggle of distant pines and stumps and dry grass in the foreground, and all soused in light and vibrating with glow. Product not marvellous but I have learned quite a bit and saw somewhat. The whole place is full of subjects. By that I mean that things speak all over the place. You have to go out and look here and there as you go. It's no good putting down a stroke till something speaks; then get busy. Form is fine, and colour and design and subject matter

but that which does not speak to the heart is worthless. It is the intensity of feeling you have about a thing that counts.

When I tried to see things theosophically I was looking through the glasses of cold, hard, inevitable fate, serene perhaps but cold, unjoyous and unmoving. Seeing things the Christ way, things are dipped in love. It warms and humanizes them. "I am come that ye might have life and have it more abundantly." God as cold, inexorable law is terrible. God as love is joyous.

September 16th

Time is racing swiftly. Before one knows it the van will be folded down and winter here. So? There are good things for the winter too —canvases to work out of the sketches, illustrations for the animal stories. My animal stories come slowly and I am truly disheartened with them; they are so crude and lame and badly put.

Dear old van! There's something very cosy about her and very peaceful about the environment. The black-faced, fool sheep and the pups and I have it all to ourselves, and a few little birds. The skies are grand and high, and the pines poke their noses up among the clouds without a quiver.

Heat and cold chase one another like pups playing—yesterday ovenish, today cold storage. This morning a sketch of "nothing in particular," one of the most difficult to perform. Afternoon a beautiful subject, the overshadowing of one monstrous tree. I worked honestly both whiles, not using my own determinings; led to both subjects and giving myself over to them. Yesterday a dreadful douse of visitors which was far more exhausting and upsetting than the most violent work. They are beginning to want me home I can see.

Oh, perfect in the pauses when the wind forgets and the sun remembers! Summer is past but the full ripeness and maturity holds still as if it were pausing in fullness before disintegration sets in. The fruits of the earth are garnered. The season's development holds.

There was a fierce storm a few nights back. Twigs and boughs snapped off my old pine and struck the van in passing with reports like pistols. The canvas did not break but it sounded like a drum and I did not know which minute a great bough, dead and hanging from the tree, would come through the frail top and—perhaps, who

knows? I popped out the lamps, for if a tree fell it would be worse to have fire added to it, and slept in my blanket chemise so if I was pinned and had to yowl for help I'd be found decent and having made full preparation. Nothing happened but it was some fierce storm everyone says.

Goodbye, dear place! Tomorrow we leave the dear gracious trees and face grouchy tenants. It's been a lovely free month. Twenty-one sketches, lots of thinking, and six stories pulled into shape. It rains a little tonight. Tomorrow I shall eat at an ordinary table in a roofed house. I wonder if the pines will miss me. I have loved them.

September 29th

To sit on a perfectly decent chair with four steady legs on a wooden floor, to eat at a solid table with four even legs, to have a plaster ceiling instead of a sky quivering with movement and light, to turn the tap and apply a match instead of adjusting the stove-pipe to meet the wind and collecting sticks from the woods and axing and buck-sawing a bit and blinking the smoke out of one's eyes and blacking one's hands (but oh, the lovely smoky smell and taste), to spread out in a wide bed and look over dim house roofs and chimneys (I remember the moon through the pine trees), to have a whole room to oneself instead of sharing a little van with monkey, dogs and rat! Ah well, there you are—some like one, some the other, but God's a little closer out there and the earth and sky and trees are very sweet. The house shuts these things out a little.

October 1st

Things can be altogether abominable and they are today. The short story class were all to meet at my house on October 1st. Only ten came and it was a hopelessly stupid evening. Two sloppy love stories were read. The words flowed easily but there wasn't any stuff in them. It was an utterly profitless evening and ended in Woo biting Mrs. Shaw's leg. I scarcely blame the monkey; the woman was stupid and all the people teased Woo till she was almost crazy, and me too. My Indian story was returned from *Maclean's Magazine* without thanks. I longed for the van and Mr. Strathdee's peaceful field and the wise, tender old pines and the all-over peace of outdoors.

October 5th
Tired into a smash. Two old girls did it, ages eighty-four and eighty-seven. Spent the day, lunch and tea and dinner. Poor old wearisomes, comparing their cataracts and rheumatisms, their lonelinesses and children, bragging about their servants and past English gardens, bewailing the immorality of the world and comparing their churches. I gave them nice soft victuals with nothing seedy to get under their plates and we had lunch in the glorious sun in the garden. One of them slipped off to sleep with her head thrown back over her chair like a towel hanging to dry, and her mouth open. One had bobbed hair with pink scalp very visible and her face a network of wrinkles —such ugly ones, pockets and bags and ditches. The other had iron grey hair drawn back into an onion and a wonderfully smooth face with pink cheeks. Goodness, I don't feel twenty years younger than they are. I feel old, old, old and stiff and tired, except when I paint; then I'm no age. At night, folded close in the blackness among the trees it was not lonesome by the roadside in the old van. In town it is different, in the great, still house. Empty rooms are around, except those filled with impossibles—souls that never touch mine, greater strangers than the strange; no common interests or doings or thoughts; thin partitions dividing our bodies, immense adamant walls separating our souls.

The world is so messy at present everyone is depressed. I don't fit anywhere, so I'm out of everything and I ache and ache. I don't fit in the family and I don't fit in the church and I don't fit in my own house as a landlady. It's dreadful—like a game of Musical Chairs. I'm always out, never get a seat in time; the music always stops first.

I've written reams of horrid letters to picture galleries that *won't* return my exhibits. National Gallery had three for *three years*, Toronto Watercolour had three for *two years*. Why should one have to beg and beg to get their own belongings? I wrote Brown straight from the shoulder. He'll ignore it like always, as if I did not exist, weren't worth a glance even from his eye.

Abominations are thick as bee stings in a hive—the horrid tenant below, the miserable woman who lost my dog, the creature I met in the street the other night who took me by the shoulders and *shook*

me because I was trying to fend her dog off mine, the insurance company who have swindled me out of cash by misrepresentation of their men—all these and more heaped in a pile and me straddled atop trying to forget them all, but they will stick out teeth and claws and gnaw and pinch and scratch and it's hard to sit steady on the pile, so tight they smother and shrivel and die! Every time you bounce up with a new burst of mad they take a fresh breath and draw strength and attack again. Out with you into the rain and wind and get blown on, old girl; you're mired.

October 20th

The wind is down on all fours pounding. The poor withered leaves do not know which way to turn; they are balked in every direction. They had no idea they would see so much of the world before they found a grave in some crevice and retired back to their elements, giving back to earth exactly what they had drawn from her. That's the plan, I guess, always giving back exactly what we have absorbed so that nothing is lost. But every time things turn over they accumulate interest. From my bedroom window I see the sea waves too. They are perplexed at being driven in four adverse ways at once and stand on end surging up in rebellious white foam with the wind tied up in its fabric, hanging on to it, imprisoning it in salt wet prisons. When the storm is over it will release it, mild and chastened.

October 21st

Mrs. Lawson is dead.

Death, serene, beautiful, compelling awe and veneration. The fragile outer petals of a little old lady, all the troublesome old problems of weariness, stiffness and aches dissolved away. A kiss of peace pressed on the loose broken petals ready to drop and to fade away like other flowers that surround her little worn old hands, hands that raised the large family through which she spread her own self and caught herself back again in the joy and pride of her grandchildren. Goodbye, little lady! I do not think you mind being gone. You only dreaded the going a little as we all must—that first footstep out "where neither ground is for the feet, nor path to follow."

October 22nd

There was a tea party today at the Arts and Crafts Society exhibition. I was invited among some ten artists and club members. The whole affair ached with horridness. The show had just opened and a straggle of the type that always go on opening days were there, faded people who have time to kill, people with no particular job and of no particular age, belonging to no particular "set." They simpered over their catalogues and smeared an asinine glance over the pictures, spent much longer looking for its name in the catalogue than examining the work of art when found. If anybody spotted an artist near his or her own picture they darted across and went into mild hysterics and spat out adjectives.

Tea was spread on three or four rickety card tables strung together so close to a row of chairs along the wall that your person was horridly squeezed. Deep breathers throbbed the tables with each respiration. There was a grand deal of talk about seating (no two women together, nor two men) and every time a late comer came, and most of them were late, everyone had to seize their cup and plate because people had to be re-sorted and everything got knocked over. There wasn't *one* of us young or vital, no spirit, no poetry, no youth, just prosey flesh picking with tired hands from meagre plates of sparsely buttered bread and dice of uninteresting cake. Oh, the pity! We represented (more or less) Victoria's art! Oh, that is not art! I do not think there can be any such thing as *societies* for art. Those are "snarling" societies (I myself no better than the rest). The fellowship of art is out among the angels in wide space and high skies, things one cannot word and can only feel dimly.

The rain has come wholeheartedly. It is invigorating to hear it pelting against the shingles a few inches above your head in the attic bedroom. Except the near houses everything is smudged out. Half of Victoria has been re-roofed this fall. I guess all that half is purring. Only one corner of mine was done and I purr even over that. These days make one feel domestic and inclined to clean out woodboxes and cupboards and straighten things and cosy up. The house sort of wraps you round. It would be nice to hibernate, to hug yourself and dream and rest your brain and your stomach and your whole being.

That's the worst of us. We streak along full stretch, top speed. Trees and beasts and every other thing rests. In old days the farmers and farm women used to enjoy recreation and ease, more or less, in winter. Oh, why have we all gone so against nature I do wonder?

October 25th
The garden is all righted up for winter. Mr. Lanceley helped me fix it and we had a lovely day. He forked up the earth which after the rain was easy and mellow. The bulbs are very busy underneath. When you turned them up you felt almost ashamed as if you had disturbed their privacy and should say, "Excuse me!" You can feel the force of life breaking through their brown jackets and starting up white shoots and you think of all that's got to happen before spring is ready for them. There they are kicking their heels like impatient children. Some day the sun will tantalize them, soaking through the purple brown earth, but as they push and push trying to pierce it, down will come bitter, biting frost and drive them back disappointed. It looks loved and tidy now all the apples are stored away and the fern bed is well leafed over and the garden chairs stowed in the shed. In another week the real winter months start.

November 1st
A letter from Lawren. He and Bess have divorced and married each other. None of my business but I feel somehow as if my connection in the East were over.

On request (mine) my pictures are tumbling home to me after two to three years of exhibiting. I don't know where; we are not kept informed and I had to hunt for them and write many letters. I shall not send again. Express is prohibitive, returns so uncertain, and—does it matter? Is one painting for the world? If one were very big indeed perhaps one would. Or is one just trying to get nearer to God and express that of him which is in all things and fills all space? Is the latter way selfish or does every soul just have to do that individually—work out their own salvation?

The world stands still like a patient child while the rain pours, drenches, washes, soaks rotten things back into earth to start all over again from the process of decay up. Miracles and miracles! But if God would only speak plainer or give us another hearing!

November 7th

After a real struggle I finished the story of the crow. Is there anything in the stories? I feel them deeply as I write. I wonder if Flora is right that my painting is waiting on my writing. How interesting it is to work on the two! They are alike and different. I want to write and write longer spells than I want to paint. Writing is more human than painting.

November 9th

I went to an Authors' Association meeting yesterday. It was very stupid. They talked about everything but writing. Mostly old women there like me, and a sprinkling of the ugliest men I ever saw, and afterwards we went to the conservatories and saw the chrysanthemums, which were far more inspiring—yellow, pink, white, red like dark blood. But even the chrysanthemums were spoilt by forcing and weren't nearly so "luscious with a tang" as the garden ones. Forced and fed on scientific fertilizers, they had never known a pure outdoor breeze or the real earth with the pull of the whole world behind it and water straight from Heaven and sun unfettered by protecting glass, so they got swollen and swollen till they were unreal and forced outsize, with their perfume and sweet freshness absorbed in their bulk. They had no imperfections that individualized them. All their faces said the same thing like a row of suet puddings made to recipe and well risen.

I am rewriting "D'Sonoqua's Cats," living it bit by bit—the big wooden image, the woods, the deserted villages, the wet, the sea and smells and growth, the lonesomeness and mystery, and the spirit of D'Sonoqua over it all and what she did to me.

November 14th

I am looking through my book and see several places where the blank pages are stuck together. Isn't that like life? Those blank days that stuck together and recorded nothing! In our carelessness we stupidly let them stick and remain blank. Instead of prying them open and rejoicing at the things that were in those days, we let them stay empty.

Flora spent the night and we worked, tidying up my stories and

deciding where to send them. Gee, it's good to have a friend like Flora, good and wonderful. She knows so much and she loves the creatures. She's enormously unselfish and generous, always doing kind somethings and cheering one when they are flagging and flat. She's an inspiration. We worked until 1:30 a.m. and I read and slept and saw the sun rise glorious in the studio east window at 7:30.

November 17th

Well, I had the chimney swept today and Caley, the sweep, and I had a long conversation over politics and religion. Fancy a few years back talking to a sweep about Jesus Christ and the state of Russia and communism and soul-stirring things! He knew lots more than me and said some fine things, broad and big, that made one think. He spoke about nothing being ours. "Now you," he said, "have a great gift, but it is not yours; it belongs to us all. It has been lent to you from God and the millionaires' gold and silver is not theirs but has been lent to them for service—empty service." He was just fine, that sweep and his views. Everywhere one goes it's the same. People are thinking and talking and one is not ashamed any more. You used to feel it wasn't quite decent to discuss God, and the name, Jesus Christ, always made you feel queer and priggish somehow; and your voice went different. But now it doesn't matter and it's wonderful. Oh, is it the beginning of the coming of the kingdom "on earth as it is in Heaven"?

November 18th

A happy day. Harry Adaskin of the Hart House Quartet came to lunch and we talked more than we ate. The Quartet was playing modern music tonight at Mrs. Hinton's and Mr. A. invited me and a friend, so Flora went. Oh, it stirred deep. Lovely music—rebellion, ferocity, tenderness, resignation—superbly played. Our hostess did not like it, which was an amaze to me. Are people afraid to dip down and find out about life, I wonder? The man who wrote it and the men who interpret it have to dig and drink dregs to produce it. It means some tearing of themselves, exhausting, searching, striving for ideals.

November 26th

It is a week since the Quartet was here. The classical concert on the

Monday was the best they had ever given, everyone said, and even the Quartet themselves said it was a good concert. Everybody and everything about it seemed to swing right and swing together. After, I went behind to say goodbye. They were tired but happy. Harry Adaskin sat on the step of the stage lovingly polishing his beloved fiddle for the night before laying it in its case. Geza de Krész took my hand and held it tight while he excused himself, with his eyes anywhere but on me. They were anxiously on his fiddle that was lying in its case loosely, and the awful fear was upon his face that I or some other would brush past the chair and overset it. I realized then how much their instruments mean to these men, the mechanics of expressing the glories they know are within them. It is splendidly wonderful, the things that lie beyond, that we try to capture with instruments or paint or words, the same things that we are all trying to build, to create, the thing that our bodies are trying to give a spirit to and our spirits are trying to provide with a bodily expression. Mr. Adaskin came to see me again Monday, and Boris Hambourg also. He is very gentle in spirit. I suppose he has to be because his wife is a tornado, but I like her; she always sends me loving messages. They're nice and their music is a whisper from elsewhere and gives one fresh courage. They found my latest work youthful and inspiring in spirit. It refreshed them. I work on at these canvases and long for more depth and intensity.

December 2nd

What a spooky place an empty theatre is when there are no lights! Clem Davies uses the Empire Theatre for his services. I did not know he had changed and went this morning. I was a little late. No one was around the door, but the theatre was open. I swung the door, crossed the vestibule and went through the inner door. The lobby was dimly lighted from the outer door. No usher and no pile of notice papers. I must be *very* late, I thought, and crept up to my usual seat in the balcony. I got no further than the gallery entrance. Ill-ventilated black met me, a dense smothering black as if all the actors and the audience had left something there, something intangible in that black hole of a place. The deathly silence was full of crying. It made you want to get out quickly, as if you were looking

at something you should not see. I came out quickly into the dull street, Government Street in Chinatown, with all the dirty curtained windows and the shut shops. Two little Chinese girls were licking suckers, red ones that rouged their tongues, and were comparing tongues in the mirror on the door outside.

I walked to the Empress Hotel, straight into the Conservatory, passing through the empty lounge and corridors. I suppose most of the guests were still in bed. Boys with dust pans looked here and there for possible dirt. The Conservatory was empty of humans—just the flowers, and they were at worship and let me join them. Cyclamen, pink, red, purple-red, rose; prunella; little pink begonia; pots of green; calla lilies (Bess' flower); and poinsettia, looking Christmasy, already hung up on straggly stems and ending abruptly in scarlet blobs. Fatherly palms and soft, motherly tree ferns stood in huge tubs, their leaves drooping low. The little fountain gurgled and splashed. Every now and then it gushed out in a bigger spray and gurgle as if it had some sudden extra sorrow and must cry harder. The sun came dancing through the glass and the light flowed over the blooms, trickled among the leaves, and showed up tiny transparent diamond drips from the pouts of the lily leaves where before only drops of water had been. A few flies buzzed. And all the while I sat quite quiet.

It was very holy in there. They were worshipping as hard as they knew how, fulfilling the job God gave them to do. The stream of life, God's life, was passing through them. You could feel their growth and their praise rising up to God and singing, not as we humans sing, but glorifying in their own way, their faces pure and lovely, growing, fulfilling, every moment. I saw an arum lily sway gently to and fro once or twice. Then it stopped, and a little variegated leafy trailer suddenly outgrew some little catch; a spray slipped loose, every leaf quivering. There was a great peace. I was glad the theatre had been empty so that I had been led to worship with the flowers.

December 3rd

The woman's crits in the short story class are perfectly futile. I was down about my writing anyhow, down in the depths. She jumbled

through my story in the reading, giving it no sense, mixing words, hurrying frantically. The comments afterwards were neither helpful nor constructive. The class hunted hectically for "complaints" and laid fingers on good, bad or indifferent, irrespective. If only there was someone who really *knew*.

December 6th

Today in the early part I walked in the park with the dogs. We were by the lake. A large band of ducks was standing on the bank. When they saw the dogs they rose all together, sixty wings, with the quick flap, flap of duck flight, all their necks stretched straight out, all their legs folded back exactly the same. Thirty squawks were one. Thirty moving creatures that combined in one movement in the sky. I suppose one would scarcely have noticed one lone duck rise but the accumulated repeat strengthened it mightily. Perhaps prayer is like that. The concerted repeat makes it stronger. Maybe that is the good of church, if the worshippers are really meaning the words and not thinking how hard the floor is, or how ugly the bobbed hair of the elderly is when their hats are bowed and their necks show, or what a scraggy neck someone has or what humped shoulders, instead of realizing the whole mob as a praying unit before God. If you could only leave your body in the porch and enter in your naked souls, it would be grand. How wonderful a church for the blind must be if everybody, you included, were blind! No, I think perhaps all this is wrong. All these delicious sights and beauties should hoist me up nearer to the source of it. One should busy their thoughts with nothing but their relation to God. We are awfully frail-minded.

December 10th

Back they come, the "Hully-up Paper" from *Saturday Evening Post*, "Cow Yard" and "Peacock" from *Atlantic Monthly*, returned without thanks, not wanted, found unsuitable. I feel my stuff will not interest this day's public. They want blood and thunder, sex and crime, crooks, divorce, edgy things that keep them on the *qui vive* wondering which way the cat is going to jump and hoping it's the

risqué way. I can't write that stuff. I don't want to learn. I won't. So I guess my little homely tales of creatures and things will sit in my box forever. I want the money dreadfully but I don't want dirt money.

December 11th

Have been struggling with "D'Sonoqua." Big, strong simplicity is needed for these carvings and forests. I am appalled at the petty drivel I get down. It feels strong when I'm doing it; afterwards it's crude. Ugh! How does one bridge "feels" with "words"? If only I were better educated, but how I *hated* school! It takes a genius to write without education. I utter the senseless squawks of a feathered fowl. Often I wonder at the desire in me being so strong and drivelling out in such feeble words and badly constructed sentences.

December 13th

My sixty-third birthday and everyone's been lovely over it. Bless them all! The rain is on the shingles overhead in the attic. All the mountains are washed out in mist and the telephone wires are solid rows of diamond drops. I've got to rattle out and vote for mayor and then come home and make pounds of Christmas candy for the Christmas boxes of the nieces. I'd far rather write and write and write—about D'Sonoqua and the West coast, about the looks and smells and feels, and the joy and the despair and the bigness and depth and sweetness and awfulness.

Alice got a letter from a boy in hospital. He saw an article in the *Province* about me and my work. What the boy said was worth more to me by far than all the newspaper slop. He doesn't know art at all but he knows the B.C. coast and the "bite" of lonesome places, and had a notion of what I was trying to get at and my stuff spoke to him and that makes me happy. A man I met the other day said much the same to me. In those he saw at the Fair he felt the power and strength of the Forest. Those are the crits that count and make one cocky. A third man who has two of my sketches told me he never came into the room where they hang without them touching him deeply. Those things are very sweet to hear.

Night 13th
We had a lovely birthday party down at Alice's, just we three old girls—tea with goodies and a cake with three dilapidated candles. We had jokes and giggled a lot. In the evening we all worked at Christmas stuff. They sewed and knitted. I pitted four pounds of dates for the candies, and then read a fine article aloud about the Prince of Wales. Now I've launched into year sixty-four.

Christmas is on the wing. In five more days she'll settle. The candies are all made and posted. The holly is gathered but it is too pouring wet to snip boughs surreptitiously off the boulevard cedars for the cemetery wreaths. Alice's school breaks up tomorrow. Lizzie's hamper-packing and church-decorating. Oh, Holy Babe in your manger, how we have spoiled your birthday and made it a greedy, toilsome time. We know it, but everybody else does the same, so we go on doing it.

December 21st
I am very ashamed because Christmas has chafed and wearied and irritated me so this year—stuffing turkeys, making holly wreaths, postings and writings, hampers, donations. A week of dragged-out tommy rot. The most joyous thing about the whole show was the smell of the pine and the cedar—delicious! So much of the rest is silliness and sentimentality instead of holiness.

December 24th
It's raw and shining, bitter and shrivelling. The post has just come and brought me a stack of cards, some I did expect, some I didn't. *The Countryman* has turned down my stories but as he could not use them he has sent them on to someone else. Not just their type, he said. In the same post came a letter from a man in Edmonton re my exhibit up there. He said, "As you are no doubt aware, your work is not popular. To the few who like it and could see what you were striving for, it was a treat." If I loved humanity *en masse* more would I suit them better? I don't like the stuff the painters and writers cater to. Ought I to like it? It seems to me so garish and cheap, so full of crime and the suggestion of indecency and dirt.

Christmas Day

It was still night when I set out for the cathedral's early celebration and it was raining hard and everywhere was dark and wet and mysterious. Only one or two kitchen lights, and all the street lights. Even the children had not opened the one eye that could shut out Santa and rest the tiredness of Christmas Eve shopping. The puddles gleamed under the street lamps and the shadow of my umbrella accompanied me all the way. There is something very holy about Communion before it is light, something dark and warm and mystic in the dim corners of the Cathedral—the pine smell of the decorations, the scarlet of the berries and the poinsettia blooms. When we came out dawn was coming, grey and wet. The street lamps were out so the umbrellas had to march alone without a companionable jogging shadow. The houses were still asleep, stuffy people with windows tight closed; robust, uncomfortable souls with blinds and windows wide so that you could picture their red noses and foggy breath emerging from the blankets. Just ordinaries were lighting their kitchen stoves and dragging in milk bottles. I woke the pups and we breakfasted over the fire.

We gifted last night.

December 30th

Went to church, that is to service held in the Empire Theatre by Dr. Clem Davies. The Kitsilano boys' band was playing, and the house was full. So I wandered back through Chinatown and saw Lee Nan seated at his organ among all his pictures. He was playing so vigorously he did not hear before many knockings, and gave me a fine welcome. I asked him to play and he did, putting aside his bashfulness and throwing himself into his Chinese music. I liked it. It was very like their pictures, very akin. Then I asked him to sing and he did that too. There is something sweet and sincere in Lee Nan, a striving for higher and lovely things. Something affecting about the neat surroundings, all decent and in order, his Chinese books and pictures, a flower or two and a bowl of goldfish, the photo of a Chinese girl, her hair in a modern fluff over one eye, in a red plush frame. On top of the organ his Chinese calendar and various Chinese photos, his Chinese arithmetic log. Oh, when will all nations be one

and understand each other's ways and thoughts! Even people of one nation are enemies to each other; how much more so people of other traditions! Perplexity, perplexity. I can't understand my own family, nor they me—born of the same parents. Every soul is so completely, totally *alone*. We don't understand our very closest, and half our trouble comes from thinking we do and reading them through our own particular coloured glasses.

The rain is pelting on the unceilinged roof twelve inches above my head, quick, jagged patters reeling off millions of little noises that make one interminable, monotonous noise. If I slept in an ordinary plastered room I should miss all those sweet sounds, the wind sighing through the cracks and sometimes a rat scrabbling and gnawing in the edges of the attic beyond my ship-lap walls. If things don't perk, I'll have to give up my house. That would hurt.

January 1st, 1935
So, over at last and back again to plain roast beef and milk pudding. We dined at Lizzie's. A happy dinner in the old home again and games and sittings round the fire, three old women and a couple of youngsters.

Edythe and Fred Brand brought a university couple round in the afternoon. They appeared to like my pictures and said lots of things in low voices that my deaf ear did not catch. Deafness is a nuisance, but perhaps it is better that one does not hear all that is said because there is so little genius in criticism. People say things they do not know and things they do not mean and maybe it is best to think things out for yourself and not be swayed by what others say. Oh to be thoroughly human, to love humanity more! I so wonder if that poor love I deliberately set-out to kill after it had overpowered me for fifteen years (and *did* kill) can ever sprout again. I think it was a bad, dreadful thing to do. I did it in self-defence because it was killing me, sapping the life from me. But love is too beautiful, too lovely a thing to murder and it musses one up. The spatter of love's blood is upon one's hands, red blood that congeals and turns black and will not wash off the cruel hands. It does not hurt the killed; it hurts the killer. Maybe if I had not killed love I would have had more intensity for the love side in my painting. Maybe I would have

163

grown further and accumulated more in this life, or maybe it was one of the lessons I had to learn—how to manage my love. It's no good pondering the maybes; too deep. Rather, better to open up all one can, grow, and know that the lesson was for my learning.

I hope 1935 will bring me more zest for work, more inspiration. Maybe I'll have to be stripped of everything, even my house, before I come down to brass tacks. God, humanity, my work—if I could only burst forth with live, spontaneous, bursting love like the throbbing love I had for the birds when I was a child and stood tiptoe to peep into a nest. The secrecy and mystery, the ecstasy of wonder and love that thrilled me to the very core! If one could only feel that all again, and the love you had for Mother when you'd been bad and she'd been patient, a sort of shy and adoring love, so thoroughly comfortable.

My house is up for sale or exchange. If it goes, the parting from the studio and the garden will be an awful wrench. The renting part would be a joy to be rid of.

Tenants come and tenants go. When unsuited and unsuitable ones come and go some jarring sensation is in the air. You feel it in the basement and the garden, in their coal bin at the back. It runs up and down their front steps even when they are out. It sits brooding in the emptiness. It steals upstairs at night and slaps me in the face. These new ones now, I like them both but I feel in my heart that the flat does not suit them. They want one of those torrid-heat apartments. Everything has gone wrong with their gear as it never did before. First the stove fell down and then the clothesline with all her wash on it. And there was the awful north wind snap and their pipes wouldn't work. They are nice over everything but disappointed, I see, and it makes me feel bad when the house falls short of expectations. Agents came and looked it over today and told me what I already knew, that it needed painting and doing up, and they were more enamoured over my dogs than my house.

I'm so dreadfully sore with writing. I verily believe my stuff gets poorer and poorer. The writing class gets duller and duller, and I *will* fall to yawning and that makes her mad and she's so dull and dense and so am I. She's bored stiff with her class and we are all bored stiff with her. I'm off painting and writing. If only the ground wasn't frost-bitten I would go and dig. Maybe I'll whitewash.

January 15th

Snow! The white ground is soiled by traffic. Very white roofs, black and white trees. Leaden sky, heavy with more snow. The chimney smoke shows light against it. The children's voices sound different, resounding back from the snow instead of from the earth. Crows look doubly black and the chimneys redder against the snow. There is a hush over everything, in sharp contrast to the roaring, lashing wind of the last two days. It is as though God had whipped the earth, then hushed her to sleep under clean blankets. There is a loveliness about new snow that wakes in one an awed wondering. The horizon and the sky are down and in. Everything is closer and more intimate. Visitors get a warmer welcome, are pulled in quickly and the door shut. Handshakes are heartier; even cold houses are warmer against the contact of outdoors. Alone inside the house it is very quiet. Outer noises become muffled.

It is very, *very* cold. Relentless frost, bitter, boring, determined, will not be satisfied till it has penetrated to the centre of every single thing and made it cold and hard like itself, aided and abetted by a cruel north wind. A cuddle-stove day. The garbage waggons are collecting ashes, cans, and soiled waste of all kinds. It looks horrid against the purity of the white world. Mother Earth will hide it away in her ample brown folds and purify it and absorb its good, bringing it back to usefulness. Or maybe fire will do it quicker and with fierce licking. We only know that nothing is to be lost—just slips from one state to another, always at work, everything in exact order.

I am trying to exchange my house for a small practical one. When the wind brawls round and the frost pinches and the whole plumbing system sits on one's chest, and the tenants, grunting and unreasonable, blame the landowner for the element's shortcomings, then one wants dreadfully to be *rid* of the thing. It's easy enough to stand up to one's own discomforts but not so easy to shoulder others' unavoidables.

There's ice in the park. The ducks look forlorn standing on one leg each, cuddling their noses, beaks tailwards, wondering why the water won't meet them and float them, and the dogs rush down the bank and out on the frozen lake and are equally astounded as to why they don't fall in, and look back to see if I notice how smart

they are. One feels kind of sorry for the sky. Suffering has turned it sullen. One must have looked like that sometimes when they wanted to cry fearfully till the wanting hurt—but they couldn't cry. The few bits of green in the garden are darkly transparent and pinched. Nothing joyous or sparkling there.

Oh, winter! one never, never loses the surprise and wonder of new fallen snow, that inexplicable something that touches the core of your innermost being as you stand in your nightie shivering and amazed at the pure glory of the transformation. In youth your young quick blood danced the cold aside. Now, winter meets winter. Stiff knees and rheumatic hip descend the stair stiffly, build the fire, and find one excuse after another to stay there hugging it. The joke has gone out of the cruel north wind, which shrieks derisively, "Whew-oo-oo-te-oo." Jam and apples freeze in the cooler so I stand them in the big studio which is shut up because of its northness. Susie gets busy, like Mother Digglebones, and samples all the pots and takes a toothful out of every apple and then she goes back to her snug rag bag and sleeps off the cold snap. When the new coal comes Woo rushes to her sleep box and draws the blankets over her. The wind rolls in the open window, but she can't resist satisfying her curiosity. As every sack thunders its contents into the bin, she draws aside her covers and peeps.

January 17th
There's a glint of moderation in the weather tonight. That which froze remains frozen, but the piercing cruelty has abated. I'm gladder for Lizzie and Alice even than for me. They look their years. Neither house has a furnace and things are difficult, Alice keeping kids warm, Lizzie waiting on sick tenants. People are morose, disheartened or mad at the weather according to the state of their accommodation and finance. It will be *choice* to open up the house to fresh air and not dread the trip to the basement, dressing for it as if one were going to the Arctic. The robins and sparrows are loose dumpy balls without pep enough to fix up their undies but let them flop on their spindle legs as close to their toes as possible. One would think that hanging loose that way the draughts would hit their skin. I expect lots creep off and die. Such spots of life to battle with a

universe full of cold, taking it all in a dumb, brave, philosophical way, without question, singing for sun, hunching for cold, and taking what comes!

It's a sweet sound, the gurgle of new-thawed taps, as though some icy fear had melted away inside you as well. It is warm enough to snow today, slow, difficult snow, reluctant little flakes with no hurry.

The church was cold. Dr. Clem Davies preached in his overcoat with his hands deep in its pockets, and stamped his feet (reverent little stamps) while he read. The woman facing my spine had a loud cold. She alternated between raucous booms and squeaks, and sneezed between verses. I envied the nicety with which she controlled the intervals, bringing the sneezes off in exact time. The congregation was sparse and everyone smiled at everyone else. We emerged like creeping cats from the cold interior of the Empire Theatre into the colder blizzard of flying snow. But the blizzard is one hundred per cent better than those icy north winds and what they do to your plumbing. The house is so cosy.

It's a straight-on-end deluge. The rain doesn't come in drops but in long streaks like macaroni. Basements are flooded (not mine). Garage roofs collapsed in Vancouver under the snow. Ships are grounded on the dry land, which I suppose was so be-puddled that they mistook it for sea. Bad weather conditions of all sorts abound, scooting from one variety into another with violent transitions. People are bruised and bumped and broken by falls and slithers and tumbles. There's a big incendiary mill fire, and sudden deaths, and crueler slow deaths, and humanity sitting and saying, "What next?" The bulbs are bravely sprouting, facing their fresh green babyhood unconcerned and orderly. The robins have demolished all the haws during the snap and have shuffled off elsewhere since the thaw.

I had a visitor from Germany yesterday. She says the tendency in German art today is to give minute surface detail. She had seen, she said, no work just like mine.

Last night I did not sleep for wondering foolishly what I would do about a studio if I exchanged my house, and I got moiled up and

bewildered. Surely art is bigger than four walls and a top light. It's a little person who can't paint big in a small place, and there's always outdoors in summer.

The Provincial Library Building is heavy, ornate—horrible. I can't imagine it heavier or more horrible than when the Art Historical Society are sitting uncomfortably humped in its middle. The ceiling of the library is heavily beamed and lumped with hideous blobbed plaster ornaments in oblong squares like an upside-down graveyard under snow, and there is a white marble coping round the dead fireplace. Never-read, dry-bones of books are locked under glass coffin-like cases along the walls, and wherever there aren't books there are horrible light-brown wooden floral wreaths and sprays. They look like brown paper. Every manner of flower, fruit, seed pod, vegetable and grain is represented, as though there was to be another flood and a pair of each specimen had to be preserved.

In the front of the room was a square table. The President man and the Secretary woman sat at it. There was a tray with a glass jug of water and a tumbler which the President banged to call the meeting to order. The members were stolid. I felt dreadfully sorry for the janitor. He was a tired-looking man leaning on his broom just outside the open door waiting to sweep out. I wanted to yell, "Sweep, sweep them out. Choke them in their own dust. Turn the ceiling upside-down and bury them under the white plaster oblongs." On they droned about preserving the old buildings and emulating England whose power and glory was in preserving her past. Hang them all! Why can't they die and move on? The needs of today are pressing. The past is past.

Sunday, January 24th
Dr. Clem Davies preached on Moses seeing but not entering the promised land. Moses knew God *face to face*. I had a little speech on the ideals of Indian art in my pocket all typed and threw it into the collection dish instead of my offering in its envelope. What on earth would Clem think at such an offering? And I am afraid it had my name on it.

An artist came yesterday and brought a thing for me to criticize,

and he did not like it when I did. It had some nice things in it and some foolishness. He had tried to distort for the sake of queerness. Distortion is all right for emphasis—to get your point over. There is something dramatic (blood and thunder threatening) about sky and houses looking dour. But there was nothing spiritual, nothing that hoisted the soul a little. Oh, it is difficult, but should not be difficult if we lived nearer to God and got our inspiration direct. If one could only rise and strike out from the heights, but I suppose first we must climb to the rise above the trivial snippiness, quit bickering and open our eyes wider and get stiller—quit fussing. Perhaps the promises given to our children and children's children work out in old maids through the channels of art. Supposing one could go up into a mountain and see the expressions of future generations, showing the unripe strivings in our own lives brought to fruit in them. We'd know the grind and perplexities we went through were part of the foundation.

I wish I knew if I really am as *completely* beastly a person as Lizzie makes me out. She doesn't allow me one good thought or feeling or trait. I come back from visiting her so discouraged with myself. She has the faculty for hauling all one's worst to the surface. At the age of four, and she was eight, she took me to a child's party at the Langleys'. I remember her wrathful indignation over my behaviour there, and telling Mother she'd never take me to a party again, as I was a disgrace. I jammed my hands at tea, lost my little white cotton gloves, cried for a prize at "Aunt Sally." I remember Mother kissed her fat disgraceful baby and did not pay much attention to all the wickedness.

February 8, 1935
I feel very, *very* old, round a hundred I should say, maybe more— just a tired, nothing-left feel; writing a humbug, painting a bore. I could sleep, sleep. I tell myself "shame," put forth a big effort and wash all the outside steps or make soap, or wash and get tireder. My manuscripts are all back from everywhere. Why do *all* one's friends seem to go back on you altogether? They might take turns. Funny about friends, you want them frightfully, but you can't find

169

any to fit. Nothing in you and them that answers each other, only commonplaces—weather conditions, ailments or food—beyond that, blank. They slam the door of their innards and you slam the door of yours.

When I contemplate the possibility of selling this place and moving I am in a panic. When I think of not selling and not being able to rent and not paying my taxes and the city gobbling my home into its maw, I'm in a quadruple panic, and where's your faith? If one could only put their finger definitely on God! Yet what more does one want when miracles are popping up every single second? *Everything's* a miracle. Every time we lift a finger or do a thing, it's a miracle that we could no wise perform alone.

Well, today has been like a day of lead. Why are there days when yeast, gunpowder and champagne are lifeless and you are brown and sagging as a rotten apple, days when one *longs* for somebody with their whole soul? Somebody that they never met or knew or saw. Somebody with no body or appearance but with an enormous love and sympathy who would not only give to you but call out from you oceans of sweetness and the lovely feel of giving it out with a lavish hand to someone who *wanted* it, giving it generously and unashamed.

Life's hideous just now, everyone anxious and pinched and unnatural and sore about something. Some wicked fairy has turned all the blood and flesh hearts into affairs of fire and lead and stone, with all the warm soft gone out, just a hard, dry ache and a hungry want. Where have you gone to, Joy? You are ached out of existence.

I am painting a sky. A big tree butts up into it on one side, and there is a slope in the corner with pines. These are only to give distance. The subject is sky, starting lavender beneath the trees and rising into a smoother hollow air space, greenish in tone, merging into laced clouds and then into deep, bottomless blue, not flat and smooth like the centre part of the sky, but loose, coming forward. There is to be *one* sweeping movement through the whole air, an ascending movement, high and fathomless. The movement must

connect with each part, taking great care with the articulation. A movement floating up. It is a study in movement, designed movement—very subtle.

A newspaper criticism on the art exhibit, in which I was especially mentioned—my work "Blunden Harbour," and the little spindly pine tree peeking up into the sky. Art criticism was flowery, from a professor of English at the University. The fact that the canvas was a sky study entirely missed them. Below was a low, beaten stretch of earth; they called it "the thicket." It was only an incidental. The sky was the subject. What rubbish these critics are, or is it one's own stupidity in blundering to the point? The professor dipped out feathery fluff, but—well—there you are.

My Indian story, "Hully-up Paper" back from International Correspondence Criticism Service. The literary critic squashed my story flat—not marketable, no plot, only a bit of narrative. Might pass in a Canadian magazine, but not in an American since "it lacks the elements that American magazines require." "Not good enough to make the grade with commercial markets," was his criticism. One *does* get disheartened, no good denying. Is it pure conceit that makes one feel so squashed? The truth of it is I don't *want to* write that popular mechanical twaddle that is called for. I know my stuff is poor in wording and expression, construction. But what joy is there in blowing oneself up with high flavoured impossibilities of plots lacking reality when one longs to just express simply the everyday lovely realities that happen in front of your nose? I suppose if I had the education I would express these realities so they were readable. What is this rebellion inside me? Rebellion against orthodox mechanics. Is it egotistical conceit? Or life's ardor dimming? Or outworn sentimentality? I want dreadfully to express something, but why? I think, old girl, you'd better quit writing.

If you don't write things down where do they go? Into the lazy bog of neglected opportunities. Thoughts we might have developed, actions we might have accomplished. Inertia and deadness. Look what is happening in the garden this very minute. All the little winter thoughts of it are bursting forth. The earth has softened

down, opened up, paid attention, and developed her thoughts. Now there is a roaring hubbub, a torrent of growth gushing forth that won't be stopped because the dear old earth has nursed and treasured her thoughts deep down in the winter quiet. Now they are paying her back gloriously. If only we did our part as faithfully.

A woman came to my studio. She is an artist with two children and an invalid husband to support. I esteemed her very much. She said, "I cannot paint. It takes all my strength to support my children and bring them up to think of beautiful things, to be with them and share with them in their impressionable years. I feel if I try to teach a good *honest* commercial art that is of service to my pupils, I am doing more good than dabbling around in paint myself, doing weary and unconsciously weak work."

She was really interested in my work. She said that it appealed to her like religion. Art and religion you can't separate, for real art is religion, a search for the beauty of God deep in all things.

I had visitors, an artist that also showed at the Vancouver show and his sister-in-law. Why can't I take all the nice things they say like a dainty dish one is offered by a hostess? Help oneself and be thankful and eat it with gusto! I just can't. I *cannot* feel that the things they say are merited. Oh, I wish I could! It would be so comfortable to smack my lips and say, "That's me. I *deserve* their praise. My work is good. All they say is true, likening me to Van Gogh, saying my work will live, and all the slop about its profundity and depth and meaning." But there is the consciousness of how I've *wanted* to sink right into it and absorb and how my mind has wandered from the point, on and on, and I've dragged it back and *forced* it instead of opening myself up and letting it fill me and then gush out at my finger tips, powerless to hold it back. When I read of artists who worked and worked, patiently expanding through the years, and all their thoroughness in mastering technique, and then look at my own spatter, I realize that it has no construction. It is raw, clumsy, unfinished. Then I feel a lazy shirker and I am sure that those who applaud my efforts don't realize or recognize good work or they'd see the failings of mine.

March

Everyone is waiting and waiting and waiting these days and nobody knows for what. There is a lonely blue brooding over everything. Everything is so difficult. People's bodies and hearts are aching. It is not all because people's purses are empty. It's some other dreary, lonesome thing. We're off the boil, no cheerful sing, no quivering lid, just a sullen lukewarmness, sooted on the bottom and furred within. Oh for a jolly old fire to set life's kettle singing and bubbling and steaming!

Housecleaning is not so bad when you throw your heart into it. I've kalsomined four rooms, with their ceilings and walls (and floors too, but that I had to scrub away after). They began to smell nice. All the clean sparkling dishes and pans look so glad and yell out, "Put me here," as if the scrubbed shelf was their heaven they longed to be boosted into. Perhaps it's the last time I'll have the privilege of cleaning dear old 646. It's so thrilling to go down the morning after to see if the evil old stains are really obliterated now the kalsomine is dry. Only one does have much too many things. I hoard trash. There's all sorts of things, and repairs to other things, to be done with oddments. I'm a specialist in utilizing refuse.

There's something *honest* about getting into bed with every muscle aching from real straight domestics, honestly acquired. Sort of a brick in your character building.

Cleaning one's domicile is terribly saddening. Out of every out-of-the-way corner that one delves into, after the dust accumulation that is not disturbed more than annually, something comes to light that reminds one of an incident or a person and sets up an ache inside you, a photo, or a letter or a little gift. Letters are the worst to make you ache. Somebody you'd nearly forgotten and you don't know if they are dead or still alive, and you wonder how the intimate friendliness could have died; how after being so close you are so far. The dead ones are nearer and not half so saddening as the "uncertains." And there are congratulation letters on little successes and sympathetic letters about disappointments, and giggly letters and indignant ones, and the pages of life that have been glued up all these years suddenly seem to loosen up so you can read them again,

and just as you are in the middle of reading, suddenly they stick together again and stay silent till next year's big clean.

Such nerve-pinching decisions about what one shall keep and what throw out! Your hand poises there over the garbage pail, weighing the article in decision. "Wretched old trash, I've housed it long enough. Still—I don't know if I should; maybe it would come in handy; after all, it doesn't take much room. But why clutter up with such stuff? Come to think of it, though, probably this year I will need it." The yawning garbage can *doesn't* get it, and it starts on another twelve month round of rust and cobweb accumulation.

I cried over one letter today. It was from a pretty young married woman, and she loved me then and had great faith in my work, and I said to myself, "Was her faith justified?" Had I made good? I felt a blighter and cried a little. You always feel when you look it straight in the eye that you could have put *more* into it, could have let yourself go and dug harder.

Spring and Summer
1935

April 2nd

The house is as clean as a new-laid egg. And now, oh horrors, an exhibition! I hate the publicity, but down deep I have felt for a long time that it was my job to do this particular thing. I am so selfish and no good and there's all the people who love painting and haven't any chance and here am I greedily hoarding up thoughts and things that are not mine—only lent to me. If the others get anything out of them then it is up to me to hand it on. Perhaps none of them will come. That will be dull and flat and worse. I don't particularly want the idle rich, the people who are always catered to in art establishments, here. I want the people who think and feel, not the ones who flatter and lie and spoon out the correct things to say. A college teacher said, "Well . . . I don't know . . . of course the idea is nice . . . but I doubt the students would want to come if the working class were specially invited." Let them stay away, then, and read their art books and go to the Arts and Crafts shows. They don't care for the real of art, only for the fashion and the correct jargon.

April 3rd

Today was the second day of the public exhibition in my downstairs flat. I showed a group of old Indian pictures, thirty in number. A lot of people came yesterday and were appreciative and interested. Today the thing drags. Quite a few have been but they were smart-alecky and priggish. A prim young photographer came. He shot out a camera and without a by-your-leave signified his intention of photographing *me*. "I prefer not," I said very firmly. Then his

wife or sister or female relation of some sort said, "Have you done it?" "No, she won't have it." He smirked and I glowered and I saw his finger straying to his camera. I think he had come intending to photograph *ad lib* and I sure wasn't going to have it, not without a by-your-leave anyhow.

Stacks more people have been, some very appreciative, some very stupid. I am tired, tired. There has been a surprising lot of people but the interest has centred more on the historical than on the art side. I feel very old. I wish the work was a million times better. I wish, I wish, I wish. People were very genuinely interested, I think. So many said they were glad they had come, it was very worth while. So I think it was.

April 5th
Now the third exhibition is hung, my modern landscapes and modern Indian things, which look somehow lacking and dark. Maybe I am tired and that's the reason. How completely alone I've had to face the world, no boosters, no artist's backing, no relatives interested, no bother taken by papers to advertise, just me and an empty flat and the pictures. Two men helped me to hang the first and last show. I did the other. It is surprising to me as many came. There were several withered little old men and women trying to paint a little, now that the hustle of their family life has eased off for them. They'll never do anything much in this life to show, but who knows but the start of thinking about these things here will help them in another world. I do not perhaps mean really to paint there but to see God's beauty, if we paint it maybe with different pigments. I don't suppose painting or singing or playing are really what matters but the expressing of the realization of God in all and everywhere.

I read Flora "D'Sonoqua's Cats." She found a *great* many faults in it. Most of them I agreed with but some I did not. The thing I had struggled hardest for she did not see, made no comment on, so I suppose I had not made it the least bit plain. In hanging the show too, the man looked disapprovingly at "D'Sonoqua and the Cats." "What's the meaning?" he asked. I just gave a sort of a laugh. "Oh, there's a story," I said, but I did not tell it. He would not have

understood. And after, I brought out another canvas and took her away. I think the story and the picture were special things experienced by me and I must put them away. I don't know anybody I could talk it out with. Perhaps I could have once with Lawren, but I am not sure he would have understood, and now that intimacy of our life work is all gone too, door shut, windows barred, ways parted. So be it! One *must* learn that one's own two feet are made to stand on and that one cannot use others as props and crutches. How extraordinarily alone everyone is! Each one walking along his own path to the one gate through which every one goes alone. Art and religion are alike. It doesn't matter what our sect or what our method, the one thing that matters is our sincerity.

Saturday, April 6th
Today's show was horrible and has left me tired out and exceedingly depressed. Have been diving down to see why. Quite a few came, some who had been to the other two exhibitions. There were the usual "babblers," little people who felt that they must say stuff, and fluttered away and left nothing said. There was not an artist among them. The artists have ignored the show except little Lee Nan. He understood more than all the rest and I felt nearer to that little Chinaman in understanding than to all those others.

April 7th
The sixth day of the exhibition is over, the whole thing done with. It has been far beyond my expectations in success. I imagine some two hundred people came, and on the whole were keenly appreciative and interested in the work, as was evinced in many of them coming two and three times. Today there were mostly the college students, boys and girls, a keen lot. The young folk like the modern stuff. The old folk shy and back, poor dears. It is a gulp to swallow after what they are used to. They can't think of power or movement or bulk or light. They want little complete objects in paint put concisely before them telling a little story completely worked out and leaving no labour for their imagination. It made you feel so old when one and another would say, "What a lot of work." Of course it is. Practically your whole life's work was summed up and laid out on a

platter before you, like a drowning man's, and now it was up to you to kick the bucket, instead of feeling as I do that I want to begin all over fresh and hit out harder. You do not feel much interest in what you have done. It's what you want to do that peps you up. I do think we all live so much in the past instead of pushing further. The greatness of the Old Masters seems to me to be their sincerity in realizing their present, rounding it out and filling it in. I'm not a proper artist at all. To be that one should be in it body and soul, giving all your time and absorption, living above paint, above colour, above design, even above form, searching the spirit, centring the eyes just above the horizon, going out into pure being to *be* along with it. How can one explain that to people? It's one of the wordless things and your spirit runs ahead of your hands and eyes that toil fleshily after, slow and clumsy. Poor soul, wrestling, striving to learn its lessons out of the old book of flesh, tossing the book impatiently aside—stupid dull print—and picking it up again to reread the words and get the sense clearer.

April 8th

How tired one can get and not die! When the exhibition closed yesterday I longed to get to painting. First, however, the flat the exhibition was in had to be got ready for a tenant. The kitchen was peeling. I bolted out of bed this morning right on to the stepladder with a knife and those walls had to be scraped inch by inch. I did not give myself time to think. I said, "Put your whole zest into that, old girl. It's necessary, so make it worth while. When it is all clean maybe you can paint." Life is such a continual struggle inside.

Everything in life seems to contradict something else. If I was a real artist I'd let everything else go, but I can't and don't and so I'm not. Even today as I went to buy kalsomine, I met two people. So sorry I was out. Wanted to come to the studio. I said, "It has been open to the public two weeks. Now the exhibition is closed." And that's to be it, too. I'm not having my meagre paint time pottered into by this one and that and have to haul out stuff. The man was forty-two years old and had just started to think about painting. The woman said he was a *genius* and should be encouraged tremen-

dously. She begged him to show me the wonderful production he had done. He drew a dirty bit of lined writing paper out of his hip pocket, a mess in blue and red, and then fell into raptures about *her* work and what a genius *she* was. All this took place on the city street. I did not ask them over. I'm horrid. I ought to help beginners, but they do make such a mock-modest fuss about themselves.

April 9th
Such sunshine is pouring over everything! Get anything between you and it, though, and it is very cold. While the kalsomine prepares I am bathing in the sunshine of the big east window. The trees are still open to let the sunshine pour through, just little blobs of transparent yellow-green. All the grand loveliness of the beach is waiting. The spring sky is high and full of movement. Steady, on with the job, old girl, so you can be free to go to it.

Since the exhibition I have been thinking a lot. People said, "Explain the pictures." How could anyone do that? Perhaps I do not know any more than they. Why? It is not a definite set goal—sort of a groping, changing day by day and yet imperceptibly. If one wanted colour or design or form or representation perhaps one could explain a little what one was trying for, but how can one explain spirit? How can one find it or know how to look? The biggest part of painting perhaps is faith, and waiting receptively, content to go any way, not planning or forcing. The fear, though, is laziness. It is so easy to drift and finally be tossed up on the beach, derelict.

April 11th
Lunch on beach with Alice and a squad of youngsters. How that woman ever has the patience—day in, day out, year in, year out—and always amiable! We sat on logs and ate mutton sandwiches and bananas. The high clear heat of morning hazed over a bit at noon. After a big washing was glad to sit and sun in afternoon. Too tired to paint.

Letter from Lawren. Good to hear of his work again. It will be interesting but I can't quite find the spirit in abstract. Maybe I am too earthy, but I want to seek out, to follow the spirit.

April 14th

Spring sunshine and frosts are dickering over the garden growth. The flowers are tattered by the pushing and pulling back. The Empress conservatory is unruffled by extremes. The great ferns are sending out long, majestically curved new fronds and the cineraria, spiraea, schizanthus, begonias, callas and other things I don't know are rioting gloriously. It is splendid to sit amongst them for a bit, and yet folk pass through with scarcely a glance.

I must pull myself together and start painting. I keep saying will I get this or that done up first and put off the more intense struggle of the higher work till things are more settled and the clutter of daily jobs is eased off a bit so my mind is clearer. I don't know if that is best or worst for development. Is it because I am too orderly naturally to work in hugger-mugger or is it that my soul is more lazy than my body?

April 20th—Easter Eve

I wonder will we ever consciously look back and see the plan of things, the reason for this and that and the good of it? This house— what a mixture of love and hate! What a dear house and studio and garden—as a renting proposition how beastly! Was this very thing needed for the good of my soul? Tenants, how I've *hated* the whole business of them—like a galling collar round my neck. Of all that have passed through my flats in twenty years how very, very few I have said goodbye to with regret. Some of the partings have been very ugly indeed, some bitter.

April 21st—Easter Day

Spring is very cold and treacherous, almost crueller than winter. Things are prepared for bitterness when nature has wrapped them up safe, but in spring the young things are all peeping out, little creatures, little flowers, in a mad rush to burst from their dark prison. They are tantalized by bits of sunshine and stretch forth into it, only to be nipped and buffeted and bruised. I suppose it tends to strengthen them, but often it leaves scars and blackens their blossoms so that they do not mature and then have to wait a whole year before they can try again. It's hard to feel sweet when icy winds are

blithering through you. What you accumulate on the one fine day in ten is all blown away on the other nine.

April 22nd—Easter Monday
The world looks round and small and complete from the top of Beacon Hill, like a toy world with no beyond. The sky fits over the top with beautiful patterned clouds. Sometimes they lid down very low. All around on every side are purple hills or snow-capped mountains on the other side of the Straits. You forget all about Asia and Europe and Africa and the rest, and the wars and famines and earthquakes. Beacon Hill is important when you are up there with the dogs. The wild flowers and the broom and the nesting birds all seem so much more important than horrible things in the newspaper. Is it selfish to feel so?

To compose a picture you have first to get an idea. Something has to hit your fancy, hit it and settle into it like a bird does into her half-built nest. She knows what she wants and why she wants it. She keeps bringing more material and more twigs and fixing one thing into another till it's firm and shaped so it will hold something. Then she gets into it and twists and wiggles and kicks and irons till it is smooth and fits her. She does not put the precious eggs in till it fits. So with the big idea; we must be sure we know what it is, what we want to express. Then to weave and weave its nest. No good just laying the ideas there in a heap so the first puff blows them away. It is easy to grab the impression, to suggest, leaving half to the imagination of the other fellow. Tighten the idea into a definite plan, take it through the sketch, find the threads, loose them again perhaps and pick them up again and again till you don't see the threads but the tightly woven fabric that forms a complete nest. I am afraid that we artists have a tendency to reduce loveliness to paint instead of making paint express loveliness. To have complete command of material and technique so your thoughts can float through it unconsciously would be great.

April 28th
Another Sunday and another good sermon from Clem Davies. Another coming out of the dingy, tawdry theatre, whose dinginess

and tawdriness you never noticed at all because everything was enveloped in quiet peace and people's thoughts lifted. You came out into the glorious spring sunshine, feeling earnest and kindly and you walked through ugly Chinatown headed for the Empress Hotel conservatory with your head high and feet light, in spite of the rheumatics in them. The wallflowers sent volumes of smell out to greet you. The joy of it climbed down your nose and throat. You were full of their smell and their richness, and the glory of colour filled your brain, climbing in through the eyes. Then you stooped and felt their cool velvety life and praised God in your heart for inventing and creating such glorious things. In the greenhouse the flowers were more languishing, pampered and a bit peevish, bending over, the big forced blossoms too heavy and their stems lacking the sturdy robustness of the direct wind and sunshine upon them; tropical beauties a little homesick. A woman hobbled through without a look to right or left. Her face said, "Corns."

April 29th

An Irishman came to the studio tonight. He appeared profoundly touched. He said he felt B.C. breathing through my pictures and canvases. He did not *know* much but he felt quite a bit, allowing for good selvages of blarney. I fancy his goods were genuine. "I go away hungry to see more," he said. I was hungry for food and tired when he went.

May 1st

Yesterday I got this letter.

Dear Madame Emily Carr:

Just a few words to express my great admiration for your beautiful picture, "Peace." To me this picture represents Divinity and I have often been sitting in front of it this last week.

Compliments,

Hanna Lund

When I read it I cried hard. I don't know who Hanna is, but somehow my soul spoke to hers, or rather, God spoke to her through me. Then he spoke back to me through her thought of writing me. I am

humbly grateful that my effort to express God got through to one person. That is between God and her and me, not a thing to be shown around or talked about but to be pondered on in the heart, a cause for thanksgiving but not conceit.

These days are filled with menial jobs. Surely they are filled with opportunity to lift the menial into the realm of the spiritual, bringing the shine of wholesome sweetness out beyond the wear and tear of the material grime. And the garden—what a joy! A sick woman slept in it yesterday. Today the wind is punishing the blossoms, tossing them this way and that, but the good old roots are not disheartened at all. They just stick on a sturdier resistance for next year's blossoms. They don't stop growing to snivel and despair.

May 9th

I must say great inconsistency is exhibited over this that we call death. A woman said today, "Poor Miss H. paid me a long, long visit yesterday. We were not interrupted and she told me all that was in her heart. Poor, poor soul, she will never, never cease to mourn her sister (who died a year ago), not as long as she lives." "But," I said, "her sister was a great sufferer. Isn't it a bit selfish of them, and she a Christian?" I don't know, but it seems to me this perpetual mourning seems a bit selfish. Aren't they mourning most for their own lonesomeness? Immensity seems to me more than anything the immensity of the universe. To be lost in *Space* would be a terrifying thought. Like an endless falling. But how can we realize these things while we are in the physical? Whatever comes we will be what Whitman calls "Equal equipped at last prepared for them." If God prepared us for this world, he can prepare us for the next and equip us. I don't suppose we'll even be surprised. We are not surprised when we come to realize we are alive in this one.

Chimney sweeps are the most arrogant of all men. Such airs, so independent. After letting you *prepare* for the beastly performance they are just as like as not to come three days late and with high head and turning heel suggest you get someone else if you are not perfectly satisfied with them, and threaten to leave you sitting in the upheaval and waiting for another fortnight till another of the

same profession feels like attending to you. Well *I'd* be extremely unpleasant if I had to follow that sooty profession.

May 28th

I have been in among the broom on Beacon Hill sketching. It is difficult sometimes to separate its yellow glory from the yolks of countless eggs. The smell gets right inside of you. It and the blackbirds' song permeate your whole you. If one could only approach a subject like that, by drinking it up to the sky! I think it is such a glory.

May 31st

Sometimes the soul gets so lonely it tries to break through its silence. The tongue and ear want to handle it, to help it grow, fertilize it. Everything is for the soul's growth. She calls to all the physical and material to help her. This physical body is so short-lived and its only use is to contribute to the growth of the soul. And yet we act as if its sole use was for itself, for its comfort and ease.

When souls touch and commune, either silently or by speech, it is the keenest joy there is, I suppose. Perhaps in later lives we shall be sorted out not in physical families but in soul families. And we'll use soul talk, soul attributes, and put on soul growth. These human contacts and relationships are very difficult—so much misunderstanding, so much binding. Perhaps we should not heed the human relationships too strongly but look about among those we meet and contact and perchance recognize some soul relatives, people who have the same common ingredients as us.

The whole of life appears to have great longing and reaching out. The trees and the plants are just the product of the longings of the root down there in the quiet earth, longing to get above ground into the freedom of the light and air. The creatures want to be close to humans, to do what the humans, who are their Gods, do, to go with them, live with them. And we, we want to push on too, to know more and do more things and peer into the unknown, and get a glimpse of the mystery beyond. I suppose the desire is growth.

June 12th. In the caravan at Albert Head

Many things need clearing up in my mind so I'd better try to write them out. I figure that a picture equals a movement in space. Pictures have swerved too much towards design and decoration. These have their place, too, in a picture but there must be more. The idea must run through the whole, the story that arrested you and urged the desire to express it, the story that God told you through that combination of growth. The picture side of the thing is the relationship of the objects to each other in one concerted movement, so that the whole gets up and goes, lifting the looker with it, sky, sea, trees affecting each other. Lines at right angles hold the eye fixed. Great care should be taken in the articulation of one movement into another so that the eye swings through the whole canvas with a continuous movement and does not find jerky stops, though it may be bucked occasionally with quick little turns to accelerate the motion of certain places. One must ascertain first whether your subject is a slow lolling one, or smooth flowing and serene, or quick and jerky, or heavy and ponderous.

Today everything is sullen and black. The wind slams things, and the trees are provoked at having their petticoats turned over their heads. The under sides have a pale, wilted look like a faded garment that has been turned and remodelled and turned back again. Every moment it seems as if the sullen sky were going to leak its waters, as it has already leaked its gloom on the earth. I have waited all morning for it to happen; now I shall defy it.

This is a strange set-apart life. How I wish I were a clear thinker. This is a grand opportunity, when there is nothing to distract, to think things right through to the finish, but there you are taking one pace forward and two back every time, whirling around as if an egg beater were mixing your thoughts. If a plum of a thought would only stick in the wheels and arrest its whirling for a few moments! What is coming? Why worry? The three dogs lie on the bed, their heads touching, a little spiral of snores ascending from the middle, just living, their little lives grown placid, contented, undisturbed about the future, with a great blind faith somewhere inside them that everything will be O.K., trusting me to attend to their wants, living for the moment. Oh, God, how their faith shames ours.

The pliability of growth is marvellous. The limbs that have life in them bend and toss and sway but they do not break. Just the dead ones snap. Life springs back joyously. It's one continuous battle with the elements here, rain, wind or heat. Moderation is at a premium.

This is a place of high skies, blue and deep and seldom cloudless. I have been trying to express them and made a poor fist of it. Everything is eternally on the quiver with wind. It runs on the short dry grass and sluices it is as if the earth were a jelly. The trees in shelter stand looking at the wobbly ones in the wind's path, like a strange pup watches two chum pups playing, a little enviously. I think trees love to toss and sway; they make such happy noises.

The camp is comfortable. It took a little manoeuvring and adapting of the tent and windbreak canvas, and the stove pipe adjusted to the wind, and the elements accepted as part of the game. Life is lovely. The Simcoe Street house and all its troubles and perplexities are in another place in my mind. They have gone to sleep and will, I hope, wake up the better for their nap. I ran in to town yesterday. The garden was a glory of huge poppies and the roses are coming on. Gardens grow so dear to one but I think perhaps we are apt to let them chain us, as we do all our earthly possessions, and encumber us instead of rejoicing us. We do let so much joy slip over our heads and beneath our feet, and let our lives be so full of care. We waste lots of time worrying about our old age that we may never arrive at. We are really awful fools, taking us all round.

A just-right camp morning! There is no rain, no wind, no scorching heat but a joyous moderation of all things, and great peace. Yesterday's visitors saw my sketches and thought them above last year's. I hope so, but there is still very much to be desired. There is a need to go deeper, to let myself go completely, to enter into the surroundings in the real fellowship of oneness, to lift above the outer shell, out into the depth and wideness where God is the recognized centre and everything is in time with everything, and the key-note is God.

One slumps fearfully as one one grows old. It is difficult to under-

stand what one should give in to as belonging to one's years and what one should combat as lazy indulgence. It is so easy to drift. There should come a time for quiet meditation and pondering over things spiritual, but great care should be taken not to sit vacant.

There's a row of pine trees that won't leave me alone. They are straight across the field from the van. Second growth, pointed, fluffy and thick. A field of fine dried-out grain bounded by a cedar-post-and-wire fence edges the field, then the public road, and close to the roadside comes the row of little pine trees. They are very green, and sky, high and blue, is behind them. On days like today the relationship between the trees and the sky is very close. That, I think, is what makes a picture, a thought so expressed that the relationship of all the objects is shown to be in their right place. I used to paint a picture and stick in an interesting sky with clouds etc. that would decoratively balance my composition. It wasn't part of the conception of the whole. Now I know that the sky is just as important as the earth and the sea in working out the thought.

June 30th

The wind is roaring and it is cold. I revolted against wrestling with the campfire and shivering over breakfast in the open field, so I breakfast in the van. It is a day to cuddle down. Even the monkey pleaded to come back to her sleeping box, tuck her shawls about her and watch me.

We worked in the woods yesterday, big dense woods, very green. A panther had been snooping around after the sheep in this neighbourhood. (They go up the trail cropping the grass.) Suddenly there was a great hullabaloo, jangling of sheep bells, and a ewe and her two lambs tore lickety split down the trail, flew over my dog and me, and rushed out of the wood. I wonder if the panther was near?

I did two sketches, large interiors, trying to unify the thought of the whole wood in the bit I was depicting. I did not make a good fist of it but I felt connections more than ever before. Only three more whole days of this absolute freedom and then I have to pack up and get back to the old routine, though it will be nice to get back to those two dear sisters who plod on, year in and year out, with never a break or pause in their monotonous lives. But it would not give *them*

a spacious joy to sit at a little homemade table writing, with three sleeping pups on the bunk beside me, a monk at my shoulder and the zip and roar of the wind lifting the canvas and shivering the van so that you feel you are part and parcel of the storming yourself. That's living! You'd never get that feel in a solid house shut away securely from the living elements by a barricade!

July 1st

I feel that there is great danger in so valuing and looking for pattern and design as to overlook the bigger significance, Spirit, the gist of the whole thing. We pick out one pleasing note and tinkle it regardless of the whole tune. In the forest think of the forest, not of this tree and that but the singing movement of the whole. I suppose that is what the abstractionists are trying to do, boil the thing down to a symbol, but that seems to me rather like cutting a flower out of cardboard. The form may be correct but where's the smell and the cool tenderness of the petal?

July 2nd

Something's happened, I don't know what. A cloud and a heaviness is on this place. It doesn't speak any more. The wind is rude and rough, the skies have lost their lofty blue graciousness. I don't want to work. My heart is like a weight inside me. I am tired of it all but I dread going home to shoulder the house burdens. It's time I broke camp. Everything needs washing and water is short and dragging it up the steep hill from the well makes one precious with it.

July 4th

It's fun to go away from home and great fun to come back. The last week at camp was very bad—such storms that I'd gladly have come home any day. I find my Albert Head sketches rather disappointing. They ought to be better. Subject not enough digested. Spirit not enough awake.

July 18th

My house is up, advertised and listed with agents. I am trying to keep neutral, desiring neither way but knowing that God has ways we know not of and that I shall be provided for.

August 3rd

Exhibition in the lower east flat by request of the Summer School. Open to the general public today, Sunday. Very well attended. Could one sift the entire sayings and conversation that passed in that flat today during those three hours, putting sincerity in one pile and insincerity in the other, which pile would mount higher? It is hard to be absolutely sincere. I believe people were absolutely sincere in their appreciation of the exhibition being open to the public free of charge. They like to get something for nothing and to satisfy their curiosity. A few were sincere in their liking of the work, but the insincere pile mounted high when it came to the work. One feels very strange, very callous.

The thing that makes one sickest is to be asked to explain. You can't *explain*. You can't any more than you can see God—physically, I mean. When people give me slush to my face and it comes to me after they have jeered behind my back, I can't respect them any more, or their honesty. I am not a bit nice to people. I try to be polite but I don't care a hang. I don't want to win them. I don't want to educate them. I don't want to coerce their favours to my own way of seeing. Then there are the horrid commercial types whose joint question is, "Do you sell much?"

Suddenly, in the middle of all the people and all the confusion of tumbling, unmeaning words, someone says, "Where's that?" And you lift your eyes to the painted husk and pass through it, out, out, ever so far, to the story that beckoned and urged you to try to express it. Then someone comes up and says, "What did you mean?" They want lettered words that can be rolled on the tongue. They can't understand you could not word those happy yearnings, those outgoings when the Supreme Spirit touches its child.

The days roll on and you laugh and cry, pout, wonder, rage, sing, and wait for what comes next. It takes all sorts of material to make a pudding. You go on stirring in spice and flour and rising and shortening and salt. Everyone is throwing all those things in, one after another, and life is mixing them up. By and by you forget about the ingredients and just wait for the cooking to be finished. And then will come the realization of the whole good pudding. The flour and the spice and rising and shortening won't exist as themselves but the pudding will exist whole and complete—delicious.

August 6th

Great and extreme weariness today after general public exhibition Sunday and Summer School exhibition Monday. A great many came and were appreciative. One stands like a bullock waiting to be killed. Then suddenly someone will, as it were, stick a pin in you by some remark, and you jump to life with a quiver because someone has laid a prick in a sensitive spot, and suddenly you are back there where the thing spoke to you and you tried to record it, and if the eye-looker does not get the idea at all you are shamed. A great crop of impatience springs up and you try to hurry away out of anywhere, away from people, back to the silent words that nature uses.

How glorious it will be when we don't have to use words at all, just a knowing in our hearts and a seeing in our souls! But first we will have to graduate in knowing and seeing. The whole world the classroom!—just to think of it makes one feel like a nestling must peeping over the edge of the nest.

It's perfect *agony* for me to work with anyone watching behind my back. Seems as if their eyes are a million needles piercing through your marrow deep. I have made a little tent affair to cover over my canvas and I squat like an Indian and work in under the wind flaps and the sun streaks. I don't mind them; it's eyes that agonize. Some artists don't mind a bit. I envy them and wish I did not. I hate every human being when I am at work. No wonder I am no painter, since love is the connect-up that unifies all things. How can one express anything with meaning without love at heart?

From observation I note married life is not all bliss. They say cruel things to each other, then they are sorry. When away from the other they are very loyal and tender; when together they twang each other's nerves to breaking. Familiarity breeds contempt, all right. Probably royalty, amid conditions where there has to be more formality, get on more comfortably, practising more reserve and not tumbling into disappointment so often. There's servants to open and shut doors, so no excuse for banging them.

A man told me he was dining at a hotel and at an adjacent table

he heard a man say to another, "Well, I've had a splendid morning, most enjoyable. I spent it with Emily Carr in her studio and she gave me the best criticism ever I had in my life. She's outspoken but she's to the point and I felt it most helpful." It pleased me much. I so often feel I am not much use to my fellow men either by working or being alive. Perhaps it comes of the quiet ignoring of my work by my own folk, that I have been reared up to feel my profession rather a useless, selfish one. So when anyone says, meaning it, that they have got any help or inspiration from my work I feel terribly glad. Life seems to have been one long tussle between my duty to art and to my people—which shows I am no *real* artist or I could not let any single thing divide honours with my work.

A Tabernacle
in the Wood, 1935

September, 1935

Blessed camp life again! Sunshine pouring joyously through the
fringe of trees between the van and the sea. I got up very early today.
The earth dripped with dew. These September days are fiercely hot
in their middles and moistly cold at the beginning and end. In spite
of its fierce heat the sun could not disperse the fog across the water
all day yesterday. It hid the mountains. All night and most of the
day the fog-horn blared dismally, each toot ending in a despairing
groan.

There is a young moon early on in the evening, but she goes off to
wherever she does go and leaves the rest of the night in thick velvety
blackness, shades darker than closed eyes and so thick you can take
it in your hands and your teeth can bite into it. When that is down
upon the land one thinks a lot about Italy and Ethiopia and wonders
how things will settle. One hangs on for dear life to the thought
there is only one God and He fills the universe, "comprehends all
substance, fills all space" and is "pure being by whom all things be."

Life looks completely different after a good night's sleep. The hips
on the rose bushes never looked so brilliant nor the light through the
trees so sparkly. Breakfast cooked on the oil stove in the van and
eaten tucked up in my bed with the window and the world on my
right and the row of dogs in their boxes, still sleeping, on the left.
Sheep and roosters crying, "Good morning, God, and thank you,"
and the fog-horn booing the fog out of existence, making it sneak
off in thin, shamefaced white streaks.

There will be sunshine in the woods today, and mosquitoes and those sneaky "no-see-ums," that have not the honest buzz of the mosquito that invites you to kill him. You neither see nor hear nor feel "no-see-ums" till you go to bed that night, then all the venom the beast has pricked into your flesh starts burning and itching and nearly drives you mad.

Sketching in the big woods is wonderful. You go, find a space wide enough to sit in and clear enough so that the undergrowth is not drowning you. Then, being elderly, you spread your camp stool and sit and look round. "Don't see much here." "Wait." Out comes a cigarette. The mosquitoes back away from the smoke. Everything is green. Everything is waiting and still. Slowly things begin to move, to slip into their places. Groups and masses and lines tie themselves together. Colours you had not noticed come out, timidly or boldly. In and out, in and out your eye passes. Nothing is crowded; there is living space for all. Air moves between each leaf. Sunlight plays and dances. Nothing is still now. Life is sweeping through the spaces. Everything is alive. The air is alive. The silence is full of sound. The green is full of colour. Light and dark chase each other. Here is a picture, a complete thought, and there another and there. . . .

There are themes everywhere, something sublime, something ridiculous, or joyous, or calm, or mysterious. Tender youthfulness laughing at gnarled oldness. Moss and ferns, and leaves and twigs, light and air, depth and colour chattering, dancing a mad joy-dance, but only apparently tied up in stillness and silence. You must be still in order to hear and see.

September 13th
How it has rained! With the canvas top of the van so close to my crown I have full opportunity to note all the different sounds: the big, bulgy drops that splash as they strike, the little pattery ones, the determined battalions of hurried ones coming with a rattling pelt, the soft gentle ones blessing everything, the cleansing and the slopping and the irritated fussy ones. It is amazing that no two of them sound alike when you listen. The moss and grass and earth are gulping it in. Every pot and pail in camp is overflowing. After

193

the water shortage it seems so reckless to throw any away. Mists rush up from the earth to meet the rain coming down so that between them both the fog-horn is in a constant blither.

All the busy bustle has gone out of the wasps' wings. They drift in drearily seeking a warm corner to give up in. It is the third day of rain; everything is soggy and heavy now. Patches of bright green show in the faded, drab fields, and patches of pale gold are in the green of the maples. Colours are changing their places as in Musical Chairs to the tune of the rain. The fog-horn has a fat sound in the heavy air.

A dreary procession of turkeys is mincing down the road. The rain drips one end from their drooping tails and the other from their meek heads. There is no gobble left in the cock and even the pathetic peep of the hens is mute. If ever any beast had the right to be depressed it is the turkey, born for us to make merry over his carcass. The peep of the chicks and the hens is downcast, their walk funereal, their heavy flight bewildered. The cock tries to put a good face on it occasionally and denounces his fate with purple indignation, but you have only to "shoo!" and he collapses.

September 15th

From the window of the van, tucked up cosily with a hot bottle across my feet, I can sit and watch the angry elements. It has poured for five days, wholehearted, teeming rain. Today loud, boisterous wind is added. The sea is boiling over the black rocks; branches of foaming white smother them. Where there are no rocks to punish, it boils in wicked waves, row upon row that never catch up. The sheep and turkeys across the fields crop restlessly. They scatter and do not lie down. The waves and trees shout back at each other, a continuous roar and hubbub. Only in the van is there a spot of quiet. The dogs, monkey and I are all in our beds in a row like links in a chain of peace. We are cuddled down listening with just a shell of canvas shutting out the turmoil.

It is very wonderful dumped here in its middle and yet not of it. Time was when I would have wanted to go out and be buffeted, join in, hit back. Years change that wish—rheumatics, sore joints, fat here and there, old-age fears and distrust of one's capabilities. I am

sorry about the work but I haven't one doubt that it's all a part of the discipline and training.

September 19th
The early morns are nippy, dewy, penetrating cold that won't be denied admittance either to the van or to your person. It ignores canvas and flesh and blood. It is after rheumatic joints and dull livers. Last night I wasn't much removed from a mollusc because I'd been behind myself pushing all day—real liverish. It was not till 4 p.m. I got up steam and a real enthusiasm over a bit of near woods. It seems an impossibility to squeeze energy to walk the big wood distance. A domineering liver is a fearsome thing.

When the horn, normal at first and developing into a despairing grunt, informs the early world that fog is on land and sea, van cosiness reaches its high water mark. One effort and you have clambered out of bunk. A match across the shelf checks the horn back. Soon the sweet kettle song rises. Toast-and-teaish odours skedaddle the fog. And there you are, washed, ready, pillowed, hot-bottled, breakfasted, and full of content.

I rose early and made tea and spent a delicious hour in bed, luxuriating. The sun is penetrating through the woods now. The green grey is coldly lit with a cool sparkle. How solemn the pines look, more grey than green, a quiet spiritual grey, blatant gaudiness of colours swallowed, only the beautiful carrying power of grey, lifting into mystery. Colour holds, binds, "enearths" you. When light shimmers on colours, folds them round and round, colour is swallowed by glory and becomes unspeakable. Paint cannot touch it, but until we have absorbed and understood and become related to the glory about us how can we be prepared for higher? If we did not have longings there would be nothing to satisfy.

Yesterday I went into a great forest, I mean a portion of growth undisturbed for years and years. Way back, some great, grand trees had been felled, leaving their stumps with the ragged row of "screamers" in the centre, the last chords to break, chords in the tree's very heart. Growth had repaired all the damage and hidden the scars. There were second-growth trees, lusty and fine, tall-standing bracken and sword ferns, sallal, rose and blackberry vines,

useless trees that nobody cuts, trees ill-shaped and twisty that stood at the foot of those mighty arrow-straight monarchs long since chewed by steel teeth in the mighty mills, chewed into utility, nailed into houses, churches, telephone poles, all the "woodsyness" extracted, nothing remaining but wood.

And so it must be. Everything has to teach something else growth and development. Even the hideous wars are part of the growth and development. Who knows? It may be that the great and strong are killed to give the shrivelled weaklings their chance. We just don't know anything. We can only trust and grow as straight as we can like the trees.

The world would laugh at these "pencil thinkings," but they help one to think, reach conclusions. Our minds are a mess of "begun" thoughts, little abortive starts. Another twitch and we are off on another thought leaving them all high and dry along the beaches because the waves of our thoughts have not swept high enough to pick them up again. Perhaps a full tide with big waves will come later and refloat them and carry them to another beach and on and on till they stick somewhere and their elements turn into something else. Nothing ever, ever stands still and we never, never catch up. One daren't think about it too much for it makes one giddy.

When the early morning nip is blueing your nose, and "Little Smelly" is tuning up the tea kettle, and the van windows have modesty blinds of steam, and the air is too full of vapour for the wasp wings to have any buzz and you hope their stings also are waterlogged, then it is good to pin a yesterday's sketch up and look it squarely in the face. Um! It did not look so bad in last night's light. It is done in swirly rings. Why? Not for affectation any more than the cubists squared for affectation. Like them I was trying to get planes but used disks instead of cubes. It gives a swirling, lively movement, but until mitigated is too blatant. Things are swirling by themselves. The thing to do now is to swirl them together into one great movement. That is going to be a thrilling canvas to work out in the studio later, refining, co-ordinating, if there is money enough to buy paints. Why worry? Here the job is to absorb. What, eat the woods? Yes, as one eats the sacrament. Munching of the

bread is not eating the sacrament; it is feeding on it in our hearts by faith with thanksgiving. It is good for remembrance.

We are still among material things. The material is holding the spiritual, wrapping it up till such time as we can bear its unfolding. Then we shall find what was closed up in material is the same as is closed up in our flesh, imperishable—life, God. Meantime bless the material, reverence the container as you reverence a church, not because of the person or the pulpit or the pews, not because of the light coming through the stained glass or the music rolling through the air, but because of those who go there to meet God, compelling their material bodies to sit in the wooden seats and allowing their souls to go out to meet "wholeness," the stream of life, God. "God is a Spirit: and they that worship Him must worship Him in spirit." How we do try to make God into an image! No conceivable image could permeate through all time, space, movement as spirit, that which *is* though it is not formed or made. We cannot elude matter. It has got to be faced, not run away from. We have got to contact it with our five senses, to *grow* our way through it. We are not boring down into darkness but through into light.

Bads and goods have hurled themselves with velocity through this day. The lamp went on the blink. The kettle broke. Woo got the salt bottle when I was out, threw the top down the bank and filled the bottle with bugs. In a moment of emphasis I waved the iodine bottle to bring home a point and deluged Mrs. McMuir, arms, dress, floor, and it won't wash off. Then I clambered up a ladder to paint the lid of the old lady and waterproof her for winter; the little devils of dogs, seeing me well set, took the lid off the meat pot and devoured today's and tomorrow's dinner. And I got a cheque for $15 for a sketch I never expected to materialize. Burned my melba in the McMuirs' oven. Came home and found the Yates girls had left a lamp wick and some good prune plums on the van step. All in one day. Such is life.

Splendid days, cold and hot; gold, grey; soft, crisp. Any hour any condition may prevail. The woods are tender one minute and austere the next, sometimes riotously rich, coldly pale in colour. I did two studies yesterday in thick, wild undergrowth. At the beginning of

each I dropped into a merry swing-off and ended in a messy con-
glomeration, but there are thoughts in them to follow up. They
swing a little but not in one sublime swinging "go." Something keeps
peeping out; look at it and it's gone.

Most men are very stupid. You ask a perfectly clear, straight
question, "Can I go through your gate up into the woods to sketch?"
He looks at you, closes the gate, looks over the top, grins foolishly,
weighs himself first on one foot and then on the other, and says, "I
don't know. It would not be any good to you."

"Why?"

"Well, you see. . . . What do you want?"

"To pass through the gate and get up the bank on to those rocks."

Again he went through all his silly manoeuvres. "It wouldn't be
any good," he said again. "There's a high barbed fence. You could
not get through."

Stupid ass, why didn't he say so right off!

The schoolhouse is at the top of the hill. A rough playground is
scooped out of the trees and brush. It looks dull. Not a sound comes
out of the open windows. The door is fast shut, and there are jam
bottles holding a few scrubby flowers on the high window-ledges.
There are two swings, two rings and two privies. I'd hate to be
educated there. At the corner, the hill takes a nasty curve. The gravel
is rough and twists ankles. The man's barbed wire fence has turned
and runs up through the jungle. Now one can turn in among the
sallal bushes. The sheep have made walks there. Their hooves have
cut the rotten fallen logs where they cross. The earth is damp and
reddish brown. Mostly it is thickly spread with coarse herbage and
fallen trees rich with moss, tough sallal with fat black berries walk-
ing single file up their stalks like Chinamen, strong naked roots
veining the red earth like old knotted hands. There are a few birds
but all the woods are mostly hushed and mysterious. When a
squirrel coughs and when wrens hop among the twigs, it makes one
jump. The big sword ferns point up in imitation of the high-pointed
pines.

A hundred yards farther on the road is lost. The forest has closed
about you. You will see neither beast nor man unless you keep to

the little sheep trail. It is all above your head, the tangle, and there is no place for your feet for the rotted tree boles that lie waist high, hidden in scrub so that you cannot perceive them. There is the next generation of pines, cedars, hemlocks; uprooted tree-roots as high as a house, the earth clinging to them still, young trees and bushes growing among them and the hole the tree left filled now with vigorous green. You need not penetrate far into this massed tangle. Here is a little stream's dried-up bed. Across it the tangle rises, the sheep path goes up. You can sit on the path and look down on the snarl of green. It is lovely. Suddenly, its life envelops you, living, moving, surging with being, palpitating with overpowering, terrific life, life, life.

September 29th

The end of sitting in the quiet has come. Tomorrow I pack up to quit camp and square my shoulders to receive the burden of the apartment house. Goodbye to these intimate friends, the trees, and this slice of deep sky over my field that is fuller with stars than any sky I've ever seen. Goodbye to the shimmer that lies between the boles of the trees on the bank near the cliff, neither sky nor sea but between the two, which shows first when I draw the van curtains. Goodbye to the jungle wood with its rich red-brown earth pungent with autumn, and flares of the late maples and calm green-grey pines.

The light goes early these afternoons leaving the forest to the grip of a penetrating chill. Tantrum complains bitterly and will not sit on the earth but jumps into my lap so that I must work across him, struggling with those swaying directions of movement, space rolling into space, this into that, blending, meeting, pursuing, catching up till the thing is one, all things settled into one grand movement which holds and looks back at you and speaks. The hammock comes down, the camp fire goes out and the little van will sit lonesome at the base of the high, high pine.

The last sketch of my van season is a study of underbrush and not successful. There is a sea of sallal and bracken, waving, surging, rolling towards you. Green jungle, thick yet loose-packed, solid, yet the very solidity full of air spaces. Perfectly ordered disorder

designed with a helter-skelter magnificence. How can one express all this? To achieve it you must perch on a desperately uncomfortable log and dip among the roots for your material. Yet in spite of all the awkwardness there is a worthwhileness far exceeding a pretty sketch done at ease. There is a robust grandeur, loud-voiced, springing richly from earth untilled, unpampered, bursting forth rude, natural, without apology; an awful force greater in its stillness than the crashing, pounding sea, more akin to our own elements than water, defying man, offering to combat with him, pitting strength for strength, not racing like the sea to engulf, to drown you but inviting you to meet it, waiting for your advance, holding out gently swaying arms of invitation. And people curse this great force, curse it for a useless litter because it yields no income. Run fire through this green sea, burn it, break it, make it black and frightful, tear out its roots! Leave it unguarded, forsaken, and from the bowels of the earth rushes again the great green ocean of growth. The air calls to it. The light calls to it. The moisture. It hears them. It is there waiting. Up it bursts; it will not be kept back. It is life itself, strong, bursting life.

There are no words, no paints to express all this, only a beautiful dumbness in the soul, life speaking to life. Down under the top greenery there is a mysterious space. From the eye-level of a camp stool you can peep in under. Once I went to some very beautiful children's exercises in a great open space. There was no grandstand. The ground was very level and it was most difficult to see. I took a camp stool and when my feet gave out I sat down. It was very queer down among the legs of the dense crowd—trouser legs, silk stockings, knickerbockers, bare legs, fat legs, lean ones—a forest of legs with no tops, restless feet, tired feet, small, big, lovely and ugly. It was more fun imagining the people that owned the legs than watching the show. Occasionally a child's face came level with yours down among the milling legs. Well, that is the way it feels looking through bracken stalks and sallal bushes. Their tops have rushed up agog to see the sun and the patient roots only get what they can suck down through those tough stems. Seems as if there is something most wonderful of all about a forest, especially one with deep, lush undergrowth.

October 11th, Victoria

The first dismal rain of winter. Summer hanging between life and death. Everything shivering and dripping like the time between death and the funeral. War news dismal, fires sulky. If one were a bear, now, how jolly it would be to take your fat-prepared body into a hollow tree already selected, ball yourself up with your paws over your face, and sink into a peaceful stupor, absorbing your own fat for sustenance without even the pest of selection, chewing or dish-washing.

I can't find a mode of expression for jungle undergrowth. It just sticks at paint as if the coming and going of mystery were abhorrent to paint. I say to myself, "Why want to paint? When the thing itself is before one why not look at it and be content?" But there you are. You want something more. It is the growth in our souls, asking us to feed it with experience filtered through us. We are very lazy experiencers, content with the surface instead of digging down.

This from Psalm 132:

> I will not give sleep to mine eyes, or slumber to mine eyelids, until I find out a place for the Lord, an habitation for the mighty God of Jacob. Lo, . . . we found it in the fields of the wood. We will go into his tabernacles: we will worship at his footstool. Arise, O Lord, into Thy rest.

Surely the woods are God's tabernacle. We can see Him there. He will be in His place. It is God in His woods' tabernacle I long to express. Others prepare a tabernacle for Him here and there, in a church, a flower or vegetable garden, a home, a family. Everyone has his own special tabernacle set aside for God in the place where He seems nearest.

October 19th

I have known for some days that I was to have an exhibition in Toronto at the "Women's Art." I felt a little thrilled about it—a chance to see if my work means anything to the outside world. The West is an absolute blank when it comes to ranking one's work. It had been on the tip of my tongue to tell my sisters, then somehow

my shoulders shrugged of their own accord and I remained silent. Alice is too absorbed in her little ones to care, or too busy, poor dear, even to waste hearing time. I said to Lizzie, "I'm having a fifty-sketch exhibition in Toronto." She replied, "Oh." And immediately, "Miss Heming's brother has just got a big commission, six pictures at $1,000 apiece. Just think, $1,000 apiece!! I hope he will give some to his sister." Our art conversation was ended; she turned off to other matters.

What was it that hurt all over? Not jealousy of Heming's luck. I can't do the "big money" stuff and I don't want to. The reproductions of his work I have seen made no appeal to my desire to do likewise. Blatant, selling things, done for money, with money in view from their first conception. I *do not* envy him his success. True, I'd be dreadfully glad to sell to help out but I would not give up the moments of pure joy I get out in the woods, searching, for his artificially gaudy "pleasers." The hurt came from her complete indifference. She did not want to know when or where or why. No money in my shows and, in my people's mind, that is the only reckoning of art of any worth. It was as if someone had kicked my favourite dog. How curious that one should care so.

For the last week I have been struggling to construct a speech. Today I delivered it to the Normal School students and staff. It was on "The Something Plus in a Work of Art." I don't think I was nervous; they gave me a very hearty response of appreciation, all the young things. (It hit them harder than the three professors, all rather set stiffs.) "Something quite different from what we usually get," they said. The most pompous person said after a gasp of thanks—"I myself have seen that same yellow that you get in that sketch, green that looked yellow. Yes, what you said about the inside of the woods was true, quite true—I've seen it myself." Pomposity No. 2, very tidy and rather fat, introduced himself with a bloated complacency, "I am so and so"—a long pause while he regarded me from his full manly height. "I have seen your work before but never met you." After this extremely appreciative remark, he added, "Most interesting." Whether he meant the fact we had not met before or my talk was left up in the air. The third

Educational Manageress was female. She said, "Thank you. It was something quite different from the talks we usually get. I am sure I do not need to tell you how they enjoyed it—you could see that for yourself by their enthusiastic, warm reception." They did respond very heartily. One boy and one girl rose and said something which sounded genuine, though it could not penetrate my deaf ear. I could only grin in acknowledgement and hope it was not something I ought to have looked solemn or ashamed over. I was interested in my subject and not scared, only intent on getting my voice clearly to the back of the room and putting my point over. Afterwards I wished I had faced those young things more steadfastly. I wished I had looked at them more and tried to understand them better. If ever I speak again I'm going to try and face up to my audience squarer, to take courage to let my eyes go right over them to the very corners of the room, and feel the space my voice has to fill and then to meet all those bright young eyes. There they are, two to each, some boring through you—waiting. Of course I had to read my talk and that makes all the fuss of spectacles on for that and off for seeing the audience. It must be very wonderful to be a real speaker and to feel one's audience as a unit, to feel them sitting there, to feel them responding, at first quizzically then interested, finally opening up, giving whole attention to what you yourself have dug up, what you have riddled out of nature and what nature has riddled into you. Suppose you got up with a mouthful of shams to give them and you met all those eyes. How you would wither up in shame! What a sneak and an imposter if you did not believe sincerely in what you were saying and were not trying yourself to live up to that standard!

November 1st
Within the last few months three men have been to the studio who were all bitterly opposed to me and to the newer creative art. All three are artists (of sorts), and all were ardent in appreciation. I wonder if it was quite genuine? Apparently they seemed to find something there that moved them. Oh, Emily, Emily, be very careful. Strive earnestly towards the real. Let nothing these or any say satisfy or puff you. It is a trust. Seek earnestly, reverently. Stick

tight and do not get dismayed. Those men do little, inefficient, foot-ling things and seem vastly satisfied, and *yet* they seem to find something beyond money value in my work. They start out by talk-ing money-value and "are-you-selling-these-days?" stuff, and brag a little if they have made a sale. Oh, if money and art never needed to be connected, how much purer art would be! It is like money and religion. Money spoils it all.

Worked on some sketches that needed strengthening in expres-sion. I must work on some canvases. If only one could combine spontaneity with more careful depth got through study.

November 3rd

Clem Davies reads the Psalms beautifully. I never realized the pro-phecy and the affirmation of God's wonderfulness were told there to such an extent. Clem stops and talks about verses. He reads and prays beautifully. You feel he is talking to God and you feel God is talking through the Bible via Clem Davies when he reads it. I'd just as soon be read the Bible as preached to. On the way home I go to see the Empress conservatory. For three weeks the chrysan-themums have slowly been bursting—raggedy ones, curly ones, spindle blossoms and great heavy-headed blooms on sturdy stems. At the base is a border of primulas. The house is quite cool and the smell of the primulas and that clean, pungent odour from the mums is delicious. Perhaps at this stage they please the nose even more than the eye.

November 4th

Life, the house is filled with it; from the attic bedroom come little inarticulate squeals. Vana has four of her new-born pups up there. More little squeals issue from the sitting-room where the overflow are in an old felt hat supported by a hot bottle and an Indian basket. Day and night Vana and I supply warm milk. We swap bunches every few hours as Vana has to undertake all the bathing operations. So we bunch the four males and the four females and alternate so that all get equal nursing. Vana has implicit faith in my arrange-ments and never disputes my judgement. There is a grand feeling

in being trusted unreservedly. Goodness, if we would only trust our God like the animals do theirs.

Nine men and women came to the studio last night. I handed out sketches and canvases for an hour and a half. It was harder work than feeding nine puppies by hand for one week.

November 16th
Sometimes my whole soul cries out in revolt at this *beastly* house, at the slaving and pinching to keep up for the one mean tenant paying so little, exacting so much, hinting at the limitations of my establishment, insinuating its age and incompleteness and how much better other places are, and magnanimously allowing that all old houses are like that, that things will wear out and following the statement by the wonderful flat Mrs. So-and-so has. She does not mention the fact Mrs. So-and-so pays double as much and has some disadvantages like tiny rooms, mere cupboards of kitchens, dark out-looks, no garden, no beloved park at the door. Oh dear, oh dear, all the wickedness in me rebels at the beastly, rotting house. I know it is crumbling up, I know it needs repairs, I know it is not modern, I know I am not a real downright good landlady, willing to grovel before my tenants, to lick their dirt and grab their cheques. It crushes the life out of me, this weight of horrid things waiting to be done because my back hurts so I *can't* do them myself and have no money to pay someone to do them. And then maybe I go into the beautiful studio and see some sketches about and feel my skin bursting with things I want to say, with things the places said to me that I want to express and dive into, to live—and there's that filthy furnace to clean out and wood to chop and sweeping and dusting and scrubbing and gardening, just to keep up a respectable appearance for the damn tenants so as to squeeze out a pittance of rent to exist on. And all the time know you are shrivelling up, growing sordid because time and strength which you need for enrichment to allow you to search and absorb and grow cost money and time and strength—and your bile boils over and you are full of bitterness and hate yourself for being bitter when loads of folks these days have worse. God seems so deaf—your prayers dwindle away half formed

or, if by effort you force yourself to form the words, they hit back at you like empty echoes.

There is not one living soul one can say things to, empty your heart out before. It is better to bottle up than to pour into a cold, unsympathetic ear and be told, "Well, you know, Millie . . . etc., etc. . . ." in a righteous endeavour to show you it is all entirely your *own* fault, your wrong thinking and wrong acting. Then maybe the friend starts out with, "It is simply a shame you have to do all these other things. You should have time, money, etc. to develop." Then a great burst of contrariness makes you leap the other way, defend the jobs, retort that it "makes you paint better to have to struggle first," and then your heart says, "Do you mean that, or are you lying for fancy-work?" And you don't know what you mean and jog on sullenly and resentfully. Now go out, old girl, and split bark and empty ashes and rake and mend the fence. Yet—should I? Or should I climb higher, shut my eyes to these things and paint? Rise above the material? No—I think you've got to climb *through* these things to the other.

November 26th
Recorded no thoughts today either in paint or words. Worried at a jungle of undergrowth. I think there must be such days and they are not lost.

There is a side of friendship that develops better and stronger by correspondence than contact, especially with some people who can get their thoughts clearer when they see them written. Another thing—that beastliness, self-consciousness, is left out, shyness, shamedness in exposing one's inner self there face to face before another, getting rattled and mislaying words. The absence of the flesh in writing perhaps brings souls nearer. It is possible to form some warm friendships with people one has never seen, only written to and heard from. Some people can become beloved friends, calling back through ages to you through written words, and you can sort of talk back too. Friendships are very delicate—apt to snap when strained—shouldn't, but do. Perhaps everybody has to have a *secret* place deep in the middle of themselves where they are not supposed

to admit others, only God, a spot you've got to keep sacred. It seems so natural and "meant to be" to stand guard in front of that inmost place as though we were meant to be solitary like raindrops falling. And then when we hit Heaven (or Heaven hits us) we won't be drops any longer but one ocean; there won't need to be a secret place inside any more, because we will have nothing ugly to hide.

November 28th
Working on jungle. How I want to get that thing! Have not succeeded so far but it fascinates. What most attracts me in those wild, lawless, deep, solitary places? First, nobody goes there. Why? Few have anything to go *for*. The loneliness repels them, the density, the unsafe hidden footing, the dank smells, the great quiet, the mystery, the general mix-up (tangle, growth, what may be hidden there), the insect life. They are repelled by the awful solemnity of the age-old trees, with the wisdom of all their years of growth looking down upon you, making you feel perfectly infinitesimal—their overpowering weight, their groanings and creekings, mutterings and sighings—the rot and decay of the old ones—the toadstools and slugs among the upturned, rotting roots of those that have fallen, reminding one of the perishableness of even those slow-maturing, much-enduring growths. No, to the average woman and to the average man, (unless he goes there to kill, to hunt or to destroy the forest for utility) the forest jungle is a closed book. In the abstract people may say they love it but they do not prove it by entering it and breathing its life. They stay outside and talk about its beauty. This is bad for them but it is good for the few who do enter because the holiness and quiet is unbroken.

Sheep and other creatures have made a few trails. It will be best to stick to these. The sallal is tough and stubborn, rose and black-berry thorny. There are the fallen logs and mossy stumps, the thousand varieties of growth and shapes and obstacles, the dips and hollows, hillocks and mounds, riverbeds, forests of young pines and spruce piercing up through the tangle to get to the quiet light diluted through the overhanging branches of great overtopping trees. Should you sit down, the great, dry, green sea would sweep over and engulf you. If you called out, a thousand echoes would

mock back. If you wrestle with the growth it will strike back. If you listen it will talk, if you jabber it will shut up tight, stay inside itself. If you *let* yourself get "creepy," creepy you can be. If you face it calmly, claiming relationship, standing honestly before the trees, recognizing one Creator of you and them, one life pulsing through all, one mystery engulfing all, then you can say with the Psalmist who looked for a place to build a tabernacle to the Lord, I "found it in the hills and in the fields of the wood."

December 1st
The year's last month. Everything broods today, the sky low and heavy. Was there ever a sun? Where has he gone? Nor ray, nor warmth has he left behind him. There is a heavy, waiting feel (like you get in a dentist's ante-room waiting your turn).

December 3rd
A dumpish day—cold spreading from the feet up, the sodden earth piercing up through your boot soles, jeering at your stockings, and aching your feet to the ankle.

People have been to see the puppies. They are four weeks old, like a box full of precious gems, sparkling and perfect. I hate to sell, to take filthy money for life and love. Isn't it horrid to mate creatures so that lives may be produced that we may sell those lives and use the money to feed ourselves and keep our lives going? Life is all wheels within wheels!

December 11th
Life, life, how difficult! The horrible doubts that come, that brood over you and eat into the very marrow, turning the whole world into an ache! This morning's mail brought an envelope full of theosophical literature. Once it interested me, now it sends me into a rage of revolt. I burnt the whole thing. I thought they had something, Lawren, Bess, Fred, something I wanted. I tried to see things in their light, to see my painting through theosophy. All the time, in the back of my soul, I was sore at their attitude to Christ, their jeering at some parts of the Bible. Raja Singh came; I hurled H. P.

Blavatsky across the room. Who was she to set herself up? Who was she to be a know-it-all of life and death? I wrote to those in the East, told them I'd gone back to the beliefs of childhood. The exchanged letters cut all the real bonds between us. Now there is a great yawn—unbridgeable—their way and my way; the gap is filled with silence.

Real success must be this—to feel down in your own soul that the thing you have striven for has been accomplished. To this must be added the appreciation of the thing done by those you love and whose appreciation you value. The person who counts is the person who has nothing to gain, who lets himself go out to meet the thing you have been striving to create, the nameless something that carries beyond, what your finger cannot point to.

December 12th

I am sixty-three tomorrow and have not yet known real success. When someone comes to my door I hide my canvas, as if it was something shameful, before I open to a stranger. If people ask to see pictures I show reluctantly. It is *torture* to exhibit to some. I say to myself, "Why? Is this some type of ingrowing conceit?" But I can't say. I do not know the answer. If anybody whose judgment meant anything real to me came, I would be very glad. But I do not know of any such person—an absolutely honest soul. There is something down deep in our own selves that is our critic and our judge. Everybody carries his own judge and jury round inside him and tries to dodge them too, or to argue them down and sass them back.

A friend brought me today a piece from *Saturday Night*. A man who had been to my studio wrote it.

WORLD OF ART*

By G. Campbell McInnes

I have made the acquaintance recently of one of the most sincere, forceful and genuinely artistic personalities it has been my pleasure to meet. She is Miss Emily Carr, of Victoria, B.C., who is having a showing at the Women's Art Association at 23 Prince Arthur Avenue. She calls her pictures "Impressions of British Columbia"; she does herself less than justice. Impres-

*Saturday Night, Vol. 51, No. 5, Dec. 7, 1935. By permission.

sions they may be, but so striking, so vivid, so full of the real *furor poeticus*, that they are unforgettable.

She paints quickly and with a fierceness and passion that are completely convincing. Her technique is astonishing. Viewed closely, the sheer audacity of her rapid brush strokes compels admiration, while each picture, regarded as a whole, has in it the concentrated essence of the impact of a deeply sensitive and fervent nature on a scene for which she feels with an intensity that only prolonged study and profound conviction can bring.

Painting to her is almost a religious experience, but there is no suggestion of a sentimental mysticism. Rather there is, in her work, despite its strength and dynamic movement, a joyous quality reminiscent of the early work of Vlaminck. But Vlaminck has since become what the cruel French call a *faiseur*; Miss Carr is a great artist and will never do that. I should not like to think that anyone would miss this exhibition. They will meet an artist who is, in her own way, as *possessed* with the creative urge as that powerful and tragic figure of the last century whose name was Vincent Van Gogh.

I felt dreadfully embarrassed and blushed up when she read it out.

December 14th

Today writing Christmas letters, saying the usual easy, tossed-off "Merrys," the same "Happy New Years." This 1936, what will it bring to the world? Will the nations rush at each other's throats and spill each other's blood? One can only wait day by day with one's hand on the little day-by-day jobs. I wonder if I shall crawl from under the weight of my house this year. I have ceased dreading the change; the wait has become irksome, unbearable. The house is like a jail about me. I feel curiously hard now, tired of it all. Honour has come to me here; some of the flattering things said in my studio have rung true. I feel to the house like a bird must to her last year's nest. What happens to the old birds that are beyond nesting? That has always been a wonderment to me.

Not so cranky today. I guess the liver is the seat of the Devil any-

how. Mercy, but Alice is patient with all those people's rasping brats and, worse than them, the mammas, papas and grands.

People have been looking my house over. I would not care so much if they confined their looks to the house. They prod the walls, smell up the chimneys, poke into cupboards, investigate leaks, examine the furnace's inside with lighted newspaper. One expects all that. But they don't stop at that; they examine *me*, and I resent it. I suppose your home is full of yourself, your own little notions and mannerisms and hobbies and idiosyncracies, the use you've put things to, the stamp of yourself on your own things. These things they smile at and remark on. That is not their business. You are not trying to sell these things any more than you are trying to sell yourself. I resent being a show for strangers, exposing the me-ness of my home, and I shiver when they peer and discuss the personality in my studio, my mode of painting and living. "And she keeps a monkey!" "And she has a van and takes all the creatures!" "And. . . ." "And. . . . "And. . . ." And I pull them back severely to the money value, income-bearing properties, to the garden, the chimney, the big windows, the high ceilings. Then there is a bellow, "Look at the chairs hanging from the ceiling!" What business of theirs where I keep my chairs? I'd strap them round my waist so that they'd naturally sit me whenever I bent, if I *wanted* to. I want to hit out, but also I want to sell, so I bottle down. But I sizzle sometimes like a tap without a new washer.

These nights the mists lie low across the lake and among the pines. They drench the earth, more penetrating than rain. Five pines, thin, gawky ones, point up over the top of the mist like long fingers with the palm they belong to down in the mist. When you look straight up you see above the mist and the sky is a deep blue-black peppered with stars. Stars frighten me and that awful space between you and them, terrifying, unknown, filled with lights and colours and sounds that we don't know yet. Even I can remember when the park was full of woods and wild flowers, and owls hooted and there were lady-slippers and wild lilies and the lakes were swampy pools with thick straggly growth round and in them. In winter we slid on the ponds. In summer they covered up with green slime and frogs hatched there and croaked madly. The flowers that grow in the

park now would turn up their noses, if they had them, at the flowers that grew then. I, walking there, am as different to what I was than as all the rest is different to what it was.

Christmas Eve, 1935
We have just had our present-giving at Alice's, just we three old girls. Alice's house was full of the smell of new bread. The loaves were piled on the kitchen table; the dining-room table was piled with parcels, things changing hands. This is our system and works well: we agree on a stated amount—it is small because our big giving is birthdays. Each of us buys something for ourselves to our own liking, goods amounting to the stated sums. We bring them along and Christmas Eve, with kissings and thankings, accept them from each other—homely, practical little wants, torch batteries, hearth brooms, coffee strainers, iron handles, etc. It's lots of fun. We lit four red candles in the window and drank ginger ale and ate Christmas cake and new bread and joked and discussed today and tomorrow and yesterday and compared tirednesses and rheumatics and rejoiced that Christmas came only once per year. We love each other, we three; with all our differences we are very close.

Christmas Day, 1935
Praise be! It's over! Why do we do it? It is not Christian. Oh, I'd have *loved* to sneak off to the woods and be hidden, the week before and the week behind Christmas, and remember the real meaning of it and give thanks in my heart. I love my friends for their kind thoughts of me, but it's all wrong; it's cheap and commercial and fluffy. You can point to all the full churches and special music and decorations, but what does it all *mean* to them? The girls would say shame and shame again on me. I get more rebellious every year.

The girls are in Vancouver. How strange to pass Lizzie's house and see her rooms dark and then Alice's house and see that dark too, to know I can't dongle their telephone bells or run in. My spirit is still black and smarting. I can't think why it riled up against Christmas so this year. It kicked with its boots on. It did not want to do, or

see, or be; it wanted to hide away from the fuss and weariness. Liver, I suspect.

Two would-be art critics came to the studio. They were "pose-y," waved their paws describing sweeps and motions in my pictures, screwed their eyes, made monocles of their fists, discoursed on aesthetics, asked prices, and expounded on technique. One paints a little and teaches a lot, the other "aesthetics" with I do not quite know what aim. Both think women and their works beneath contempt but ask to come to the studio on every occasion. Why?

December 31st
Nineteen thirty-five has two hours more to run. Then 1936 and what? What will the poor old world get up to?

Beckley Street
1936

January 1st

1936 has sniveled in. The darkness held hard as though the first day did not want to start. It did not blow or bluster; it just wept down-heartedly as if it did not know quite what was the matter. I wonder will it find out before the year ends. The man next door let his guests out of the house at 5:55 a.m. They were not noisy. In fact they seemed depressed, though one man kept wishing Harry "Merry Christmas." Old "Two-Bitty," the aged Chinaman, came half an hour late to do the chores. When I expostulated with him he groaned, "No care. Me too welly tired." Fellow feeling made my wrath dry up. He *is* very old. His breath is gaspy and he collects heaps of boxes to mount his basket to his shoulder because he can't swing it up. He loves his dinner. I try to make it tasty for the poor soul—his head is so bald.

I painted one of the thick jungle sketches. Perhaps I am getting "junglier." They won't be popular. Few people *know* the jungle or care about it or want to understand it. An organized turmoil of growth, that's what those thick undergrowth woods are, and yet there is room for all. Every seed has sprung up, poked itself up through the rich soil and felt its way into the openest space within its reach, no crowding, taking its share, part of the "scheme." All its generations before it did the same. Mercy, they are vital! There is nothing to compare with the push of life.

Max came in and thought many of my new sketches lovely. People often connect my work with Van Gogh—compare it. Van Gogh was crazy, poor chap, but he felt the "go" and movement of

life; his things "shimmered." Mine wriggle and move a little but they don't get up and go like his.

"The eye is not satisfied with seeing, nor the ear filled with hearing. . . . In much wisdom is much grief." [Eccl. 1-8, 18.] Certainly this applies to artists, both painters and musicians. We look and look, listen and listen, but we are never full. No matter how much we absorb we want more, more, more—to know more, to see further, to hear higher. The whole study is teed up with longing. If it were not for ideals and our longing after them, what would life be?

Some days I feel *very* old, my body stiff with pains and soreness, brain tired and somnolent as though I wanted to be down and sleep and sleep. It is not good to feel like this; it is shocking. I am ashamed because I am not so old really, in years. I see the girls, who are both my seniors, shouldering their heavy burdens and pushing on valiantly. Have they more grit and endurance? They don't go up and they don't go down like me. When you walk a dog on leash he runs by your side demurely. When he is free he helter-skelters far and wide, takes many more steps, noses into everything, learns lots, takes more risks, may get run over, may get lost, gets mud-spattered and weary. The girls heel better than I.

January 17th
Over and over one must ask oneself the question, "What do I want to express? What is the thought behind the saying? What is my ideal, what my objective? What? Why? Why? What?" The subject means little. The arrangement, the design, colour, shape, depth, light, space, mood, movement, balance, not one or all of these fills the bill. There is something additional, a breath that draws your breath into its breathing, a heartbeat that pounds on yours, a recognition of the oneness of all things. When you look at your own hand you are not conscious of feeling it (unless it hurts), yet it is all intimately connected up with us. Our life is passing through it. When you really think about your hand you begin to realize its connection, to sense the hum of your own being passing through it. When we look at a piece of the universe we should feel the same.

215

Perhaps it is a gradual process of becoming conscious of the life of nature, the hum of life in us both, tuning-in together. If the air is jam-full of sounds which we can tune in with, why should it not also be full of feels and smells and things seen through the spirit, drawing particles from us to them and them to us like magnets? Creative expression, then, must be the mating of these common particles in them and in us. First there is a wooing on both sides, a mutual joyous understanding, a quiet growing, waiting, and then.... Oh, I wonder if I will ever feel that burst of birth-joy, that knowing that the indescribable, joyous thing that has wooed and won me has passed through my life and produced one atom of the great reality.

January 18th

Today I looked at a home near Five Points. Rentable, saleable, but, for me, not liveable. The worst of me is that I picture myself in a place immediately. I can see myself doing thus and so, here and there, the dogs, the monkey, the studio. In this house I could only see a most miserable me. I couldn't see the easels, I couldn't see the pups or Woo. It was too clean and spandy in every corner for paints and pictures, though the easy heating and the nice basement charmed me. The woman had slaved making it liveable and fancy. Mind you, I could make any house *do* me but some places don't belong to your type—squares in rounds and rounds in squares. I want a place I can be free in, where I can splash and sling, hammer and sing, without plaster tumbling. I think I want a warm barn. I want space and independence with people not too near and not too far. There must be a place *somewhere* for me. Where is it? That woman was awfully proud of her house. She'd slaved away, side by side with her husband, fixing it. Her face was worn and furrowed. Some of its lines had been made by the cement basement floor. She had worked at it down on her knees, troweling the wet cement flat. She was proud of the sunporch. It housed a canary and an aspidistra and was full. If I took the house and wanted to sun myself in the sunporch, I couldn't keep a canary and an aspidistra. It *would* make a nice pup pen.

Some things that we do or earnestly desire to do surprise me very much. Why should I want to express "Mrs. Drake"? I began the story, a description of a visit to Mrs. Drake's, when I was in camp seven months ago. It tickles away at my brain. There is something in it I want badly to get out, to express. It won't leave me alone. It was a horrid visit, made when our Mother was very ill. I hated Mrs. Drake and admired her too in a way, because she stood for—what? Now, there it is. What did she stand for in my child eyes? Maybe a certain dignified elegance—breeding—not humanness. My mother stood for human motherliness; she was like a beautiful open, sheltering alpaca umbrella. Mrs. Drake was like an elegant silk one neatly furled and banded, shut so tight and long that the wear showed in the cutting of the delicate folds not in the umbrella's honest use, a splendid, elegant mother to possess but not a sheltering one in storms.

January 20th
Our good King George is dead. People said it in hushed voices, then passed on. You knew they were thinking, as you were, "What next?" Everyone is sorry; he was a good king. The new King is good too and well prepared to take on the job. What a terrible, overwhelming responsibility! One feels as if they had lost something, as though something had gone wrong with the Empire and there was a hole where King George was.

The Hart House Quartet are here, such dear, beloved men! Mr. Adaskin and Mr. Hambourg called on me this morning. They did look so gentle; they looked like their music. The concert was grand tonight. A great, overwhelming audience. It was very hot. They played magnificently. I do not know one composer from another but I suppose most of the big audience did because they have radios and become familiar with good music. Some of them sat very still and some turned this way and that posing absorption.

January 28th
I am returning from a week in Vancouver with Edythe and Fred. They were very kind and hospitable and their little home is very

cosy and tasteful. At the end of a perfect trip from Victoria to Vancouver Edythe met me with a warm welcome and a cold in her head. One hour before I left Victoria I gave my word to sell my house, or to exchange it rather, for a cottage—with glad and bad. But it seemed everything had sort of slidden into place as if it was to be. I will miss the studio and garden bitterly. I will miss the tenants and the furnace agonies and upkeep delightedly. Mrs. Finlay who takes it is a nicer woman than I, amiable and kindly. They will like her above me. All the trip up I thought about it. The house is not pretty, it is not new, it is not the locality I want to live in. It has no place I can paint but it is in good repair and is a nice little place, more saleable and more rentable than my big one. I shall try to rent it and find a hovel to live in with the dogs and monkey, and near the girls. I can see that Lizzie dreads me going away far. We do need each other in emergencies. They don't come to me often but I can go to them, and it is comforting to know that we could go quickly if things were wrong.

Vancouver is quite different from Victoria. The character of the houses, the mountains, the woods, even of the vacant lots is different. The houses are an ugly hodge-podge of every kind of architecture. A house will be all jumbled up like an omelet—stone, brick, wood, shingle, cement. The University has extensive lands but the buildings are crude, squat and temporary, with only a few portions permanent. The floor of the big hall leading to the Art Library is badly kept. There is far too much licence allowed in handling and borrowing of books and pictures. They belong to the country and should be better protected from, and by, the students and young college professors, who borrow and handle them in an irresponsible manner. It annoyed me. The young folk of today are very haphazard. They get things and privileges so easily.

The view from Edythe's windows was across the North Vancouver mountains. Mist ran in and out among them. All day long they changed: pinks, mauves, all blues, purple. It is grand to live where one can see them always. They are more intimate than our mountains. Out by the University is a new part. Houses crowd close in some spots and leave great gaps of second-growth bush in others.

There was a smear of black and purple drapery over the front of the station for King George's funeral tomorrow. Everyone speaks of tomorrow as a "holiday." It is given to honour the memory of a good dead man who did his best for his empire. Kings are just *men* from whom strenuous self-sacrifice and much diplomacy is demanded.

The boat is hot, the sea smooth. Boats are terribly alive; all the bits of them pulse together as a unit. When you go in them you belong and are part, going with it, jiggling with it, feeling its heat and cold and its movement, utterly dependent on it. You've got to put up with the boat's joggle if you want to get home. And I have not got a home any more. For twenty-two years my growth has clambered over that place; now I've got to dig it up, prune, chop, reset it again in new soil. Not so easy as planting a slip; the roots are bruised and torn with being ripped up.

This morning an old decrepit Chinaman came and we hurled antiquities out of the attic, mostly my early art efforts. I wished there had been someone to giggle with at some of the funny old things. That's the penalty of being an old maid. There is no one to hand on to, no one interested in your past, no one to carry on the old family traditions and peculiarities. So you just burn and burn all the old sweet things, the sad and the merry, turn over the new leaf, so near the end of the book, a little wearily. It's good to destroy the old botched and bungled things. Every one brought back some memory of models or students or friends. I was surprised to see how much life work I had done. It was all pretty poor, and yet there was a certain something. I could see a feeling of the person behind the paint. It is funny how I went back on the humans afterwards and swung out into the open, how I sought my companionship out in woods and trees rather than in persons. It was as if they had hit and hurt me and made me mad, and cut me off, so that I went howling back like a smacked child to Mother Nature.

I am glad no one will ever have to groan over my accumulations. It is a decent thing to clear out before you die. The thought of a new home has many attractions. I feel as if all I wanted was peace and a quiet place to study and paint and die in. Am I getting pessi-

mistic, or lazy, or indifferent, or perhaps a little disgusted or is it that I feel I have not fulfilled the promises of youth?

The old Chinaman looked at a pile of old sketches I was about to heap on the bonfire, and carted them into the basement. "Maybe good put there. You look more. Some burn, some maybe keep." But I think all will burn. They are not good or big enough to whip up any imagination in others.

January 29th

Cleaning out progresses slowly. I took a bag of old letters, childish poems I wrote mainly when in love, dear, kind letters from lovely people when I was ill in England. They touched a magic finger to spots I thought were dead. Such tender, loving sympathy, dear fatherly letters from our beloved old guardian, letters from fellow patients at the San and from old school pals, a letter from my mother to her children and grandchildren! What does it all mean, this giving and receiving of love? Love like a merry ball bouncing back and forth from one to another—new fellows joining in the game, old ones dropping out, but the ball always bobbing, gaining something from every hand that touches it. When is its final bob? What is love? It has so many aspects, so many kinds, is good, bad, merry, sad, absorbing, selfish, heroic, fierce, gentle, tender, cruel, God-like, devilish. It goes on right through our life, from cradle to grave, never leaving us quite alone. It is a God-like thing—God is love. Love is a grand, grand thing, the most magnificent there is. That old green bag, the one I used to carry my dance slippers in, was chock full of love, love coming to me in letters, love burst from me in the poor, silly little rhymes that eased me in writing. For writing is a strong easement for perplexity. My whole life is spread out like a map with all the rivers and hills showing.

January 31st

Oh, I want to cry but I have no tears. Two drawers full of memories, words, letters, photos, tumbling out of old creased envelopes, faded faces, my own and others looking out from old photos. I did not know people were so dear, so kind. I have not been half grateful and now they are gone! What sweet, tender, kind little things are

in those old yellow letters, things that my conceit took as my due, lightly, without thought. The two deep drawers of the writing table were stuffed with memories—dog registrations and photographs, exhibition catalogues, insurance policies, mortgage papers, Dede's will, Father's will, my will.

Oh, oh, oh! Every one of those things had a hand in the making of me. Oh, life and love! What are you all about? I wonder and wonder.

February 2nd

Does anything make one feel more paltry and inexcusable than to see one's things, the things of one's cupboards, laid out in the blare of daylight? The basement and the attic have yielded up their hoards, trivial, dust-wrapt, tied together with memory strings—no use, no ornament—why kept? Yet it takes resolution and hardening to throw them out. Is it good or bad to be dragged back by the scruff over rough ground? To another the oddments would mean nothing. When one laid them away they were very live. They went deader and deader as the years passed. The good old dust tried to hide them away. Then suddenly you raid the attic and blow the dust and the sparks of memory ignite. Memory is not dead, she just needs a jog. Biff! off she blazes. It is good to hoard, good to walk back over the years. No good whining because they are gone—others are coming and others after them. It is good to rejoice over the finished years, to be glad over the glad things and glad over the sad things, lessons all of them.

The top attic and the studio are the places filled with tender things. I wonder what the house will feel like to the new people, if any flavour of *me* will be in it after my things are out, if my spirit will immediately abdicate. When the chairs I keep hung from the ceiling to economize space in the studio are down, when all the daubs of paint are covered up with clean kalsomine, when the floors the pups and I have worn and scratched and spattered as we painted, when the wood box I've cursed as I filled, and the woodwork that Woo has chewed and the nails I loved to drive in everywhere to hang things on have all been extracted and the holes puttied up and the walls and ceilings have ceased to resound to dog barks,

221

typewriter clicks, singing and talking to the pup and monkey, when the door latches are all mended and hinges oiled, the taps have stopped dripping and the mended gutters don't require that you dash under to avoid the splash—when all these things are fixed and decent for the new occupiers, then all the me will be gone and the personality of the new folk planted. The tenants will like my new people; they will do better by them, be more even and steady. Temperamentals should not "run" places to house other people. I was not cut out for a landlady; I'm not a nice one. But I guess I had to learn things through that particular way and the tenants had to learn painfully through me. I was honest enough with them, but peppery. They were just a necessary evil. Oh, I'm glad my apartment days are nearly over. Always wondering what was going wrong next for complaints, if rents were coming, if No. 1 was disturbing No. 2, how long No. 3 would be empty, if the pipes were going to freeze, if the sinks were going to stop up, what made the chimney smoke, if the next-door man was going to get drunk or his dog was going to bite his butcher, which my tenants would complain to *me* about. All these things will be grand to miss. But it's going to be *awful lonesome*. I wonder how the others feel about it— glad or sorry?

February 9th

Days race! The work of destruction goes on, tearing down what has taken years to build, tearing up a home, my real, permanent, mature womanhood home. I am glad I have had a real experience in home-making, in fitting up an atom of the universe to fit myself, imposing my taste and queerness and individuality and me-ness on a place. It has doubtless taught me a lot, some bitter lessons through tenants, some happy experiences through studio, garden and creatures. The weather has done its beastliest, so that the agony of waterpipe anxiety, fuel bills, etc., have been grand weaning. Both shoulders must go to the wheel the next two weeks. Most of the tender things are finished up, the old letters and sketches with their hoards of memories. The thing that has amazed me is the love that has been given to me from odd folk here and there, friends I had about forgotten, those who knew me when I was ill for so long in

England, those who knew me when a student in San Francisco and London and Paris, Indians, dog breeders whom I have corresponded with, our introductions exchanged solely by dog business, each rubbing against the other solely through our "doggie" sides. (One calls me, "my dear unseen friend"; we corresponded for years and knew each other intimately from that side.) Lovers' letters I destroyed years back; no other eye should see those. But there was a note, written forty years and more after the man had been my sweetheart and he loved me still. He married as he told me he should. He demanded more than I could have given; he demanded *worship*. He thought I made a great mistake in not marrying him. He ought to be glad I did not; he'd have found me a bitter mouthful and very indigestible, and he would have bored me till my spirit died.

There were such lots of dog photos, dear, faithful bobtails and griffons, twenty-two years' rotation of dog adoration looking back from the pictured eyes, forgiving all the meanness, irritability, selfishness I ever had; just loving and worshipping me as their god. I have not touched pictures yet. This week I attack material things—chairs, tables, pots and pans and shall be *very* practical—no memories.

The junk has gone. The auction discards have gone. One big bonfire has blazed a thousand memories into oblivion and another waits for the match. Whenever I come into the great light studio, spacious and half dismantled, a pang darts through my innards. When the agent of my new house said, "May I ask why you gave up such a splendid studio?" I wanted to bite. Irony—you give up the *working place* because there is not time or strength enough to paint in it and you go to a poor place to gain time and strength and lack the *working place*. Which is going to prove the greater, work or environment? Willie Newcombe's help and courage help enormously. My spirit periodically flits down and flaps round my new abode, fixing. I think it's willing. It's like a bird that has selected the crotch to build in and flies round and round, getting used to the environment.

February 16th
Well, the studio looks like a junk shop rampant. But the bantams

are laying fine, twenty-seven eggs, and all through this bitter weather. I love giving away new-laid eggs for people's teas. Weather continues bitter, keeping householders in spasms of apprehension about north wall pipes.

Things are getting down to their bare bones. The essentials of life only are left intact, all the etceteras are packed.

When I look over things I see that I have been careless over my receipts. I have had lots of recognition. Way over West it has come to me and I have not properly appreciated it. Why? It did not seem to mean much to me. I was wasteful of it, did not follow it up. I might have, and perhaps would have, become well off and financially successful. Things were suggested but I let them slip, was saucy over them. Now bad times have come; I cannot reach the public and the public soon forget. Some tire and look for a new person of interest. I would not kowtow. I did not push. Praise embarrassed me so that I wanted to hide. You've got to meet success half-way. I wanted it to come all the way, so we never shook hands. Life's queer.

You can be too tired to say so, too tired for the exertion of going to bed. There is a gnawing in your innards that resembles hunger, but is exhaustion. When you sit you have to stand again because you are too tired to sit and in bed you're too tired to sleep and your darn brain goes whizzing on, thinking of how tired you are. The only comfort is that your tiredness is legitimate, because you really have put enormous exertion into great activity. If life was not so overcomplicated and cluttered up you'd not need to sort out your possessions, you'd own a coat and a cup, you'd sleep anywhere like the beasts, and when you fell sick you'd die without physic or operation.

February 23rd
The world is wide and white today, with sky low and frowning blackly over it. Live things are humped up. The big studio is all of a mess with packages and cases everywhere. The reflection of the snow through the uncurtained windows gives off a cold white light.

224

The trees have shaken off their snow and stand outside in naked black. The cottage will have to wait for me till the snow has cleared. Often I find myself down in it, going from room to room experiencing it. It is always full of sunshine when I am there. The rooms are all fixed and I am happy there. There is just one room I don't *know* yet, which my spirit is not at home in, and that is the studio. It is not a studio yet. I have written, sewed, cooked, slept, eaten, gardened, but so far my spirit has not *painted* there, nor have my pictures hung on the walls, nor have I seen myself at an easel painting. Nobody has ever painted in that room nor thought about painting in it. It was probably the eating place of the household. Rooms take on habits. I will have to teach that environment. It may repulse me and I shall have to woo it. I wonder how the old studio will react on the Finlays, whether a little of me will stay behind. I would like to leave a picture behind to hang there always. The pictures in the Finlay house are awful. They are waterfalls, mostly of a blackish-brown cromotype, and dry, unlit water. One dreadful one was a row of three waterfall panels in one frame. Mrs. Finlay likes paper flowers. I just can't see the old studio decorated with waterfalls and paper roses, and I expect my pictures are equally repugnant to her. And I wonder how the studio will stand up under two men. It's a woman's room, was built by a woman for a woman. The bedroom too, with the frogs and big spread eagles gallivanting over the low ceiling above my bed. I expect they will kalsomine them down. And the garden where the trees and shrubs knew me! I feel rather like a deserter. The animals will be just as happy or better; just the flowers I have fussed with may miss me as I them. But that is silly—growth is just growth; it takes what is necessary from whatever source it can reach.

White, hard, defiant winter holds my cottage. It has burst the pipes and broken the porch and hidden the burning rubbish in the yard so that we can't clean up, so there's nothing to do but smile and sit back in the dismantled studio with all the inanimates laughing at you. Glorious to be a bear or chipmunk and hibernate over winter. Plumbers earn every cent, freezing there under houses, coaxing toilets and ungreasing sinks.

Nothing is left in my flat but a bed and a pup and me. The studio clock has gone. Twenty times I have looked up where its face used to be. There is a clean spot in the kalsomine where she hung and a horrible stillness which bursts at any knock or sound. This sleeping in the emptiness is like sitting up all night with a corpse.

The King, Edward VIII, spoke for the first time to his empire as sovereign this morning. I went to a flat below to listen; it was very impressive, very, very solemn. Big Ben struck and they sang "God Save the King" magnificently. I pooh-poohed Lizzie at dinner when she said all in their house sniffed and wiped eyes surreptitiously, but it was only the presence of strangers that prevented me.

March 2nd
I have moved! I have slipped out of the chemise of worry that 646 Simcoe dressed me in. I have dropped the chemise and the Finlays have put it on. The cottage is shaping nicely and beginning to live. I liked its sun-shininess from the beginning but it was cold and empty then. I brought the central stove and put it up, and gradually warmth spread from the centre of the house. Presently the studio clock was throbbing on the wall beside the stove, its tick-tock penetrating every room, and then the creatures came pattering in and out of all the rooms, delighting in investigation, and the place became a living thing, warmed, responding. The workmen have been abominable, undependable, impertinent, lazy. Ugh, I loathe them, all but the truckers who were kind and obliging. But the engineer who set the whole works going was Willie. Those kind, keen eyes penetrate into every corner, sum up needs, set things to rights. In the avalanche of dirt and cold stone I'd have been snowed under but for his help a million times. Willie's a wonderful individual. I do not know what his beliefs are but the motivation of his whole life seems to help, always doing something for somebody, giving generously of time and strength and knowledge.

March 5th
Things are getting straightened out. Each corner suggests objects. Sometimes the objects object, but mostly, if the corner calls, the object responds. Furniture is very alive. It knows who it wants to

hobnob with. Sunshine has poured into the cottage all day and has gladdened everything. I am beginning to love the cottage. It's homey. Woo is very rambunctious, screeching and barging. She has torn every wire clip and snib off her cage and wrecked the wire front already. She has removed every cork out of every bottle in the kitchen, overturned, scattered, tasted, and finally hid in the oven which fortunately was not too hot. If this weather continues she can go outdoors soon. That will calm her burstings-out.

At last a letter from Yvonne about my paper sketches in the East. She was very enthusiastic. She said that many people were *thrilled*. Said they *made her want to work*. She said that they were alive and stimulating, that they talked and meant more to her the more she saw of them, and that she was glad to see so many of mine together. She got the conviction that the artist was used to open space and distances, and not only to closed, dense woods such as they had always associated me with. Well, that's that. I believe Yvonne to be genuine. I'm glad, not conceited glad, but earnestly glad.

The bantams have sampled the surrounding yards but come back to me. Breast to breast, with a board fence between, my rooster has defied the neighbour's rooster. The dogs love the new place—it is sunny and I most always in their sight. I too like it. It is "homing" up, all but the studio, that has not caught on. How can it? It does not know what is required of it, nobody having thought art there.

The cottage is dominated by the cook stove and the cook stove has the sulks. The wood is wet; and the wetness disheartens the coal. The air is keen today too. Seems there are too many rooms. Not for my possessions—they are all overfull—but too many for my spirit. It has not formed its "rest spot." Big community Indian houses must have been very jolly, each family with its own fire—public privacy. One apple on a tree is lonesome, a crop is jolly; they must encourage each other no end.

Sunday, March 8th
Living solo in a place built for a whole chorus is . . . nice and not nice. There is a strong sense of isolation. The new little studio is as unfamiliar with me as I with it. There is a cosy, popping fire with

227

a rug full of dogs and monkey. There is the rack Willie made me, so handy and right for its piled shelves of sketches. The lighting problem has been satisfactorily solved, but the little room is big with lonesomeness. Similarly time, unpunctuated with "janitarian" jobs, is long. There is something about both time and place that feels selfish. The newspaper is very disquieting with its wars and rumours of war.

What am I going to do with this life of mine now that I am free? "No man liveth to himself and no man dieth to himself." I wish I could make my paintings help the world. Somehow all this stuff hoarded up is a great encumbrance. I do give away some when I find an odd person to whom they mean anything, but those persons are few and far between. My heart tells me that there is something in my work that appeals to some people, I mean that explains in a wordless way something that they know. Yvonne said they "spoke" to many in the East. But you cannot go round handing out pictures like free samples of breakfast food. Also one has to live. Why buy a picture if you can get it for nothing? It is hard to think straight, and to nail thoughts into words or paint is like crucifying them.

Someone has asked me if I will write a splurge to go into the catalogue of a post-mortem show of her mother's paintings. Oh, yes, I will. It's tommy-rot, but I will. But I won't lie. If the bouquets are garden flowers and homely they shall be sweet, wholesome posies from my own garden.

March 21st

B.B's body was brought home today. Lizzie wanted to go over for the funeral but we advised her not. She's a strong one on funerals. She enjoys the flowers and the hymns punctuated with sniffs, and the coffin on its perambulator trundling up the aisle, and counting the followers and noting their places in the procession, and driving to the cemetery after the hearse, and hearing the earth thud, thud on the coffin and coming home again and telling all about it and repeating tid-bits of the death-bed sayings. She does not say "dead" or "died" but "passed away" or "gone." It's all a very melancholy, lugubrious affair but, on the whole, satisfactory to attend and to discuss after and to say "dreadful" over. Sometimes, when I have

heard her describing death scenes and sayings quoted mostly from her parson I have felt I'd like to die quite alone. I saw Father die. Just as he was doing it the Bishop came and he prayed. Father did not like the Bishop. Alice and I were kneeling at the horse-hair sofa with our faces hidden.

March 27th
"Millie, will you come to tea—6:30 and spend the evening tomorrow? I made a nice pudding."

"Thursday? Sure. Thank you."

(Tomorrow) 5:30—furious ring at telephone.

"Millie, what time are you coming to tea?"

"You said 6:30."

"No, I did not! Well, that's all right but be sure to come on time."

6:15: Millie arrives, tea nowhere near ready.

"Hello!"

"Hello!"

"Millie, hang your things in the hall; *don't* come in here with them; don't hang them too near the telephone; don't hang them too near the stove, and, Millie, put your rubbers *out*side."

"I want a drink of water."

"Well, go into the Owens' flat, but don't be long. Tea will be ready soon, so don't stay."

Table set prettily—chop cooked to a turn—pudding in centre of table.

"Sit here, Millie. No, don't sit there. . . ." Shafts of long frowning at dog on sofa. "Don't let the dog muss the pillows."

Follows a long grace in a sanctimonious, guttural mutter. I like grace, believe in grace but I can't stick *her* grace. I look round at her bent white head and eyes screwed to lean dashes, at the chop on my plate and the flowers, taking plenty of time and some to spare before her slow, apologetic "Amen." She'd have liked longer grace.

"Why don't you eat all the chop?"

"I have—all but the bone."

"Why don't you give the dog the bone? . . . on the *verandah*; don't give it in here."

Then comes the particularly messy, uninteresting sweet.

"Have some more?"

"No, thanks."

"Oh, why don't you have some more? Won't you have some more?"

"No, thanks."

"Why?"

"I don't want it."

"Well, have some more of the fruit part."

"NO!"

"Well you need not be so rude and horrid. If you asked me in your house to have more pudding. . . ."

"Well, I would not pester you. I'd think you meant No when you said No."

"Well, you are horribly rude."

"You do pester so!"

"Well, why don't you want more?"

"Oh, darn the pudding! I do *not want* more."

"Well, you're rude and horrid."

Meal concluded—the pudding remnant is served on to a dish.

"Millie, take this pudding up to Alice if you are going."

Alice: "What's that mess?"

"Leavings of Lizzie's pudding."

Alice: "I hate left-over puddings."

' So do I. I hate that particular pudding, anyhow."

"Give it to your dog."

"Not good for him. Give it to yours."

"Won't eat it."

"Let's pitch it out."

Plop! It's in the garbage. Ssss! the dish is under the tap.

March 30th

I have decided that I want a radio so that I can hear the news, keep up with the times, get to know music. Physically my whole nature revolts. When I go to houses where they are turned on full blast I feel as if I'd go mad. Inexplicable torment all over. I thought I ought to get used to them and one was put in my house on trial this

morning. I feel as if bees had swarmed in my nervous system. Nerves all jangling. Such a feeling of angry resentment at that horrid metallic voice. After a second I have to clap it off. Can't stand it. Maybe it's my imperfect hearing? It's one of the wonders of the age, simply marvellous. I know that but I *hate* it. All the time I am wondering how anything could be so wonderful. I remember how I marvelled over the telephone when that came out. But somehow that is the real voice of your friend. The other is a beastly, mechanized strident thing, all the life whipped out and the cruel hardness of the machine and the new, hard, modern people whipped in. A terrifying unreality, as if man had ceased to be human, all his flesh and blood and feelings gone. Not a human mouth and throat, not a human heart and feelings at the back of them; just mechanical noises like steam whistles tearing, cutting through the air, and the sounds of lovely instruments harshened to cracking point. I spent the evening at a house last week where they had a beautiful, tip-top radio. It was turned on most of the evening in the next room; unconsciously everyone's voices were pitted against it. Oh, if I could have thrown it out the door! By 8 o'clock I was so nervously exhausted I could have cried. I am sorry about this feeling of mine and ashamed to own the agony it is for me to live with a radio. It is not affectation. It's a straight nervous loathing, as if the power of the thing was using me to pass through, like drawing a nutmeg grater across a piece of satin, ruckling it up and catching the threads.

The young man placed the machine on the table. I was in the other room when it began to sputter, and the silence of the cottage ripped. I wanted to shout, "Take the brute away! The quiet of this cottage is mine. How dare the whole world mob it! Go away! Go away! I can't bear it." There she sits like a black baby coffin full of tinned voices, of horrid sounds and pip, pip, squeal, squeal, and the awful roarings, unearthly, cruel.

April 1st
The radio and I are getting reconciled, that is in some measure. The newcasts are fine, Clem Davies fine, organ concerts fine. Choruses, jazz and opera turn me sick—loud, quick noise and the sputter of static wrack me. The man came today and I paid for the radio

($11.95) and now it is mine and I am linked up with the world. The world comes into my room, kicks the silence about, smashes it to smithereens, builds little cobweb bridges so your thoughts can cross to Germany and Russia, to France.

April 4th
Humphrey came last night with an armful of breeches, sweaters, bathing suits, etc., which he invited me to trade for some of my old sketches, cast-offs he spied the other night. So we swapped derelict clothes for derelict pictures. His pants and coats will be converted into useful rag mats. I hope he will get something from my old tattered thoughts.

April 7th
Yesterday a boy child sang a solo. He was small and sensitive, perfectly natural and so sweet. The little song was,

> Light the lights, lamplighter,
> Light the candles, grandmother,
> Light the stars, Gabriel.

Why did one suddenly splash over big tears down on your gloves and feel like a fool? There was a big orchestra of young people from Vancouver. They were so lovely, so young and fresh. I liked looking at them better than their music. They had won lots of championships. Clem gave them his sermon time, and half the collection.

April 8th
Been working on two canvases, one of dense undergrowth, the other of sky. I am keen as pepper. It is good to feel keen and not like a boiled onion. Why can't one always? The sky study should be exultant, leading up with vibrating light, and full of movement.

Good Friday
The trouble with our painting lies largely with our trying to impose our ideas and our technique on the picture instead of allowing our subject to *impose itself on us*, asserting ourselves instead of making

ourselves a blank and letting the subject express on that blank that which it will. When you are out in nature she works for you. In the studio your imagination steps in, your sense of design, what *you* want. That is why the first sketch done on the spot smacks of something bigger and more vital than the fixed-up product of the studio. In the one we dominate, in the other nature does. If the spirit has climbed up honestly from solid fact to solid fact, good. If she has floated idly without experiencing, bad.

April 15th

A dense undergrowthy thing—two great moss-grown stumps. It must be *organized chaos* with the elimination of unnecessaries, massing of individuals into group movements, space swinging into space, movement meeting movement, balance, borrowing and paying back, a density and immensity that is so obvious in our Western woods. I want my work to be typically Western.

Nobody mentions the war clouds hanging so low and heavy over everything. They listed to radio, read newspapers and make no comment. They switch off the radio and cast aside the papers and are quiet for a little, perhaps staring into the fire. Then they shut the ugly thing out of their minds and plunge into something that will turn their thoughts. *What* are people thinking about these days, I wonder. Perhaps we do not know ourselves, we are just drowned under perplexities.

April 20th

It is many days now since I last wrote because I have had no thoughts in particular. I have seen and heard and done things but nothing has said anything in particular, nothing made me skip other jobs and write it off my chest. A teacher of English is going to swap some crits of my poor writings for a sketch. The mechanics of my construction and wording are very bad, commonplace and small. Will she help? Can anyone help anyone else? We all stand so totally alone like standard rose trees blossoming at the top. The suckers that come up round our base spring from our wild, ungrafted roots. That which is grafted into our juice produces the good bloom. The other is only wild growth.

I admire cows enormously. They are so patient, chewing, chewing, chewing instead of gobbling up the new spring grass, grabbing, grabbing furiously, always after more. I'd like to be a cowish artist, gather (in sketches) and chew (in studio). I do not produce good, rich milk, only lick and crop more and more. Cud-chewing rasps me.

April 23rd
It is time to stir among this lethargic mass of brain debris before it corrodes. The neighbourhood is pleasing to me. I pine for the old 646 Simcoe Street not at all. These folk live more. The men dig, the women wash, clothes-line pulleys screech their freight in and out, wheelbarrows groan up and down Beckley Street with their beach-drift loads. There are good-natured mongrel dogs and well-favoured cats. How gloriously the children play, fluttering and squalling like sea-gulls over the rough, open ground in front! Hop-scotch is very much in vogue. Every house and cottage has a garden of some sort, mostly utility. There are daffodils and wallflowers, but the brown earth is better acquainted with onions and potatoes and beets. There are no lawns to speak of. At this month rows of sticks with seed-packets crucified on them head and tail the garden beds.

Phyllis next door is a joy. She and her brother have built a house in their apple tree opposite my kitchen window. Our hands are always a-flutter waving to each other. She tells me I am the nicest lady she has ever known (as though her six years were aeons of ages), and that I am not so fat as some of the ladies in the funny papers. She's an enormous waggletongue, chattering all day long, happy chatter. She's rushing pell-mell in and out of the kitchen door, down the steps and up the ladder into the playhouse she and her brother have made in the old apple tree. It has an oil-cloth roof, sack sides, and its floor is a table perched in the prong of the apple tree high up. The "smoke" Persian rushes out of the kitchen, down the other steps, up the apple tree just the way the child does, just a swoop of grey movement, down and up again in a lovely curve. Then I call from my kitchen, "Hello, Mrs. Bird," and she calls back, "Where's the monkey?" and I say, "How's the measles?" and she says, "They are all gone now." She has a horse, too. It's an old trestle with a hearth brush tacked on for a tail, but no head—that

appendage is unnecessary; Phyllis is its brain. There is a saddle and a bridle—a rope with two loops and wooden strips for stirrups. Phyllis is attired as a cowboy with a rope lariat and, of course, a whip which the stick legs get plenty of. The horse is carefully brushed down, its own tail being used for the purpose, and tethered to a wallflower bush. Other days Phyllis is a Highlander. She has a Scotch cap and khaki jacket and a huge red lard pail for a drum. Again, she is a lady with a fur cap, a black satin skirt trimmed with red crepe paper frills, and shawls and feminine gewgaws, mink, drapery, and two hideous rag dolls, a boy and a girl, who claim to be twins and have very scant clothing as though the mother had only expected one. Next day, Phyllis is just a little girl catching bumble bees in a bottle. She bursts out of the kitchen with a jam jar, unscrews the lid, climbs the plum tree, shakes the glorious foamy-white blossoms, and then the triumphant screech, "I got a bee!"

April 26th
This neighbourhood is all peaceful little streets with peaceful little gardens, well tilled, and homely men and women, and happy, un-spoiled children playing their games. Every garden has wallflowers and sweet alyssum and just a few sweet old flowers—the rest is vegetable. Every yard has wash and a cat and an apple tree. The wild bit of Armadale is bursting out in tender leafage and the birds do a great deal of discussing there. Wild lilies of the valley are shoot-ing up umbrella-like leaves to hide the blossoms they are going to get. The salmonberry bushes are dotted with deep pink blooms. Skies are fine these days. White clouds dance over the blue dome. Oh, that dome! The blue is so much more than blue, the illusive depth boring into Heaven's floor. Nothing stands still these days. It is growing and moving double-quick. Trying to keep up takes one's breath. Everything is absorbed in reproducing its kind, always with the hope of producing something bigger and better than itself and yet picturing itself in the new thing it's making. As soon as every single thing becomes adult its desire is always the same, to keep the thing going. Unmated things are never quite complete. They lack experience.

May 4th

Spring has gone ahead by leaps and bounds. Everything has burst out; old used-up bud skins are cast everywhere. I am hurrying to finish up mounting, framing, shipping to Ottawa for the Jury of Selection to sit on my canvases, among others, for a Southern Dominions Exhibition. Rain is softly blessing the earth, caressing her new sprouts. World events are pushing on like spring growth, only they are terrible instead of lovely. Ethiopia is crushed. All sorts of countries are doing all sorts of horrid, spitty things in each other's faces. It seems as if war was inevitable.

May 9th

Three pictures are ready for Ottawa. Am a little disappointed in this year's trio. I feel them a bit studied over—feel their groans.

May 10th

Tonight was perfect through the little bush trail. The mountains beyond were high and very, very blue, clear and ringing colour. The sky and sea were greys. As the evening latened the mountains crouched down and the sky went high. The wind threw just the right degree of coolness against one's face. Dogs had all had a bath and looked red and fluffed up. Pout and Vana are mated and very content. Health and satisfaction are the order of the day. On the beach I was wondering about things, all the new marvels for our ears and eyes, noses and senses.

I think it must be rather illuminating to be a garbage man—the dregs of human discards pouring out of the big, dirty cans: dust and mildew, mold, decay, roots and parings, papers full of old news that has flared in the world and gone out, offal of the cheery fires that have finished warming and gone to their gritty ash, cans that shone gaily on pantry shelves when in tight-full splendour—empties now, with all their respect gone, dismally blushing rust. The giant grey cans themselves, labelled "Property of City of Victoria," always relegated to the meanest spot on the property, a utensil to be hidden. But, let him wear out and leave his proprietor without his useful

presence, what a howl goes up! The noses of sanitary inspectors come snorting out of nowhere demanding that a new can immediately replace the old.

We are in full spring. Winter bareness, full firing, heavy clothes lie behind us for five or six moons. There is a little treachery under spring's loveliness. Youth, so tender itself, is often hard and a wee bit spiteful. What different faces the world can put on, such hideous ones and such splendid! A gentle rain is misting down. Sweet smells are running up and down the earth kissing every nose. Some noses don't heed, some do. Flower heads hang heavy, drunk with pure water. The race to maturity is full on. When the goal is reached there will be a long pause, fullness, content, balance, the scales full and steady, before autumn starts tipping down the one that is up now.

This morning an artist of Budapest visited me. He looked at sketches as a nature lover looks at a live wood, seeing the trees and the space between. He looked two and a half hours. He began by looking over Indian old ones, enthusiastic over the barbaric totems. That was what he had come to see, really. Then I rambled out the modern woods and his spirit answered to something in them more strongly than to the others. He left off being historic and decorative and floated out. The man who had brought him here reminded him that he had a boat to catch shortly. "There will be another tomorrow," he said. "Had I left Victoria this morning I would have got nothing. I do not like Victoria, but now I have got something from these. I have got something. I cannot find words easily."

He thinks music comes nearer than any other medium to expressing the spirit because it is less material. We discussed many things, the difficulty of finding a medium to express in. I felt that more difficult than finding our way through the medium was finding out just exactly *what* we had to say, getting it perfectly clear in our minds. If that was crystal clear then I think the medium would wrap it round. Perhaps too much medium is like a fine wrapper with no goods to wrap. He found my work more like a man's than

a woman's. He thinks women find it harder to separate things from themselves, to forget themselves in their work, to concentrate. He had none of his own work here. I would like to have seen it. It is wonderfully heartening to speak with another artist. I have missed the contact with Lawren bitterly. To both of us religion and art are one. He opened his door a crack and I peeked in. I went just a little way in and found it was a fair garden, serene and beautiful but *cold*. When I touched the lovely flowers they were wax. They had not the exquisite feel of live petals and no smell. I was frightened and ran out of his garden and the door shut and I grabbed the homely, sunwarmed weeds and simple wild flowers that grew outside the gate and held them tight.

I feel a fraud and rather mean. I claim to despise women's clubs and here I've just come from the Business and Professional Women's Club annual dinner (invited by Margaret Clay) and enjoyed every minute—good dinner, good talk by Irma Sutter. Met new good people and old good ones I had not seen for years. Everyone was so nice to me and I was the *worst* dressed person in the room too. I was driven there and back. There was a large percentage of elderlies and middle aged and such a display of shoulder blades and vertebrae I never saw before. Afterwards some of us sat outside the ballroom. The May Queen Dance was going on and hussies three-quarters naked buzzed in and out. I never saw such dresses—tighter and more suggestive than their own skins, so tight across the seat and thighs, draggling long and nakedly low at back. I did not see one pretty bare back. They all looked as if they were prepared for the chiropractor. Hideous vertebrae and shoulder blades, ugh!

June 1st
Theresa took me to see my camp spot. It's covered with ant hills. There's the great yawning gravel pits, the vast flat sea, and there's the pines, and bleached and blackened stumps, and sheep, a water tap, a kindly care-keeper who had selected the exact spot where I was to sit. I felt like a child: spanked and set. It's rather far from habitation—the vast pit, sky, sea and me. And how it pours and pours! I'm glad I am not there *yet*.

June 4th

I'm here but the van is not. The clock, mounted on a stump, says 11 o'clock. It is three hours since we locked the door of 316 Beckley and got underway. It rained, a fine drizzle. Now it's quit, but sulkily. The sky is low and dull, sea flat and misty. Everything has that waiting look. Pines all have their new dresses. There are immense ant colonies all round. I can't see eye to eye with Solomon about ants. It is a good opportunity to see if I can cultivate a placid admiration of the brutes. One cannot see into the gravel pits from here. There is greeny-grey grass with a ripple as the breeze passes, and then sea and sky with no division line. If you saw it for the first time you might think it was all sea or all sky. And the air on the land is full of wet too. It's a watery day—air, sea and sky. A robin is trying to whisper to his mate but jerky notes like his talk cannot whisper. There are two immense brown upturned roots behind me, with all their underground secrets exposed. The lying logs are bleached or fire-blackened or chewed to rusty meal by the ants and ready to mix right with the soil and go back to their beginnings.

June 5th

It is perfect weather. I woke with the glorious sky looking into the van window and I lay thinking it was a painting. Just enough breeze to stir and keep things from grilling. The camp is splendid, complete; everything fits comfortably. I know *how* to camp and this one is extra excellent. Despite the vow I would never make another one—my camp days were over—I shall go on till ninety. The grass is dry, soft and green. I ran barefoot all morning—such a lovely, lovely feel.

I painted this evening. Not greatly successful, but a beginning, and the palette set. It was a mellow, high-keyed night with no clouds, only a few white streaks sideways. A slash of blue sea and an impossibly glowing, grey-green stretch of grass with two stumps and a bush. The predominating characteristic here, perhaps, is space, the great scoops out of the gravel pits, the wide scoop of sea (trees are not close), wide patches of that indescribable, lit-up, very live grass, thin, fine stuff that quivers over the earth, not luscious, luxuriant growth. It's like baby hair compared to adult, but it is not young-

239

looking like the other kind in spring. It's adult pigmy grass with seeds on it and three hot days would turn it to standing hay. The ants are very active. Immense colonies everywhere. Solomon can say what he likes; I am sure their housekeeping is frenzied chaos. The sea must be very still. Each Victoria light has a trickle of glow below it. The lights themselves wink furiously. Here I lie in bed miles away and see the lights clearer than when I'm living on top of them.

June 6th

Casually, you would think the world very still this morn, but really, when you consciously use your ears, there's quite a bustle and stir. One is so lazy about life, about using our senses. It is easier to jump into the luxurious vehicle called Drift and go nowhere particular, then wonder why we don't get anywhere. There's smells—they have to fairly knock us over before we heed them. They are such a delicate joy, and we miss three-quarters of it because we don't tune our noses in. Fussy enough about taste because our stomachs are so demanding, we take sight for granted and only half use it, skimming along the surface. Nor do we listen in to the silence and note all the little, wee noises like the breezes and insects. Good heavens, the row there'd be if you could hear the footfall of all the ants! And then there's feel. We don't get one one-hundredth what we should out of feels. What do we bother about the feel, the textures of things alive, and things made, and things soft, and hard, cold and hot, smooth and rough, brittle and tough, the tickle of insects, the touch of flesh, the exquisite texture of flower petals, the wind's touch, the feel of water, sleep pressing our eyelids shut? We accept all these things, that could so immeasurably add to our life, as a matter of course, without a thought, like animals do. In fact animals seem to get more out of their senses than many people, yet we are supposed to have minds and they not.

June 8th

It is 6 a.m. Change has come. The sky warned of it last night. A little wind is creeping over the grass, that thin wiry grass heavy with seed. Each separate little gust runs alone. Back from the woods it

seems to come running like a fire in wavy creeps, passing over the grass, bending and shaking it till the edge of the cliff is reached. Then it jumps from the grass over into the big gravel pit. Presently another little gust comes, and another, in quick procession but never overtaking each other. They neither begin nor end, but just succeed with an almost imperceptible pause between each.

Suddenly, the little runs trembled and stopped. Then the rain came, gently, then hard patter, patter. Big heavy tears chase each other down the window. Distant Victoria and the sea and the pits are all smothered out with fine white wet. Even the burnt stumps are vague, and there's more water than substance to the bowed grass. Yet this 12 x 5½ is dry and cosy, a tin and canvas haven saying with authority, "Keep out." It must be lovely to be a creature and go with the elements, not repelling and fearing them, but growing along through them.

The best part of a week gone already. It's been very wet for work. Did one sketch. Fairly happy over it. Have read "D'Sonoqua's Cats" through. There's some good thoughts in it if I can simplify and sort them out.

June 9th

The sun is right there but it seems as though every time he peeps a great black cloud slaps his face and struts in front. Then it is patter, patter on the van top again. An old sheep was just below the van window when I woke. This old girl winked her right eye and waggled her right ear furiously. She was round Woo's stump trying to figure out the smell, her seeing and hearing all tangled up. She lipped a piece of orange peel into her foolish mouth and began a silly side-to-side chew. She liked its hot nip and went off flipping her tail. A lamb's tail that has not been cut is the most inane append-age, just dangling there expressing nothing.

Now for my bath, or rather, dabbing three pores at a time in a small receptacle. After the whole surface has been dabbed you take a vigorous scrub with a harsh scrub brush. How much more sensible it would be to roll naked in this soft, sopping grass, a direct-from-heaven tub. Maybe in a former state I was a Doukhobor. The *live-ness* in me just loves to feel the *liveness* in growing things, in grass

and rain and leaves and flowers and sun and feathers and fur and earth and sand and moss. The touch of those is wonderful.

June 10th

Still pouring, only worse. Poor world, she looks so desolate and depressed, as if she did not know what to do with all the wet. The earth won't hold any more. The sea is full and the low clouds are too heavy to hold up. The sky leaks, earth oozes, so the wetness sits in the air between and grumbles into your breath and bones and rheumatic aches. The sweetest thing in the universe is a hot bottle. The sheep go right on eating, fine or wet, poor darlings, contentedly making mutton.

June 12th

Everything that makes for exquisite weather is contributing today and the earth, her young tenderness ripened almost to maturity, is exultant. I read, rested and sketched in fits. Have not got any notion how to tackle them so far, those big emptinesses. They must work together with the sky—that I know. They must express emptiness but not vacancy. They must be deep. I run back into the woods with their serene perplexities, their fathomless deeps and singing fresh green tips. These days when the sun is bright they just chuckle with glory and joy.

Sunday and pouring rain again. Hibernated till 8:30. Now I will work on "D'Sonoqua."

Yet another day's weeping Heaven. Two days I have slaved on "D'Sonoqua" but she remains choppy and inadequate. Why do I go pounding on when results are so poor? What is the tease within me that won't give writing up?

June 17th

Shan't mention weather again till it improves. It's just awful. Suffice it to say rain continues to pour. The Spencers are "straight nice," Father, Mother and boy. Mrs. likes to talk and Mr. to joke and all

three like the dogs. I keep remarkably busy tending beasts, cooking for them, fixing the good old van—everything has to sit *so* or we couldn't move. Then there's writing and a *very* occasional sketch in a five-minute period of "fine," and letter writing and reading and singing to the dogs to keep their hearts up and playing "this pig went to market" on Woo's toes and fingers to make her life less drab in the wet. Two families come to my tap in the woods to get water. I notice they come no more. All they have to do these days is hold a cup up to the sky and hang clothes on a line and iron. Poor strawberry growers! Their crops sopped to mush!

There is a deal of satisfaction in singing rubbish to the beasts. They take it for what it is worth. Today is radiant though now and again the sky puckers up. I have sketched this morning near the van. This afternoon will attack the gravel pits. The stuff about is big. Its beauty consists of its wide sweeps and is difficult, for space is more difficult than objects. Objects are all well enough for studies, but what this place has to say is out in the open. It is like a vast sound that must be produced with very few notes and they must be *very true* or else it will be nothing but noise. There are no interruptions to complain of for beyond the baker not a single soul has been to the camp. I can go to the Spencers' when I want to. Three black bears were down in the next bay two nights back. They killed one and wounded one.

June 19th

There is great heat. The earth has forgotten all about the sousing it recently received. This poor fine little grass is drying into hay that will never be cut. The sheep pant and crop just the tidbits. For the first time in days one of the people who use my tap in the woods has come. I suppose their cloud water is finished.

It is not good for man to be *too much* alone unless he is really very big, with stores of knowledge to draw from and a clear brain to think with. That's the whole problem: a clear brain that can take thoughts and work them out, can filter—clean out—muddy, confused thoughts, can read meanings into things, draw meanings out of things and come to conclusions, a brain that converses with life

and can, above all, enable a man to forget himself. The tendency in being alone and not having anyone to exchange thoughts with is to be always on the fence between yourself and yourself.

June 20th

It's one of those days that blare. Sky high and blue, sun dictatorial, wind uncertain, puffing here, huffing there. The grass is ripe. It is turning pinkish and leaning. The seeds are heavy on the sere stalks. The sea has no depth. It is all shimmering like a glass-topped table. You could slither things over its surface and they'd go on and on as far as the momentum of your throw. Nothing would sink, just slide over the top. It looks like ice except that it *looks* hot, not cold. The pines are solid colour now, no contrast between the new tops and adult needles. Lambs are blithering for their m-a-a-as. How *do* the lambs know the silly face of their own m-a-a-a from all the other silly faced m-a-a-a-s or each sheep know its own waggletail, woolly child. All their b-a-a-a-s are in exactly the same key.

June 22nd

Up at six—van gets hot. All the camp chores now done. Powerfully hot but a nice breeze. Last night I called on Mr. Strathdee, my camp host of two years ago. We conversed, me holding three dogs, he leaning on the fence. I heard all the little neighbour gossip and told about my move and the monk and dogs. He was pleased I went; his life must be very humdrum. What a help radio is to those isolated souls too shy to exchange much with humans! The un-bodied voice comes to them; there is no one there to make them self-conscious by scrutinizing their reactions. They can talk back if they want to, they are utterly free, they have neither to agree nor disagree. Thoughts and news and music tumble into their minds to be sorted by them at leisure—very wonderful and humanizing. I got home just at dark. The Spencers were going to bed as I passed. My pines were black. There was no moon or rather such a baby he was hardly born. I meandered through the black stumps keeping to the road for fear of treading on an ant hill but I was not scared even when I thought of the three bears in the neighbourhood. I ate doughnuts and strawberries in bed and read myself to sleep amid

snores and puffings of the beasts. "D'Sonoqua" is laid by again for more blemishes to rise and be skimmed off at a future date. It disappoints me.

This morning is a morning superb. The camp jobs are jobbed, pups and monkey bathed, all our beds aired and made up. Woo is tethered to a five-gallon shiny coal-oil can. She can boost it round camp and I can keep tab by the clank, and she cannot get it through the van door on a wrecking bout. Now for a few moments of quiet and then the woods. Did a good sketch yesterday—woods, light, movement, and wrestled with the gravel pit last night of which I made a botch and learned something. I suppose the whole hitch is I am not sufficiently interested in the pits. They are spacy but there is the crudity of men about them, and they smell commercial. The merry rattling stones and the glistening gravel are now roads and buildings, married to other ingredients, dead and uninteresting, and nature has not had time to heal the scars and holes yet. Fluffy little trees are bobbing out of the gullies. The pines are wrapped about in warm, sunny greens and standing still. Yesterday those silly single spikes on top of the young growth bobbed and bowed to each other like gawky, immature youths. Today they are trying to straighten and brag who can reach the sky first.

Humphrey came out to camp this morn. Nice of the boy to bicycle ten miles in the heat to see an old woman. (There is such yards of clean, fresh *him*.) I made buckets of fresh lemonade for him. I can't help wishing I had been in town this week. There were lots of ones I knew came for a medical conference, many from a long way away. But from the paper it seems that most of the time was spent in garden parties. I'd think that after the expense and all they'd want to hear and hear and talk, talk, compare, consult and chin over all the new stunts, not gad and garden-party. Gee, if we only had artists' conventions and all met, how luscious it would be!

June 23rd
I don't know anything as cold and deep a blue as the sea today with the sky high and blue above it. There sits Mount Baker, very unreal,

nosing up in the sky, and there Victoria, rather dull and aggressive today, between sea and Heaven. I got lost in the woods. Did not note the direction I took going in. I was very hungry and very cross and went round and round and came out where I least expected. It must be awful to be really lost. I knew the woods I was in were not vast and that I'd get somewhere some time. When I came into camp the monkey had eaten my dinner—I was mad!

June 27th
Indians must have felt the same way as I did when I ran into town for one hour yesterday. The town felt and smelt stale. It was hot, airless and noisy. Folk looked feverish and sweaty and ugly. My sisters' gardens looked lovely, one mass of flowers, but when I got out of the motor, such a rush of heavy perfume from all sorts of blooms burst out at the gate it was almost nauseating. Country smells are sweeter and wilder, more subtle and mysterious and evasive.

What a place this is to dream and drift and let the world go by, to go on and on and never catch up with your thoughts, to chew and stare like cows and sheep! The sky is low and full over a grey sea, and the breeze is moist and sticky.

The sun shouts, "Right about face," and every little dandelion looks him plumb in the eye. The grass is full of them, bright and pale yellow among the now warm pinky ochre of the drying-up grass. It is cloudless. Heaven has put on her blue dress and climbed to the top beyond all reach.

July 3rd
It's not raining but very cold and miserable. The grass and trees, even the birds' wings, are all heavy with wet, and the sheep look waterlogged. If there is going to be another deluge like June's I'm glad to go home though I've done good work these last few days and am in the swing of it. Yesterday it was the open spaces; burnt stumps and sea and sky trimmed up the edges, but it was the hole that I was trying for.

July 4th

Therese and Dr. Gunther brought us in. House dirty and much housecleaning necessary. Great tiredness. Welcome from Phyllis and Mary and the other kids in the neighbourhood did the heart good. Sisters looking bleached with weariness. I feel bad about it and can't do anything. They are impossible to help. Weeds in garden knee-high, weeds in yard neck-high, a wilderness. Nan Cheney came Saturday. We had a long talk. Willie, Sunday. Edythe, today.

Goodbye to Lizzie
1936

July 8th

I'm just whizzy! Sold four pictures, one from Vancouver Gallery, "Shoreline," one paper sketch, one French cottage, one Victoria. What a help to finances! Mrs. de Pencier of Toronto bought the first and her daughter the other three. Edythe and Fred came to supper and we had a lovely evening. I read them my "D'Sonoqua's Cats." Some of the descriptions they thought beautiful. I felt there was something did not satisfy Fred though apparently he could not quite put his finger on it. He suggested condensing it more and he took it home to read again. How sweet a place the world and all its inhabitants are at times!

Everything seemed shining today, from the freshly cleaned house and the sleek new pups to sunny little "Mrs. Bird" and my visitors, one of whom was the daughter of an old pupil of mine and brought such happy memories of her mother and me in the old studio in Vancouver. The world of today was clear, bubbly, and just straight nice.

July 13th

Yesterday the Cathedral bells were consecrated. I did not go to the service but went to my radio. Suddenly joy burst right into the room. The whole air seemed alive. It was as if the tongues of those great cold, hard metal things had become flesh and joy. They burst into being screaming with delight and the city vibrated. Some wordless thing they said touched something so deep inside you that they made tears come. Some of them were given in memory of dead

people. That's a splendid living memorial, live voices speaking for the dead. If someone were to die and you were permitted either to see *or* hear them, I think it would be best to hear their voice. What a person says comes out of his heart; you have to use your own imagination to interpret his looks. People reacted far more to the bells than they would have to a picture.

July 22nd
Received $120 for picture "Shoreline." Gallery took $30 commission from $150 sale price to Mrs. de Pencier. Also got $75 for three sketches from Miss de Pencier.

Glorious weather. Bright sun. Spanking breeze. I went with Alice to Gorge Park. How good she is, dragging those million kids to pleasures! The gardens were so lovely, with the flowers, birds and fish, and the Japanese waiters all smiles. Children bobbed everywhere and sunshine trembled on to the walks under the trees in little pools. The trees were so tall and green and protective. There was a hum of chatter as people unpacked baskets and the Japanese ran here and there with teapots and ice cream, the children revelling in revels and licking lick-sticks.

July 31st
Lizzie has been in the hospital four days now, suffering patiently. Oh, why? Alice is wonderfully competent and untiring. I feel such a flab. All the prayer people poke in to pray beside Lizzie. Why can't they do it at home? I think they like to be *seen* doing it. Seems like I can't pray much these days. Seems like I just want to lean up against God and say nothing. I take myself to task for not praying more but I guess He understands. Why is it when one goes to a hospital they want to burst out blubbering first thing? I feel blunted all over and very old. Tonight is very lonesome. Lizzie lies in St. Joseph's Hospital very ill. Alice lies in her little house, with the children's soft breathings all about her and the great powerful dog Chum standing guard on them all. And I down in my cottage with just the dogs.

August 1st
Lizzie's room swarms with posies and reeks with their smells, heavy,

cloying smells. They are very lovely and stand for many, many kindly souls and kindly thoughts, but oh, if I were there I'd rather have Indian flowers, a sprig of cedar, of mignonette, of lemon verbena or lavender, to hold and feel. The great branches of sweet peas are so flabbily determined to last out every other flower. The gladioli are glorious but if they collide against one another they sulk and shrivel. The carnations look like paper. Cut flowers are so cut off from life. Outside or on their roots they are so joyful.

Lizzie lies among the flowers facing death. I wonder how she feels about it. I wonder how I should feel if it was me. I can't believe that Lizzie is dying. She seems so usual. Any minute she might go or she may linger on and on. Anything would be better than that slow eating of disease. That is horrible.

August 3rd
Lizzie died at 5:45 this morning. I can't use the words "passed away" or "gone" or "fell asleep." They seem to me an affectation. I just have to say "dead." A little past six Alice and I went to the hospital. The sisters were lovely. Lizzie died quickly and quietly. It was merciful and blessed. The day has been interminable. Alice is so brave and I snivel easily. The nieces are here, at Alice's house. I came home to the pups and slept at night. It is nice to be alone. We are glad, everyone is glad, she was spared a long agonizing end. I don't think of her as at the undertaker's but as somewhere free and surprised and glad, somewhere over beyond. Dear Lizzie!

August 4th
Old ladies have been to see us all day, such decrepit ones, not quite contemporaries but older. We all quietly rejoice in Lizzie's quick, peaceful end. The old ones are half-envious. Alice and I went to see her. We took flowers from her own garden, beautiful gay marguerites and verbenas and asters, yellow snapdragons, geraniums, godetia, mignonette and honeysuckle. She was not ready. Another service was being held in the chapel. A hard-voiced, rouge-lipped, noisy woman was in the office where we sat waiting. She took the nightdress and stockings in a cold, callous way and said, "You can

sit in the office and wait." Then a man came in and they laughed and joked noisily. People whistled and banged doors. There was a spittoon next my feet filled with stale cigar stubs. "Come on," I said to Alice, "into the parlour. It will be quieter." Alice followed grudgingly for she hates my nervy "uppiness." The other room was little better except that there were no people. There were pictures of cemetery plots and diplomas for undertaking and embalming. The sun blazed in and showed lots of dust and grime. In the hall were pots of aspidistra and some deadish gladioli. People in black went through to the other funeral. Two girls in grey, who could not make up their minds to go into the chapel and face the coffin, peeped in the door and went away again quickly when the organ spoke. The hymn was quavery. It stopped. There was sniffled shuffling, and the sound of car doors shutting. Then a coarse, horrible person in black came to us. "She's not ready," he said. "Come back later." "We were told to come an hour back," I said. "Wait then," he said and left us.

Then at last the noisy woman clanked over the tiles and said, "Come to the chapel." She threw open the door and clicked on the lights, and slammed the door, and we were with Lizzie. The touch of Alice's quiet hand through my arm turned a tap behind my eyes. All that was left of the old Carrs stood looking down into the quiet grey coffin. All the fret and worry was ironed out of Lizzie's face. Every bit of earthiness was washed out and Heaven flooded in. I did not know she was so beautiful, so dignified and so sweet. It is good to look on the faces of the dead. They look like crumpled old lace that has been beautifully laundered and renovated. We laid the flowers from her own old garden in the coffin.

August 5th, 1936
The three long, long days of marking time, muffled voices and shuffling feet, whispering voices and dripping tears are over. Today the scrap of ground that Father bought and coped with granite yawns open for the fifth time. Alice and I, the pitiful remnant of Father's nine children, must put her away among the others, hear the hollow rattle of the sod against the box way down below, and

mound the brown earth and pile it high with the flowers that loved her and she loved so well. Then the shorn family must creep back to finish up the family chores.

It's 7:30 and time to face the day. I wish the funeral was from the church instead of from those loathsome parlours. It would be comforting, I think. Carr funerals always have been, but Lizzie said it was desecration, "to take dead bodies to the house of God." So we are carrying out her wishes. Perhaps she was really denying herself as she always did.

Later

The funeral chapel was crowded to the doors—all kinds of people. I'll bet everyone had had some kindness from Lizzie Carr. At the back was a little room for family so that we could cry in peace— Una, Alice, Gardner, Emmie and me. The place was banked with glorious flowers and Lizzie lay among them perfectly serene and gloriously happy, with all that crust of fret chipped off. The graveside service was not sad. The dear brown earth was covered with a spread of mock grass, bright green. A man pushed a button and the grey coffin sank noiselessly and took its place between Father and Mother, earth to earth, dust to dust, ashes to ashes. The man who ran things threw three handfuls of sod.

Then we left her. Several people came and shook our hands. They cried but they smiled too. I think they were the ones who had looked into the coffin and had seen how happy she was and realized how splendid God had been to take her so easily and spare her so much. We had tea at Alice's and then she and I went down to feed the pups. In the evening Una took us to the cemetery. The plot was massed with lovely flowers but already the wind had hurt them.

People say, "I want to remember Lizzie as last I saw her in life." But I love to remember her as last I saw her in death. Life had always seemed so full of frets and worries for her. Quick, troubled movement. So often she prefaced her sentences with, "I'm afraid," or "I'm worried over." It was like being introduced to a new Lizzie, this radiant person in the coffin. It was as though the spirit, stepping out of the clay, had illuminated it in passing and showed up the serene, queenly presence within. People are afraid to look at the

dead. Sometimes they say they want to remember them going about their ordinary tasks. I want always to remember Lizzie's coffin face. It was so completely satisfied.

August 8th

There is a dishonest feeling almost like indecency or eavesdropping in being thought dead when you are alive. Someone told me today that a girl next her in the funeral chapel was crying bitterly. Then she got up and looked in the coffin. "Oh, I've made a mistake," she cried. "It is not my Miss Carr, the artist." Someone cried because they thought I was dead. That was nice of them. They did not know Lizzie. There has been much confusion because the name Emily belongs to both of us.

August 14th

How hard it is to fill up a hole that somebody has gone out of! The empty feel, the hollow quietness, that ache that you can't place as if one were sickening for something you don't quite know what. Every day we go over to Lizzie's house for a few hours. Her flowers, her bantams, the big clematis vines over the verandah, the still, empty rooms that echo to the bell pull. The upstairs flat so clean and polished, left ready for a new tenant to jump into, the downstairs half empty of furniture, odd bits sitting round like orphans staring at the empty spots where the other furniture had been, and now the shabby places were bare and exposed. It was dreadfully heart-achy today. We were sorting the little, last things she used, the table-napkin in its ring, the table cloth and knives and forks and cup and plate she always used. We just choked up and cried over and over. The last entry in her diary—surely by it she knew she was to go soon.

We divided the silver and the knives and the linen. We agreed that if either wanted anything in particular to speak. Now and again we could joke over some poor old family thing or some little oddity Lizzie had harboured. The joke was only a cloak to cover the awful heartache. When we came to some frightful vase or teacosy, "Yours," Alice would say, "No, yours," I would reply, and we would push the article back and forth.

We were crying over the things in the table drawer when suddenly Alice ducked under the table and pointed towards the window. I saw a black and white female passing it with a stooped, melancholy back. I ducked too, even forgot my sciatica. There was a mournful rapping on the front door. The emptiness rapped back. Then a horrible thought—the blind was up a little. Alice oozed further under the table. I pulled my tell-tale legs further behind the sofa. We did not breathe till the gravel had stopped crunching. We were stiffer getting out than going under. The work has to be done. We had to stop the day before to mop a visitor's eyes, and got nothing done.

The bedroom is the hardest; the empty clothes, moulded and trained to Lizzie's body, the dip of hat brims, shoes like stopped clocks, woolly jackets and little grey hair nets, her purse and her handkerchiefs, shawls, lavender water, the drawers full of well-worn things. Alice shut them quickly. "I can't. There's no immediate hurry. Let's do the household linen first." The table cloths and sheets were more impersonal.

So we divided Lizzie's linen. Dainty, well laundered, so beautifully kept. She took such pride in these little ways, like a real woman. She scolded me so often—"Don't muss that cloth." "Millie don't fold the cloth like that." I remember how she used to make one take the end of the big table cloth and fold it, running her fingers down the fresh creases while I hung on to the other end, and how we used to fold for the old mangle, holding the sheets and shaking and shaking and her so vigorous shakes wrenching it out of your hands—the white sheets soiled—the heat of her wrath—the quick nervous jerk. What a trial I was to her! She taught me to make beds. How she pressed and smoothed, smacked pillows and set up the shams! And how bored I was! She called me a "filthy child" because I did not dust the top of the doors, and she left me the rungs of the chairs and the fat table legs to do. And I persistently started to dust the stairs from the bottom just to annoy her. What a peppery pair we were! She said I was a disgrace to the name of Carr, with slovenly ways. I was always a thorn in her side. She loved Alice way and ahead more. That's why I want Alice to have all her *nicest* things. She'd have loved her having them. But Alice

254

wants us to have everything equal. I don't think Alice could ever quite understand what happened when Lizzie and I collided. Lizzie and Alice could wear each other's clothes. They went to the same church, and "served" people, and their properties joined. Lizzie did not have to go on a public street. She ran to Alice's carrying the same thought that started in her own home and caused her to go there, but when she came to me she met other people on the way and distractions, so the thought she started with got mixed up *en route* and when she got there, there was me and out shot both our horns.

The glove drawer—that was the worst of all. Black, white, brown folded neatly in pairs. We pulled the drawer open. There were two half sobs and a great deal of blinking before we saw clear enough to begin sorting. We worked steadily from 11 to 4 o'clock. "Yours," "Mine," "Rubbish," "Yours," "Mine," "Rubbish." Five drawers in the mahogany chest, four in the white chest. Why do we hoard? But the oddments are handy. I have a bothersome way of finding a use for everything. I know I am thrifty. I hate to waste. An article would dangle with our four eyes appraising it. Alice would shake her head, "No room in my house." My knot would nod; it would come in for so and so. Seemed like everything could be used some way, and it would be rammed into my trunk. I can't think what will happen when I bring them home. "This?"—Alice held up a layette outfit (paper patterns). "One of us might have a baby," I said, and we went off into a "sixty-year cackle." It was those silly cackles that kept us up. Cackle or cry? Alice looked very white. My sciatic limp was bad coming home.

Lizzie had millions of tracts; prayer circle literature, missionary societies, little framed recipes for pious behaviour, pious poems, daily reminders, church almanacks, church of the air, British Israel, Christian Endeavour, Y.W.C.A., Sunday school, church gazettes, and enough Bibles to supply the whole British and Foreign Bible Society. I can't think how she could read them all in three life times. She was that way from her cradle up—*pious* and *good*.

I do not think it is any healthier to have drawers, shelves, tables, cupboards stuffed with tracts and holy books, recipes for when,

where, and how to pray, daily reminders, etc. etc., than it is to have every room of the house stuffed with edibles. Dear soul, how she worried over how to get there. She *got* there—the radiant glow in her face told *that*—but she travelled by a different route. All the routes are hard anyhow, I guess. Maybe those who take the hardest enjoy most the joy of arriving. It seemed rather horrible burning up all those hundreds of pamphlets. Lots of the recipes for prayers were good and well tested, but rather elaborate. (Mrs. Cridge used to make the most *delicious* little dropcakes. Once a week we went over to the Cridges' and read one of Dickens' books aloud. About ten minutes before we were due Mrs. Cridge seized a mix bowl, ran to the cupboard, dipped out flour, raisins, sugar, spice—pinches of things—beat them together with her own fingers. The batter dropped off the end, bumpy with raisins, and set in little blobs higgledy-piggledy over a black square pan. Oven door banged, fire crackled and lovely smells ran to the front door. When we rang there was flour on Mrs. Cridge's nose, even when she kissed us. Those cakes were just grand—no recipe at all, just Mrs. Cridge's common sense and good will and nice material.)

My backyard is wild. It is bounded by a board fence and a tangle of blackberry and loganberry vines, and the chicken house and shed, two plum trees, two pears and one apple, all heavy with fruit. Woo sits in one plum tree very content. The bantam cock and hen have a little bower under some seeding parsnip tops. A great pile of wood is sunning itself, storing up glow for the winter grates. The big griffons are sprawled dead with sleep. The baby griffs are cutting teeth on each other's ears; life is jokey with them. My pupil is scrubbing away, making a blue sky, two sunny houses, and a bit of plum tree. She is happy. I am trying to get behind her eyes and poke them out into space. The backyard is full of peace. No one overlooks me. Clean wash hangs high in neighbours' yards. Sometimes a reel-line squeaks, a chicken clucks about an egg, or a man chops wood. No children play in the backyards. The vegetables grow there; the children play in the streets. There is quiet shady space under the fruit trees. Space is more real than objects.

August 22nd

I am proud of our ancestry and our family. Today we have been through Father's and Mother's desks. Alice's eyes hurt, so I read. There was Grandfather's and Grandmother's letters to our father when he was a young man, and there was his sisters' and brothers' and cousins' and nephews' letters to him. Every one of theirs expressed great love for the young man out on his own, seeing the world, great anxiety for his welfare, and concern over the dangers of the wild life and place he was exposed to. But every one of them had some expression of gratitude for some kind thought or remembrance or help he had given to them. They seemed mostly to be poor, and he was always sending them money, and newspapers to the old men, and letters when he could. Apparently they had to know someone going who could take a packet and the vessels were most uncertain and trips perilous. But you felt they loved him, and he was good to them, and that he was high-principled and honourable, and that they were sure of him. Then there were all the letters about Dick's death down in Santa Barbara, away from all his people, fighting tuberculosis. What long letters they write about him! One man, his closest friend, writes, "He was the most honourable young man I have ever known—a beautiful character, loved very greatly by all he contacted." They mentioned innumerable good things of his, done so quietly they would never be known. There were letters written to Dede and Lizzie mentioning their extreme kindness and hospitality in the old home and garden, particularly to strangers and missionaries. There were letters telling of the helpful through-and-through sweetness of Tallie, and her patience in her sufferings, and always cheer and kindness for others. And there are all the letters we have just answered about Lizzie, her unselfishness to humanity and Christ's work. The last two days has been steeped in reading of these dear souls, and long letters of Mother's and Father's, and of little Lizzie to her mother and father, a shy sensitive lovely soul, reverently offering a little note with a card or drawing done by her little young hands, thanking them for her lessons. Such a conscientious little person! I never knew she was so sweet a little girl.

We were rather surprised to find our forefathers so earnestly

religious. Perhaps people know others really better after death than before because the shyness and self-consciousness is absent. When Father died, he was worth about $50,000, hard and honourably earned. He stood on his own feet and owed no man. I wonder what soured him, drove him into his shell and hardened him over? He had much physical suffering—perhaps it was that. Mother was a dear affectionate wife. I always thought him hard and selfish to her, an autocrat, but it seems he was loving too, and quite religious, and very honourable.

August 30th

Visitors have been to my studio. Do people mean those things they say? Does the work warrant it? One man said no work had moved him so much except Van Gogh's. Another said that the vitality of it was astounding. A woman said that they went away feeling uplifted as if they'd been in a different world. I don't know. Sometimes I feel *almost* as if it was good and sometimes not. One man called me long distance from Vancouver on passing through from Japan to New York. "I wanted to hear your voice," he said. "You know, I believe in you." When people say that it makes you taller. You've simply got to put your best foot forward. I want the woods and sky and sea, the whole outdoors. The cottage is too comfortable, too shut in. Rheumatic joints plead for inactivity, only my soul strains on its leash.

August 31st

Flora took Lizzie's big begonia to live with her today. Now all the life is gone from her sitting-room. It was a great plant with handsome leaves. It spread itself in front of the window and made a screen. Lizzie loved it, fed and watered it, admired it and upheld it when I used to growl that it kept out too much light. When she was gone it gloomed the room, shedding loneliness. The other plants Alice and I took to our homes but the big begonia was too big for our houses. Alice watered it and there it sat for one month all alone. Flora was glad to have it and we were glad to see it go. The sitting-room is dead now. None of the things that breathe are there. Everything in it has stopped. The windows are shut and no air moves

round. The door bell on its old curly wire spring sits quite steady. The walls give no echoes. Taps don't drip. No clocks tick. No fires crackle. "Finished" seems to be written on everything, on our babyhood and girlhood and womanhood, on our disappointments and happinesses, tendernesses and bitternesses, joys and sorrows. Dreams have been born there and have flown out of the windows again, dreams that only the dreamers knew, some that grew up and became fact, some that were still-born. I wish the dear old house could fold up and fly away. It is so tired. Lizzie cared for it very tenderly and kept it so decent and in order. It is such a lady of an old house, rather prim. The tops of the windows are curved like surprised eyebrows and the door wide and hospitable. I never have been up in the attic. A wide ladder went up through the broom closet. The top ended in blackness and terror. I was so scared of the dark! It took awful heart beatings and resolution to go down cellar. There was an electric light, but you had to go down into the black and grope to find it. How enormous the upstairs seemed before there was any electric light, and we went to bed with candles—a weanty little glow a few inches round! The nippy cold smell of upstairs on winter nights. If by any chance I was left *alone* in the house, I always opened all the doors and windows, or went out in the garden among the trees and shrubs, so much more companionable than sofas and tables and chairs full of nobody. Dear old house, if we could only give a great puff, Alice and I, now we have finished with you, and blow you into nothing—not sit and watch you rot. The house was something special to Lizzie. We took from it. Lizzie coaxed and petted it, denying herself things so it could be kept decent—painting a floor and stingeing on a hat, upholding its tax honour, wreathing it about with flowers, upholding the dignity of the front gate, and keeping the lawn well barbered.

September 6th—In camp
How easy it is to rip three months off the face of the calendar and what a lot of things they represent! Lizzie has gone, even her things are tidied away, and her grave smoothed and seeded down. The old house is empty and the agents working to sell it. Summer has come and gone. Alice's school has reopened and the new-born pups I took

in from camp, three inches and a squeal, are now half dogs. I was ready to leave on Saturday, but a friend was ill and I wanted to know how things were with her, so I came Sunday. There were five dogs to bring, and Woo. I bustled for two hours and then a grand calm the rest of the day—sleep, write, read, look. The sheep grass is silver-yellow and lies flat on the earth. If you part it the new green is underneath. At 5 o'clock this morning the van was filled with chill murk. I used the torch to see the clock. Outside, the moon and dawn were at grips. The moon was very high and superior, but dawn was pushing with a soft intensity. The rawness was aching my bones. I lighted the stove and got a hot bottle. I cosied down, waking at eight with sun roaring over my bed, and the dogs wanting out.

September 8th
It is 3 o'clock in the morning and *bitterly* cold. The creatures were so restless I got up and put the oil stove on to take the chill from the air. The lamp smells to Heaven. There is a magnificent moon and the sky peppered with stars, and a holy hush. The monkey has been restless all night. "Oo-oo-oo" punctuates the clock at irregular intervals.

Did good work this morning. Did poor work this afternoon. I am looking for something indescribable, so light it can be crushed by a heavy thought, so tender even our enthusiasm can wilt it, as mysterious as tears.

Wind has come up; rain clouds are skulking round. Have worked hard—two sketches in woods, with a bite in between. The woods are brim full of thoughts. You just sit and roll your eye and everywhere is a subject thought, something saying something. Trick is to adjust one's ear trumpet. Don't try to word it. Don't force it to come to you—your way—but try and adapt yourself *its* way. Let it lead you. Don't put a leash on it and drag it.

The pines are wonderful, a regular straight-from-the-shoulder tree. From root to sky no twist, no deviation. They know no crookedness, from trunk to branch-top hurled straight out, with needles

straight as sewing needles. Other trees ramble and twist, changing colour, clothed or naked, smooth or knobbly, but the pine tree is perpetually decent. In spring she dances a bit more. How her lines do twirl and whirl in tender green tips! She loves you to touch her, answering in intoxicating perfume stronger than any words. I'd rather live in a pine land than anywhere else. There is a delicious, honourable straightness to them.

September 11th
It pours in a ladylike, drizzlish manner. Everything looks drab. I don't mind usual rain but this is beastly revolting stuff. I am going home tomorrow morning.

September 23rd
I painted *well* today, working on the summer sketches, reliving them—loving them. I think I have gone further this year, have lifted a little. I see things a little more as a whole, a little more complete. I am always watching for fear of getting feeble and *passé* in my work. I don't want to trickle out. I want to pour till the pail is empty, the last bit going out in a gush, not in drops. I must get the sketches cleaned and clarified. Some I do not need to touch. I have said what I thought and moiling over them would bungle the point, where there is one. But others I can see the thought sticking half through and it needs a little push and pull and squeeze. It's muddlesome, a bit. I wonder will I ever attain the "serene throb," that superlative something coming from perfect mechanics with a pure and complete thought behind it, where the thing breathes and you hold your breath as if you had spent it all, had poured it into the creation. Sometimes when you are working, part of you seems chained like a bird I saw in England once, tied by a thread on its leg to a bush. It fluttered terribly, and I went to see what was wrong. The string cut through the leg as I came and the bird fluttered harder. The leg was left on the bush with the string, and the bird was free. Has one always to lose something, a very part of them, to gain freedom? Perhaps death is like that, the soul tearing itself free from the body.

A man told me recently that my painting was like music to him. A woman said yesterday my writing was more like poetry than stories. Now this is silly. Why shouldn't pictures be pictures and stories be stories? Ruth Humphrey liked my stories "Mrs. Drake" and "D'Sonoqua's Cats" very much. "Unnamed" she found wanting. I feel myself that it is wrong and yet I feel that there is something more subtle way back in it, where the wild crow contacts the humans, than perhaps there is in the other two stories which are straight experiences. "Mrs. Drake" more or less satisfies me. It was the easiest. "D'Sonoqua" brings in the supernatural element and the forest, but "Unnamed" touches something too delicate to define and I have overpowered it by the brutality of the man. I will lay it by but there is something there I must dig out. This morning I began "White Currants." I want it to be so dainty, so ephemeral that it just melts as you look at it like a snow-flake.

Alice sat opposite the lawyer and I at the side. The baize covered table was spread with papers. Some of them had seals on. Some were peculiar paper with the look of money and divided up by little perforated fences. The lawyer said, "I have divided the bonds as evenly as possible." He gave us each a statement to read and went and stood at the window while we read. He asked if it was satisfactory and gave us his fountain pen and we signed. Then he put part of the queer money-like paper by Alice and part by me and told us to go to our two banks and each get a box and put them in. So Lizzie's estate was divided. I wanted to cry dreadfully. My throat hurt and I expect Alice's did too. It was like Lizzie's strength and blood lying there on the table. It was her life's work. Oh no! Not that. That is all saved up in people's muscles and bones, in crippled children, and old folk's aches that she eased. That money was only the earthy side of the thing. Alice had to go home to those pestiferous kids. I bought an armful of lovely flowers and went to the cemetery and cried. I had the flowers all fixed and the car was coming, but I went back and cried some more and took the next car. Life will be some easier for Alice and me because of what Lizzie left us, but an ache goes with it.

I finished "White Currants." It appeals to me rather because I suppose it is true of that corner of the garden. I can see it so clearly and the boy "Drummie" who came sometimes—just a felt presence, not a seen one. I so often have wondered who and why he was. I don't remember anything he did or said—only the jog trot of my own fat legs which was the jog of the two white horses. The whole thing was "white currant clear." I never told a soul. I would never have dreamt of telling even Alice. She would not have understood then any more than she did tonight when I read "Mrs. Drake" to her. Once or twice she laughed when she remembered one of the incidents, a superior unhearty laugh that somehow hurt. I could never read "White Currants" to her or to anybody, I think. Why do I *want to* write this foolishness? Just to hide it away? It hurts getting it out and then it hurts when it is out and people see it. The whole show is silly! Life's silly. I'm silly and it's silly to mind being silly.

October 22nd
I fought against starting a canvas for weeks. I wanted to but I was afraid; did not know where to begin. First I'd say, "No, you can't begin a canvas till you've cleaned up and mounted the summer sketches." So I finished them. Then it was this and then that, sewing, gardening and seeing people, and all the time the new canvas lay on my chest as clean as the day it was stretched. Today I said, "It shall be," and still I hovered round dallying. Even when everything was ready I had to eat a pear and smoke a cigarette and do things I did not have to do. Finally I did get out the sketches and sat before them and thought. The canvas was an upright and the subject a horizontal. There were three clamps fixing it to the easel. Back and forth through the picture room I went measuring other canvases, and then . . . I spiritually kicked myself, got up and unclamped the three clamps, turned the canvas, and suddenly seized the charcoal and swung in. Most of the day was gone by then, but no sooner did I put touch to canvas than the joy of it came back and I spent one happy hour. I do not understand this great obstinacy, wanting and won't all in the same moment. Seems as though I am chained up and have to wait to be loosed, as though I got stage fright, scared of my own self, of my blindness and ignorance. If there were only

someone to kick me or someone to be an example (I'd probably hate them), but it is so dull kicking and prodding your own self. When I'd broken the ice and made a start I was excited at once.

There's words enough, paint and brushes enough, and thoughts enough. The whole difficulty seems to be getting the thoughts clear enough, making them stand still long enough to be fitted with words and paint. They are so elusive, like wild birds singing above your head, twittering close beside you, chortling in front of you, but gone the moment you put out a hand. If you ever do catch hold of a piece of a thought it breaks away leaving the piece in your hand just to aggravate you. If one could only encompass the whole, corral it, enclose it safe, but then maybe it would die and dwindle away because it could not go on growing. I don't think thoughts *could* stand still. The fringes of them would always be tangling into something just a little further on and that would draw it out and out. I guess that is just why it is so difficult to catch a complete idea. It's because everything is always on the move, always expanding.

November 1st
Wills are pesky. To sit down in healthy cold blood and portion out your stuff, to appoint an executrix (a word you don't even know how to spell), to talk about your stuff as if it was not yours any more and you were very much to blame for encumbering your nearest and leaving things behind that they did not know what on earth to do with, all this makes you feel small and mean. Of course, any goods—money, bonds, or ordinary useful articles—are another matter. Nobody minds those, the more the merrier, but it's that load of pictures that nobody wants. The relatives sigh and say, "Oh, lor!" The lawyer obviously thought so very little of them or of the chances of their ever selling, he said I should empower their keeper to *give* them away if he could not sell them. He seemed so sorry and sympathetic for those they were left to. I came home feeling like a mean soul. I almost wished the cottage would burn and the pictures with it, to relieve everyone of bother. And then Alice told me something that hoisted me wonderfully. She said Muriel told her the picture she has of mine helped her when she felt bad. It sort of

gave her peace. Whew! I was pleased. I always thought the nieces despised my work. One is very greedy. Why should they expect every picture to speak? They ought to be so darn grateful if just a few say just a little.

Ruth Humphrey is helping a lot. Writing is coming easier and I see more. She said "White Currants" was beautiful and she likes "D'Sonoqua" and "Mrs. Drake." She helped me a lot in criticizing the "Cow Yard."

I have not written in my book for a long time. I have been writing stories and that, I expect, eased me, pouring out that way. It seems as if one must express some way, but why? What good do your sayings or doings do? The pictures go into the picture room, the stories into the drawer.

November 6th
It is Lizzie's first birthday away. Her affairs were just settled up, so Alice and I took a plant for Mrs. Owen and the cheques for the church and for Mr. Owen that Lizzie left for them. We went first to the cemetery and then to the Owens'. The little parson talked like an eggbeater. Mrs. Owen was quiet but pleased at us going. Now we have done up everything as far as we know that Lizzie wished. I suggested most of the things. The ideas just seemed to come to me. Alice always acquiesced. Lizzie was much fonder of Alice than of me. She never talked to me of her affairs or wishes or health or friends; she talked to Alice. Perhaps she could do it more easily after she died. Possibly she was able in death to say things to me she could not in life. I do like to remember her face as it was in her coffin, so perfectly happy and radiant and only just beyond reach, at one with the aloof loveliness of her flowers.

I had an evening showing in the cottage with about twenty-five guests. In one room were modern oils, in one Indian mixed periods, and in the studio woods things. My sketches were shown in the kitchen. The people were seated at the end of the room, the lighted easel and I at the other. One man sat on the stove which was not lighted. I showed about twenty-five 1936 sketches. The people sat

pretty stodgily. Willie was among them at the back and said the mutters were appreciative. My deaf ear was towards them. It is a trying job. Fifty eyes done up in pairs scrutinizing your soul—bewildered, trying not to give offence, yet wanting themselves to seem wise and deep. The old ones are the most dull and annoying, particularly would-be art teachers and critics. "How long does it take you to make a sketch?" "What time of day was the sketch taken?" "Was that north or south of so-and-so?" Others want to know the exact materials you use, or the exact size of brush. I am glad today has left yesterday behind. Today I have no patience.

November 25th
The horrible Christmas turmoil draws near. How I hate it. It is not Christian; it is barbarous. Am I mean or is it consequent on seeing people give so lavishly when *unable* to do so that has set up revolt inside me? I do not know. I am always making up my mind to give my paintings away freely, and then I don't much. So often doubt of people really wanting them stops me. I can see the people so bored, wondering where to hang the thing, or groaning over getting a frame for it, or sitting it down behind some furniture to hang someday and never doing so. I shall give away six for Christmas.

December 1st
I have been requested to send some pictures to Toronto on approval, all expenses paid! I wonder if they will buy one or just return them with thanks. Every night I go to bed, put the light out, and remember something I'd like to have written. In the morning it is gone—where? Sleep overtakes one's intentions so vigorously and suddenly. I think that to try to express each day some incident in plain wording would help one to build up one's writing, painting, observing, concentrating and all the other things. I have painted vigorously the last two weeks, running a race with the daylight.

The big fat man asked if I was Emily Carr. He had a big envelope in his hand. His fine automobile was at the gate. Perhaps it was a summons for something. My knees got shaky while I rapidly surveyed my past life. (When one had the apartment house one never

knew what might go on in any of the flats and you be held responsible.) "The letter will explain," he said between chews on his gum. It was only about the pictures. Everything was O.K. The man said, "My daughter has a turn for art. She can copy magazine covers in pencil fine. I guess she ought to be cultivated." (As if she was a turnip.) He represented the Gutta Percha Rubber Company, tires, etc. It seemed as if he was chewing on a tire, he did it with such strength and length.

Willie brought a Dr. Something (anthropology). The youth had brown eyes—and a cold. Willie unearthed *everything*. We had tea off the kitchen oil cloth. The house was fairly tidy. People roam round it without embarrassment. If I kept it any cleaner I really would get no time to paint at all.

Oh, I do want that thing, that oneness of movement that will catch the thing up into one movement and sing—harmony of life.

Why when people are *extra* kind to you do you want to run and hide, or to cry? Why does praise make one humble? The whole world is a question mark this morning, and outside the gloom is livened by raindrops hanging like diamonds from everything. Three yellow old apples are still on the bare tree outside the kitchen window, shrivelled and lonely like three old, old maids. I am troubled in the head, or rather in the heart today. Things, thought things, are congested, stuck. I can't go ahead; have to detour over a bad road and ruts and woods. Those woods with their densely packed undergrowth!—a solidity full of air and space—moving, joyous, alive, quivering with light, springing, singing paeans of praise, throbbingly awake. Oh, to be so at one with the whole that it is *you* springing and *you* singing.

I went to two parties today. I was sent for and treated with such kind consideration. All the others were young—not very, but not old. The supper was delicate and the conversation bright. No one touched on the big matters that the air is full of, our beloved King and the perplexity of the nation, and his obstinancy about Mrs. Simpson, and Queen Mary's tears. The nation is trembling with

apprehension but nobody spoke of that although it must have been at the back of all our thoughts.

Then we went through the dripping rain to the second party. The hostess had a nice flat and apologized for everything. She showed us into a clean, empty room and gave us an illustrated lantern lecture on modern art. She did not know the subject and apologized for the painting and the pictures and herself. It was too long and too heterogeneous. Everyone tried to sparkle but when it went on and on they flattened. She bit round the edges of her subject for two solid hours. I wished she would not keep asking me things as if I knew everything just because I painted. When I said, "I don't know," she thought me mean, but I meant I did not know. She is the one who thinks that everything is done by a rule of technique and that you should be able to sift out all the influences that contributed to an artist's mode of expressing himself, what he got from this person and what from that. I think that one's art is a growth inside one. I do not think one can explain growth. It is silent and subtle. One does not keep digging up a plant to see how it grew. Who could explain its blossom? It can only explain itself in smell and colour and form. It touches you with these and the thing is said. These critics with their rules and words and theories and influences make me very tired. It is listening; it is hunting with the heart. How can one explain these things?

December 9th

The sky is flat and the sea cross. Irritated waves reared up but the wind came all ways. The waves hissed and spluttered but did not hit. These white splutters tormented the deep green-grey. The horizon was a dark line overhanging space, thick, smothering space. There were just two things ahead, sea and space.

The King and Mrs. Simpson, that is all you hear these days. It is the national scandal. People do not know what to say. We love our King but feel it lowering to have a double divorcee for the first lady of the land. Which will conquer, the people's love of a kind tender-hearted King or virtue and the Church? The nation cannot decide; neither can the individual. Will God point? Is it one of His mysterious ways to right things—national things?

December 10th
All for the love of a woman Britain's King has abdicated.

December 11th
The thought of the King bursts, oozes from people according to their natures. Many are already finding the Duke of York more suitable for the throne. How swiftly people change! They are sore because the King let his job down. They are personally slighted at his not wanting to remain their King, at his preferring a divorcee to them. Some say it is preordained. The young King is going to be dreadfully homesick for British soil. Fancy owning half the earth and the hearts of the people and homage to be nearly worshipped by them, and then suddenly to be a banished nobody. Is England's crown no greater than a shuttlecock that he prefers her to an empire?

December 17th 2:30
We have just said goodbye to Edward VIII, our beloved King. Who is to condemn him, who to praise him? I do not think any public national event has ever moved me so deeply. I am glad no one was here at my radio. I cried right from the deep of me.

December 19th
It is rather wonderful to get a Christmas letter from a man who loved you forty years ago. And he tells you he thinks of you very often, and in the folder he has put pressed flowers. He ends the greeting with, "I send you my very dear love," remembering the girl in her twenties who is now in her sixties. All that love spilt over me and I let it spill, standing in the middle of the puddle of it, angry at being drenched and totally unable to accept or return it.

Three old women lived together separately, that is, they each had a house. Each house was on a different street, but altogether none of them was a block away from the others. They were sisters tied close in affection to one another and miles apart in temperament, in habits and likes. By and by one moved further off and one died. Then the remaining two, though they were further apart, were tied closer together than ever.

December 24th

Alice and I took wreaths of holly and of cedar to the cemetery. The grass has covered the scarred earth. It is smoothed down and green over Lizzie. It was raining and dark. We placed our wreaths and came quickly away. I went straight home and lighted the fires. Alice shopped and followed. There were parcels at my door. I switched on the light and the tiny Christmas tree in a pot in the front window burst into twinkles of red, green and blue. The shiver of gloom fled and that holy hush that shimmers about a lighted tree filled the little parlour. Down the hall the kindling cedar crackled and popped, and presently the smell of turkey roasting swept up the hall. Alice looked so tired when she came. After our meal we felt better. Willie came and brought a great barrow full of dry logs for me. We sat round the fire chatting. When he left we opened our parcels and letters and cards and got chokey when there were messages about Lizzie. I walked almost home with Alice. We took the turkey carcass.

December 25th

This morning we met in her church, dined at her house. We wanted it just quiet. There were more letters and more chokes. Then we went our ways till supper at my house. There was a stack of mail again—dear kind letters. Oh, very, very lovely letters from all over. When 9 o'clock came, we took the streetcar into town to see the beautiful lights. When we met the return car we got off and boarded it and came home, parting where the car turns. She would not let me go on home with her. I worry when she is out at night, she is so blind. But I phoned later. The wind is crying out long bitter wailing sobs. Christmas 1936 is past.

To be in a position to criticize one must have one or both of the aspects to work on. He must understand the medium or he must know the subject matter. So-called critics who get a smatter of "book art" and do not enter into the field of nature are absolutely incompetent to criticize pictures.

Old 1936 is bundled up ready to depart. He is at the very door.

Just a second or so and the door will slam behind him and he will never come back, never, never, and poor little 1937 stands naked and shivering, waiting to come in. Now he has come; that strange nothing has taken place that ticks off another year and leaves a clean new sheet. If we could stop its coming, make it stand still always at '36 we would not do it. It's the going on that is really worth while and exciting.

Hospital
1937

January 1st, 1937
At twenty to seven the cab came for us. We were dressed in the best we had. Alice looked sweet in her dark prune with the ruche. I had on my black and Dede's cameo brooch.

They are great friends of my sister's. We have known them since we were all girls. We are Alice and Millie; they are Millie and Alice. Their Alice, our Millie are the bossy, disagreeable ones. All of us were grey haired and our hands knotted and bony. I had not been in their house for years. We sort of stepped on each other's tails. It's all over now; they've had sorrow and we've had sorrow and I guess we've forgotten all about our tails now. Dinner was good and there was lots of talking.

It was delicious to get home again, warm and peaceful in the cottage. I love this cottage more and more. It's humble, quiet, suits my needs. I went into the studio and turned the light on two sketches I worked on today. I seem to be after something without a name. It's to do with movement, a transcendental thing but not quite clear. People don't know what I'm after now. How would they when it's so misty to myself? I'll just go straight on. Maybe it will clarify. Maybe someone else will pick up the thread where I leave off. One can't tell what they don't know. I wonder will Lawren understand—I doubt it.

January 2nd
Two men asked if they might come to the studio to see what I had been doing. I had to go out and post some sketches to Lawren and Hatch and so only had one hour to spare. I told Jack and John that

but they came half an hour late. I brought out several canvases and sketches. They sat staring, but neither said one word. It became very embarrassing. After showing about six with no comment whatever I clapped them back to the wall and showed no more canvases. A few sketches received the same reception so I sat down and quit. It's rude of them. Even if they had condemned it would have been easier. They are unmannerly cubs anyhow and their comments not worth registering but these things do affect an artist. Perhaps there is nothing in my present work. I had hoped there was joy and movement. Joy and movement would not appeal to Jack. His outlook is very morbid. He likes blood and thunder. His big idea is design. He does not know and feel woods. That bunch over there in Vancouver don't. They want design and technique and colour. The spirit passes their senses without touching. Or am I a doddering old fool weakly toddling round my grave's brink, nearly through with "seeing"?

January 5th
It is one of our bitterest days. Everything is fighting everything else. The wind is roaring and the ground adamant. The few plants that have not dropped every leaf and gone to sleep are drooped low begging the hard, cold earth to shelter them. It says, "Nothing doing," and relentlessly shuts down harder than ever. Everything cruel is loose, biting and battering. My cottage is moderately warm, but what of those without fuel, and the cutting winds piercing in through the cracks?

January 9th
Yesterday the pain that has come and gone intermittently for many years came and stayed, protesting at the bitter cold snap. Finally I sent for Dr. MacPherson. He diagnosed it "heart" immediately. I am not to lift or stoop or walk, not even to Alice's. I have to rest, rest, rest and crawl "crock's pace" to the tomb. It's a bit of a blow but today I feel somewhat better and am trying to count up the things I can do and forget the ones I can't. It will take some reconstruction, like learning to think in a different language. I hope my patience hangs out. I have been a roustabout from a babe, going

pell-mell after what I wanted. How can I learn to shove not lift, kneel not stoop, to walk no more in the glorious woods with my sketch sack on my back? Ah, but while my heart sits pumping furious rebellion, my soul can glide out of itself and be among the trees and the sea of growth. It can smell the damp earth. Oh the joy of a travelling soul that has learned its way about the woods! Suppose I lived always in a city and my soul only knew houses and streets! I do thank God for all the freedom I have had and the power to relive it. I will not moan in self-pity. It is going to be hard enough for Alice, with me so stodgy who had planned on being so useful to her failing sight.

January 10th
Had attacks of pain one on top of another. The whole world seemed full of pain with an extra share of it stuffed into my house and just me to cope with it. Should I send for the doctor? No, certainly not on a Sunday night! So I left undone all the things I should have done and tumbled into bed. Then I fell asleep only to wake to a fresh pile of pain. When I saw it was only 10:20 my mind was made up. The doctor's young son answered the phone.

The doctor gave me a hypo and expected me to sleep till morning. Not me. After two hours of exquisite, rosy quiet I burst into another attack. Then came three hours' sleep and from five o'clock on for twelve hours life was good and mean. Now as long as I am still I'm fairly happy. The doctor's orders are "bed entirely." Such a comic household, with me in bed, Alice and Elinor and Mrs. Hudson coming and going, Willie trotting in and out, Woo in the kitchen bombarding everyone, and the dogs evading them to sneak in on to my bed. It's all right till they start to fight on my prone body. Then it is more than I can stand and the silly little pain grows bigger and bigger, tweaking every organ in my body.

January 15th—In hospital
Myriads of nurses fluttering about like white butterflies, sisters as dignified as pine trees, the gracious round-aboutness of them spreading and ample. One could never reach their hearts. If you crushed up close to a prime young pine it would give forth a glorious spicy

sweetness, its boughs would sweep round and fold you, but always they would hold you a little aloof; so far, no further; its big branches would hold you back from its heart, though it would bathe you with fragrant sweetness. I do not know my Sister's name but she's beautiful and radiant. She is young and straight and serene standing there near the door. Unless you need something she will not touch you and you would never dare to put out your hand to touch her.

Outside I look into a quiet enclosure that sinks down several stories and is floored by a flat roof. It has a quiet north light such as I love and such as cats, too, like when they are sick and crave shadow. There are four stories above us on the other side of the court. The only window that shows life is a semi-private. Nurses are always passing back and forth, and there is a pink cyclamen and a primula looking out across to me. In one corner of the court over the semi-private is a square of sky, the only living, moving, free thing not held in by bricks and mortar. At first I thought the court was just dead windows and tar roof but today, first, a pale woe-begone sunbeam sneaked in half-heartedly and the next time I looked snow-flakes were jiggering crazily every way. It was much more entertaining than my book. Three gulls swept over very high just as the sunbeam was going.

Out in the sunroom at the end of the hall is a canary. Throb, throb, throb purrs the note in his throat till the whole ecstasy bubbles up and over and splashes down the corridor. All night the flowers sit outside the doors and watch. One night when I came here to see someone flowers were massed outside some rooms, big groups. Gladioli and gay summer fellows seemed to see who could look most giddy and bright. Outside one door was a tiny bunch of common marigolds. I wanted to stoop and kiss the homely little bunch from someone's own garden, their faces were so honest. When I told Alice about the marigolds she said she would be in-sulted if any one sent *her* marigolds. I have a bunch of precious January daffodils and some chrysanthemums. I was crying when they came, the dreadful depression that follows hypos, but when I put my head down into the box something extraordinary happened to the blues. They put them on my bed table and I kept jigging the bed so that they would nod their heads at me. I crushed up a leaf

and it poured out that delicious pungent chrysanthemum smell that is as strong in the leaves as in the flowers. Just above them opposite my bed is a wooden cross with a silver Christ. No matter what light is in the room it always gleams on Christ's body, across His heart and on His feet.

January 21st

It is a drizzle of a day. I had four visitors besides Alice, and a pudding. Down flat you are a horrible prey to their kisses. Take notice, me, don't kiss the sick.

A new doctor came to see me. He told me too much and was mad with himself. I told him I knew it before he told me and that I would not tell my own doctor that he had let it out. He patted my head like a good pup. I drowsed all day neither awake nor asleep. Now I have written letters about the dogs and the monkey. It's like scraping on your raw heart with a dry pen. The babies in the maternity ward have not cried today and the old man across the corridor has not groaned. My nurse has quit and she who substitutes has neither years nor intelligence. I feel as helpless as a nutshell boat with no little boy with a long stick to guide it.

January 22nd

More lovely flowers came today. There were daffodils, high fellows, from a sunny young boy and violets from Mrs. Hudson, sweet-scented, modest, afraid of intruding. There were white chrysanthemums that I buried my face in a long while, from a sweet, thoughtful woman. The parson came (not my parson), and offered a little prayer for Alice and me. Alice comes every day at the same time. The door comes gently open and she steals in like moonbeams. We tell each other the happenings. It is difficult to believe that there is cold and snow and bitter slop outside. In here it's spring, with daffodils and tulips and violets. I lie selfishly in the peace forgetting the horrible tumult of the angry nations, the floods and freezings and murders and kidnappings. The top of the chapel is just outside my window, which is always open. The sisters' prayers pass right up past it. If I send mine out maybe they will catch up with and join the bunch.

January 23rd

My little square of sky is blue and a wash of pale sunshine illuminates the court, the grey-washed bricks and the big wasps' nest opposite. The bird sings very gaily this morning. Someone screamed terribly early and the sisters' singing in the chapel came up dimly. Now the Cathedral chimes have burst out. The patter of the little white people and the chatter of the bells and buzzer is incessant.

January 25th

Sister, our Sister, has gone into retreat. I wish I knew what "retreat" meant. I know they retire, speak to no one, and take no part in the work, but why? Who tells them it's for the good of their souls? Do they tell themselves? Does the stress of seeing people suffer and die become too much so that they must pause to collect their garment of peace? Is it because their faith is shaken and they have to seal up the cracks afresh? Or perhaps they've kicked over the traces and dipped into worldly thoughts, and have to sit down and untangle themselves. Perhaps it is not self-discipline but a law of the order to sit meditating only on holy things. How can they? Everything is God-filled. Just to sit and contemplate the fact in one's soul is surely prayer. To say prayers over and over is to churn words and tire God. Is it voluntary or enforced? That's what I want to know. I miss her beautiful face. I seem to feel a serene light under the sombre trappings. I wish I knew about it. I wish I knew that it was not selfish to quit and pray and pray. The new Sister is playful and bright and radiant but not so serene.

The evenings are long and silent but the visitors of the day have left themselves, some in books, some in flowers, some in the kind things they said. Ruth read "The Little Street" aloud to me. She went away a little thoughtful and took it with her. It is amazing how kind everyone is. I did not guess that people would be so tender and loving to me. I seem so little to deserve it. Alice is the peach of them all. My room is full of kind, gentle things and thoughts.

When a boy thumped on my door and bounced a telegram at me I went to pieces. Of course at first I was quite sure that Alice was dead or at least broken, though afterwards Reason said, "Why wire?" Well, it was from a man at the Vancouver Art Gallery ask-

ing for an appointment next Friday for an art critic from the *Manchester Guardian* who had been told by the Canadian National Gallery to inspect my pictures. I began to write, "No," and then asked the telegram boy what he thought I had better say. I lost my breath and saw fifteen telegraph boys at once. Fortunately a friend was there and saw what a mess my brain was in and phoned to Willie to answer the telegram. I blithered and dithered and recovered after a bit till they came back from the telegraph office to say that Vancouver was waiting for an answer. Then I broke up again and this time Alice and Harry came in and sorted me out. The rest of the day I was like a beached cod. The doctor says that I have kept going all keyed up and now I have cracked and will have to relax. I guess I need the prop of St. Joseph's a bit longer. Again I have rolled the load over to Willie but I believe he'll like showing the pictures. I believe he almost feels as if he'd done them himself. He does not know that one day they will be half his, half Alice's. Oh, I wish they were ever so much better, that I could have been pure-souled enough to see deeper and express what I saw in paint or words or something. Maybe next time I shall see and understand more.

January 29th

Mr. Eric Newton, art critic for the *Manchester Guardian*, came to see me in hospital. He is medium-sized, lean and earnest. I should like to have heard his lecture. Willie and Ruth and Alice had him down at my cottage but he said that he had only seen a little. He and Ruth came to the hospital to see me during hours. He stayed half an hour and my heart bore up well. He was quiet. He said what he had seen had impressed him very greatly, more than anything he had seen anywhere else, even in London, because it was honest and deep. He said that he'd driven through such country all day coming from Duncan and in my studio he had seen it expressed. "Get better," he said, "and go on. Those hands must not lie idle there when you can do things like that with them." He liked the woods best and I am so glad. I was just afraid that the queerness of the totems might have led him off the track, but I believe he was very sincere. Dear Willie, he had everything all tabulated, dated,

dusted and in order. Ruth took Mr. Newton for a bite to eat and then they went back to my house to see the pictures. He said, "I have till midnight to revel and glory in them. I'm looking out for a good time after seeing a few. I knew that I'd have to see *you* and then come back." It is a big honour he did me. It is those honours that make one feel very lowly and get down and beg God to let you see clearer and interpret more wisely.

Willie came in earlier in the day. I went through a lot of things with him and rocketed about and collapsed hauling out papers about exhibitions and dates. He left, scared, and told my nurse and she came in and brought brandy. They were for not allowing me to see the man, but Dr. MacPherson *knew* it would bother me less to see him and said go ahead. I kept a good hold on my wits and came through fine, but I wish I'd been healthy to talk to a big man like that and get his ideas on things. He evidently has the big outlook and spirit counts with him.

January 30th

I have suffered from great weariness all day and a severe headache. Have not seen Willie or Ruth since Mr. Newton made his selection. Willie sent me a list. Rather a poor choice, I thought, from my different periods. Drat periods! They don't seem to me to matter. Today I seem to have lost all interest in the pictures and the choice, and would rather think of the great outdoors and what it is trying to say through me. I want to hear more distinctly. Why must everything one does be measured up, tabulated and exhibited? It ought to be just joy, not information.

Willie and Alice have both been here. Willie brought some pictures I had to sign and a bottle of gas and a brush like a kalsomine brush. They've wired again from Ottawa to send on Mr. Newton's choices. What a time they did have there by themselves last night! It's comic. It must have been almost as if I was dead. I don't want to be dead; I want to search and understand deeper. This I know, whether here or there it will be the right place for me to be growing.

February 1st

I don't seem to get much stronger. I'm not fussing to return. It would

be hard on everyone, and I have not got a cat's strength at present. Alice looks tired and a little down. Living in perpetual twilight is enough to make one so. I'm not thinking about things. For me it's O.K. somehow. For Alice it's blur and blind and alone. I could almost wish her to be gone first. She is very alone, but for me. Sister is back, gliding into my room like a sea gull with the sun on it and all the calm of the sea behind. I was so glad my hand flew out and touched hers. She gave no response except a smile. "I enjoyed my retreat," she said, "but it's nice to be back on the floor. The nurses need a sister. They've been so busy." Bless them; they have indeed.

February 2nd
Rain is falling in sheets. Nothing in the air of my court is ever done; it is always doing. The snow-flakes are fluttering and rain pouring, but you never see them arrive, only on the way, because for me the court has no bottom. I haven't seen dear Mother Earth for three weeks. Even the gulls never come into the court. They fly over the top. Just their shadows flicker down, if there is a sun.

February 3rd
I progress slowly. These queer blobs beneath me are not my own feet yet. Being sick is a horrid way to spend your money. Alice brought me all her cherished Chinese lilies and her Christmas cactus. I just revelled in their perfume all night. Smells lift you, and the heart knows their words well. If in the next life we have no noses or ears or organs we will surely have some medium of contact with these lovely things, a beautiful drawing of these essences into ourselves; ourselves being drawn into still bigger ones.

February 9th
The doctor told me I could begin to make arrangements for going home in a day or two. When he'd gone out of the room I cried. I felt so unequal to coping with life on my own and with the "person" who has yet to be found. I suppose I might give her the chance to be a nice one, but I am all prickles out when I feel her in the air. It is intolerable to think of her bossing me and my house, and I don't

feel fit to boss a caterpillar. I want to be home, but I'm so flabby that I shall miss the care. But after the first kick-off I'll begin to get stronger and throw out new shoots. I think perhaps it's the beginning of leading an invalid's life that I hate so, but I must not let Alice see.

The last few days have been *bad*—overpowering headaches, hot salty tears running down into my pillow. Because I got exhausted trying to walk a few steps, blub. Because my bell broke, blub. Because the door banged all day and night, blub. Because the next-door radio boomed, blub. Because two would-be ladies-in-waiting came to interview, blub. (Not to their faces but as soon as they were gone, from the effort of talking and explaining.) Because I got a cheque for $200 for a picture I lay awake all night, dry and exhausted.

Funny about that girl. We both liked her so. She seemed so suitable and she liked us and was definitely engaged. Elinor took her down to the cottage, lit fires, etc., then she came and said, "I can't stay. I can't accept the post. I'm sorry, but I can't." She went up and told Alice she did not know why, but she could not live there and she couldn't explain why. She just could not. It was as if she'd seen a ghost. Very baffling. Possibly she was afraid of my dying, being alone there with me. It seemed as if she had a hunch or something. So it's all to do over again. The first question all ask is, "How much time do I have out?" And then money. Few want to sleep in. Mother used to say, "There's as good fish in the sea as ever came out of it." They are over-full and short staffed at the hospital. Home would be good if I only had a little more strength to cope with it.

February 14th
Tomorrow, joyful tomorrow, home! There are two pots of tulips and one of hyacinths on my table, and the air is like spring and my eyes have dried up. A lovely letter from Lawren, one from Mr. Band and one from Mr. Brown. All say they can't see me any way but on the bustle and in the woods. They don't see a meek me by the fire with my hands folded so I must buck up patiently and paint again. Lawren and Bess like their sketch, feel it, feel the joy of the growth, and live happily with it. Blessed, blessed woods! I

want to be out in them. It's a long time yet to summer. Maybe by then I can kick the moon. If the "person" is satisfactory to me and I to her I shall get on famously. There are stories to be worked up, things to be rooted out of the storage of young womanhood—Indian forests and deep waters. What words are there for these things, solemn big things with joy wrapped deep in their middles? Episode after episode comes back, not photographically, not the surface. I was consciously striving to reproduce; I was unconsciously absorbing. We are always hearing things we don't recognize at the moment. Alice has packed me and I'm terribly excited for tomorrow.

February 16th
Said goodbye to hospital yesterday. Mr. and Mrs. Hudson came for me, one boosting each side with Elinor behind. I mounted the four or five steps and was hustled straight to bed. Everything looked lovely. I was not allowed to wait to inspect. I feel one hundred per cent better already. The "person" I dreaded is nice and the dogs are all back, but not Pout yet. It's delicious to feel their warm bodies cuddling into mine. Home is heavenly!

February 24th
I progress slowly, lying in bed to do it. Getting up is not so good— sudden spells of extreme weariness. The nurse says that I'm a good patient, taking my treatment well and not fussing. She told the doctor and I swelled proudly because I'm considered a crank.

February 27th
Every day is the same and yet every day is different a little. At seven in the morning Mrs. H. comes in, toothless and tousle-headed and her elbows sticking out of a hole in her sweater. She does not want to be spoken to. I used to say, "Good morning," but now I don't, as it's not advisable. After my breakfast tray, when Eliza and Matilda are out and the chickens' hot mash is given, she always comes in quite bright. It's the beasts that do it I think. She chats to the pups. She really likes them I think. Me she tolerates and does her duty by, also the house, keeps us clean, overlooks our shortcomings as much

as she can. We are just a woman and a house and we don't touch her heart at all. Her job touches her sense of duty and self-respect. She says I'm a good patient, and I think she is an excellent nurse, and there we stop. We don't want to know any more about each other and probably never will. She has absolute control over everything and does what she wants to, but I am there and so are my things. They do not unbend or kowtow. The pictures shut themselves up and have no meaning.

March 9th

I have been home over three weeks. I can do more now, I can see, looking back, but it is slow work. I get up for a few hours and dress and listen to Dr. Clem and do some typing. I have two stories, "Eight From Nine" and "Time," roughly typed and corrected, and a beginning to "Indian." I am getting restless as the days get spring-like. I don't want to paint yet. I get too tired just sitting. Mrs. H. goes when her month is up. She has kept things and me beautifully. I dread a new person. It won't be a nurse now; it will be a housekeeper. I'll take care of myself.

March 10th

Mr. Band has bought "Nirvana" for $200, Mr. Southam "Haida Village" for $150, and Lawren Harris another for $200. A number of others are over in the East being sat on and considered. It is funny, but I can't enthuse over my sales. Sort of ashamed that the pictures are not worthier. Praise always makes me feel humble. I do rejoice in the sales in that I am able to pay my bills. I am truly grateful to the pictures for that.

March 14th

An old pupil of some thirty years back in Vancouver came to Victoria and looked me up. She is a charming woman. She came in with arms out to me and a smile on her face. Not one bit changed. She exclaimed and laughed at the griffons asleep on my bed, one under each arm. She looked through my sketches and went off with one really pleased. She told me that she had always been glad she had taken lessons from me because it had put something into her life that made her outlook bigger and her seeing of nature different.

We had good times in the old Vancouver studio. Belle, who used to help me there, writes letters full of memories. There were seventy-five pupils, little children and young people, and we made a joy of it. There was always fun flying round, and dogs, parrots, white rats, bullfinches, parents, exhibitions, sweethearts, Indians, artists. I cried little in those days. There were lonely spots and some bad health, but there was joy, independence, and lots of laughing. Life's that way, but one remembers the ups more than the downs, afterwards. The best endowment we've got is humour.

March 16th

Dead alone for first time in nine weeks. I am very helpless, not a soul to call upon. Alice could not come anyway because she could not see. Dear soul, how patient she is! I'd rail, I know I would. How it must hurt to be tied like that!

March 23rd

Soon I'll have tried all the women in the world. It embarrasses me to think people will blame me for a crank, but only one has left nastily. The others seem like bad luck.

Alice has been to see about her eyes. The verdict is not clear yet. It does not seem too good, but the doctor has not said it is definitely hopeless. If only she had gone sooner, but she is so hopelessly stubborn and put off longer the more we wanted her to go. Poor darling, if only she does not have to go into the dark for good. I am afraid it will break her heart to depend on others, and me so useless. I shall take all the care possible and do what they say so as to stand by her. I wish she had friends, loads of good ones, but she has ceased to cultivate them for so long; she has drowned herself in school and now that is failing. They've sucked her dry, taken everything, and now they forget how good she was to their children and how patient with all their tomfoolery.

March 24th

How selfish *everyone* is, and me too, I suppose. These women who come to tend one don't give a hoot. They want to get as much as possible and give as little as they can. They like to make one feel it is

very good of them to look after anything so lazy as you are and to indicate that they are rather martyrs and that you are taking rather more care than necessary and are quite capable. Poor old women, we are not nice as we begin to decay, to slow up and grow stupid. We hang on to youthful ideas and the youngsters laugh at us. We love our liberty and ability whereas we have no strength and ought to be in homes and cared for like the too-young-to-be-sensible are. We are no more fit than they to cope with heavy problems but we have known the freedom of independence and they have not.

Today I sat in the back yard with the chickens and dogs, seeing a million things that needed doing, little things but beyond me. I said to myself, "Quit it. Remember that you've done these things in your day and now you must sit and watch others do some things for themselves, not for you. You're finished. You now take on a different phase of life. What is the good of struggling to keep up? That's going back. Your job now is different. If you would go forward you must adapt and press on into something new befitting the development you have attained, less bodily activity and more spiritual activity, accepting the change happily."

March 28th—Easter Sunday
It is a glorious day with a bitter wind. I am restless and empty. Want to stir and live again, to refill and relive. I do not want to write. I am dried up. Funny, sometimes you are juicy and ripe and sometimes you are like an empty cocoon. Mount Tolmie is quiet. Even the wind that buffeted it all day is dead. Under the brown of everything the sap is running. The green is bursting, shouting, hollering a song of growth.

April 3rd
Ottawa has bought two canvases, a paper sketch, "Blunden Harbour," a Haida village and "Sky" for $750. Madame Stokowski, wife of the composer and conductor, bought a small canvas for $75. Mr. Southam bought a small Skidigate sketch in oils for $150 and Mrs. Douglas a French cottage for $15. An old Vancouver pupil took a Pemberton sketch, also for $15. How lucky I am, or rather, how well taken care of!

$$15$$
$$15$$
$$150$$
$$75$$
$$750$$
———

$1005 Goodness!

April 6th

How comfortable Willie is! We had a long talk. If there was war and he had to go I'd die I think. It's so awful about Alice's eyes. If you sympathize with her she says, "Don't moan, I hate it." It seems so heartless just to say nothing, and all the time you ache for her. Barriers, why must they be between all humans, even the ones we love best, things our self-consciousness will not let us voice, so scared of showing ourselves. Sometimes I feel as if it would be easier to see Alice die than go blind. It's going to hurt her independence so. She just can't stand being led or pitied or helped. I think I like a little to be babied and wheedled and coaxed (by some people). Alice repels petting or softness. She gives grandly and takes poorly.

April 10th

Alice goes into hospital Wednesday to have one eye done. She is brighter, talks freely, so it's much easier.

April 14th

Alice did not go to hospital. They could not operate for another week. I'd have been all edgy. She is calm and resigned.

I have been painting a Nass pole in a sea of green and finished "Cauve," an Indian story. I sent four pictures off to the Vancouver exhibition, "Massett Bears," "Metchosen," "Alive," and "Woods Without Man" (invitation B.C. Artists show). I got a nice little maid, a farm girl from near Edmonton, called Louise. She mothers me.

April 16th

I heard yesterday about my one-man show in Toronto. There were about twenty canvases collected from Toronto and Ottawa. I got

two good write-ups from different papers and two letters, also a cheque for $50 from a Miss Lyle for a canvas.

I have been thinking that I am a shirker. I have dodged publicity, hated write-ups and all that splutter. Well, that's all selfish conceit that embarrassed me. I have been forgetting Canada and forgetting women painters. It's them I ought to be upholding, nothing to do with puny me at all. Perhaps what brought it home was the last two lines of a crit in a Toronto paper: "Miss Carr is essentially Canadian, not by reason of her subject matter alone, but by her approach to it." I am glad of that. I am also glad that I am showing these men that women can hold up their end. The men resent a woman getting any honour in what they consider is essentially their field. Men painters mostly despise women painters. So I have decided to stop squirming, to throw any honour in with Canada and women. It is wonderful to feel the grandness of Canada in the raw, not because she is Canada but because she's something sublime that you were born into, some great rugged power that you are a part of.

April 17th
Today another cheque came, for $225. It's almost unbelievable. Mr. McLean of Toronto bought one little old canvas and one brand new. Everyone is tickled. One thing I must guard against, I must never think of sales while I am painting. Sure as I do, my painting will roll downhill. Mr. Band writes, "I am considering 'Grey.' Do you like it? I do." Yes and no. I did like it and many people have liked it, but since painting it my seeing has perhaps become more fluid. I was more static then, and was thinking more of effect than spirit. It is like the difference between a play and real life. No matter how splendid the acting is you can sit there with your heart right in your mouth but way down inside you know that it is different to the same thing in life itself.

April 19th
It seems to me that a large part of painting is longing, a fluid movement ahead, a pouring forward towards the unknown, not a prying into things beyond but a steady pressing towards the barriers, an

effort to be on hand when the barriers lift. A picture is just an on-the-way thing, not something caught and static, something frozen in its tracks, but a joyous going, towards what? We don't know. Music is full of longing and movement. Painting should be the same.

April 20th
Alice went into hospital to have her eye operated on tomorrow.

I have been painting all day, with four canvases on the go—Nass pole in undergrowth, Koskimo, Massett bear, and an exultant wood. My interest is keen and the work of fair quality. I have been sent more ridiculous press notices. People are frequently comparing my work with Van Gogh. Poor Van Gogh! Well, I suppose they have to say something. Some say I am great and some that I am not modern. I don't think these young journalists know what or where or how I am. I am glad that all seem to agree that I am pre-eminently Canadian. I do hope I do not get bloated and self-satisfied. When proud feelings come I step up over them to the realm of work, to the thing I want, the liveness of the thing itself.

It's splendid to have the money just when Alice and I need it. I don't feel as if it was money paid for my work joy. It doesn't seem to have any connection. It is as if the money had tumbled out of the clouds, not as if I had bartered my thoughts for it. I feel that it came fairly and honestly and welcome. Alice is pleased about it, and very glad for me but the pictures or press notices or work don't enter her head. When I mentioned that I had been sent more press notices in letters she said, "That's nice," but she never asked to hear them or were they good or bad. She just rejoices in my luck as a bit of sheer luck; that's all it is to her.

April 24th
Alice's eye was operated on this morning. I went to hospital where she lies patiently, bandaged up, shut into the blackness. It sickens one. Is it the beginning of the dark for her? I find myself shutting my eyes and imagining it night all through the day. We took sweet smelling flowers to her.

April 25th
She's had a good night and does not feel too bad this morning. I am back in bed. Felt weepy and not up to shucks. Guess the nervous tension was higher than I realized the last few days. If one could only *do* something for her. There's going to be heaps of heartaches.

April 26th
Victoria University Women's Club are making me an honorary member. "In appreciation of your contribution to the world of creative art," the letter said. It is very lovely of them and very embarrassing to me. Why should one be honoured for doing what one loves to do? If I have "contributed" it was because it was my job and I couldn't help it.

April 30th
I had a letter from Toronto this morning. Toronto Art Gallery has purchased "Western Forest," "Movement in the Woods" and "Kispiax Village" for $1,075. I was stunned when I opened the letter. It is wonderful. I should feel hilarious. I am truly grateful but so heavily sunk in pain (liver or gall) that I am dull as a log and rather cranky. I'd rather have twenty-five sick hearts than one sick liver. The doctor came today. Says heart fairly improved but liver ructious. Ruth came to say goodbye. She is a staunch and true friend.

May 3rd
I am afraid. Vancouver Art Gallery is considering buying some pictures. Suppose this sudden desire to obtain "Emily Carrs" were to knock me into conceit. Suppose I got smug and saw the dollar sign as I worked. That would be worse than dying a "nobody," a thousand times worse. When they sat picking possibilities to be sent forward a great revolt filled me. I did not mind parting with the old pictures. I was glad of the money and a little glad that those who had always jeered at my work should see it bear fruit, but there was not the deep satisfying gladness of letters from someone who has felt something in my work that thrilled or lifted them.

May 12th

King George VI and Queen Elizabeth were crowned today. I went to bed feeling punk and determined not to get up at 1:30 a.m. to listen to the broadcast but I woke promptly on time. I woke the maid, who was sleeping like a log. She is young and it seemed right that she should hear it to remember. She came in like one drugged. We sat till 4:30 listening. I was disgusted not to hear a peep out of the Queen. On and on it spun, one giddy succession of gaudiness and magnificence. Your mind saw them, up and down on their knees, sitting in this state chair and that and saying, "I will" and "I do," putting on crowns and taking them off. I just thought that if the King and Queen could be off in a wood and vow their vows straight to God away from the crowd, how much happier they would be, but perhaps they would not.

Night

King George VI spoke to the people all over the world. I honour him tremendously. He spoke with extremely slow deliberateness. It must have been an ordeal for a nervous man with an impediment that has only recently been overcome holding that enormous position and facing the world. What he said always included his Queen and was solemnly grand too. Long live our King! I am glad the popular hail-fellow-well-met with all his lovableness has given place to this more sober, home-loving man, dignified and kingly.

May 14th

The day is too glorious for words. Things are growing like wildfire. I am in a blither of embarrassment over a great coffin full of lovely flowers that came from the University Women's Club to welcome me as a member. It's wonderful. I feel like old Koko at the Empress Hotel when they brought him a huge silver salver of cream that was upset. He was far too embarrassed to lap it. But I have sniffed and gloried in the flowers. Only it seems as if it was all a mistake, just old Millie Carr being a member of that group and being so honoured, and here I am such a liverish wreck, too nauseated and depressed to put a brush to work. I want to cry, but I haven't any tears. I want to work. There are such lots of things to do and maybe

only a little time to do them in. I don't know, sometimes I feel finished and in tatters and then I think I am good for aeons of ages. Ruth has gone. I did not know how blue I'd be without her. She has meant an awful lot these last months. Must hurry and get to another Indian village. It is marvellous how they help to keep one in place. There is something about the great calm of them.

May 22nd
Ruth has seen Dr. Sedgewick who likes my stories and will be glad to write an introduction if Macmillan's will publish them. He is also willing to edit them.

June 10th
I have been too busy writing Indian stories to enter my diary. I have been very absorbed. Some days it seems hopeless trying to say what I want. I just flounder in mediocre thoughts and words and paint. Well, those days one should plod away at technical difficulties and not worry or be depressed because that which is greater than one-self seems to have forsaken you and that which is greater than the objects to which it belongs seems to be asleep.

I am very tired. I corrected and typed the Skidigate story, "My Friends," and worked on the gravel pit picture. Jack Grant came.

June 14th
Dr. Sedgewick came to visit. It was the first time I had met him. He is a funny, merry person.

June 24th
I posted twenty stories to Dr. Sedgewick for his reading and criticism. I had worked on them very hard and felt that there was good stuff in them but bad workmanship. I was very disgusted and tired and felt one minute that I never wanted to see the things again and the next was ardently anxious to know what Dr. Sedgewick would find in them. The stories were "Ucluelet," "Kitwancool," "Sailing to Yan," "Tanoo," "Skedans," "Cumshewa," "Friends," "Cha-atl," "Greenville," "Sophie," "Juice," "Wash Mary," "Martha's Joey," "Two Bits and a Wheelbarrow," "Sleep," "The Blouse," "The Stare," "Balance," "Throat and a Monkey's Hands," and "The

Heart of a Peacock." The last three are not Indian stories. Probably when people do not know the places or people they will be flat but they are true and I would rather they were flat than false. I tried to be plain, straight, simple and Indian. I wanted to be true to the places as well as to the people. I put my whole soul into them and tried to avoid sentimentality. I went down deep into myself and dug up.

August 1st

It is a long time since I wrote here. The stories have taken all my energy and satisfied for the time being my desire to express myself in words. It is a week since I finished them. For some days I was too tired to think about writing or painting. For the last three days I've painted. I turned out a box of small paper sketches and found some thrill in them. I did not know that some of them were so good. I can see what I was after more plainly than at the time I did them. Some seem stronger than the things I am doing now. Now I understand the things I did then better than when I did them. I was, as it were, working ahead of myself.

August 3rd

Little Beckley Street got a shock today! The vice-regal chariot rolled into its one-block length of dinginess. Just before Lady Tweedsmuir was due the most disreputable vegetable cart drew up at my gate and John went up and down pounding at doors and coming back to his cart for dibs of vegetables in baskets. The old horse hung between the shafts and the tatters of oilcloth flaps drooped over the vegetables. Thank the Lord, John moved his rusty waggon and musty roots just in time for the resplendent vice-regal motor. As I went out on to the porch to meet her Vice-Highness, I could not help an anxious look across the street and, thank Heaven, "the Nudist" had his shirt on.

Lady Tweedsmuir looked like a racing yacht as she headed for my door. Her lady-in-waiting and equerry trailed behind. I said, "It is very kind of you to come to see me, Lady Tweedsmuir." She replied, "Not at all. I am much interested in your work. I have one of your canvases in Government House in Ottawa." I hauled out

much stuff—Indian and woodsy. She liked the woods best. The good-natured equerry helped me, also the English lady-in-waiting. Lady Tweedsmuir wanted to see some rugs and so I took her into my funny little sitting-room. They stayed three-quarters of an hour, bought a sketch and trooped out.

August 4th

The equerry brought the sketch back to be signed today. Had four good days' painting. I worked on a mountain and the inside of a woods, up a hill. So far it is mediocre; it all depends on the sweep and swirl and I have not got it yet.

My blue budgerigar is like a lovely flower. I keep him close to me and he is taming fast. He gives me great pleasure. His colouring and marking are so exquisite. Had a letter from Ruth from Norway.

In the afternoon a professor from Edmonton, a Mr. Kerr and wife, came to buy. He was charming. They bought a paper sketch for $30. Then I painted.

September 6th

I started a new canvas today, a skyscape with roots and gravel pits. I am striving for a wide, open sky with lots of movement, which is taken down into dried greens in the foreground and connected by roots and stumps to sky. My desire is to have it free and jubilant, not crucified into one spot, static. The colour of the brilliantly lighted sky will contrast with the black, white and tawny earth.

September 9th

I have started a woods canvas. I am aiming at a trembling upward movement full of light and joy. I blocked in movement first thing with a very large brush and was thrilled. Mr. Band came from Toronto. It was a real treat to see him. We had one and a half hours of hard talking on work and news. He has ordered three canvases to be sent to Toronto, where he thinks he can sell them. They are "Lillooet Indian Village," "Trees in Goldstream Park" and "Sunshiny Woods." Willie is going to crate them tomorrow. I sent Vancouver the pictures for the show today.

September 14th

It is intensely hot. I have been painting up to all hours and am very tired. I am working on two woods canvases. One shows a small pine in undulating growth and the other is a tall shivery canvas. I began them with huge brush strokes, first going for the movement and direction such as I got in my sketches, and with great freedom. The danger in canvases is that of binding and crucifying the emotion, of pinning it there to die flattened on the surface. Instead, one must let it move over the surface as the spirit of God moved over the face of the waters.

October 12th

Alice and I are clearing up the old home at 207 Government Street, preparatory to letting it go to the city. We plodded up and down, up and down, lugging trash out of the cellar. It was mostly broken and empty bottles. We had the stuff put on the back verandah and sorted—hoarded inanities of Dede's, religious books of Lizzie's. The house that was once the pride of Father's heart is a dreadful place, dingy, broken and battered. Apart from Lizzie's personal things, there is no sentiment.

October 18th

Alice's birthday. I went to dinner and provided a chicken. Louise iced her a cake and I put a big tallow candle in the middle and "Happy Returns" round it. Took a bunch of gay autumn flowers.

October 25th

Yesterday we finished the sorting and clearing. The stoves are gone, Lizzie's massage books and electrical things. Florence has taken some of the old suite of Lizzie's furniture. Everything else is trash. Great bonfires have roared on the gravel walk. Tomorrow we are going to attack the garden. We will transplant some of Lizzie's favourites to Alice's garden and mine.

November 17th

I have had such a treat this week. Nan Cheney has been here every

day. She is over from Vancouver to paint a portrait of me so we have chatted for long hours while she worked. She has made me look a jolly old codger and did not force me to sit like the dome of the Parliament Buildings. I could wiggle comfortably with Pout in my lap.

I finished "The House of All Sorts" two days ago. I *think* the sketches are a little more concise and to the point. They are in a series of what Dr. Sedgewick calls "pen sketches" on the various tenants who lived in my 646 Simcoe Street house. Nan likes them very much, so does Flora. They are the only two who have heard them. There is room yet to have them more smooth, but I am pretty old to start in to write and am thankful if they even improve some. I don't believe they will ever be up to an editor's standard. Already things are teasing in the back of my brain for a fresh spasm. A new picture is fermenting to get on canvas, too, a big woods picture.

November 28th

We are nearly at November's tail and are hurrying towards December and Christmas, hurrying on through our span and soon out of life. I think about death a lot, always wondering what the surprises of death will be like, the things that eye hath not seen nor ear heard, nor that have entered into the heart of man. When the shudder of the plunge is over and our spirit steps out of this shell we have treasured, and all its aches and pains, I don't suppose we will ever turn back to look at it. A buttterfly bursts its cocoon and leaves it hanging there dried up without a thought of it again. I can't see people hovering round their old treasures or desires after they have gone on. Youngsters don't hang round the doors of the classroom after they have passed out. They are too proud of having passed on.

Three new pictures are on the way, an immense wood, a wood edge and a woods movement. These woods movements should be stupendous, the inner burstings of growth showing through the skin of things, throbbing and throbbing to burst their way out. Perhaps if one had felt the pangs of motherhood in one's own body one could understand better. Until people have been fathers or mothers they can hardly understand the fullness of life.

When you want depth in a woods picture avoid sharp edges and

contrasts. Mould for depth, letting the spaces sink and sink back and back, warm alternating with cool colour. Build and build forward and back.

December 13th

Sixty-six years ago tonight I was hardly me. I was just a pink bundle snuggled in a blanket close to Mother. The north wind was bellowing round, tearing at everything. The snow was all drifted up on the little balcony outside Mother's window. The night before had been a disturbed one for everybody. Everything was quietened down tonight. The two-year Alice was deposed from her baby throne. The bigger girls were sprouting motherisms, all-over delighted with the new toy. Mother hardly realized yet that I was me and had set up an entity of my own. I wonder what Father felt. I can't imagine him being half as interested as Mother. More to Father's taste was a nice juicy steak served piping on the great pewter hotwater dish. That made his eyes twinkle. I wonder if he ever cosseted Mother up with a tender word or two after she'd been through a birth or whether he was as rigid as ever, waiting for her to buck up and wait on him. He ignored new babies until they were old enough to admire him, old enough to have wills to break.

December 21st

I have got my stories back from Dr. Sedgewick. He says, "I have no criticism of the sketches. The pieces need no revision but what can be supplied by a publisher's office. They are very sharply etched as they are now, in the main, and should not be tampered with. Matter and manner seem to me very well fused indeed. . . . They certainly should be published for the benefit of those who have eyes and ears. They aren't likely to have a large audience. The select few will be appreciative."

December 22nd

Somewhere there is a beautiful place. I went there again last night in my dreams. I have been there many, many times. It is extremely Canadian—typically Vancouver Island. It ought to be in a par-

ticular coastal spot not far out from Victoria but it is not there. I know all that coast. It is a wide snubby point. On the east it is bounded by a deep bay with a beach along the edge. I had never seen it from that side till last night. The beach is sandy and covered with drift-wood, and all the steep bank above is covered with arbutus trees, monstrous ones with orange-scarlet boles twisting grandly in a regular, beautiful direction that sings, slow powerful twists all turning together, shifting angle and turning again. It is a long, long row and superb. Other nights I have been to other sides of this place so I know what is up beyond the arbutus trees. That is where the buildings are. I have only seen the tops of the roofs. It is not public property. You approach the other side from a high earth road, unpaved, and you look down on the tops of the pine trees. Something seems to keep you out, I don't know what, a certain private feel, not law but delicacy. I wonder where this place is, what it belongs to, why I go there and love it and am content, for the present anyway, to keep out.

Christmas Day

There is deep snow but it is not bitter. I heard King George VI at 7 o'clock this morning speaking to his empire. It was wonderful. Maybe one day it will come so that the empire can shout back to the King. There is great peace in the cottage this morning. Louise is very busy "lining up" so that she can get away early for all day. Alice and I Christmased yesterday. We had a tiny tree in a flower-pot on the table and the presents round it. In the other window burned three red candles in my old red Swedish candlestick. Louise cooked good turkey and plum pudding and brandy sauce. There was a dandy fire. The lovebirds, chipmunks, and dogs and we ate, enjoyed, and were thankful. Then we undid the tree. Willie came. Edythe and Frederick came in the afternoon. I got millions of presents. People were good and we were happy.

December 31st

In one and a half hours it will be 1938, and a new year will have begun. What has 1937 contributed to life? Invalidism. Teaching me what? Alice says I've been sweet-tempered over it. Perhaps I've

been too busy to cuss for I've written a lot, painted a lot, and have had lots of visitors. Illness has not meant idleness. It's drawn Alice and me closer. It's seen the last of our old 44 Carr Street-207 Government Street home. It's seen Alice and me setting out in our little, frail old boats on the last lap. The year has aged us both. Both of us have had a lot to give up, loosening of the ties. I have thought about Death a great deal this year. Sometimes he seems quite close and then again as if there'd have to be a long hard kick before it finished. And the world? Oh, the world that is said to be going to be finished in this era is breathing hard but going on just the same, on and on and on forever.

I am very settled in the cottage. It has grown round me. If I were pulled up now there'd be a tearing of roots. I have made it to fit myself. All my bumps are accounted for and my peculiarities taken care of nicely since the old house stuff came into it. It is very homey. Everyone says how cosy the cottage is and how attractive.

The little Christmas tree burned for its last time tonight. Such a silent, still glow the lights of a Christmas tree have. Up the street there is a wink-light tree—on and off, on and off. It has lost all the still radiance of Christmasy holiness and become a jazz show tree.

11 p.m.
I rang the bell and yelled, "Happy New Year" to Louise and it was only eleven, not twelve, that struck. There is one hour more of 1937 to live.

12 p.m.
It is 1938. Without one second's pause between old and new, 1938 is here.

The Shadow of War
1938-39

January 8th, 1938
I am writing "Birds,"* a sketch of the sanatorium in England where
I stayed for eighteen months. How dreadfully real the places and
people are as they come back to me! The experiences must have
been *burnt* as in pyrography. The story is a bit grim so far but I
want to weave it round the birds, give it the light, pert twist of the
birds. Birds are not tragic.

January 9th
Last night I was on the way to "the place" again. How strange that
I am so often conscious of that place. It is very familiar but where
is it? I am never quite there. I look up at it and down on it and on the
way there I know the country all about it but actually I never enter
the estate. I wonder if I ever shall.

I have burnt and destroyed stories, papers, letters. If you knew
when you were going out you'd destroy all. There is no one to be
interested or care after. Alice has destroyed everything, she says,
and yet I like a few old letters, a few old notes of the past. You
forget how much some of the friends out of the past loved you till
you read again some loving letters. Some men and lots of women
loved me fiercely when I was young. I wonder when I read the old
letters from friends not given to talk and flattery, was I as generous
with love to them? My love had those three deadly blows. Did it
ever fully recover from those three dreadful hurts? Perhaps it
sprouts from the earth again, but those first vigorous shoots of the

*Later *Pause*.

young plant were the best, the most vital. I have loved three souls passionately. I have known friendship, jealousy and dreadful hurt.

February 25th
I have been slaving away at the sanatorium sketch. In a way I think it is the best thing I have written but don't know. I know so very little about writing and not too much about life. I think this is deeper than "The House of All Sorts" but I don't know and who is there to tell me, or who to care if it is better or worse? Every one of us matters so little, and yet all of us must have a reason for being.

March 20th
I gave the sanatorium sketch its third typing and read it to Flora. She was enthusiastic, read it to Margaret.

June
I have been working in Macdonald Park. Very delicious. May has just abdicated to June. The birds are settled into their nests and calling and singing to their sitting mates swaying quite violently in the June greenery because there is a lot of wind. The grass is long. People are chewing off tag ends of wild grass. The wild roses are particularly intoxicating this year. Banks of them are rolling round the base of the old trees of Macdonald Field—a big flat "splank" for each blossom, deep in its middle fading to its rim. The voice of their smell is beyond everything convincing, rushing at you, "I'm here! I'm here!" pulling you closer, closer with their ardent perfume, compelling you to come and look into their vital round faces, and lay your cheek against their coolness and draw deeply of the rich spiciness at their hearts.

The bracken is not yet adult. Each tip is an exquisite brown coil, very tight and very bashful, and the lower leaves that have opened are hothouse-tender and yellow-juiced rather than green. Little white butterflies quiver among the roses and ferns and over the heady grass powdery with pollen. Every minute the leaves draw closer, denser, about the birds' nests in the trees. Mrs. Bird's family will be quite shrouded in green seclusion by the time they are old enough to attract attention by their movements; by the time the

tightening down of the mother's feathers conveys to them the sense of "hush" when danger is near.

June 25th

The secrets are out. The bracken tips have unfurled and baby birds are squawking and flapping among the dense foliage. The trees are fully dressed, brilliant and "spandy" in their new clothing put on with an imperceptible and silent push. There is nothing so strong as growing. Nothing can drown that force that splits rocks and pavements and spreads over the fields. To meet and check it one must fight and sweat, but it is never conquered. Man can pattern it and change its variety and shape, but leave it for even a short time and off it goes back to its own, swamping and swallowing man's puny intentions. No killing nor stamping down can destroy it. Life is in the soil. Touch it with air and light and it bursts forth like a struck match. Nothing is dead, not even a corpse. It moves into the elements when the spirit has left it, but even to the spirit's leaving there is life, boundless life, resistless and marvellous, fresh and clean, God.

November 3rd

I am tired of praise. The "goo" nauseates me. It has pleased me *very* much, the warm reception of my work. It is satisfactory to feel that people have got something from your interpretation, that you have been able in a small degree to let life speak *through* you, using your mind and fingers. I hear that there was one adverse criticism, one who jeered. I should like to have seen that. I was the only one mentioned in particular in the London *Times* write-up by Eric Newton. What he wrote I think was more what he saw in my studio when he was out here than what was over there in the Tate Gallery. I have been doing portrait sketches, turning from my beloved woods for fear that all this honeyed stuff, this praise, should send me to them smug.

Life carries some exquisite pleasures! Outside my window grows a fuchsia bush. Three years ago I planted it and this year it crept up to peep in the window. It is scarlet and purple, a tiny, dainty,

swaying bell silently ringing with the slightest breeze. The organs on each side of your head don't register the sound but the soul does. The crimson-pointed tops catch the sunlight. They throb with colour as one would imagine the blood of a pure heart would glow, glistening with health. The purple of the bell is royal. The small insignificant leaves of the plant are eclipsed by the scarlet and purple of the bells. The bloodstream of the plant flows scarlet up the twigs and branches.

My fuchsia tree is loved by others than me. As I lie in my bed close to the open window there is a constant humming, a soft fine whirr quite different to mechanical, metal sounds. It is a velvety sound of flesh and blood. The air dandles it like a loved baby. Hummingbirds are sipping the nectar from the life of my fuchsia, jamming the bells by their hum and thrusting long beaks into the centre, into the inexplicable core and essence of the fuchsia's being. The hummingbirds whizz and whizz and whisk away with the flashing dart of a spontaneous giggle. It is as though you had been able to stick out a finger and stroke the joy of life. The fuchsia bells hang like scarlet drops; their secrets are still inside them folded tight, gummed up in silence and sweetness that even the hummingbirds cannot penetrate.

September 3rd, 1939
It is war, after days in which the whole earth has hung in an unnatural, horrible suspense, while the radio has hummed first with hope and then with despair, when it has seemed impossible to do anything to settle one's thoughts or actions, when rumours flew and thoughts sat heavily and one just waited, and went to bed afraid to wake, afraid to turn the radio knob in the morning. It was recommended by Clem Davies that we read the 91st Psalm for our comfort. I read it when I went to bed and went on reading psalm after psalm. What most struck me was the repeated "Praise the Lord," "Bless the Lord," "Praise, Praise, Praise." At 8 o'clock I turned on the radio and I knew it was war. It was almost a relief to hear it settled one way or another. All day we have listened, not able to keep away from the radio. You felt your job, the job of every soul, was to go on as reasonably and unselfishly as possible. I re-

member so well twenty-five years ago. I had just built my apartment house and war had been hovering. I went over the field to Dede's and heard there that war was declared. After the word had been spread by newspaper, telephone and extras yelled in the street by boys, we all just looked blankly at one another. No one had any idea what the next move was going to be. Everyone wondered. This time, we who went through the last war have an idea, though we can't tell very much. Things have changed so, with the air and the radio. We know more things that are, perhaps, even more cruel. The *Athenia*, a great merchant ship carrying passengers and refugees, has been torpedoed and sunk off the Irish coast with 1,400 passengers.

The radio announcers seem sometimes as if they can scarcely get their tongues to word things, to throw such beastliness on the air. The blackened cities at night must be fearful. How can Hitler hold up, knowing what he has done to the world, under the black weight of nations cursing him.

September 4th
There is a singular emptiness in the air. The world is crying out. Nations glower at one another spitting hatred and condemnation, looking each other hatefully in the eye with their feathers loosened and flaring like creatures of the chicken-yard measuring each other. Their hot blood is still inside their own skins. They have not yet clashed and spilled it. Perhaps some day radio will be so powerful that battlefield screams and the suck of sinking ships with their despairing chorus of the drowning will reach our ears. That frightfulness would surely end war. We could not bear it. My maids know that they have only to dissolve into tears for me to soften to a pulp, no matter how they have angered me. If the air were filled with sobbing nations one could not bear it.

Today is Labour Day, a holiday. The street is quiet. The children reflect the mood of their grown-ups and everyone is wondering. A tremendous war has started and millions of human beings are holding their breath, asking one another, "What next?" All love their own harder than they did before. When I told my maid that there was a war she laughed. It made me very angry. It was so with the

two maids before this one. War conveyed no meaning to them. It was a big ugly word tumbled into their world. Their main feeling seemed to be one of careless curiosity. Here was some new half-joke to explore and they sniffed around it, pleasurably excited at any change in the monotony of life that would make for variety. When it comes to the curtailment of any liberty or pleasure for them it will look very different. They don't particularly love their country. Oh, of course, it's "all right" but what's the use, things have always gone on and they always will. Why fuss about them so long as one can do what one wants for the moment? Let the other fellow look out for himself. Why should Canada fight for Britain?

We went to the Japanese Garden and took our lunch. It was very calm and beautiful there. A few people strolled through the garden. Nobody was smiling. Everyone was spending Labour Day guiltily.

On the other side of the world they are fighting, bombing and torpedoing. Vessels here and there are sinking to the bottom. Buildings and people are being hurled into the sky from the cities and coming down in scraps and tatters. Here we are in melancholy peace.

September 5th
The news seems vague and far off, not as if it were really happening. It sits on us like an ache. We are trying to ignore it lest the pain become unbearable.

September 6th
German planes have been hovering over London and Paris but have been driven off. There is fighting on the fronts but there is little news that is definite.

September 7th
The Montreal show that was to be held has been assembled, named and priced. Tomorrow it will be dusted and then sit waiting to hear if it is to go forward or not. War halts everything, suspends all ordinary activities. Fear and anxiety top everything. It seems that the only thing to do is to shove ahead day by day and make oneself keep busy.

September 14th

I am camping in Mrs. Shadforth's little one-room shack on Craig-flower Road. It is very cosy, set upon a ridge among unspoiled trees, tall firs, little pines, scrub, arbutus bushes and maples. It is filled with great peace. One forgets that beyond the bushes, beyond beyond and beyond, across the world, there is war. Nations are hating and hissing, striking and wrecking and maiming. People are being hurt, maimed. The sea is swallowing them up in submarine explosions. Earth is drinking their blood. The sky hurtles their planes out of itself and their bodies crash and break in falling, and all because that hideous monster, war, is loosed and is dashing around the world. The earth is hideous with his roar. Any moment he may rush anywhere and devour. He is too strong for his keepers to have the courage to chain him up again. No gate is strong enough to pen him. His teeth are cruel and his talons rip.

Here in this spot is peace. There are just the dogs, the bird, Florence and I in this cabin in the woods. It wants to rain and a few drops squeeze down and hang around on the leaves, forgetting to tumble, or roll sullenly off the roof. Everything is quite still. There are no shakes or quivers. No birds twitter. Nature seems motion-less, but all the while she is slowly, slowly swelling to the moisture, earth loosening, moss rising, leaves taking on a shine, not the danc-ing, shifting shine of sunlight but the calm slow glow of wet. From every point of the maple leaves outside the cabin window hangs a diamond. The green of the thin flat leaves is clear. Some of them have already turned golden, and the old rusted "locks and keys" jangle in a whisper above the maple. Far up in the sky is the blue green-grey of the tall pines.

The rain drops hit the roof with smacking little clicks, uneven and stabbing. Through the open windows the sound of the rain on the leaves is not like that. It is more like a continuous sigh, a breath always spending with no fresh intake. The roof rain rattles over our room's hollowness, strikes and is finished. Outside the water drips from leaf to leaf and comes to the sipping lips of the earth. She drinks joyously. The colours are brightening, rich and deep under the wet. The arbutus leaves are new and tender, not finished and done like the others. It has thrown off the old bark of

its limbs in crinkly little rolls and under them the new bark is satin-smooth, orange and red and green-gold. The wasps are drunk. They crawl and fly with no buzzing, tired, drowsy, unvital, like old folk nearly finished with a life that is fun no more, only achy.

Young Florence sits reading, only half interested. She is "wondering" behind the words. Her wonders nearly smother the sense of the print. She is thinking of odds and ends mostly, lipstick, hair curlers, her sore finger, her firewood that is getting wet under the rain, and what about dinner? One dog is on my feet, her side hugged to my hot bottle. The other in his box emits short, uneven snores. Blue Joseph is breakfasting. Between seeds, as he pares the husks with his tongue and beak, his head twists this way and that and his eye rolls up at the sky, indifferent to a joy he has never tasted.

In a grey woollen gown under the scarlet blankets, with pillows at my back and hot bottle at my feet, I find the earth lovely. Autumn does not dismay me any more than does the early winter of my body. Some can be active to a great age but enjoy little. I have lived.

September 16th

It is a foggy morning. A clammy cold clings to everything. It douses the pale sunbeams off the floor and greys the tree tops. It keeps the wasps down to the earth. The fog-horn comes thickly, shouting a stomachy blare like a discontented cow. Our cabin is cosy. The air-tight heater draws fiercely enough to permit our two windows and door to be wide open without discomfort. Outside, cobwebs staked at corners sag with dewdrops. As I sat on the doorstep brushing my teeth, I saw hundreds of them in the grass. Florence is sweeping the floor, erasing the dirt down a large knothole. Her one sorrow in this camp is that I brought no dustpan. She keeps the camp nice and orderly. The two beds covered with red blankets are neatly tucked. The frying pans hang side by side, velvety black at the bottom. There is a bench for the water pails, a meat safe, a table and a cupboard. The table is very stout. We built it.

We each have our own shelf by our bed for our particulars. Florence's has her curlers and her powder boxes, lipstick, fancy purse and mirror. All her things are young. On my shelf are books, hair brush, work basket, knitting, a jar of black jam, physic, and

a dictionary. We each have a lamp on our shelf and read in our beds to which we retire at seven. My painting things are under and behind my bed, hanging in canvas sacks. Finished work is under my bed, flat. I should like to have one or two on the wall to study. I would if I were alone. But the old hiding of my work from a sniffing public has become a fast habit amounting to actual physical pain when they are under critical, unsympathetic eyes. It is foolish how even a little servant girl's eyes upon my crude, half-born thoughts hurts. When they are home and I have looked at them critically and clarified my thoughts about them a little I don't mind so much, but for people to criticize a half-made sketch breaks something and then it is done for.

Noises come across the Gorge waters from the highway but they don't have any connection with our life here. They and an occasional speedboat fluttering down the Gorge are outside. Dogs bark and roosters crow but they, too, are over the water like the boat and mill whistles. They have nothing to do with us, nor has the howl of war on the other side of the earth. Only when one opens the news-paper does it throw a streak of hurt across the world.

It is queer how totally I forget my own home when I go to camp. It belongs to another world. I suppose it is comfortable to have it in the background but I am glad it has the good taste to sit in the back pew and not push up to the woods' altar when I am there.

September 17th
A long stagnant Sunday. No newspaper, no visitor, no work. I took the doctor's insisted weekly rest. Suspended stillness, suspended sunshine, suspended work, suspended news, everything hanging mid-air in heavy tolerance of being.

September 18th
Had breakfast at 7:30 in crisp, sparkling sunshine, still and cold. The wasps have no buzz and little appetite. They crawl sadly over the jam and are petulant. The dogs balk at being put out and Joseph noses his beak into his beard plumage and grouchily chews the upper mandible on the lower. Today I shall paint. A little brown bird hops into my cabin and runs over the floor looking for crumbs.

He thinks Florence keeps the cabin over-clean and hops out again. Why is a hop more cheerful than a run?

September 24th

We quit camp tomorrow. I have worked hard. It is rather interesting stuff I think, but it is scuttled under the bed as soon as it is done. I can tell its worth better when it is home and I look at it in cold blood. The woods are trembling under the glow of autumn. There is a still, vibrating quiver, moist and luminous, over everything, as incongruous as a "slow-hurry." Summer is lingering, winter pushing, and autumn standing contemplative, impatient to get to winter, yet reluctant to leave summer—just as I feel about camp this minute. I want to stay and to go. It is dark and cold soon after six o'clock. We have had supper in the hut for two nights. The chilly night air brings on heart pain.

September 25th

Florence is all stir and bustle at 7:00 a.m. I restrained her from rising at 6 o'clock to pack our few oddments. We do not leave till 2:00 p.m. She pounds round the cabin so that it wobbles and quivers like a jelly house, and the tin equipment clanks. The maple tree leaning towards the uncurtained window has given me great joy. The grey twisty stems swoop down and curl up again. The big flat leaves are brown, yellow and green. Through them you look up to the grey-green pine towering in dignified silence up in the sky which is an amalgamation of greys and blues. And so I leave another camp and return to that ordinary part of the city known as Beckley Street. So be it. It houses me and my work. Back to war rumours, sad wonderings, censored news, and long faces, doubtful faces, angry faces.

Home

We brought the woods with us, a bundle of pine boughs for the aviary, huge sacks of moss for the chipmunks, also a bag of rosehips for them and a pailful of sword ferns for the corner of the garden. As one drives through town a change takes place in one's being. Not quite so bad as when I would come to London again after holi-

days in English country, and the train glided through those endless drab brick workingmen's houses, all alike in monotonous streets in districts where big chimneys belched smoke and smell. I will never forget that feeling of heaviness and dark in me as if someone had turned your illumination off from the switch and you were a solid-right-through lump of black. Victoria was not as bad as that, only the town looked tired and Beckley Street hopelessly sordid, with scraps of paper and peel, dirty-faced youngsters, yapping dogs and scuttling cats. The garden still has flowers but all the past-and-done brown shrivels are blown into the corners of the porch and steps. My flowers *wanted* me and so did my birds. All had been fed and watered, even too lavishly. Plants stood in puddles but they missed the wholesome picking off of dead blossoms and leaves. They looked desolate in the closed, airless house.

The aviaries are bursting with life. I have never heard such a whirring of wings. I have to run out every hour or so to sit among them, with the whole flock whirring round me. The bird house is over-full. There are nearly fifty budgies of all colours, beautiful, smooth young birds, still fluffily innocent-eyed and babyish. I love this winged life. It is like no other. It is so irresponsible and un-earthy. There is such chortling, such bowing to each other and kissing. Bashful babies crowd upon each other in the corners of the nests when you peep into their boxes. To throw a pile of greens upon the floor and see the flock settle to feed is perhaps the loveliest thing of all. Their heads bob and the greens, blues, mauves, and yellows weave in and out in perpetual motion like a kaleidoscope. Each is intent on the business of keeping noisily alive and of repro-ducing himself as prolifically as possible, singing about it all the while. I have no desire to fly. I love the earth and am afraid of the infinity of the sky. It is over-vast for my comprehension.

September 27th
We broke camp just in time. The wind is blowing and the Balm of Gilead trees in Macdonald Park are rattling their leaves in a fury of clacking racket. My neighbour's late apples are falling too soon. The light that dips through the windows is a gloomy glower with no sparkle. One of my new sketches is up opposite my bed on

a little shelf I have behind the door, hidden from every eye but mine. The foreground is delicate with washes of autumn colour. The trees behind are wave upon wave of quiet greys. A blue sky recedes wave upon wave behind that. It is outdoorsy and I think I like it.

September 28th

I have been through my twenty-three new camp sketches. Autumn is in them and a certain lighthearted joy strangely out of keeping with war. I can remember the French painting teacher in San Francisco badgering me into rages so as to get my best work out of me. I think perhaps war in its heaviness pressed this gaiety from me. It escaped through my finger-tips and autumn borrowed it and together they hoisted a few little blobs of cheer-up into the dreary world. Or is it just that I was born contrary? Or is it the smaller the cage a bird is put into the better he sings?

October 3rd

The fog-horn is blaring. Fog squeezes into the house and lurks in the corners of the rooms, dimming and stupefying, but Joseph sings beside my bed and the young canary practises his trills in the studio. The hall stove is lighted for the first time. It is a sulky old brute. Lying awake a couple of hours last night I got to thinking about my manuscripts. Flora is correcting them and it galls me. She has command of English and I have not. I am glad of the help; I want it; but when she and Ruth have finished with the manuscripts I hate them. I feel that the writer (me) is a pedantic prig. If they'd only punctuate and let me be me and leave them at the best I can do! Heaven knows I sweat over them hard enough! Flora wants too much sentiment and Ruth strips and leaves them cold and inhuman. A hint of anything religious is crushed out in the modern kill-God way. I am disheartened. I know I am raw. Ruth and Flora have helped me, but their way of expressing is not my way. When I put in their words and changes, even though they are better, I can feel myself shrug and quit. Now is this conceit? When Ruth wants to cast out one of my words and is looking for her own substitutes I note that she has great difficulty. The words don't come to her. Flora wants my English to be perfect, but in the biography I'm talking

as myself, of very average education, my words learned of decent parents rather than from a stabilized school education.

I think this is the last time I shall hand my manuscript over to others. What does it matter anyway? They won't be published. They just give me easement in writing. Were they any good, as Mr. Brown thought, in encouraging young students of Canada, then they'd do their job better, I feel, in my own words than in A-1 language that does not belong to me.

New Growth
1940-41

January 17th, 1940

The owner of my house wants to sell it. I have to move from this comfortable cottage that has housed me and and my pictures and my beasts for four years. It is a great upheaval. I have been happy here. At first I was dismayed at the news, but now I know it's just one of those giving-up things that come to old age and must be calmly faced. It has a purpose in my life. Jogs are better than ruts. The balm of the whole show is that Alice anyway half wants me and it is luck that I have her empty flat to go to. Houses are hard to get and I shall be near her yet independent in my own flat. She has given me leave to alter the flat to suit my needs, which makes me more anxious not in any way to go against what she wants. The big room is all wrong as to light for work (it faces south) but somehow I shall manage, I know, and will make it cosy too. It will be nice for old age to be so close to each other. There will be many advantages and *some* disadvantages. I have made the owner an offer of $500 for this house. Should she accept I will repaint and resell it at a small profit to help finance the fixing of the other. If she won't, well I'll be quit of the worry and must do the best I can without it. Worries have a way of solving themselves. There's the dogs; they will be right on the street unprotected, but I shall contrive something for them I'm sure.

February 1st

We are awaiting a building permit and tomfoolery. It takes a quorum of three to decide whether or not you may have your toilet

twisted back to front or your bath put into a legitimate bathroom instead of under the kitchen table. One of the three is sick, one is away, and the third could not possibly decide so momentous a question, and so the world waits for one to return or one to recover.

I wanted to paint the house. I have money enough. The painter roughly estimated that it would cost $65-$70. Alice was furious when I said I wanted to do it. I tried to put it all the nice ways I could, so as not to let her feel that *I* was doing it and that I was getting too much hold on the house, which seems to be what she fears so terribly. Then I said, "Alice, I won't have it painted, but I want to give you a cheque for $70 with no tabs on it, a free gift. Paint it any colour that suits you. It would improve and preserve it."

She flew into a towering rage. "The house is not mine any more," she said. "It was good enough for me. It is good enough for any-body."

I said, "Alice, the old man who did your part just left patches of white, grey, or any old colour. My new boards will have to be done. Why not let me do the whole while the man has all the stuff here for the inside work?"

"Do what you like," she flung back. "The place is mine no longer!! Be quiet, I won't talk about it any longer."

"Then I shall paint it," I said and I cried a little. "I only want to do the house good."

But she sat in a dumb rage so I got our book and read steadily for two hours. Then she went home without a goodbye, without a word. I had a bad night. I am trying to face up to it and do what is fair and right. I shall pay my rent and let the house fall down if it wants to. Today I am sending her a letter saying, "I am *not* paint-ing your house. I shall always remember, I hope, that the house is yours and I am a tenant."

Alice's house is her obsession. She resents having a thing done to it by anyone else. There was a like scene when I got some extra money last spring and tried to help her with the taxes. Does she feel that I am a smarty-prig because I keep my own place up as tidily as I can and because people love my studios with clean animals about and my paintings, and say complimentary things? I seldom mention what they do say just because she acts so queer

and jealous. Perhaps she felt bad yesterday. Perhaps she felt sad because she was sorting up her school things, battered desks and tables and books, to make room for me. She *acted* as though she wanted me to go there to live. I so want to live happily beside her and yet I can't bear disorder. I'm like Father. Things about me must be straight and nice, except for art litter which is unavoidable.

February 2nd

I have just had such a warm greeting and appreciation from a woman unknown to me. She did not even give her name. She wanted to know if she could get my books. She had heard my broadcast and loved "Sunday." She said it made her own childhood so clear. She did not know when she had ever enjoyed anything so much. I have had several calls of appreciation. One woman said, "What a fine man your father was to bring you up like that." I was glad that I had shown them Father's straightness.

Last night I did a lot of cleaning out of oddments, things necessary and things unnecessary to one's life. We clutter ourselves with a great deal of stuff, and yet when we turn that accumulation out we feel that there must have been a purpose in hoarding it. It shows us we were not quite through with it. Some of us assimilate so slowly that we have to go over and over a thing before we have got what was in it for ourselves. The half-thoughts that I wrote down bring back some memory of an experience. Maybe we have outgrown it now, but it helped establish our underpinnings. And all the odd people we meet in our lives, they too are grains of sand piling up to be mixed into life's foundation. The patchwork of our lives is made up of very small stitches keeping the patches in place.

Has a root or bulb the power to look up through itself and see its own blossom? Or must it live always in its own dark domain, busily, patiently sucking its life from the earth and pushing it up to the flower? How terrific the forces of nature are! To see roots split stone appals one. I think that has impressed me more than anything else about the power of growth. An upheaval is good, this digging about and loosening of the earth about one's roots. I think I shall start new growth, not the furious forcing of young growth but a more leisurely expansion, fed from maturity, like topmost boughs reflecting the blue of the sky.

February 7th

I have been having a kind of general regurgitation of my work preparatory to moving. Everything has had to be cleaned and sorted in a general review of thoughts that had shaped themselves into sketches and sketches that had shaped themselves into canvases. I've done an immense amount of work. In looking back I can see the puckerings of preparation for ideas that burst later and bore fruit, little brown acorns that cracked their shells and made little scrub thickets full of twists, and a few that made some fairly good oaks. Tired though I am, I want to start working again. The after-looks at some things have made me anxious to wriggle out of that particular rut and to try another. After four months lying dormant owing to moving and flu, I itch to hold a brush and catch up with myself. I have written a lot in bed, even during the upheaval of moving preparations, for I can only put in from noon to six o'clock at manual work. But in the early morning I can write, sometimes as a sedative. I write when I can't sleep for planning. Usually I dare not write at night or my mind is too stirred for sleep, but in this stress writing seems to calm it. I can lose myself in my story.

February 8th

The last two Mondays I have been "on the air" and listened to my own thoughts coming back to me like echoes out of space. Dr. Sedgewick reads them beautifully. The first he read was "Sunday." The public chuckled, at least Victorians who have mentioned it did. It amused them and many tell me that it brings their own childhood back to them very clearly, and others say the pictures are very vivid to them. The second time Dr. Sedgewick read three short Indian sketches that were from my account of Ucluelet. The first gave the church and the old man who came without pants and the second was a description of the village itself. The third was "Century Time." I think I liked these better than "Sunday." They were not so amusing but went deeper, and were more adult in perception. Perhaps I shall never do anything beyond my Indian stuff because it struck into my vitals when I was freshly maturing into young womanhood and my senses were keenly alert. The ever-growing universe called to the fast-developing me. The wild places and primitive people claimed me.

Last Saturday the picture half of me moved. Next Saturday the rest of me moves. Today is Thursday. The little cottage looks mournful. Partial emptiness leaks out of the rooms. The "derelicts" waiting in one room to be taken to the auction room look dilapidated and forsaken. That which moves with me waits, huddling together like a lot of sheep waiting to be herded into a new pasture. Houses don't like being empty. The corners cry out when you speak.

The creatures are suspicious of all the stir. The canaries sing harder as if they wanted to drown the lonesome echoes. The garden has grown bald spots. The old Chinaman dug the flowering shrubs gently and wrapped cloths about their roots, tipping a gentle shovel of earth into each bundle like giving to each sad child a lollipop to soothe it. Then a waggon came and I drove off with my shrubs, sitting among their roots, their leaves tickling my ears as we drove. We lowered the plants into the new-dug holes as soon as possible. I can fancy the little roots feeling their way into the new environment slowly, exploring the soft, strange earth. The leaves were a little drooped and the good new earth silently called to them, anxious to give them life when they were in heart again to tackle it.

It is a sober business this uprooting, this abandoning of a piece of space that has enclosed your own peculiarities for a while. Up and down the street each house and lot is full of individual queernesses seamed together by fences, a complete patchwork-quilt affair, with a street running down the centre. Alice's street will be different, more select, with no bawling youngsters, no workmen's dinner pails, no up-and-downers to the corner shop, to return with loaves and milk. The street cleaner goes down St. Andrew's Street but Beckley Street knew him not.

Alice is hurt so easily and I am rather clumsy, I fear. If I enthuse over the new flat, she withers up like a fern you have drawn through a hot hand, or shrugs and says, "It suited *me* before all these changes." If I don't enthuse, she thinks me unappreciative and hard to please. It must be dreadful groping round in perpetual twilight with blindness peeking and mowing at you from all the corners. It must be my special care to watch my clumsy steps, to leave her as much alone as she wants and yet to watch how I can help without seeming officious, never, never trespassing beyond my rights as a

tenant. That house is her obsession and she craves admiration for it. I shall have the better part of it. My workmen have done a good job. The old derelict who fixed her part did a rotten job but she would not heed either Joan's telling or mine, and only got furious with us for trying to warn her. There is no one in the world more obstinate than Alice.

February 23rd

Goodbye to Beckley Street. There is one load left. All else is packed. I am very tired. A new page of life is about to turn and my finger is licked to flip the corner. It is four years to the day since I took possession and cried for the awful ache of the moving forlornness. I came in alone because Lizzie was too sick and Alice was busy with her kids. Good old Willie found me crying on a stool behind the front door. How little my sisters ever entered into the important shake-ups of my life! Alice, nearly blind and so bent and decrepit, has done all she could this move, working more than she ought to have done, and Willie is again to the fore, good, dependable, fussy old Willie. Fourteen-year-old Florence has done well; she stuck at it like a Trojan.

The canaries and Joseph are already in place in the new house. I do not regret leaving any of my neighbours. They are all right. I have found them good enough neighbours but we meet so surfacely. Our interests and outlook are entirely different. I resent the unswept, dirty street littered with chocolate bar papers. Now I am going home to end my life a few yards from where I started it. How shall I paint and how write in the new environment, or are my work days done? Goodbye, little cottage.

Everyone says, "Ah, that is much better! It will be so nice for you to go back to the old place." The insinuations are a little dig in the ribs to Beckley Street, as if to say, "That was a pretty poor part." Well, it was not. I have had four of the calmest and best working years of my life there. I have had more distinguished visitors, sold more work, had more recognition and been more independently myself than ever before. Lizzie criticized my living. She was always watching for things that were not up to her conservative estimate of what Carr actions should be. Alice was equally indifferent to

whether I was 646 Simcoe or 316 Beckley, though she did rub in the superiority of St. Andrew's Street.

February 25th—218 St. Andrew's Street
At 10 a.m. we moved. I said goodbye to Mrs. Newal and Mrs. Leckie, to Grannie and Mrs. Hobbs, and to the children who swarmed to see the last things being put into the van. The new house was ready, in a way, with good Willie waiting to help. Florence was a little aghast at the smallness of the kitchen and the immensity of the packing cases. The dogs were patiently excited in their boxes. Their little yard was all ready for them. The birds were fretting at the small cages and rejoiced ecstatically when they were liberated into the verandah cage. The chipmunks, all newly mossed down, nervously sniffed the change. And me all mussed and pretending not to be fussed.

The verandah was one awful mess of recent rain on oily paint, indescribably mussy and dirty. The dreadful floors are still unpainted. The garbage pail was flaunting its beastliness at the front door, being as ugly as it could in its short spell of aristocratic location. The pictures were hiding their faces to the walls. The old clock was willing to tick, given an upright position, even though it was bereft of its appendages. Alice's bush was full of sparrows, cheeping their hearts out and watching the affluent canaries and doves with their full seed hoppers. Neighbours' eyes followed neighbours' noses as near to the fence as their dignity permitted. Their curtains fluttered between curious fingers and peeking noses. The wind knifed in draughts round the blindless and curtainless windows. The calmest things in the house were the geraniums sitting on my bedroom window-ledge, green and scarlet and serene, chewing sunlight and air as contentedly in St. Andrew's as in Beckley Street, growing every moment and taking their lowly sips of life from a tiny flowerpot full of earth.

Florence and I went to the forlorn and forsaken Beckley Street and cleaned up the empty house, ravished garden and voiceless bird house. We burned the last of the bird house's cedar boughs and they crackled up to Heaven with parched, independent roars and a sweet

smell. Then we doused water on the live ashes. We locked both doors and got into a waiting taxi with the cage of grumbling love-birds. I ran back again to gather a goodbye handful of wallflowers from the bush by the step. I had to take a great many heart pills yesterday, more than any day; weariness and fear of a final stroke agitated my heart.

We came back to 218 St. Andrew's to find the great glutton of a fireplace cleared out and my little old stove giving the whole place a fine heat. It was a great relief for I was anxious about the cold of the flat and how I was going to make do. The birds tried in every way to break their bonds and I have had to swathe their cages in muslin. Lovers have got parted in the three separate cage groups and there are bitter quarrels. Willie is working on the aviary but until it is finished there will be civil war in birddom.

The wild riot of furniture begins to sort itself a little. Tables are tables again and chairs prepare to accommodate people instead of a miscellany of objects. The pictures are still dumb. The geraniums alone are exultantly cheery. They like life and human society better than the colder aloofness of a cottage front room, though I used to visit them often. The big begonia sulks and has flung his leaves to the ground. His gnarled, woody stalks were pruned back and tied together to avoid breaking in transit, and he is mad.

Night

As I cannot sleep, I may as well write. The house begins to be a home. The unfamiliar places are beginning to fold the familiar objects into their keeping and to cosy them down. Objects that swore at each other when the movers heaved them into the new rooms have subsided into corners and sit to lick their feet and wash their faces like cats accepting a new home. The garden is undeniably mine already, with its neat fence and the griffon dogs. The great brooding maple is thinking of spring and with half-waked stir is drawing the juice from my little patch of earth. The big fuchsia and the young japonica, blushing with its first year's blooming, are set orderly against the newly painted walls, with thongs of moose hide from the North softly restraining their young branches. Spring won't be long now. We two old winter birds will welcome her.

Alice says pitifully, "What is there?" as she stoops and feels some tender young thing springing from the earth. It must be terrible knowing that she cannot expect to see them with those eyes any more, and having to rely on other people telling her. It is like learning a new world, comprehending by touch, smell and sound. Thwarted sight cries out to sort things for itself in the accustomed way.

My bedroom is large and has a great deal in it, not only furniture but millions of memories, memories of when it was the school dining-room and I took noon dinner at my sister's. Alice carved at one end of the big table and Lizzie slapped vegetables on plates at the other, making cheerful or fretful conversation. Many, many children have sat in this room, nice ones and nasty. Suddenly they all come trooping hungrily in again from the schoolroom, clambering into high chairs or mounting upon the big dictionary or a cushion to allow their fat elbows and round faces to appear above the table edge, nice, funny little tykes or rude, home-spoiled horrors. Alice patiently pecks at them, "Other hand, Billie. Don't chew out loud, Sally. No talking. Eat a little of the fat too." Then there is the scraping of chairs after being excused and a row of children standing by the kitchen sink to have the maid untie their bibs and sponge their lips and fingers. Lizzie would streak like a stone from a catapult back to her own house, to her dusting and her charities, and I would have a little chat with Alice as she dribbled water on the flowers in the glass alcove of the schoolroom, one eye and ear on the children playing in the yard, running to the door every five minutes to say, "Stop yelling! I won't have it, children!" Then I would go round the corner to my own house and the job of landlady, which I detested, or would scurry off to paint in some woods, which I loved. Time dragged on, pulling us with it regardless of everything, drawing us through the successive seasons indifferent to our grunts or grins. Life's interesting. There is so much to see, so much to bite off and store and chew on—chew, chew—like cows converting our croppings into the milk and meat of life.

February 29th
I am unutterably weary but happy in the satisfaction that we are

on the high road to being established permanently. It is nicer and cosier all the time. I had visitors today and the carpenters came to finish up odds and ends. I feel very content with it all. I think Alice is too but she would not admit for worlds that it was improved. The builders tell me that the house was practically tumbling down and was waterlogged and rotted at the corners from broken gutters. Every door was out of whack. Blinds, oh! Floors, oh! Paintwork, oh! Now it is beginning to look loved and cared for. The poor old lilac tree has had the trash cleaned from between its branches and the suckers pruned out. The brambles and trash outside my windows are gone. The bird houses are neat and will be attractive when painted. Alice mourns over these innovations. It seems as if she wanted these things to age and grow dilapidated to keep pace with our own ageing.

March 2nd
Big things bump into you, bruising. Little things chafe and nag and have no finality. The thousands of little chores pertaining to cleaning up and to the decencies of living squeak, "Me, me, me!" all clamouring to be done first. Big things have taken all my energy and bounce; the squeaking of the little ones irritates me now.

The sun is determined to show up every blemish in the window fixings. I promise myself a day of recovery in bed but I cannot hoist myself high enough above minor details to rest. The birds are liberated into the new aviary and the chipmunks are there too. All are delighted after a week in small, crowded cages. The budgies stretch and preen. Reunited lovers kiss and beak each other's whiskers. The chipmunks creep with little jerky darts, scampering in and out of their cage which serves as a mossy run so that they can go in and hide when they feel exclusive. The birds do not notice their comings and goings. The aviary is a weave of beautiful colour and swift movement. It is delightful. I called to Alice, "Come and see." She came crossly. "I can't see them, so what's the good of my coming?" She began grumbling about the cage's location, able to see the scattered lumber and missing the lovely bird part. Good old Willie has tried so hard to please us and has done everything so kindly and well that I feel ashamed of her nastiness to him. "Give us time," I

said, "and we will get everything cleared up soon." But she slammed off with a growl.

March 5th

The world is horrid right straight through and so am I. I lay awake for three hours in the night and today as a result I am tired and ratty even though the sun is as nice as can be. I want to whack everyone on earth. I've a cough and a temper and every bit of me is tired. I'm old and ugly, stupid and ungracious. I don't even want to be nice. I want to grouch and sulk and rip and snort. I am a pail of milk that has gone sour. Now, perhaps, having written it all down, the hatefulness will melt off to where the mist goes when the sun gets up. Perhaps the nastiness in me has scooted down my right arm and through my fingers into the pencil and lies spilled openly on the paper to shame me. Writing is a splendid sorter of your good and bad feelings, better even than paint. The whole thing of life is trying to crack the nut and get at the bitter-sweetness of the kernel.

Some copper wire, a spot or so of electricity and a curly-headed youth have hitched me to the round world and, marvel of marvels, voices, travelling unaccompanied by their vocal cords and all the other fleshly impedimenta, are visiting in my studio. Silly gigglers, ghastly crooners, politicians, parsons, advertisers of every known commodity, holy music, horrid music, noise with no music, the impartial air carries them all, distributing to any who have a mind to tune in. The ghastly breath of war roars and bellows. Someone has collected the dregs of terror, stirred them into a fearful potion, and poured them on to the air.

The wind is tearing and roaring. The heavy cedars on the boulevard of St. Andrew's Street writhe their heavy, drooping boughs. Shivery and flexible, they never break; they only toss in agonized swirls. It has been a brutally bullying day.

March 6th

Today I received a compliment which pleased me. I was just through with giving a grocery order when the grocer's rather gruff voice said, "Say, are you the Miss Carr whose stories were on the radio recently?" "Yes." "Well, I want to tell you how much my wife and

I enjoyed them. We were sorry there were not more. Say, won't there be more? We liked them. They was humorous, they was." And Una wrote how thoroughly she's enjoyed them. That was most *warming*, from one of the family.

The house is now curtained. Curtains are foolish. Why leave "see-outs" in walls and then blind the vision with cataracts of curtaining? I have only done what is necessary to quell the fierceness of the sun for painting, to comply with the law about the world seeing one's raw flesh, and to satisfy Alice that her house looks decent. All are on quickly pushed-back rings so that except when absolute modesty or painting necessitates I can face the outside. I can see the beautiful cedars on the boulevard and the decorous well-blinded windows of St. Andrew's Street on which, unlike Beckley Street, every soul is respectable, every garden trim, and down which the street sweeper and boulevard attendants make periodic visits. I like decency. Wild places are totally decent but tame places that are slovenly and neglected are disgusting beyond words.

We have supper at Alice's and then bed. The dog boxes are one each side of me, two boxes of calm snore to my bed full of toss. Alice kisses me goodnight and says it is nice to be under the same roof.

Morning brings cold and wet. The house is very cold this morning and it caused great indignation when I said so. I must go carefully. Alice cannot bear one criticism of her house. Her answer is always, "It suited *me*."

Later

We had tea round the studio fire—on top of it, grilling like steaks. It is comfortable enough but the great maple tree over the house is the real heat sucker and benefiter by the studio fire. When we pile logs into the huge cavern the old tree yowls, "That's my relative," and claims the heat, permitting us to have the ash. The chimney is big enough to have the boy sweeps of old go up with a hand broom. Necessary and unnecessary articles are heaped one on top of the other in the studio. The great blank windows stare. In bed with two hot bottles is the only comfort I've found yet. In time I'll get used to it. The layout is nice if only there was heat in my bedroom cup-

board. The water has soaked down the wall for epochs of time; it is sodden. What a freeze-up would be like I cannot imagine. This winter is mild, though yesterday there was sleet and penetrating cold that chilled one to the heart, and the doors and windows leak draughts. I feel like an alligator who has swapped places with a polar bear. Life is harsh, as though it had turned its deaf ear towards you.

I used to wonder what it would feel like to be sixty-eight. I have seen four sisters reach sixty-eight and pass, but only by a few years. My father set three score years and ten as his limit, reached it and died. I, too, said that after the age of seventy a painter probably becomes poor and had better quit, but I wanted to work till I was seventy. At sixty-four my heart gave out but I was able to paint still and I learned to write. At sixty-eight I had a stroke. Three months later I am thinking that I may work on perhaps to seventy after all. I do not feel dead, and already I am writing again a little.

I used to wonder how it would feel to be old. As a child I was very devoted to old ladies. They seemed to me to have faded like flowers. I am not half as patient with old women now that I am one. I am impatient of their stupidity and their selfishness. They want still to occupy the centre of the picture. They have had their day but they won't give place. They grudge giving up. They won't face up to old age and accept its slowing down of energy and strength. Some people call this sporty and think it wonderful for Grannie to be as bobbish as a girl. There are plenty of girls to act the part. Why can't the old lady pass grandly and not grudgingly on, an example, not a rival? Old age without religion must be ghastly, looking forward only to dust and extinction. I do not call myself religious. I do not picture after-life in detail. I am content with "Eye hath not seen, nor ear heard." Perhaps it is faith, perhaps indolence, but I cannot imagine anything more hideous than feeling life decay, hurrying into a dark shut-off.

The days fill out. They are happy, contented days. I am nearer sixty-nine than sixty-eight now, and a long way recovered from my stroke. There is a lot of life in me yet. Maybe I shall go out into the woods sketching again, who knows? I have got the sketches out that

I did on the trip just before my stroke. They are very full of spring joy, high in key, with lots of light and tenderness of spring. How did I do these joyous things when I was so torn up over the war? They were done in Dunkirk days when we were holding our breath wondering if those trapped men were going to get out. We did not know the full awfulness of it then; we were guessing. Yet when I went into the woods I could rise and skip with the spring and forget my bad heart. Doesn't it show that the good and beautiful and lovely and inspiring will of nature is stronger than evil and cruelty? Life is bigger than war and the tremendousness of spring can wash out the dirt of war. The terrific thing that is working over the nations is quite beyond the human. It is no good being dismayed. It is as inevitable as night. Tomorrow can't come till the night has finished today. Nature finishes off one season's growth and begins all over again. Her worn-out cast-offs contentedly flutter down to the honourable joy of fertilizing the soil so that the new growth may better thrive from their richness. It is not dismayed when it turns yellow and sere, when it shrivels and falls.

October 23rd

Lawren and Bess Harris came to Victoria from Mexico and paid me a three-and-a-half-hour visit, rooting well through my picture racks and expressing pleasure in them. I said to Lawren, "You have not told me of the bad ones," and he said, "There are none." But I expect he found them tame after abstraction. He said that I was after the same thing as he was but had not gone so far. He thought my work had gone on. He seemed, I thought, to hanker back somewhat to the more advanced Indian material. He spoke little. I felt that they were both taken aback to see me aged and feeble. For days on end I have had a steady headache and feel very, very tired and old.

December 13th

I am sixty-nine years old today. It has been a nice birthday—cold, bright and frosty. Such lots of people remembered my date. Lollie Wilson and Hattie Newbery came to tea; Ruth Humphrey and Margaret Clay looked in, one with cigarettes and one with flowers. Alice asked Flora Burns to supper and we had a nice evening round

the fire chattering. A *very* satisfactory birthday. Only one more year of man's allotted time to go.

I do not mourn at old age. Life has been good and I have got a lot out of it, lots to remember and relive. I have liked life, perhaps the end more than the beginning. I was a happy-natured little girl but with a tragic streak, very vulnerable to hurt. I developed very late. Looking back is interesting. I can remember the exact spot and the exact time that so many things dawned on me. Particularly is this so in regard to my work. I know just when and where and how I first saw or comprehended certain steps in my painting development. Of late years my writing has shown me very many reasons for things. I do not resent old age and the slowing-down process. As a child I used to say to myself, "I shall go everywhere I can and see and do all I can so that I will have plenty to think about when I am old." I kept all the chinks between acts filled up by being interested in lots of odd things. I've had handy, active fingers and have made them work. I suppose the main force behind all this was my painting. That was the principal reason why I went to places, the reason why I drove ahead through the more interesting parts of life, to get time and money to push further into art, not the art of making pictures and becoming a great artist, but art to use as a means of expressing myself, putting into visibility what gripped me in nature.

December 20th
A week of my new year has gone already, apparently quite uneventfully. But who knows? A seed of something may have been sown and be turning over, preparing to root. I don't suppose we know from moment to moment what trivial happening is going to develop into something big or is just going to snuff right out. Maybe it is a sentence in a book or a statement by someone on the radio, or a true start, like a flight or a flower or a bird, the alive in us being caught up by the alive in the universe.

I am not writing but I have three new canvases on the way. I am being objectively busy making garments for refugees and letting my brain lie lazy after writing "Prim Pyramids," which Ruth says is not successful in its human side. The cedars are good. I know that. I ought to stick to nature because I love trees better than people. I

don't know humans as deeply. I see their faults above their virtues and they are so hideously self-conscious.

December 22nd
I have spent a long Sunday in bed. I like staying in bed on Sundays now, first because after the week of pottering busily to top-notch of power I'm tired and tottery and need it. Sunday begins at 8 a.m. when it is still very dark, with the newspaper rattling and the kindling crackling, and the kitchen door opening, and the studio door shutting, and the slip-slop of Alice's retreating footsteps. Then comes the effort of turning the radio dial and clutching the glass of lemon juice. Both are on the bedside table. "This is London calling on the overseas service of the B.B.C." and with businesslike velocity the news is vomited into the room, a mess of war. After fifteen minutes one is quite awake, completely of the earth again and not earth at its best. A tray of beastly melba toast and tea sits beside you and you feel like a stall-fed cow with her eye on the dewy pasture while munching the dry, dusty hay. Then comes a church service to which I lend an ear while I sew for refugees. Then, in my gown, I do the birds with Alice, followed by a bath and dinner, nap, tea, letters and reading aloud. The dogs never move off the bed the day I am in it. At last Alice goes off and I read a little and think a lot and Sunday has gone.

December 24th
Lawren and Bess came in today. Lawren pulled out a lot of canvases but his crits were not illuminating, although they were full of admiration and appreciation. He seemed to pick on some small, unimportant detail and never to discuss the subject from its basic angle. Trivialities. I observed that he turned back to former canvases often with epithets like "swell," "grand," "beautiful," and the later canvases he was perhaps more silent over. I wonder if the work is weakening and petering out. Perhaps so. I feel myself that the angle is slightly different. Perhaps the former was more vigorous, more disciplined, but I think the later is more thoughtful. I know it is less static. Perhaps the static was more in line with his present abstract viewpoint. He was enthusiastic enough and complimentary—but

not enlightening. Praise half as warm many years ago would have made me take off into the sky with delight. Now I distrust criticism. It seems to be of so little worth. People that know little talk much and folk who know halt, wondering, self-conscious about their words. Perhaps the best thing I got out of this visit of the Harrises was a calm looking with impartial eyes at what Lawren pulled out of my racks, things I had almost forgotten that stirred my newer and older thoughts together in my mind and made me try to amalgamate them.

December 26th

Christmas over. That anticipatory feeling lies quiet, dead level now, mixed with relief. It was a nice Christmas. Paul Newel, Alice and I dined in the studio. Alice was rather flat over it but fairly cheerful. It was to have been in her sitting room but she put her tree on the table. She'd have liked it in her kitchen with all the news and suffocation of turkey sizzling and plum pudding steaming and the low, flat roof crowding the smells down on to us, and someone falling over a cooking utensil at every move. I simply could not face it, after my stroke under similar conditions in the same place a few months back.

Paul did all the extra carrying and running. Alice cooked the meal calmly, without fuss and crowding. We ate a very nice dinner and Christmas mail came just at the end. Then we sat round the picture end of the studio enjoying cigarettes and animals, and Marjorie Henry and Willie Newcombe looked in. Then we went into the bedroom and listened to the King's speech. We had a simple supper and cleared up. Then the calm of being alone and sewing refugee garments an hour before bed. Paul may have felt it a wee bit flat his first Christmas from home in a big family, with only two old crows for company, but he did not show it.

December 28th

Why do inexplicable sadnesses suddenly swell up inside one, aching sadness over nothing in particular? There is generally some self-condemnation at the bottom of the feeling, disappointment with yourself by yourself, or else a disappointment with someone else who

makes you mad. (But in that case it is more mad than ache that ails you.) I am disappointed in everyone just now. I don't feel as if there was one solitary soul that I could open up to. Sometimes you forget and find yourself opening up. Then, like a stab, the other person suddenly shows that they don't understand, don't agree, have a different viewpoint, and you bump back on yourself with a thud that nearly stuns you. Morals and religion are the chief subjects for disagreement. Am I intolerant? I don't know. Lying, sham, belief in God, there are only two sides to questions like that—right and wrong. I don't mean the *way* of regarding those things, I mean those actual things. To church-goers I am an outsider, but I *am* religious and I always have been. But I am not a church-goer and my attitude towards the Bishop, whose narrow church views I could not accept, made my family's disgust of me thunder upon my being and pronounce me irreligious and wicked. I could not sit under a man whose views I despised. It would have been hypocrisy. Alone, I crept into many strange churches of different denominations, in San Francisco, in London, in Indian villages way up north, and was comforted by the solemnity. But at home, bribed occasionally into the Reformed Episcopal, I sat fuming at the mournful, "We beseech Thee to hear us, Good Lord," and "God be merciful to us miserable sinners." They said them in quavery, hypocritical voices, very self-conscious, and I hated it. I wanted to stand up and screech and fling the footstool and slap the prayer books. Why must they have one voice for God and one for us? Why be so conscious of their eyes on the prayer book and their glower on you? Why feel disapproval oozing from them and trickling over you? Why feel yourself get smaller and smaller, wilting like spinach in the process of being boiled? I longed to get out of church and crisp up in the open air. God got so stuffy squeezed into a church. Only out in the open was there room for Him. He was like a great breathing among the trees. In church he was static, a bearded image in petticoats. In the open He had no form; He just *was*, and filled all the universe.

December 31st
We have come to the end of 1940, and goodbye to it. Nineteen forty-one is coming in with a stir and a burst like a baby that is giving its

mother an awful time, screaming and shrieking. Will the child thrive or shrivel? It *can* die. That would break the continuity but God alone knows if it will go from one convulsion into another till we wish it would be out of its agony. I fear that we are a long way from the worst yet. Mercifully we can't see ahead. Moment by moment is enough. You can always bear the present moment; why anticipate the next hour?

I hate painting portraits. I am embarrassed at what seems to me to be an impertinence and presumption, pulling into visibility what every soul has as much right to keep private as his liver and kidneys and lungs and things which are coated over with flesh and hide. (He'd hate *them* hanging outside his skin. He'd be as disgusted as the public at the sight of his innards exposed.) The better a portrait, the more indecent and naked the sitter must feel. An artist who portrays flesh and clothes but nothing else, no matter how magnificently he does it, is quite harmless. A caricaturist who jests at his victim's expense does so to show off his (the artist's) own powers, not to portray the subject. To paint a self-portrait should teach one something about oneself. I shall try.

January 1st, 1941
At a quarter to twelve I put my 1940 light out. Alice and I had drunk some port wine and eaten some shortbread, and later we kissed and wished and separated. I had read from the hymn book this verse:

> God the all wise by the fire of Thy chastening,
> Earth shall to freedom and truth be restored;
> Through the thick darkness Thy kingdom is hastening,
> Thou wilt give peace in Thy time, Oh Lord.

Repeating it, I slipped into sleep and did not wake till the half-light of 1941 had dawned.

The radio has bawled and buzzed its string of war events. I feel sixty-nine and wonder how I would feel about war were I six or nine instead of sixty-nine. I am glad I had a childhood without war.

I finished "Wild Flowers" and gave it to my sentimental critic. She rang me with volumes of assurance that the manuscript had arrived safely—silence—"Did you read it?"—long hesitation—"Yes"—then ha's and hem's. Of course I knew it had not registered. She began picking on the construction. It had no plot. (Of course it had no plot but it had something else; it had life.) Flower character it had but that had passed right over her. I have not the least doubt it is rough, unlettered, unpolished, but I *know* my flowers live. I *know* there is keen knowledge and observation in it. I don't know how much one should be influenced by critics. I do know my mechanics are poor. I realize that when I read good literature, but I know lots of excellently written stuff says nothing. Is it better to say *nothing* politely or to say *something* poorly? I suppose only if one says something ultra-honest, ultra-true, some deep realizing of life, can it make the grade, ride over the top, having surmounted mechanics.

I was so disheartened by my critic I felt like giving up. For a week I have lain flat but today I perked slightly and decided what my other two critics have to say will interest me. If all three agree as to the badness of "Wild Flowers" I'll either quit or hide; I won't show anything to anybody again. But I think I shall work on still. I still feel there is something in "Wild Flowers." I've never read anything quite like it.

The inevitable is coming; it is surging over all. Stupendous things are happening moment by moment, terrific forces are at work. The old world is being smashed and ground and powdered. I don't think we should mourn it so much. All those marvellous cathedrals and churches were built by men who believed and worshipped. They built them to worship God in. They are now primarily for show. The holiness clinging to them was the holiness of past generations. The young have rooted God from their lives, explained him away with science. Life is nothing without God.

It is the ugliness of old age I hate. Being old is not bad if you keep away from mirrors, but broken-down feet, bent knees, peering eyes, rheumatic knuckles, withered skin, these are *ugly*, hard to tolerate with patience. I wish we could commune with our contemporaries

about spiritual stuff. With death getting nearer it seems to get harder. We think of it often, but rarely mention it, then only in stiff, unnatural words.

March 7th

Today Miss Austie took me for a drive round the park and to the Chinese cemetery. The sun was powerful, the Olympics strong, delicate blue, Mount Baker white. The cat bush is already green and the weeping willows round the lake droop with the weight of flowing life, but there are no leaves yet. Everything was splendid. The lend-lease bill has gone through in the States. The war is staggering. When you think of it you come to a stone wall. All private plans stop. The world has stopped; man has stopped. Everything holds its breath except spring. She bursts through as strong as ever. I gave the birds their mates and nests today. They are bursting their throats. Instinct bids them carry on. They fulfil their moment; carry on, carry on, carry on.